CAMERA PORTRAITS

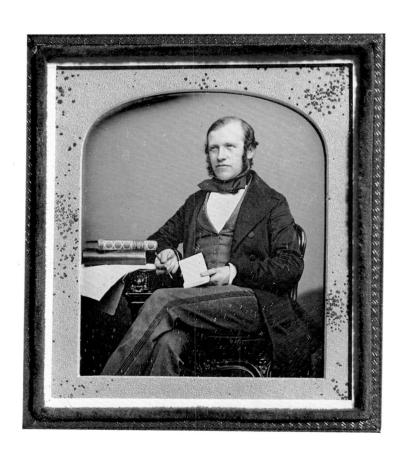

William Edward Kilburn, *Sir George Scharf, the first Secretary and Director of the National Portrait Gallery*, 1847, daguerreotype.

CAMERA PORTRAITS

PHOTOGRAPHS FROM THE
NATIONAL PORTRAIT GALLERY 1839–1989

MALCOLM ROGERS

NATIONAL PORTRAIT GALLERY PUBLICATIONS

SPONSORED BY
Mobil

Published for the exhibition held from 20 October 1989 to
21 January 1990 at the National Portrait Gallery, London
Exhibition organizer: Malcolm Rogers
Exhibition designer: Ivor Heal

Published by National Portrait Gallery Publications, National
Portrait Gallery, St Martin's Place, London WC2H OHE,
England, 1989

British Library Cataloguing in Publication Data
National Portrait Gallery. *Great Britain*
 Camera portraits: photographs from the National Portrait
 Gallery 1839–1989
 1. British portrait photographs – Catalogues, indexes
 I. Title II. Rogers, Malcolm
 779′.2′0941074

ISBN 1-85514-004-7
ISBN 1-85514-005-5 pbk

Catalogue edited by Gillian Forrester
Designed by Tim Harvey
Colour origination by P.J. Graphics, London
Typeset and printed by BAS Printers, Over Wallop, Hampshire
Limp edition bound by W.H. Ware & Sons Limited
Cased edition bound by Hunter & Foulis Limited

Front cover: Aubrey Beardsley by Frederick H. Evans, 1894 (no. 62)
Back cover: Top (left to right): Charles Dickens (no. 19); Lillie
Langtry (no. 45); Edward VII (no. 72); Amy Johnson (no. 98);
Henry Moore (no. 119). Below (left to right): Charles John
Canning, Earl Canning (no. 1); Anita Roddick (no. 150).
Jacket inside front flap: Top (left to right): Charles John
Canning, Earl Canning (no. 1); Lillie Langtry (no. 45). Below
(left to right): Amy Johnson (no. 98); Henry Moore (no. 119).

PHOTOGRAPHIC ACKNOWLEDGEMENTS

The Gallery would like to thank the following for kindly giving
permission to reproduce copyright photographs in the catalogue
in the following entries: © Gilbert Adams FRPS (110); © 1959 by
Richard Avedon. All rights reserved (131); Cecil Beaton
photograph (115) courtesy of Sotheby's London; © Bruce
Bernard (141); © Michael Birt (140); by kind permission of Noya
Brandt copyright 1989 (114, 117); © David Buckland (148);
© Cornell Capa/*Life* (121); © Jonty Daniels (109); © Daniel Farson
(124); © Mark Gerson (129); © Fay Godwin (137); © Brian
Griffin (147); © Hulton-Deutsch Collection (120); © Geoffrey
Ireland (128); © Paul Joyce (139); © 1949 Yousuf Karsh (119);
© John R. Kennedy (127); © Monika Kinley (125); © Trevor
Leighton (150); © Jorge Lewinski (134); © Simon Lewis (146);
© Cornel Lucas (122); © Mayotte Magnus (138); © Felix H. Man
Estate (113); © Angus McBean (116); © Lee Miller Archive, 1985.
All rights reserved (112); © Lewis Morley (132); © Arnold
Newman (126); © Helmut Newton (136); © Terry O'Neill (143);
© Norman Parkinson (133); © Dudley Reed (144); © reserved
(123); © Snowdon/Camera Press (130); © Wolf Suschitzky (118);
© John Swannell (145); © John Walmsley (135); © Denis Waugh
(142). Fig. 10 is reproduced by kind permission of Godfrey
Argent ©.
All other photographs are copyright of the National Portrait
Gallery.

All original photographs were photographed in colour by Frank
Thurston except for nos. 76, 90, 96, 98, 101, 108, 119, 133 and
fig. 12 which were photographed by Barnes & Webster.

AUTHOR'S NOTE

The photographs are arranged in approximately chronological
sequence.

Sizes of photographs are given (height before width) in
centimetres with the size in inches shown in parentheses.
Photographs are reproduced at the same size as the originals
where the originals measure 20 centimetres or less on their
longest dimension.

Inscriptions are noted where they give significant information.
The date given for each photograph indicates when it was taken,
and not the date of the print. The National Portrait Gallery
accession number is given at the end of each entry heading:
numbers prefixed by 'P' are in the Gallery's Primary Collection,
and those prefixed by 'X' or 'AX' are in the Reference Collection.

The names of sitters are given in their fullest form, except in the
case of living sitters where their professional or preferred names
are used. Photographers are generally given their professional
names.

Camera Portraits

As a relative newcomer to Britain (only four years into our second century here) it is appropriate that Mobil should sponsor this book, which celebrates the richness of one of the newer art forms.

The National Portrait Gallery's collection spanning one hundred and fifty years of portrait photography encompasses some of the most important personalities in Britain's past – as well as some of the most intriguing. *Camera Portraits*, chosen from the riches of this collection, offers the reader a unique opportunity to transcend the barriers of time and lock eyes with history – not in some Keatsian 'cold pastoral', but in the warm, sometimes even startling, immediacy of a private encounter face to face.

As in the case of *The National Portrait Gallery Collection*, the companion volume of paintings, drawings and sculpture in the National Portrait Gallery's unsurpassed collection published in 1988 and also sponsored by Mobil, these remarkable images speak best for themselves.

ROBERT W. WHITE
Chairman and President
Mobil North Sea Limited

Contents

Foreword

Twenty-five years ago photographs were still assigned a secondary role in the Gallery's collecting policy. Julia Margaret Cameron may have been accepted as an 'old master', but there was nothing by Cecil Beaton in the Gallery. Eminent sitters were asked to sit to the Gallery's chosen photographer, but this was purely for record purposes. There was no question of contemporary photography being considered an art form that would contribute to any deeper understanding of the personalities of the makers of British history.

All this has now changed. Today the Gallery's collection of photographs is one of the most important in the world; and, in point of distinction as well as comprehensiveness, unique as a collection of portrait photographs. However, since many of these photographs remain in our research collections, they are not as well known as they might be. The intention of this book and the accompanying exhibition is to highlight some of the masterpieces of the art which we now possess.

This volume has been prepared and published as part of the celebrations of the 150th anniversary of the invention of photography. Its contents illustrate the work of as wide a range of photographers as possible, and are virtually a history of British portrait photography. We are grateful indeed to Mobil for sponsoring so significant a publication.

JOHN HAYES
Director

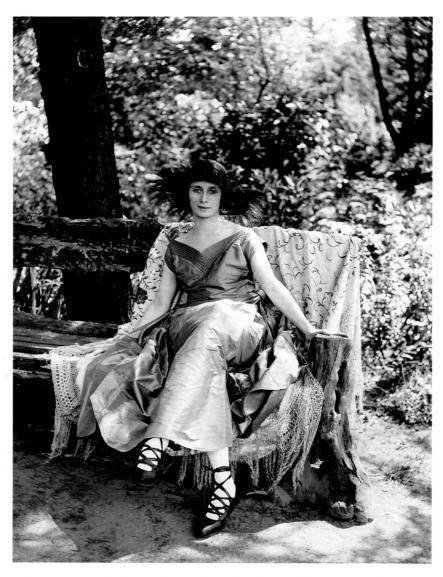

1 Bassano, *Anna Pavlova in her garden at Ivy House, Hampstead*, 28 June 1920, from the original glass negative.

Introduction

The idea of a National Portrait Gallery was first put forward in the House of Commons in 1845, and the Gallery itself founded in 1856, seventeen years after the invention of photography. This 'Gallery of the Portraits of the most eminent Persons in British History' was created in a spirit of high idealism. Lord Palmerston (no. 18) in the debate on its foundation put this into words:

> There cannot, I feel convinced, be a greater incentive to mental exertion, to noble actions, to good conduct on the part of the living, than for them to see before them the features of those who have done things which are worthy of our admiration, and whose example we are more induced to imitate when they are brought before us in the visible and tangible shape of portraits.

Among the first Trustees of the Gallery were Disraeli (no. 39) and the historian Lord Macaulay; the first vacancy was filled by Carlyle (no. 31), and the second by Gladstone (no. 38). All the Trustees were men distinguished in public life, and with a powerful sense of the history of a great nation.

They chose as the first Secretary (later Director) of the Gallery (Sir) George Scharf (1820–95; frontispiece), the son of a Bavarian draughtsman and lithographer of the same name who had come to London in 1816. Scharf studied with his father and at the Royal Academy Schools, and, like his father, worked largely as a draughtsman and book-illustrator. His natural bent was antiquarian. In 1840 he travelled with the archaeologist Sir Charles Fellows to Asia Minor, and three years later was official draughtsman on the government expedition to the same area; among the works illustrated with his efficient line drawings were Macaulay's *Lays of Ancient Rome* (1847), Layard's books on Nineveh, Dr Smith's celebrated classical dictionaries, volumes on Italian painting, Greek history and Indian ethnography, as well as the poems of Keats. In the 1850s he worked with Charles Kean (no. 9) on his revivals of Shakespeare's plays at the Princess' Theatre, advising him on the design of authentic classical costumes and scenery, and was an enthusiastic organizer of art exhibitions. But from 1857, the year of his appointment to the Gallery, Scharf devoted himself almost entirely to the study of portraiture.

When it opened to the public for the first time in 1859 at 29 Great George Street, Westminster, the Gallery owned fifty-seven portraits; when Scharf retired in 1895 (just a year before the opening of the present building) there were nearly a thousand – paintings, drawings and sculptures, but no photographs. This omission was to be expected, for the Gallery had been founded with one of its specific aims to inspire portrait artists 'to soar above the mere attempt at producing a likeness, and to give that higher tone which was essential to maintain the true dignity of portrait painting as an art'. Photography is not mentioned explicitly here, but there is an implied comparison in the dismissive 'mere attempt at producing a likeness', and perhaps also the recognition of

the threat it posed to 'portrait painting as an art'. The odds against photography were further increased by the Trustees' rule that no portrait of any living sitter (apart from the sovereign and his or her consort) was to be admitted to the collection.

Despite this, George Scharf was himself a keen collector of photographs, and as from 1857 until his death in 1895 his bachelor life was inextricably entwined with that of the Gallery, it is entirely reasonable to regard his personal collection as the beginning of the Gallery's own. Indeed, he bequeathed it to the Gallery, along with his notebooks, papers and library.

Scharf himself first sat to a photographer in 1847 – to William Kilburn of Regent Street, for a daguerreotype which is still in the Gallery's collection (frontispiece). This was taken ten years before he joined the Gallery. He is shown (in reverse, as is always the case with a daguerreotype) with a copy of Macaulay's *Lays of Ancient Rome*, and a map, presumably of Asia Minor, in allusion to his travels with Fellows, which, like the *Lays*, were published that year. In his hands he holds one of the sketchbooks which he used throughout his life as a kind of visual diary.

In the course of his career he sat to a dozen other photographers, among them Ernest Edwards (see nos. 30 and 34), Maull & Polyblank (see nos. 14 and 29), Bassano, and, in Paris at the end of a visit to the Exposition Universelle of 1867, to the celebrated French photographer Nadar (see no. 26). Scharf records in his diary for Wednesday 21 August 1867: 'Had my portrait photographed by Nadar'. In his sketchbook on the previous day he had drawn the view from the window of Nadar's studio (fig. 2). Two poses survive from the sitting. The first (fig. 3) shows him holding his exhibition catalogue; the other (fig. 4) drawing in his sketchbook. Scharf commissioned photographs of himself to commemorate significant events in his life, but above all, as was the fashion, for presentation. One of the Nadar cartes-de-visite is inscribed 'Mother'; a cabinet photograph now in the collection was presented to his Masonic Lodge, and his diary records several distributions to friends, usually at the New Year. On 6 January 1876 for instance he 'sent out Photographs of self (by [Cecil W.] Wood) to various friends', and on 13 January the following year paid Wood 12 shillings for a further twelve cabinet photographs 'of self'. As a collector of photographs Scharf was also typical of his day. He restricted himself almost entirely to cartes-de-visite and cabinet photographs, and his favourite subjects were royalty, distinguished figures in public life, singers and actors, and sportsmen. He also assembled a small album of views of places he had visited. Many of the figures in public life were his friends or acquaintances, and Mayall's carte of Charles Longley, Archbishop of Canterbury (fig. 5), for instance, was bought, as Scharf noted on the reverse, immediately after he had lunched with him, on 10 July 1863. It was his habit throughout his career at the Gallery to record his purchases of photographs in his diary, and he noted under the entry for that day that he spent 1s 9d on 'Carte de visite of the Archbp. & Punch'.

What he did not collect is more surprising. In his time at the Gallery he acquired none of the published pantheons of the famous, such as Herbert Watkins' *National Gallery of Photographic Portraits* (1857–8), Maull & Polyblank's *Living Celebrities* (1856–9; see nos. 14 and 29), Lovell Reeve's *Men of Eminence* (1863–7; see no. 30), Barraud's *Men and Women of the Day* (1888–91; see nos. 48 and 50), or Ralph W. Robinson's *Members and Associates of the Royal Academy of Arts in 1891* (see no. 55). Nor did he show any interest in the photographers who were trying to raise photography above the 'mere attempt at producing a likeness', as, for instance, David Wilkie Wynfield (no. 25) or Julia Margaret Cameron (nos. 28 and 33). Yet Scharf was aware of the value

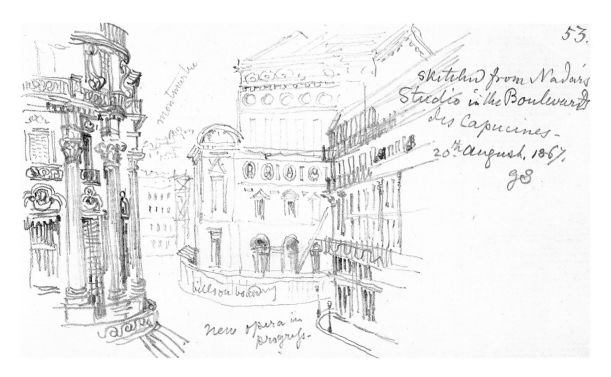

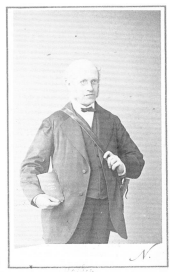 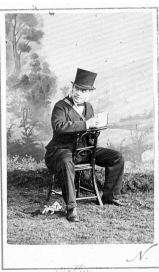

2 Sir George Scharf, *The view from the studio of the photographer Nadar, 35 Boulevard des Capucines, Paris, 20 August 1861*, silverpoint on paper.

3 & 4 Nadar, *Sir George Scharf*, 21 August 1867, albumen cartes-de-visite.

of photographs as historical evidence, and, on a visit to Florence Nightingale's home, Embley, Hampshire, in December 1857, he sketched there (fig. 6) her photograph by Goodman of Derby (no. 17).

In the years which followed Scharf's directorship and bequest – the early years of this century – the Gallery began to acquire photographs by purchase and gift for its 'Reference Portfolios'. The first to be noted individually in the Gallery's *Annual Report* was the imposing print of Queen Victoria at Frogmore (no. 60), purchased in 1901–2, in the directorship of (Sir) Lionel Cust. There followed a group of photographs of Edward VII and Queen Alexandra purchased shortly after their coronation, and in 1903–4 the Day Books of Camille Silvy (see no. 22), containing some 10,000 of his photographs 'of celebrities and well-known persons in society between 1860–1866'. This substantial acquisition did not set a precedent, and between 1904 and 1913 a mere half-dozen photographs were added to the collection. The *Report* for 1912–13 however does record one

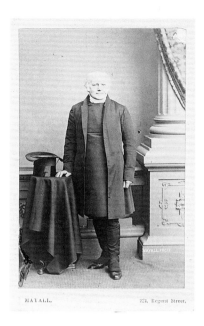

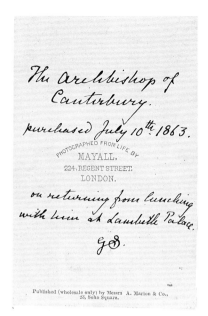

5 J.J.E. Mayall, *Charles Longley, Archbishop of Canterbury, c.*1863, albumen carte-de-visite (recto and verso).

innovation: the first photograph acquired for the Gallery's Primary or Display Collection as opposed to the Reference Collection. This was the ambrotype of Barbara Bodichon (1827–91), benefactress of Girton College, Cambridge (fig. 7), received as a gift, and given only a supplementary register number. It had to wait until 1920 for a companion – Kilburn's daguerreotype of the Reverend F.W. Robertson, author of *Two Lectures on the Influence of Poetry on the Working Classes* (1852), and then until 1932 for Mrs Beeton (no. 16).

In 1917, in the directorship of J.D. Milner, the Gallery's photographic policy advanced one stage further, with the foundation of the National Photographic Record. This had its origins in a project undertaken as an independent venture in 1916 by the photographers J. Russell & Sons of 51 Baker Street, London. In 1917 Russells donated the first batch of their photographs for the Record to the Reference Collection, and the Trustees of the Gallery then decided to adopt the project themselves and

> to commemorate by a uniform series of permanent photographs . . . the features of all distinguished living contemporaries of British nationality. In this series they hope to include all persons, naval, military or civilian, holding important or responsible positions, and others who have rendered service to their country by their valour or by their promotion of the welfare of the Empire.

Invitations to sit were sent out to a host of eminent figures (with varying degrees of success), and the official photographers were naturally Russell & Sons, a choice which aroused considerable criticism in the photographic press and anger in their fellow photographers.

Between its foundation in 1917 and demise in 1970 some 9,000 photographs were taken for the Record, mainly by Russells, and their chief photographer and chairman Walter Stoneman (see no. 111). After his death in 1958 the firm was taken over by an employee, Walter Bird, becoming Walter Bird Photography Ltd in 1961. Bird retired in 1967, when the firm was sold to Godfrey Argent, who continued the Record for a further three years.

The scheme was called a 'record' with some appropriateness, not just because it aimed at comprehensive coverage, but also because the format of the photographs (head

and shoulders or half-length), studio location, and the choice of photographer, ensured that the likenesses themselves rarely rose above the documentary. The whole project is a frustrating missed opportunity, as time and time again the eminent figures of the age are fossilized in likenesses of unimpeachable dullness (figs. 8 and 9). Moreover, Stoneman boasted his opinion that 'Women do not make beautiful photographs. Men have more character in their faces', and from 1932 onwards ceased to photograph women for the Record, with the exception of members of the Royal Family. Under the stewardship of Walter Bird the formats were varied a little to include the three-quarter-length, props such as spectacles introduced, and occasionally the photographer even ventured beyond the confines of the studio, but it was not until Godfrey Argent that the deadpan approach was finally banished. With the encouragement of the then Director of the Gallery (Sir) Roy Strong, he brought to the project a new flair and invention. He introduced new formats (including double portraits of distinguished husbands and wives), captured a wider range of emotions in his subjects, and liked to work on location. His portrait of Lord Ramsey, taken in 1969, shows the then Archbishop of Canterbury contemplating Howard Coster's photograph of one of his predecessors, William Temple (fig. 10).

In 1926, six years after the founding of the National Photographic Record, the art critic Roger Fry wrote in his introduction to a book of photographs by Julia Margaret Cameron:

> One day we may hope that the National Portrait Gallery will be deprived of so large a part of its grant that it will turn to fostering the art of photography and will rely on its results for its records instead of buying acres of canvas covered at great expense by fashionable practitioners in paint.

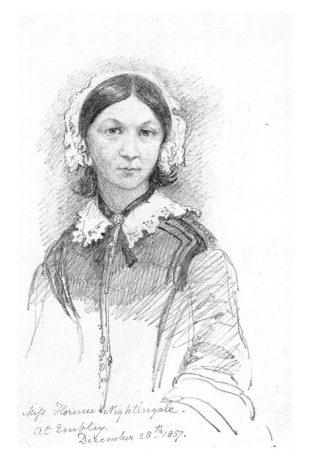

7 Silas A. Holmes of New York, *Barbara Bodichon*, 7 October 1863, ambrotype.

6 Sir George Scharf after Goodman of Derby, *Florence Nightingale*, 28 December 1857, silverpoint on paper.

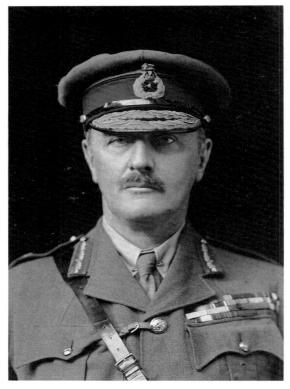 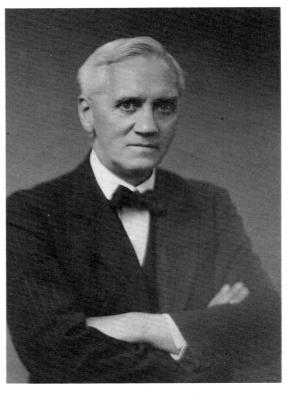

8 J. Russell & Sons, *Field Marshal Viscount Allenby of Megiddo*, 1919, bromide print.

9 J. Russell & Sons, *Professor Sir Alexander Fleming*, 1943, bromide print.

The Gallery had, in fact, acquired by gift a photograph of Thomas Carlyle by Mrs Cameron in 1922 (though in the *Annual Report* for that year the photographer is given as 'Beatrice Cameron'), and it purchased its first Cameron, again of Carlyle, in 1931. Nevertheless, Fry's views suggest that the Gallery was perceived as taking little interest in photography, either historic or contemporary. Attitudes, however, seem to have changed about this time, for in the second half of the 1920s and the 1930s the rate and significance of the acquisitions for the Reference Collection increases. Outstanding among the purchases of this period is the collection of the writer, critic and literary portraitist Sir Edmund Gosse, acquired from his estate in 1929 (nos. 25 and 56). In 1934 the then Director (Sir) Henry Hake, less than a month after Sir Edward Elgar's death, was in touch with the composer's friends about likenesses of him, and acquired two 'admirable photographs' (see no. 68). Photographers and their heirs increasingly came to see the Gallery as an appropriate home for representative collections of their work – G.C. Beresford (see no. 65) in 1933, Mrs Albert Broom (no. 81) in 1940, and Olive Edis (fig. 11; nos. 85 and 90) in 1948. The Gallery also took steps to acquire significant groups of original negatives. Negotiations were in hand to buy Beresford's negatives in 1943, and a group of them was finally acquired in 1954. Two years later the Gallery was given some 12,000 of (Sir) Emery Walker's negatives by Emery Walker Ltd (no. 49).

This process of growth continued throughout the 1950s and 1960s, but the Gallery's whole attitude to photographs and the collecting of them was transformed by four events which took place around 1970. First, the retrospective exhibition of the photographs of Sir Cecil Beaton, held at the Gallery in the winter of 1968–9, the first photographic exhibition to be mounted at the Gallery. Organized by Roy Strong and designed by Richard Buckle, this was seen by some 77,000 people, and did much to establish the taste for photography among museum visitors. Secondly, in 1969 the Trustees' rule which

barred any living sitter or person who had died during the last ten years from inclusion in the collection was abolished. Thirdly, in 1970, the National Photographic Record was discontinued in favour of a policy of buying photographs from a range of contemporary photographers: a decision which would have pleased Roger Fry. Finally, in 1972 the Gallery established a separate Department of Film and Photography with its own Keeper, Colin Ford, now Director of the National Museum of Photography, Film and Television, Bradford. From that time forward the display and acquisition of photographs for both Primary and Reference Collections have been recognized as major functions of the Gallery. There has been an outstanding series of photographic exhibitions, including one-man shows of the work of Paul Strand (1976), Arnold Newman (1979), Norman Parkinson (1981), Bill Brandt (1982), Robert Mapplethorpe (1988) and Helmut Newton (1988–9). Thematic exhibitions have included 'The Camera and Dr Barnardo' (1974), 'Happy and Glorious' (1977) in celebration of The Queen's Silver Jubilee, 'The Victorian Art World in Photographs' (1984), and 'Stars of the British Screen' (1985–6). Important acquisitions include the Hill and Adamson Albums (1973; nos. 2 and 3), and major groups of the work of Cecil Beaton (1970; no. 115), Madame Yevonde (1971; no. 106) and Dorothy Wilding (1976; no. 102), and in one extraordinary year, 1974, 2,000 prints and 8,000 negatives of distinguished figures, mainly writers, by Howard Coster (no. 108); 2,000 prints of his parliamentary colleagues by Sir Benjamin Stone MP (no. 73), and some 30,000 negatives of the firms of Bassano & Vandyk (fig. 1) and Elliott & Fry, dating from the 1890s to the 1950s. These last constitute, like the Silvy Day Books before them, an invaluable survey of English society of the period. In recent years a particular effort has been made by the Gallery's Twentieth Century Department to watch and encourage the careers of the best young portrait photographers, as exemplified by the exhibition

10 Godfrey Argent, *Baron Ramsey of Canterbury when Archbishop of Canterbury*, 1969, bromide print.

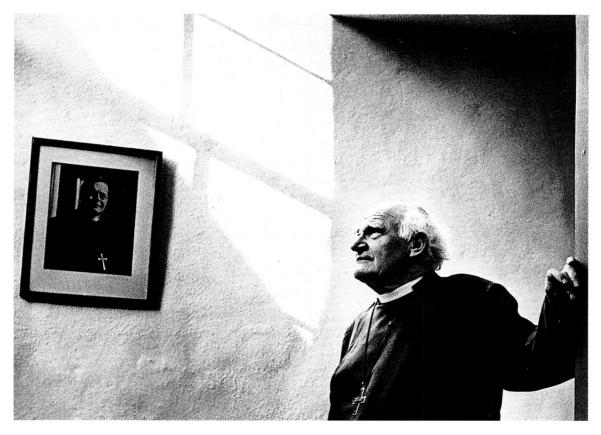

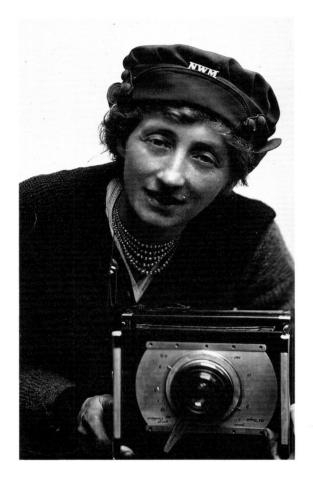

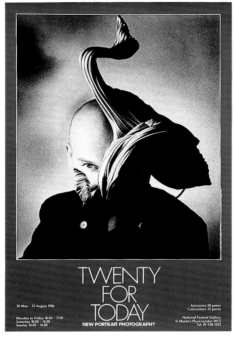

12 Poster for the exhibition 'Twenty for Today',
with Nick Knight's portrait of Stephen Jones, 1985.

11 Olive Edis, *Self-Portrait 'ready to start to
photograph the British Women's Services in France
and Flanders'*, 1918, platinum print.

'Twenty for Today' (fig. 12). This included the work of Michael Birt (no. 140), David
Buckland (no. 148), Brian Griffin (no. 147), Trevor Leighton (no. 150) and Dudley Reed
(no. 144). The collection has been greatly enriched as a result.

In 1989 the Gallery's photographic collections comprise more than 100,000 images,
dating from the early 1850s to the present day: an extraordinary accumulation, brought
together partly by chance and partly by design. At its heart is a certain ambiguity,
for, though it contains many masterpieces of portrait photography, the collection has
always been envisaged as a historical one: a collection of eminent figures, who may
or may not have been captured by great photographers. This book reflects that ambi-
guity. It contains many photographs which are objects of considerable aesthetic beauty,
and some which are not; the humble snapshot (no. 93) has its place beside the most
rarified concoction of the art studio (no. 94); all have been chosen for their historical
and cultural significance. This is not historical academicism, for these images have a
power to stimulate the imagination and stir the emotions. As portraits they bring before
us men and women who are now, or one day will be, lost to us as physical presences,
and they are thus a means of making contact with the great spirits of the past. Thomas
Carlyle wrote of his own experience:

> In all my poor historical investigations it has been, and always is, one of the most
> primary wants to procure a bodily likeness of the personage inquired after – a good
> portrait if such exists; failing that, even an indifferent if sincere one.
>
> In short, any representation made by a faithful human creature of that face and
> figure which he saw with his eyes, and which I can never see with mine, is now
> valuable to me, and much better than none at all.

And again:

> Often have I found a portrait superior in real instruction to half a dozen written biographies. . . . or, rather let me say, I have found that the portrait was as a small lighted candle, by which the biographies could for the first time be read.

He was thinking primarily of painted portraits, but his remarks apply equally to photographs. Indeed, the initial impact of a photograph may well be greater than that of a painted portrait. Whatever insight it gives into character or qualities of mind – and this may be as great as in any portrait – it offers above all a magical illusion of that physical reality, of a specific moment in time and place, which has gone forever. We see, as the camera saw, Lord Raglan in the Crimea (no. 6), a courageous man in a situation where courage is of little help; Queen Victoria quietly working in her garden at Frogmore, her *munshi* standing silently by (no. 60); the poet Isaac Rosenberg, a Private on leave from the army in a commercial studio in Notting Hill Gate (no. 83); E.M. Forster in Aldeburgh struggling with an idea (no. 120). Some photographs, like the ambrotype of Derwent Coleridge and his wife (no. 10), may still be timed to the very minute, and, though they are only fragile objects, seem to represent a triumph over time. Marie Lloyd (no. 51), photographed in New York a hundred years ago, is caught at that moment and, it seems, forever in the thinnest layer of albumen. She beckons to us across the years and offers the promise which is also the promise and fascination of all photographs; that is: 'Yours Always'.

Acknowledgements

In the preparation of this book I am indebted for their help to Miss Frances Dimond of the Royal Archives, Windsor Castle; Professor Urmilla Khanna of the University of Delhi; Miss Louise West of the Ferens Art Gallery, Hull; Dr Pieter van der Merwe of the National Maritime Museum, Greenwich and Eddie Chandler, Dublin. Many of my colleagues at the Gallery have given me advice and encouragement, but I owe a particular debt to Terence Pepper of the Photographic Archive, without whose enthusiasm for the subject and great expertise this work would have been impossible. His colleague, Ian Thomas, has given invaluable support, as have Dr Tim Moreton, Julia King and Penny Dearsley. Gillian Forrester has been a meticulous and creative editor. Above all I am grateful to those contemporary photographers whose work is featured here who have supplied biographical information, donated or lent prints and transparencies, and waived copyright fees.

MALCOLM ROGERS

I

Charles John Canning, Earl Canning 1812–62

Richard Beard 1801–85

Daguerreotype, with the photographer's imprint on the gilt slip, early 1840s
5.1 × 3.2 (2 × 1¼)
Purchased, 1979 (P119)

A son of the great statesman George Canning, Charles Canning entered politics in his twenties, and rose rapidly. In 1841 Sir Robert Peel appointed him Under-Secretary for Foreign Affairs, and this daguerreotype was probably taken in London shortly after that date. A controversial Governor-General of India (1856), he steered the subcontinent through the crisis of the Indian Mutiny, and in 1858, following the transfer of the government of India from the East India Company to the Crown, became the first Viceroy. He was created an earl in the following year.

Richard Beard, a coal merchant from Blackfriars, London, set up in photography as a business speculation. He purchased a licence to use the daguerreotype process in March 1841, and opened the world's first photographic portrait studio. There were huge profits from his studios in London and Liverpool and from the sale of licences to take daguerreotypes, but Beard was ruined by his many legal actions against rivals, above all Claudet (no.4), and went bankrupt in 1850.

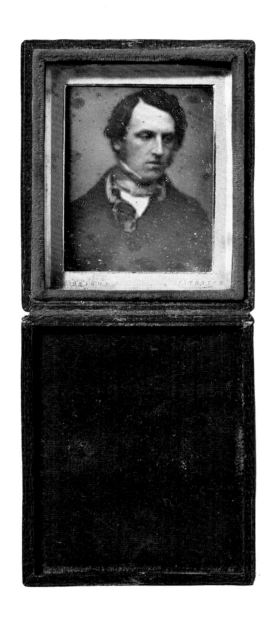

2

Sir David Brewster 1781–1868

David Octavius Hill 1802–70 and Robert Adamson 1821–48

Calotype, *c.*1845
19.4 × 14.4 (7⅝ × 5⅝)
Given by an anonymous donor, 1973 (P6/10)

The Scottish physicist Sir David Brewster was a founder member of the British Association for the Advancement of Science (1831), and a key figure in the early history of photography in Britain. Much of his own experimental work was devoted to optics – he invented the kaleidoscope (1816) and the lenticular stereoscope (see no. 4) – and he was a close correspondent of Fox Talbot, inventor of the calotype, who wrote explaining the process to him in May 1841.

It was Brewster who persuaded Robert Adamson to make a profession of calotype photography, and who introduced him to the painter D.O. Hill, with whom he worked in partnership from a studio in Edinburgh until 1847. In their photographs, 'executed by R. Adamson under the artistic direction of D.O. Hill', Adamson's scientific technique is transformed by Hill's aesthetic sensibility. The Gallery owns three albums of their finest work, presented by Hill to the Royal Academy in 1863, and given to the Gallery by an anonymous benefactor in 1973. They contain 238 prints, covering the whole range of Hill and Adamson's work: portraits, studies of fishermen and fishwives, topographical and genre scenes. See also no.3.

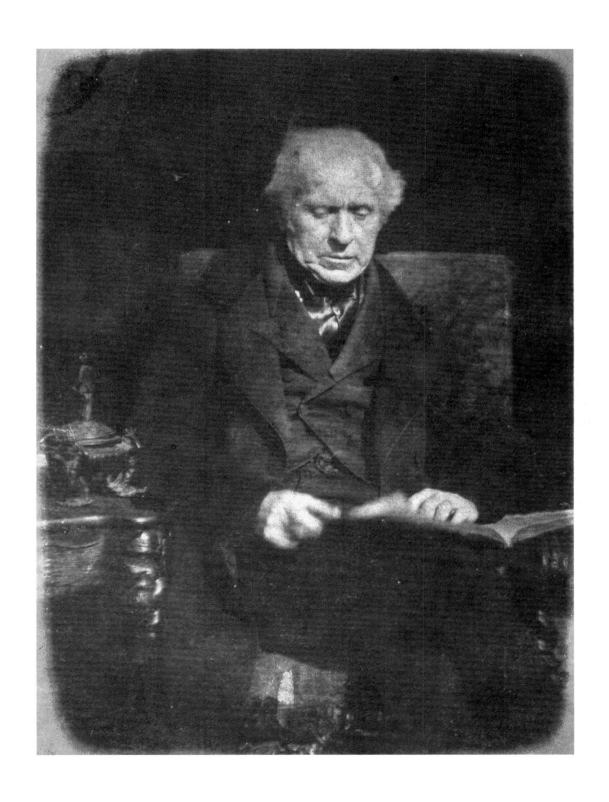

3

Anne Palgrave, Mrs Edward Rigby 1777–1872
and her daughter Elizabeth, Lady Eastlake 1809–93

David Octavius Hill 1802–70 and *Robert Adamson* 1821–48

Calotype, *c.*1845
20.1 × 14.8 (8 × 5⅞)
Given by an anonymous donor, 1973 (P6/134)

Mrs Rigby was the widow of the physician Edward Rigby of Norwich, by whom she had twelve children (including quadruplets). In October 1842 she moved with two daughters, Elizabeth and Matilda, to Edinburgh. There Elizabeth, who had already travelled in Germany and Russia and published *A Residence on the Shores of the Baltic*, worked for the publisher, John Murray, at whose house she met Hill. She, her mother and sister often visited Hill and Adamson's studio at Rock House on Calton Hill, and were photographed there on several occasions. This double portrait of mother and daughter, which has the atmosphere of a genre study, is one of the photographers' most poetic treatments of the fall of light on fine fabrics.

In 1849 Elizabeth married Charles (later Sir Charles) Eastlake, future President of the Royal Academy, Director of the National Gallery and first President of the Royal Photographic Society. In London this statuesque bluestocking (she was almost six feet tall) moved in the highest intellectual, literary and political circles, and pursued a long career as critic, art historian and biographer (among her subjects was the sculptor John Gibson [no. 26]).

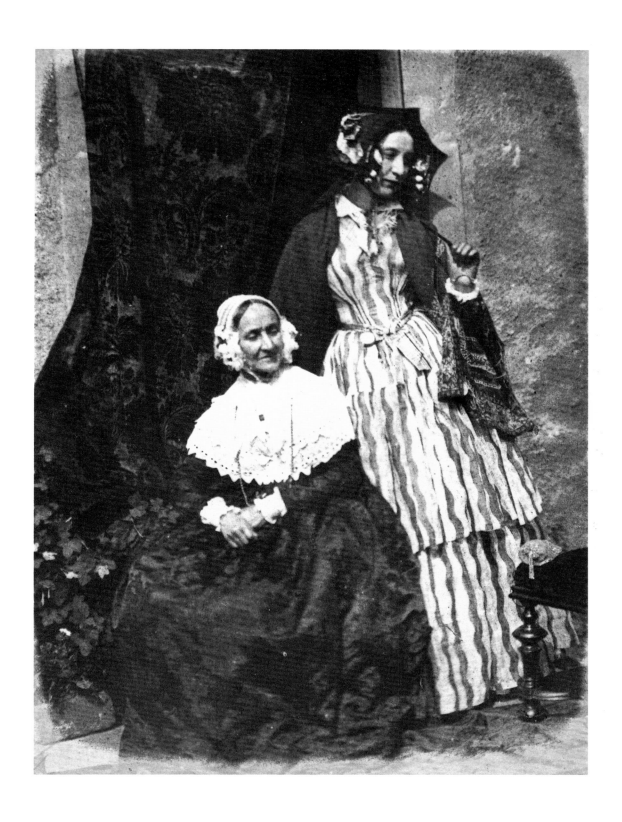

4

Sir Charles Wheatstone 1802–75 and his Family

Antoine François Jean Claudet 1797–1867

Stereoscopic daguerreotype, with the photographer's label on the backing, c.1851
Each 7.3 × 5.7 (2⅞ × 2¼), arched top
Given by the Governing Body of King's College, London, 1980 (P154)

The sitters are (left to right): Arthur William Frederick, son (born 1848); Wheatstone; Florence Caroline, daughter (born 1850); Charles Pablo, son (born 1857), and Emma West, Mrs Wheatstone (c.1813–65), who died before her husband's knighthood.

Charles Wheatstone began his career as a musical instrument maker, and from the start revealed his powers as an inventor when he patented the concertina (1829). He was the first to make possible the sending of messages by electric telegraph, a pioneer of submarine telegraphy, and instrumental in the creation of the modern dynamo. In the history of photography he has a special place, for in 1832 he invented the stereoscope, by which an impression of solidity in an image is obtained through the combination of two pictures in slightly dissimilar perspective. He announced his discovery in 1838, a year before the invention of photography, and, on the publication of Fox Talbot's and Daguerre's work, he quickly asked the leading photographers (among them Richard Beard [no. 1]) to take pictures for his instrument. It was not however until the invention of the lenticular stereoscope by Sir David Brewster (no. 2) in 1849 that it was possible to obtain a satisfactory result from stereo-daguerreotypes. These were displayed at the Great Exhibition in 1851, and thereafter achieved widespread popularity. This seems to have gone to the head of Brewster, who claimed pre-eminence over Wheatstone, and there followed a war of words in which the Scotsman showed especial spite.

Claudet, a native of Lyons, came to London in 1829 and opened a glass warehouse in High Holborn. He was the first to import daguerreotypes and cameras from France, and soon eclipsed his rival Beard. He applied himself keenly to the development of stereoscopic photography, and was largely responsible for its popularity. His pictures were taken by two cameras set up side by side – there was no binocular camera – and this gives them an effect of exaggerated rotundity. This historic photograph shows the inventor of the stereoscope surrounded by his family. A man of 'an almost morbid timidity', he turns away from the cameras to examine one of his own inventions, the wave model (c.1840) by which he demonstrated the wave properties of light.

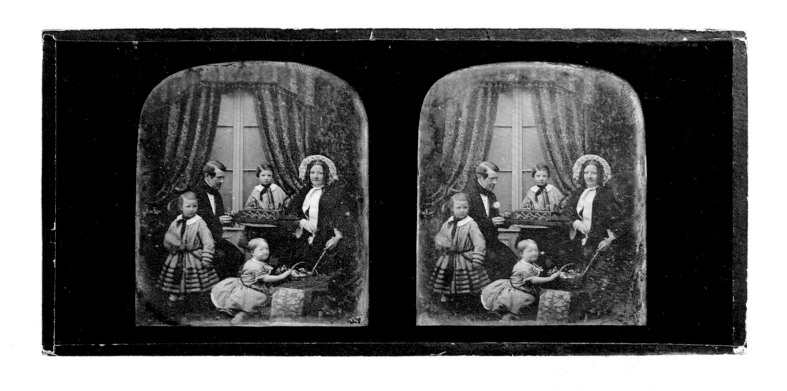

5

Robert Stephenson 1803–59

Unknown photographer

Daguerreotype, *c*.1851
11.4 × 8.9 (4½ × 3½)
Given by Miss M.K. Lucas, grand-daughter of the painter John Lucas, 1927 (P4)

The only son of the pioneer of railways, George Stephenson, Robert Stephenson's early career was spent in the locomotive business, and the famous *Rocket* (1829) was built under his supervision at his father's Newcastle works. But his enduring fame rests on his work as a civil engineer, and above all on his bridges: the high-level Tyne bridge at Newcastle, the Royal Border Bridge at Berwick, the Britannia Bridge across the Menai Straits (1850), in which tubular girders were used for the first time, and the Victoria Bridge across the St Lawrence at Montreal.

To commemorate the building of the Menai Bridge the artist John Lucas painted for the Institute of Civil Engineers his group portrait *Conference of Engineers at the Menai Straits prior to floating a Tube of the Britannia Bridge* (*c*.1851–3). In this the central figure of Stephenson is based closely on this daguerreotype, which was given to the Gallery by a descendant of the painter, and may have been taken specially to help Lucas in his project. If so, it is likely that the artist himself suggested Stephenson's thoughtful pose.

6

Lord Fitzroy James Henry Somerset, 1st Baron Raglan 1788–1855

Roger Fenton 1816–69

Salt print, on the publisher's printed mount; taken between March and June 1855
20 × 14.9 (7⅞ × 5⅞)
Purchased, 1983 (AX24901)

The youngest son of the Duke of Beaufort, Raglan entered the army at the age of sixteen, and was later aide-de-camp and military secretary to Wellington. He lost his right arm at Waterloo, and after the amputation called to the surgeon: 'Hallo! don't carry away that arm till I have taken off my ring'. In 1854, aged sixty-five, he was chosen to command the British troops against the Russians in the Crimea, but, though highly experienced in warfare and heroically brave, he had never led troops in the field. His victory at the Alma raised hopes for the prompt capture of Sebastopol, but the calamity of the Light Brigade at Balaclava (October 1854), a winter of starvation, and the disastrous attack on the Malakoff and the Redan before Sebastopol in the spring of 1855 were blows to morale both in England and at the front. He died of dysentry on 28 June, 'the victim of England's unreadiness for war'.

Roger Fenton first trained as a painter in Paris with Paul Delaroche, famous for his pronouncement, when confronted with a daguerreotype, 'From today painting is dead'. In 1852 Fenton circulated his 'Proposal for the formation of a Photographical Society', and, after its establishment, became the first secretary. He was the British Museum's official photographer, and in 1854 had a dark room built at Windsor Castle for the use of Queen Victoria and Prince Albert. In 1855 he was commissioned by the art dealers Thomas Agnew & Sons to photograph the Crimean War, and with the support of Prince Albert gained access denied to others. Nos. 6 and 7 are from the Gallery's copy of his *Historical Portraits, Photographed in the Crimea during the Spring and Summer of 1855*, and published by Agnew's in 1855–6. The photograph of Raglan, taken shortly before his death, is characteristic of Fenton's unforced documentary style, which gives his work its acute historical poignancy. Its perfection of technique belies the conditions in which he worked – in extreme heat, often under fire, and threatened by disease (he left the Crimea suffering from cholera).

7

Sir John Campbell Bt. 1807–55 and his aide-de-camp Captain Hume

Roger Fenton 1816–69

Salt print, on the publisher's printed mount; taken between March and June 1855
19.8 × 17 ($7\frac{3}{4}$ × $6\frac{5}{8}$)
Purchased, 1983 (AX24906)

Campbell (seated), who joined the army aged fourteen, had served in India, Burma, the Mediterranean, the West Indies and Canada when he was posted to the Crimea as Brigadier-General. He was present at the Alma and Inkerman, and in December 1854 promoted to Major-General. On hearing of the intended attack on the Redan he volunteered to lead a storming party. On 18 June 1855, contrary to strict orders, and sending away Captain Hume, this was 'exactly what he did, and accordingly lost his life, and did not win. Poor fellow, he was as kind-hearted and gallant a man as you would meet anywhere but, alas for his wife and family, he thought of nothing but carrying the Redan with his own sword' (Colonel C.A. Windham). For Fenton, see no. 6.

8

Jane Baillie Welsh, Mrs Thomas Carlyle 1801–66

Robert S. Tait active 1845–75

Albumen print, April 1855
14.6 × 11.6 (5¾ × 4⅝)
Given by Major-General C.G. Woolner, 1975 (x5665)

The self-willed and precocious daughter of a country doctor – on her tenth birthday she burnt her doll on a funeral pyre in imitation of Dido – Jane Welsh was known because of her wit and beauty as 'the flower of Haddington'. In 1826 she married, against her mother's wishes, the essayist and historian Thomas Carlyle (no. 31), her social inferior, determined to make a great man of him. Together, in Edinburgh and later in London, they forged one of the legendary marriages of literary history, formidable in public, turbulent in private: Carlyle was demanding and self-absorbed, Jane frugal yet deeply romantic, obsessed by her childlessness, intensely jealous, and, in her later years, a great invalid.

Tait, a relatively obscure portrait and genre painter and amateur photographer, became friendly with the Carlyles in the 1850s, and painted and photographed them and their house at 5 Cheyne Row, London. This photograph conveys much of Jane's passionate *Angst*, within the confines of a conventional format. It once belonged to the sculptor Thomas Woolner, who in 1855, the year it was taken, made a medallion portrait of Carlyle which is in the Gallery's collection.

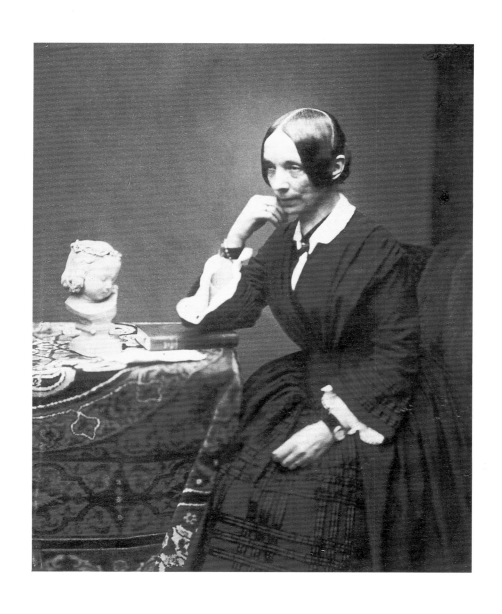

9

Charles John Kean ?1811–68 and Dame Alice Ellen Terry 1847–1928 as Leontes and Mamillius in Shakespeare's *The Winter's Tale*

Unknown photographer

Salt print, inscribed and dated on the reverse of the mount, 26 April 1856
22.3 × 17.6 (9⅛ × 6⅞)
Given by Miss Hipkins, 1930 (X7954)

Born into a theatrical family, Ellen Terry made her stage début on 28 April 1856 at the age of nine, as the boy Mamillius in *The Winter's Tale* with Charles Kean's company at the Princess' Theatre, Oxford Street. The performance was attended by Queen Victoria. This photograph, one of the earliest theatrical photographs in the Gallery's collection, was taken two days before, when the play was in rehearsal, and shows Terry and Kean in costume.

Kean, the son of the celebrated tragedian Edmund Kean, and married to the actress Ellen Tree, was the first of the line of successful actor-managers who dominated London's theatre in the nineteenth century. Terry, following her disastrous marriage to the painter G.F. Watts (1864) and a liaison with the architect E.W. Godwin, went into theatrical partnership with Henry Irving at the Lyceum (1867). She played alongside him in a wide range of Shakespearian roles, and with her vitality, luminosity and intelligence, established herself as the leading actress of the period. She gave her last performance in 1925. Over many years, she enjoyed a spirited correspondence with George Bernard Shaw (no. 49), who wrote: 'Ellen Terry is the most beautiful name in the world; it rings like a chime through the last quarter of the nineteenth century'. Edward Gordon Craig (no. 77) was her son by Godwin.

10

The Reverend Derwent Coleridge 1800–83 and his wife Mary Pridham

Unknown photographer

Ambrotype, 19 August 1856
12.7 × 10.2 (5 × 4)
Purchased, 1986 (P322)

The second son of the Romantic poet Samuel Taylor Coleridge, Derwent was educated with his brother Hartley at a small school near Ambleside, where Southey and Wordsworth watched over them. His later career was dedicated to education and the church, and he was the first principal of St Mark's College, Chelsea (1841–64). He was a passionate believer in the teaching of Latin as a form of mental training, and considered the most accomplished linguist in England. Expert in all the major European languages, he knew Hungarian and Welsh poetry, and could read Arabic, Coptic, Zulu and Hawaiian.

This ambrotype shows him with his wife, whom he married in 1827, and is unusual in being precisely datable. Among the still-life of objects on the table is a ?calendar lettered: *FIELD FOOT AUG 19 1856*, and the watch on a stand gives the time as ten minutes past one. The Gallery also owns an ambrotype of Derwent alone, from the same sitting, taken, if the watch is to be believed, at seven minutes to eleven. The significance of 'Field Foot' is unknown, but may perhaps be the name of the otherwise unrecorded photographer.

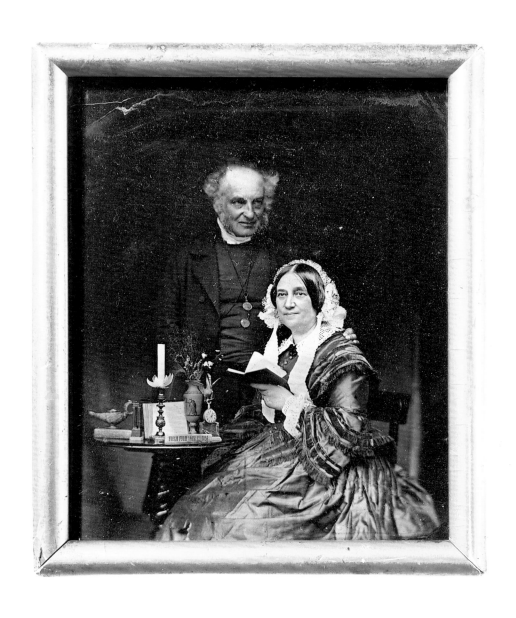

II

Charles Lutwidge Dodgson (Lewis Carroll) 1832–98

? Self-portrait

Albumen print, *c*.1856–60
9.1 × 5.7 (3⅝ × 2¼)
Bequeathed by G. Edward Pine, 1984 (P237)

The shy author of *Alice's Adventures in Wonderland* (1865) and *Through the Looking Glass and what Alice found there* (1871) was a mathematics don at Christ Church, Oxford. Fascinated by all forms of gadgetry, he was from about 1856 an enthusiastic amateur photographer. Although always interested in the techniques, he saw photography primarily as a means of expressing himself artistically, and often signed his prints 'from the Artist'. Of portrait photography he wrote in 1860:

> a well-arranged light is of paramount importance . . . as without it all softness of feature is hopeless . . . In single portraits the chief difficulty to be overcome is the natural placing of the hands; within the narrow limits allowed by the focussing power of the lens there are not many attitudes into which they naturally fall, while, if the artist attempts the arrangement himself he generally produces the effect of the proverbial bashful young man in society who finds for the first time that his hands are an encumbrance, and cannot remember what he is in the habit of doing with them in private life.

This photograph is perhaps a self-portrait, set up by Carroll, with a friend or assistant on hand to take off the lens cap. In it he has taken particular care with 'the natural placing of the hands'. In addition to a number of individual prints, the Gallery also owns an important album of twenty-eight photographs by Carroll of his friends and contemporaries at Oxford. See also no. 24.

12

Clarkson Stanfield 1793–1867

William Lake Price 1810–96

Albumen print, on the photographer's printed mount, with a facsimile of the sitter's signature, *c*.May 1857
28.9 × 24.8 ($11\frac{1}{2}$ × $9\frac{3}{4}$), arched top
Given by an anonymous donor, 1976 (X1397)

The marine and landscape painter Stanfield, whom Ruskin (no. 47) regarded as 'the leader of the English realists', and 'incomparably the noblest master of the cloud-form of all our artists', spent his early career in the Merchant Navy, and this gave him an enduring love of the sea. He first came to London as a theatrical scene-painter, working above all at the Theatre Royal, Drury Lane. He also supervised the scenery for Dickens' (no. 19) private theatricals. He soon turned to painting, however, and his accomplished works, usually variations on well-tried formulæ, quickly won him academic and commercial success. A characteristic work stands on the easel in this photograph. It is a reduced version (location unknown) of his large canvas *A Dutch Blazer coming out of Monnickendam, Zuyder Zee* (1856), which Stanfield presented to the Garrick Club, London.

William Lake Price trained as an architectural and topographical artist with C.W. Pugin, but took up photography in the early 1850s. He is best known for his elaborate genre studies, studies of architecture and topography (some commissioned by the Queen), and for portraits, especially of artists. His writings on photography in the *British Journal of Photography* (founded in 1854) reveal his interest in the aesthetic possibilities of the medium, and he endows the heavy features of the worthy Stanfield with a notable romantic intensity. He wrote to Stanfield on 27 May 1857 from his house at 58 Queen's Terrace, London:

> I write to say that I am happy to find your Portrait the most admired of any which I have done and on the Printer sending me some more which I have ordered, I will do myself the pleasure of sending you up six copies for yourself. The one you have will not be permanent being full of Chemicals which I did not take time to remove. (National Maritime Museum, Stanfield MSS)

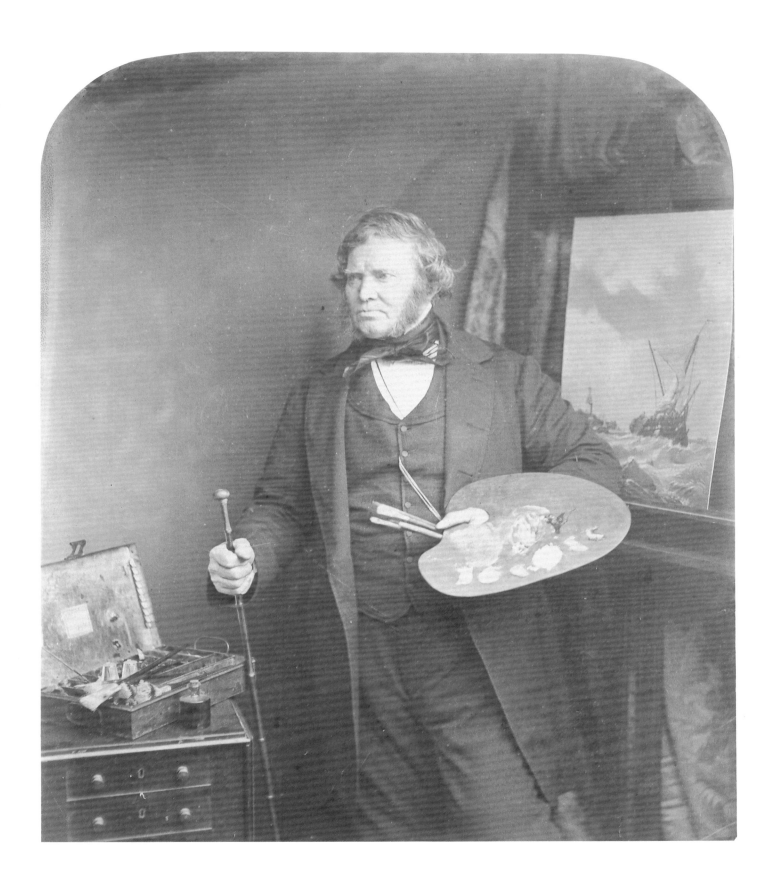

13

The Royal Family on the Terrace at Osborne House

Leonida Caldesi active 1850s–90s

Albumen print, 26 May 1857
15.9 × 21.3 (6¼ × 8⅜)
Purchased, 1977 (P26)

The sitters are (left to right): Prince Alfred, Duke of Edinburgh 1844–1900; Prince Albert 1819–61; Princess Helena 1846–1923; Prince Arthur, Duke of Connaught 1850–1942; Princess Alice, later Grand Duchess of Hesse 1843–78; Queen Victoria 1819–1901, holding Princess Beatrice, later Princess Henry of Battenberg 1857–1944; Princess Louise, later Duchess of Argyll 1848–1939; Prince Leopold, Duke of Albany 1853–84, and Prince Edward, later Edward VII 1841–1910.

Queen Victoria and Prince Albert first began to collect photographs in the early 1840s, and did much to encourage the spectacular rise of photography in Britain. Photographs were included in two sections of the Great Exhibition (1851), and the Queen and her consort were the first patrons of the Photographic Society of London when it was founded in January 1853. Their collection was wide ranging, and included not just portraits, but also topographical, architectural and genre studies. But above all they valued photography for the opportunities it gave to commemorate the major events in their large and closely-knit family.

Princess Beatrice, their youngest child, was born on 14 April 1857, and the Queen went shortly afterwards with the infant princess and the rest of her family to Osborne on the Isle of Wight to recuperate. On 23 May the Florentine Signor Caldesi of Caldesi & Montecchi of 38 Porchester Terrace, London (see also no. 22), a firm much patronized by the Royal Family, was called to Osborne to photograph the new baby and the rest of the party.

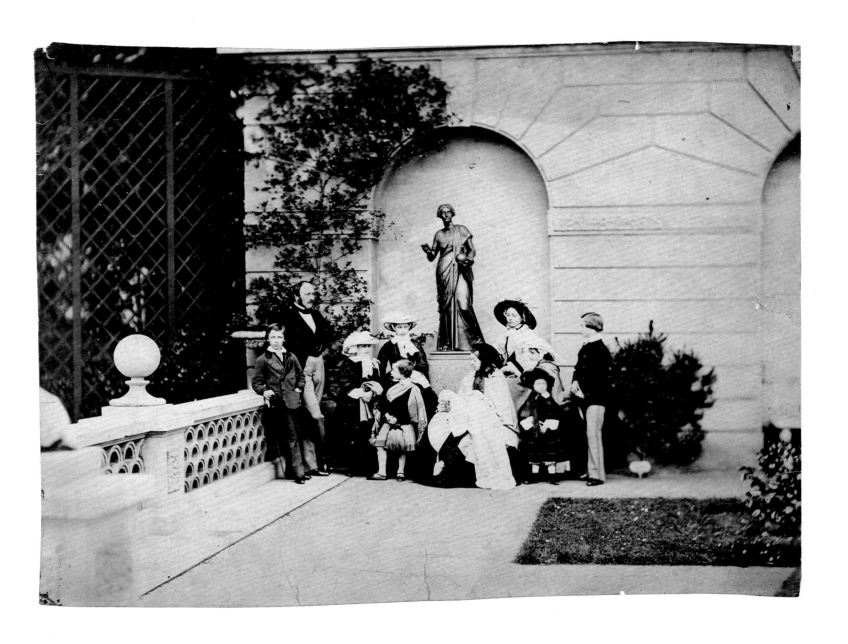

14

Michael Faraday 1791–1867

Maull & Polyblank active 1850s–60s

Albumen print, 1857
19.9 × 14.7 (7¾ × 5¾), arched top
Purchased before April 1938 (AX7281)

The son of a blacksmith, Faraday began work as a bookbinder's errand boy, but went on to become one of the greatest of British scientists. From 1812 to 1823 he worked as assistant to Sir Humphry Davy in his research on the properties of gases, and witnessed the discovery of chlorine. Later his own researches at the Royal Institution, carried out in experiments of the greatest elegance, made possible the development of electricity as a source of energy by his discovery of electromagnetic induction (1831) and of diamagnetic repulsion (1845). He also originated the theory of the atom as the 'centre of force'.

The London commercial photographers Maull & Polyblank had studios at 55 Gracechurch Street and 187A Piccadilly, and produced from the late 1850s a series of 'Photographic Portraits of Living Celebrities' which were widely collected. The portrait of Faraday was issued in October 1857, and was presumably taken at the Piccadilly studio, which was close to the Royal Institution. He was by all accounts a brilliant lecturer (with typical thoroughness, he took lessons in elocution), and the photographers have shown him as if in the act of lecturing. He holds up a magnet, as he used to do; he would knock it with his knuckle, and exclaim: 'Not only is the force here, but it is also here, and here, and here', passing his hand through the air around the magnet at the same time.

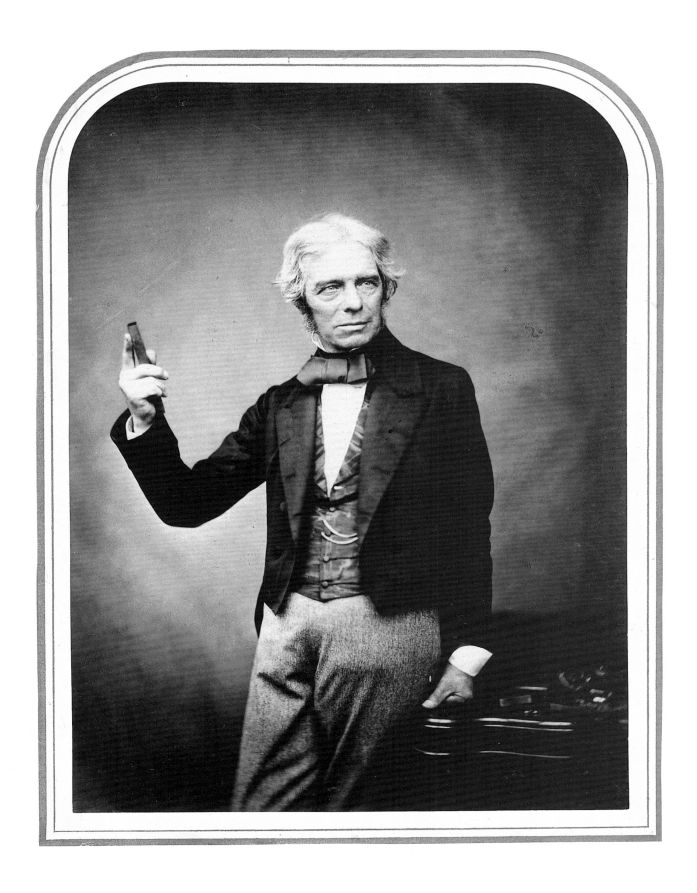

15

Isambard Kingdom Brunel 1806–59

Robert Howlett 1830–58

Albumen print, November 1857
38.6 × 22.5 (11¼ × 8⅞), arched top
Given by A.J.W. Vaughan, 1972 (P112)

The only son of the engineer Sir Marc Isambard Brunel, Brunel gained his earliest experience as an engineer working on his father's Thames Tunnel, where he showed his ability to work impossibly long hours, and in several emergencies, his sheer courage. He was the designer of the Clifton suspension bridge, and built railways in Italy, Australia and India, as well as at home, where the Great Western Railway is his most celebrated creation. But his greatest fame came as a designer of ocean-going steamships, of which the *Leviathan* or *Great Eastern*, as it came to be known, was the last and greatest. It was five times the size of any other ship, and in both design and construction revolutionary.

The photographer, Howlett, and his partner Joseph Cundall, were commissioned to take a series of photographs of this prodigious vessel by *The Illustrated Times*, a popular rival to *The Illustrated London News*, and a special number devoted to the *Leviathan* was published on 16 January 1858. Howlett portrays Brunel standing, casual and confident, in front of the ship's massive anchor chains, the symbols of the power he had created. Little is known of Howlett whom *The Illustrated Times* rightly called 'one of the most skilful photographers of the day'. He died less than a year after this photograph was taken, poisoned, it was suggested, by his own photographic chemicals.

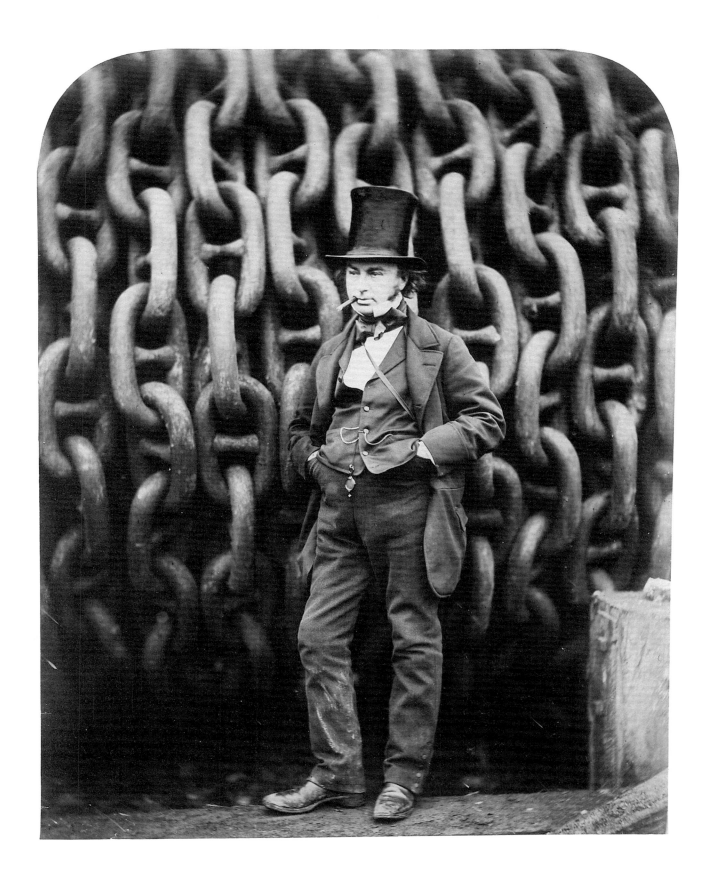

16

Isabella Mary Mayson, Mrs Samuel Beeton 1836–65

Maull & Co active 1850s–70s

Albumen print, with ?later hand-colouring, on the photographer's printed mount, 1857
18.4 × 14.4 (7¼ × 5⅞), arched top
Given by the sitter's son, Sir Mayson Beeton, 1932 (P3)

Isabella Mayson, from an old Cumberland family, married the editor and publisher Samuel Beeton in 1856. She worked with her husband as a journalist, writing fashion articles and notes on housekeeping for his periodicals, among them *The Queen* and *The Englishwoman's Domestic Magazine*, the first journal to issue paper dress-making patterns to its readers. At the same time she began 'the four years incessant labour' which led to the publication of her *Book of Household Management*, an encyclopaedia of information for the efficient running of the home, in which all the recipes had been personally tried. This was issued in twenty-four monthly parts from October 1859, and in book form in 1861. The second edition appeared after her death, in 1869, with a preface by Mr Beeton paying tribute to his wife. She died giving birth to their fourth child.

Sir Mayson Beeton, when he gave this photograph to the Gallery, stated that he believed it had been coloured by his sister after their mother's death. The successful firm of Maull & Co had premises in London in Piccadilly and the City.

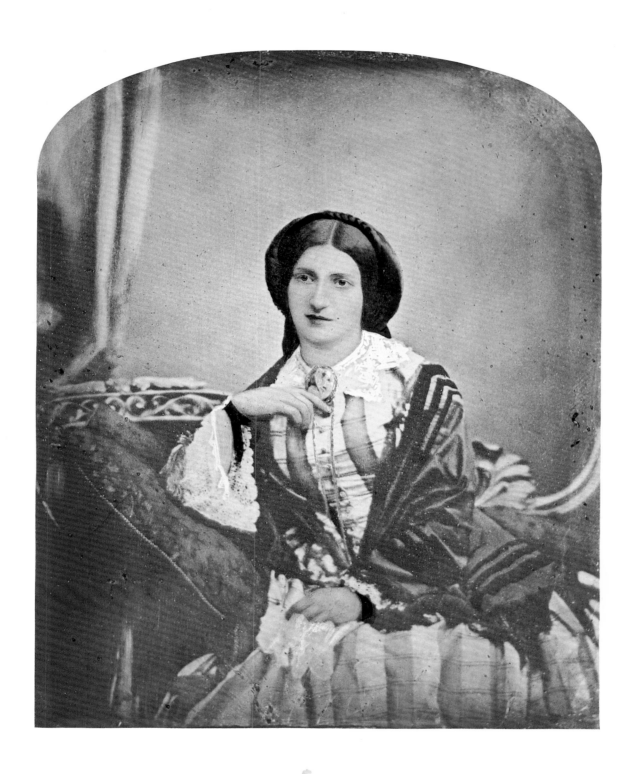

17

Florence Nightingale 1820–1910

Goodman of Derby active 1850s–60s

Albumen carte-de-visite, on the publisher's printed mount, *c*.1857
8.8 × 5.8 (3½ × 2¼)
Given by Hugh Tolson, 1936 (X16139)

Florence Nightingale arrived in the Crimea with a band of thirty-eight nurses on 4 November 1854. She went there in the face of official opposition, and found appalling conditions. But 'the Lady-in-Chief', as she became known, established herself at Scutari, and succeeded against all odds in transforming the military hospitals there. In the process she laid the foundations of the reforms which led to the modern nursing system. A national heroine, she nevertheless returned to England in 1856 with a minimum of fuss, and lived afterwards the retired life of an invalid, though never slow to give encouragement to those who continued her work. She was the first woman member of the Order of Merit.

At the time of Florence Nightingale's greatest fame there was an enormous demand for photographs, and this image, by the obscure Derby photographer Goodman, was widely published in carte-de-visite form. She is said to have referred to it, with characteristic incisiveness, as 'Medea after killing her Children'.

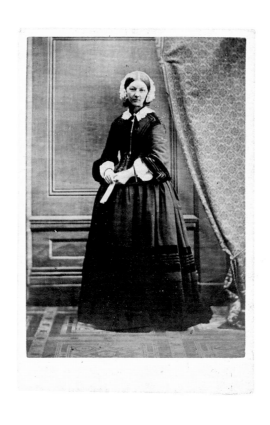

18

Henry John Temple, 3rd Viscount Palmerston 1784–1865

(William) Graham Vivian 1827–1912

Salt print, with the photographer's blind-stamp, inscribed and dated on the mount (now detached), 1858
17.9 × 12.4 (7 × 4⅞), oval
Purchased, 1980 (P152)

Palmerston was a dominating figure in British politics for more than fifty years. As Foreign Secretary (1831–41 and 1846–51) he raised British prestige to unparalleled heights by a mixture of craft, bluster and force. He was largely responsible for establishing the new state of Belgium, rescued Turkey from Russia, and went to war with China. As Prime Minister (1855) he brought the Crimean War to an advantageous peace, and his political position seemed thereafter virtually unassailable. In 1858, however, about the time of this photograph, 'Pam' was defeated on the Conspiracy to Murder Bill, and resigned. He became Prime Minister once more a year later, and died in office. Queen Victoria wrote shortly after his death: 'He had many valuable qualities, though many bad ones, and we had, God knows! terrible trouble with him about Foreign affairs. Still, as Prime Minister he managed affairs at home well, and behaved to me well. But I *never* liked him!'

Graham Vivian was the second son of J.H. Vivian, FRS, MP for Swansea and, like Palmerston, a Liberal. Rich and well-connected, he owned houses at 7 Belgrave Square, London and at Clyne Castle and Parc le Breos in Glamorgan (where he was High Sheriff for a period); his uncle was the 1st Baron Vivian; his elder brother, the 1st Baron Swansea. As a young man, between the 1850s and 1870s, Vivian was an enthusiastic amateur photographer, a member of the Photographic (or Calotype) Club, which had many aristocratic members, and which in 1853 became the Photographic Society. He specialized in portrait and topographical photography. This portrait of Palmerston, in a pose which recalls full-length paintings by Van Dyck and Gainsborough, was taken on the steps of his country house, Broadlands in Hampshire, where Vivian was no doubt a member of a house-party.

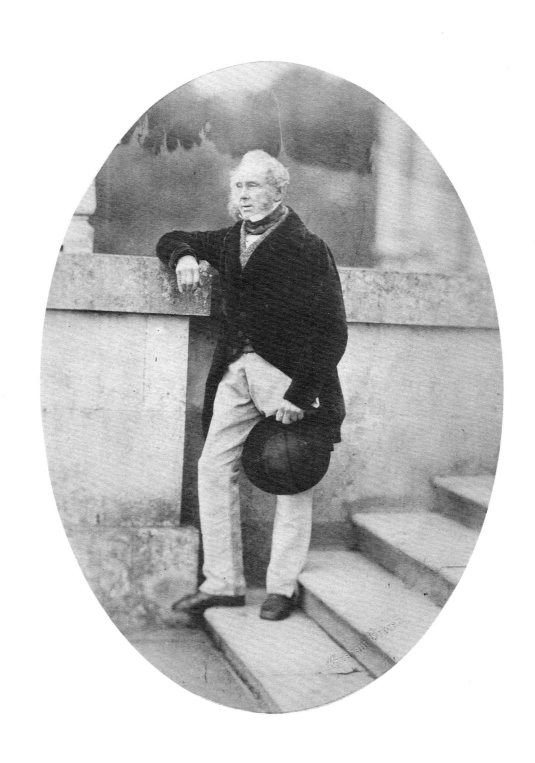

19

Charles John Huffam Dickens 1812–70

Herbert Watkins active 1850s–90s

Albumen print, 1858
20.3 × 15.1 (8 × 6), arched top
Purchased, 1985 (P301/20)

The year of this photograph, 1858, between the completion of *Little Dorrit* and the beginning of *A Tale of Two Cities*, was a momentous one for Dickens, for it was at this time he first became infatuated with a teenage actress, Ellen Ternan, and decided to separate from his wife. In the same period he began to give public readings from his works on a fully professional basis. Financial pressures made the readings a necessity, but the ageing Dickens soon found that he could not live without the excitement and public acclaim which they brought as well.

Herbert Watkins worked from the Institute of Photography, 179 Regent Street, London, from 1856 and produced a series of photographs of distinguished contemporaries, which he published with printed biographies under the title of *National Gallery of Photographic Portraits*. His portrait of Dickens shows him at his reading desk, about to begin a recital. Watkins claimed in his advertisements that his photographs were 'as remarkable for their agreeable fidelity to nature as for their brilliancy of production and their economy of cost', and 'untouched'. There is no doubting the vivacity of this likeness, but it has in fact been heavily retouched, most obviously in Dickens' hands, his book and in the still-life of objects on the desk. The Gallery owns two albums of Watkins' finest work. See also no. 20.

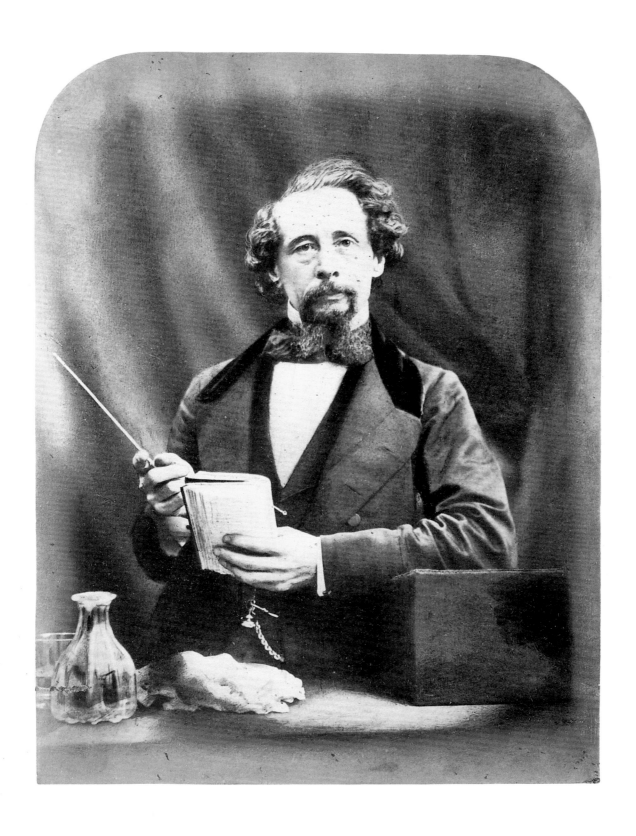

20

Sir Charles Barry 1795–1860

Herbert Watkins active 1850s–90s

Albumen print, 1859–60
20.8 × 15.8 (8 × 6¼)
Purchased before April 1938 (AX7339)

Barry was already one of the most prominent architects of his day – the builder of the Travellers' Club, the Reform Club and Bridgewater House – when in 1836 he won first prize in the competition to design the new Houses of Parliament. Work began in 1840, and was nearing completion at the time of his death (it was finished under the supervision of his son E.M. Barry). As a work of the Gothic imagination his Palace of Westminster is unrivalled in its scale and vision. The Tsar of Russia called it 'a dream in stone', and, on its site by the Thames, in all seasons and weathers, it has been an inspiration not only to Londoners and tourists, but to many artists, among them Monet.

This photograph was taken shortly before Barry's death from heart disease, and yet still shows a man 'of the toughest fibre, of almost super-human industry, . . . thirsting for fame' (George Aitchison). For Watkins see no. 19.

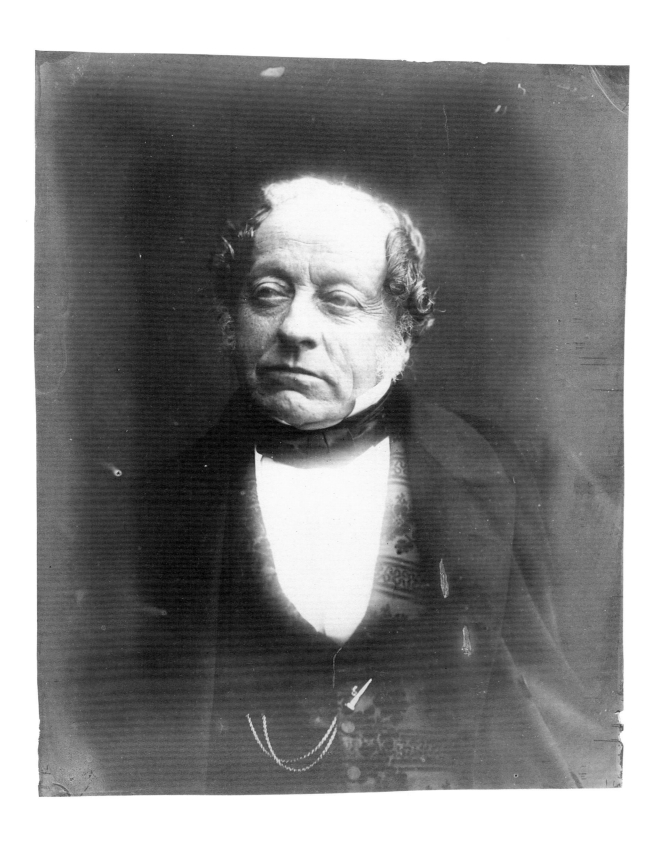

21

Alfred Tennyson, 1st Baron Tennyson 1809–92

Attributed to James Mudd active 1852–1901

Albumen print, early 1861
24.6 × 19.4 (9⅝ × 7½)
Given by the Pilgrim Trust as part of the Macdonnell Collection, 1966 (x8005)

With the publication of his Arthurian poems *Idylls of the King* in 1859, Tennyson, who had succeeded Wordsworth as Poet Laureate nine years earlier, finally won popular recognition and a celebrity which lasted until his death. As a result the demand for photographs of him greatly increased, and his strong, idiosyncratic features made an especially good subject. Carlyle (no. 31) described him as 'one of the finest looking men in the world. A great shock of rough, dusky, dark hair; bright laughing hazel eyes; massive aquiline face, most massive yet most delicate'.

This photograph, which has previously been attributed to Lewis Carroll, is probably by the Manchester photographer James Mudd, best known for his photographic inventory of locomotives built by the local firm of Beyer-Peacock. It was given wide currency by its publication on 15 April 1861 by Cundall & Co (founded by Joseph Cundall 1819–95), whose Photographic Institution was at 168 New Bond Street. Unlike the later photographs of Tennyson by Julia Margaret Cameron, which are distinguished by their heroic, poetical mood, Mudd's photograph conveys something of the truculence of this reclusive man, impelled to the studio by fame.

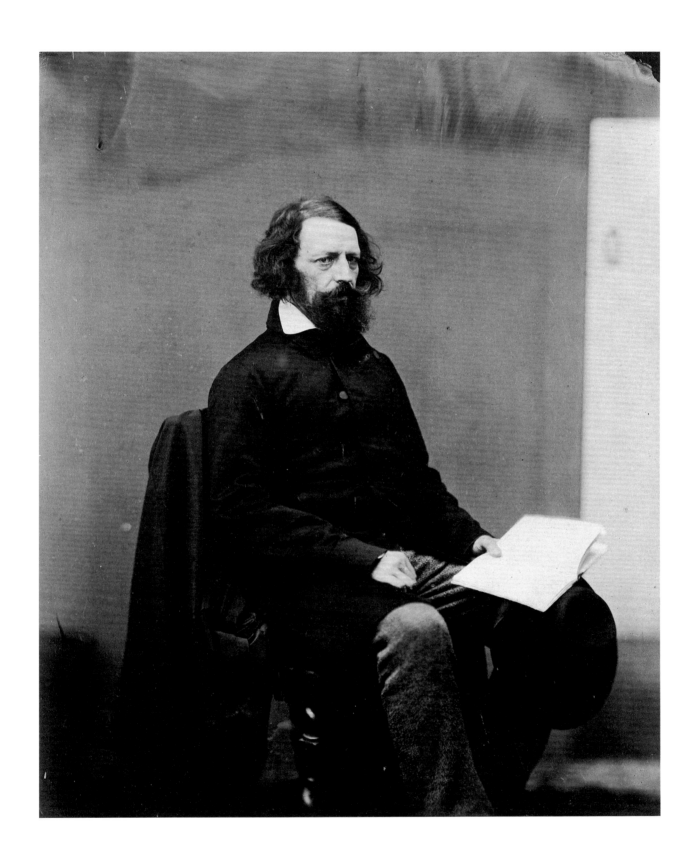

22

Adelina Juana Maria Patti, Baroness Cederstrom 1843–1919

Camille Silvy active 1850s–60s

Carte-de-visite albumen prints (5), all, with the exception of x12680, on the
photographer's printed mounts, July 1861
x12677: 8.4 × 5.5 (3¼ × 2¼); x12679: 8.3 × 5.5 (3¼ × 2⅛); x12680: 8.1 × 5.2 (3¼ × 2);
x21724: 8.6 × 5.6 (3⅜ × 2¼); x25072: 8.5 × 5.6 (3⅜ × 2¼)
x12677: given by an anonymous donor, 1947; x12679: given by an unknown donor, 1973; x12680: given
by M. Hutchinson, 1965; x21724: given by Clive Holland, 1959; x25072: given by Algernon Graves, 1916

The Italian opera singer Patti, the last of the line of great coloratura sopranos, made
her London début on 14 May 1861 at the Royal Italian Opera, Covent Garden as Amina
in Bellini's *La Sonnambula*, and from that time, as Lucia (x12677; below left), Violetta
(?x12679; above right), Zerlina, Martha (x12680; top left), Leonora (x21724; below
right) in *Il Trovatore*, and above all as Rosina (x25072; top centre) in *The Barber of
Seville*, she delighted audiences throughout Europe and in North and South America.
Her public career lasted nearly sixty years, and is virtually without parallel.

The French aristocrat Silvy came to London at about the same time as Patti, and
rapidly established himself as one of the most fashionable of portrait photographers,
with a studio at 38 Porchester Terrace, noted for its elegant furnishings and range of
elaborate painted back-drops. Several of these are seen in his photographs of Patti, taken,
no doubt with an eye to publicity, shortly after her sensational début, and illustrating
the range of her roles, and her considerable charm.

In addition to many individual prints by Silvy, the Gallery also owns the photo-
grapher's Day Books, which contain some 10,000 prints, and which constitute a unique
record of London society of the day.

 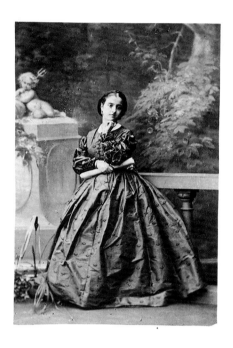

 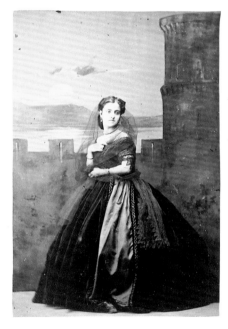

23

James Glaisher 1809–1903 and Henry Tracey Coxwell 1819–1900 in their balloon

Negretti & Zambra active 1850s–60s

Albumen carte-de-visite, on the photographers' printed mount, probably late 1862
9 × 6.2 ($3\frac{1}{2}$ × $2\frac{3}{8}$)
Given by the Earl of Harrowby, 1957 (x22561)

On 5 September 1862 the intrepid balloonists and meteorologists Glaisher and Coxwell ascended from Wolverhampton in their hot-air balloon to a height of 37,000 feet, the greatest height ever reached by balloon. Glaisher lost consciousness and Coxwell, who had lost the use of his hands, managed just in time to pull the valve-cord with his teeth, and brought the balloon down at Ludlow, dropping 19,000 feet in fifteen minutes.

This tiny photograph almost certainly commemorates the record-breaking ascent, and is an example of the inventive skills of the photographers Henry Negretti (1818–79) and Joseph Warren Zambra (born 1822) of Hatton Garden, Cornhill and Regent Street, London, who superimposed an image of the aviators in their basket on an aerial back-drop, and painted in the superstructure of the balloon. A year later Negretti himself made with Coxwell the first aerial trip for purposes of photography.

In 1870, at the outbreak of the Franco-Prussian war, Coxwell went to manage the Prussian fleet of war-balloons, while in later life Glaisher devoted his time increasingly to astronomy.

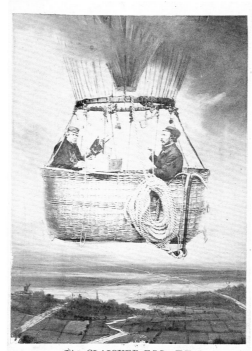

JA? GLAISHER ESQ. F.R.S.
& M? COXWELL.

Ent.ᵈ Stationers Hall.

24

Gabriel Charles Dante (Dante Gabriel) Rossetti 1828–82

Charles Lutwidge Dodgson (Lewis Carroll) 1832–98

Albumen print, numbered 85 in the print, with the sitter's clipped signature on the mount and his letter heading: *16 Cheyne Walk*, CHELSEA with the motto FRANGAS NON FLECTAS and his monogram GDR; probably 7 October 1863
14.6 × 12.1 (5¾ × 4¾)
Purchased, 1977 (P29)

Lewis Carroll (no. 11) spent four days in October 1863 photographing the Pre-Raphaelite painter Rossetti, his family, friends, and some of his drawings. The sessions took place at Rossetti's home, 16 Cheyne Walk, London, which he shared with his brother William Michael, and the writers Swinburne and Meredith. He photographed Rossetti by the steps which led down from the house to the garden. It was a time of great sadness and uncertainty in the artist's life, for he had only recently moved to Chelsea from Blackfriars, following the death of his wife and obsessional model Elizabeth Siddal in the previous year. She had died of an overdose of laudanum, and Rossetti never ceased to reproach himself. Indeed, this was thought to be one of the major factors which contributed to his mental instability in his later years. Dependent on chloral, he became obsessed with the idea that people were plotting against him. According to his brother, one of his later fantasies was that Lewis Carroll's own *Hunting of the Snark* was a satirical attack on him.

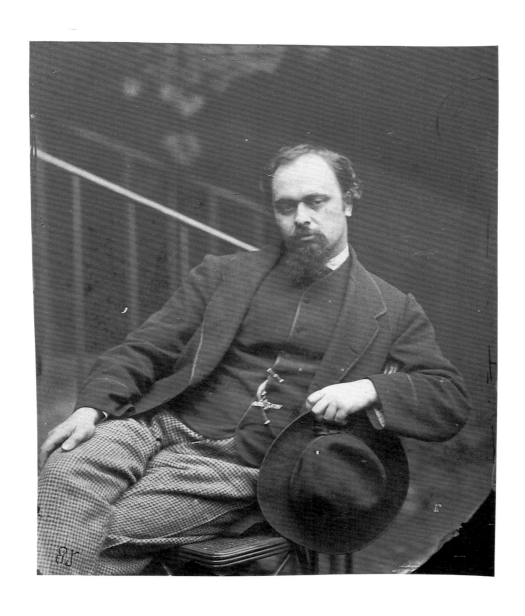

25

Sir John Everett Millais 1829–96

David Wilkie Wynfield 1837–87

Albumen print, with the sitter's clipped signature on the mount, *c*.1863
21 × 16.2 (8$\frac{3}{8}$ × 6$\frac{3}{8}$)
Purchased from the estate of Sir Edmund Gosse, 1929 (P79)

One of the original members of the Pre-Raphaelite Brotherhood (1848), Millais' artistic career is a classic example of the young revolutionary who turns with artistic recognition and material success into a pillar of the establishment. This photograph was taken about the year of his election to the Royal Academy, when the hostility aroused by his early works such as *Christ in the Carpenter's Shop* (1849–50, Tate Gallery, London) was long forgotten.

David Wilkie Wynfield, nephew of the painter Sir David Wilkie, was himself a painter, and one of the founders of the St John's Wood Clique, a group of young artists devoted to preserving the tradition of genre painting. He took up photography in the early 1860s, and photographed many of his artist friends, usually in fancy dress evocative of the Renaissance period, and appropriate to the character of the sitter. Millais is presented in a way which recalls the poet Dante, in profile, wearing a laurel wreath, and clutching a book to his breast. Wynfield gave at least one lesson in photography to Julia Margaret Cameron (nos. 28, 33), who wrote of his influence on her: 'To my feeling about his beautiful Photography I owed *all* my attempts and indeed consequently all my success'.

This print is one of more than thirty photographs by Wynfield owned by the Gallery. Like no. 56, it once belonged to the writer Sir Edmund Gosse.

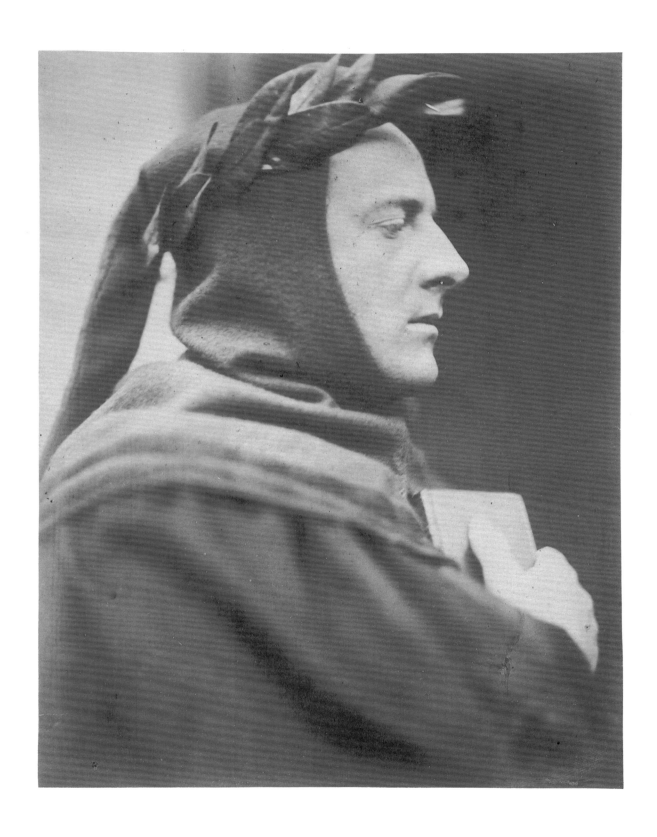

26

John Gibson 1790–1866

Nadar (Gaspard Félix Tournachon) 1820–1910

Salt print, with the photographer's blind stamp on the mount, *c*.1862
22.2 × 17.1 (8¾ × 6¾), oval
Purchased, 1983 (P227)

'The human figure concealed under a frock coat and trousers is not a fit subject for sculpture', said Gibson, the last great British neo-classical sculptor, who lived for most of his life in Rome, and who in all his work attempted to embody abstract ideals through the human form. In this he consciously followed the Greeks, imagining that Phidias would have said of Michelangelo: 'He is a most clever and wonderful sculptor, but a barbarian'. It was imitation of Greek practice which led him to produce his 'Tinted Venus'; this caused a sensation at the International Exhibition in London in 1862, when according to Lady Eastlake (no. 3):

> every young lady at dinner-table or in ballroom in that London season . . . felt herself called upon to tell her partner what she thought of Gibson's coloured Venus. . . . In truth the question lay totally beyond the English public, who at best have scarcely advanced . . . beyond the lowest step of the aesthetic ladder.

Nadar, arguably the greatest of French nineteenth-century photographers, and the friend of most of the leading writers and artists of his day, became one of the country's most celebrated caricaturists before drifting, with a characteristic blend of nonchalance and rashness, into photography in the mid-1850s. He opened spacious premises at 35 Boulevard des Capucines, Paris, in 1860, and it was there that Gibson sat to him, one of few British sitters to do so, perhaps on his way to London to the International Exhibition. In that same studio the first Impressionists' exhibition was held in 1874.

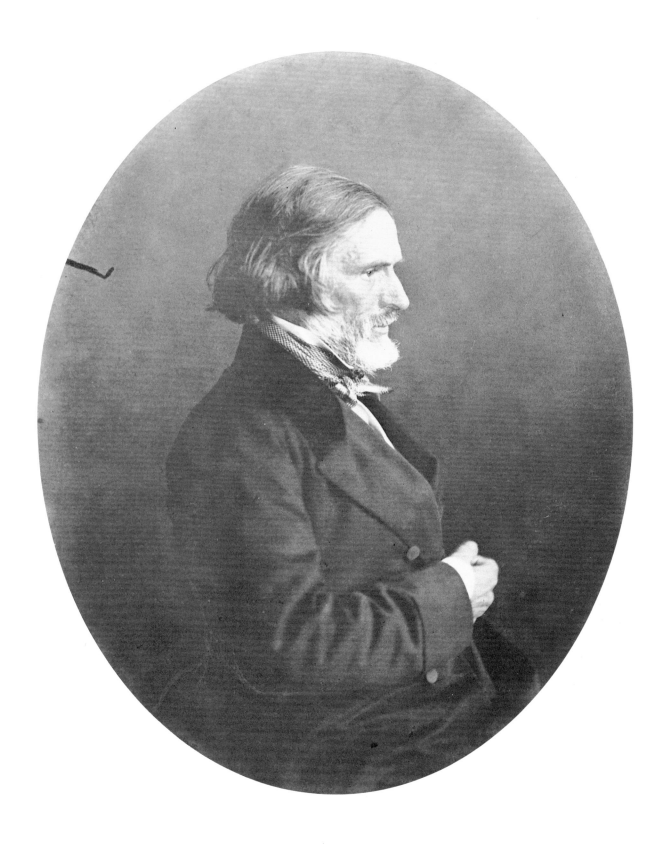

27

Charles Samuel Keene 1823–91

Horace Harral active 1844–91

Platinum print, signed by the photographer on the mount, 1860s
24 × 19.4 (9½ × 7½)
Given by John A. Hipkins, 1927 (X20150)

The humorous artist and illustrator Keene, whose name is forever associated with *Punch* and *The Illustrated London News*, and whose spirited draughtsmanship brought added vividness to the works of Meredith and Thackeray, was by all accounts a shy and uncommunicative man. This rare photograph was taken by a friend and associate, the wood-engraver and etcher Harral, who like Keene worked for *The Illustrated London News*, and on a number of occasions produced etchings or engravings after Keene's drawings. It shows Keene holding 'the thick-stemmed, small-bowled "Fairy" pipe which was his special weakness'.

The Gallery owns a small group of Harral's photographs of his friends and associates, which are distinguished by their technical assurance and faintly theatrical air. This platinum print must have been made some years after the original sitting, for the process was first used in 1873. As a wood-engraver, Harral made the engraving of Robert Howlett's photograph of I.K. Brunel (no. 15) for the issue of *The Illustrated Times* devoted to the launch of the *Leviathan*, published on 16 January 1858.

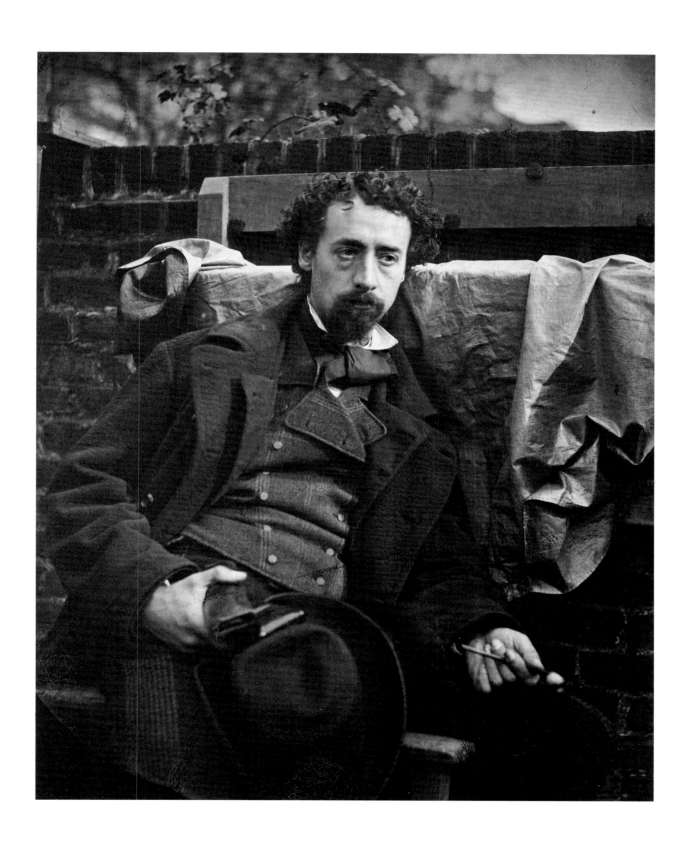

28

Anthony Trollope 1815–82

Julia Margaret Cameron 1815–79

Albumen print, signed by the photographer and sitter on the mount, October 1864
25.4 × 19.7 (10 × 7¾)
Purchased, 1982 (P214)

In 1863 Julia Margaret Cameron, the wife of a retired coffee-planter, was given a wet collodion photographic outfit by her daughter and son-in-law. As a young woman she had corresponded with Sir John Herschel (no. 33) about the new medium, and she now began to practise photography with great enthusiasm and idealism: 'My aspirations are to ennoble Photography and to secure for it the character and uses of High Art'. She took many portraits of her family and friends, servants and photogenic villagers on the Isle of Wight where she lived, but above all, like the commercial photographers of the day, she pursued celebrities.

This image of the novelist and postal-official (the inventor of the pillar-box) Trollope was taken when he was on holiday at Freshwater, Isle of Wight in 1864, at a time of crisis in his career with the post-office. In March that year his enemy Sir Rowland Hill, founder of the penny post, had retired, and Trollope hoped at last for preferment. He was, however, passed over, and, though it took him two years to make up his mind, he finally retired. It was the right decision for this passionate devotee of fox-hunting, who found daily attendance at the office to be 'slavery', but it stung him. Yet he was by this time firmly established as a best-selling novelist; his great human comedies, the Barchester novels were, with the exception of *The Last Chronicle of Barset* (1867), behind him; the ambitious late political novels such as *The Way We Live Now* (1875), to come.

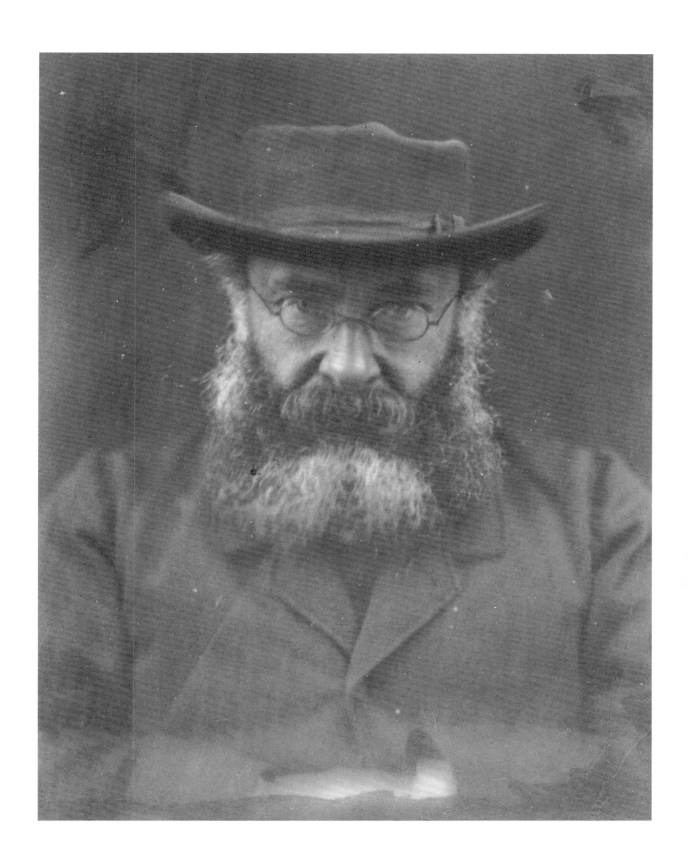

29

David Livingstone 1813–73

Maull & Polyblank active 1850s–60s

Albumen print, c.1864–5
19.8 × 14.7 (7¾ × 5¾), arched top
Purchased before April 1938 (AX7279)

The legendary African missionary and explorer Livingstone arrived in England in July 1864, for the first time in seven years. He left a year later, having visited his mother in Scotland, and written *The Zambesi and its Tributaries*. He never saw the country again. During his stay he was photographed on several occasions, but his heroic personality appears cramped by the photographer's studio and conventional day dress. In this photograph the rhinoceros horn is included to symbolize Livingstone's African interest, but it is his tormented expression which conveys the years he had spent in conditions of extreme deprivation and danger, and the unflinching energy which drove him on to bring Christianity to the natives, to stamp out slavery, and to find the source of the Nile. His devotion to the continent was overpowering, and once, when ordered by the British government to withdraw from his exploration of the Zambesi, he wrote: 'I don't know whether I am to go on the shelf or not. If I do, I make Africa the shelf'. For Maull & Polyblank see no. 14. See also no. 36.

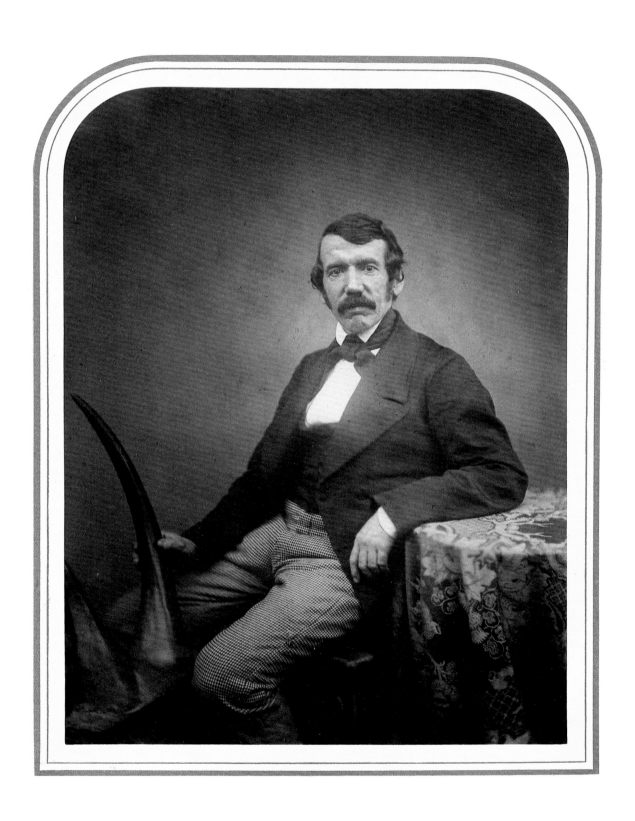

30

Sir Richard Francis Burton 1821–90

Ernest Edwards 1837–1903

Albumen print, on the photographer's printed mount, April 1865
8.7 × 6.8 (3⅜ × 2⅝)
Purchased, *c.*1935 (AX14771)

Explorer, author and translator, Burton was a man of insatiable curiosity, whose exploits in Africa, the Middle East and South America earned him a reputation for great daring. He made the pilgrimage to Mecca in disguise, explored Somaliland, travelled with Speke to discover the sources of the Nile, crossed the Andes, and visited the gold and diamond mines of Brazil.

After a controversial period as Consul in Damascus (1869–71), Burton travelled to Iceland and then, in 1872, was appointed Consul in Trieste, where it was felt he could do no mischief. He remained there for the rest of his life. His later years were made financially more than secure by his translation of *The Arabian Nights*, which was ensured a *succès de scandale* by virtue of his explanatory footnotes. According to a contemporary assessment, 'The whole of his life was a protest against social conventions'.

This photograph was taken for *Portraits of Men of Eminence*, a series begun by the conchologist and antiquary Lovell Reeve, in which photographs of the famous were accompanied by short biographies. It appeared in Volume 3, edited by Reeve's successor Edward Walford, and was published in 1865. It almost certainly dates from April that year when Burton, then Consul in Fernando Po, off the coast of West Africa, came to England to be entertained to a public dinner by Lord Stanley, later Earl of Derby. Burton sits on the floor, wearing Levantine costume, amidst the exotic trappings of the photographer's studio, posed against an elaborate, if not especially appropriate, backdrop. For Edwards see no. 34.

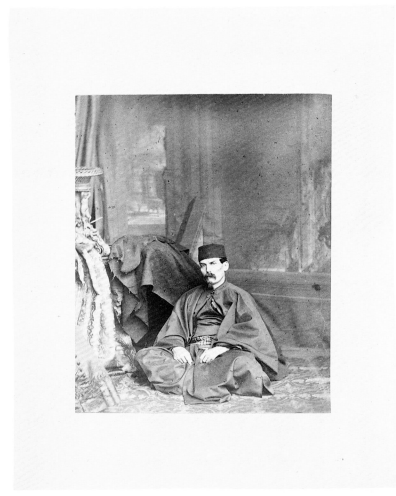

Photographed by Ernest Edwards 20 Baker Street W

31

Thomas Carlyle 1795–1881

Elliott & Fry active 1863–1963

Albumen print, on the photographers' printed mount, *c.*1865
20.2 × 14.6 (3⅜ × 2⅝), arched top
Given by Major-General C.G. Woolner, 1975 (X5661)

The son of a mason from Ecclefechan in Dumfriesshire, the essayist and historian Carlyle, supported by his forceful wife (no. 8), went on to become a figure of towering intellectual authority, 'the sage of Chelsea', so like one of those great men, the 'heroes', whom he revealed in his writings as the makers of history. Handsome and intense, he was painted, sculpted and photographed almost more than any other non-royal figure in the nineteenth century. He seems to have taken pains about his own portraits, just as he was anxious to acquire portraits of anyone he was writing about. One of the earliest Trustees of the National Portrait Gallery, he wrote: 'often have I found a portrait superior in real instruction to half a dozen written biographies . . . or, rather let me say, I have found that the portrait was as a small lighted candle, by which the biographies could for the first time be read'.

The firm of Elliott & Fry (Joseph John Elliott and Clarence Edmund Fry) was based at 55 Baker Street, London, and remained there until the 1960s. Carlyle sat to them at about the time of the completion of his biography of Frederick the Great (1865), shortly before the death of his wife.

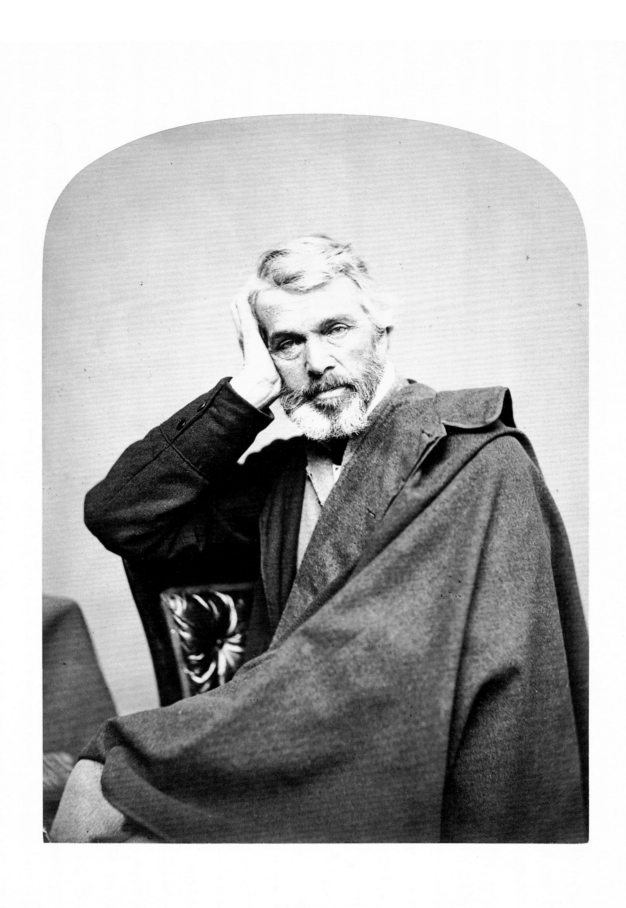

Elliott & Fry, Photo.

55. Baker St Portman Sq. W

32

Sir John Fowler, 1st Bt. 1817–98

John Jabez Edwin Mayall 1810–1901

Albumen print, hand coloured with oil paint, with remains of the photographer's label on the reverse, *c*.1865
35.2 × 26.7 (13⅞ × 10½), arched top (P326)

As a civil engineer Fowler devoted his life to the railways, and he is best known for his Pimlico bridge, the first railway bridge across the Thames in London, the development (from 1853) of the Metropolitan Railway system, and (with Sir Benjamin Baker) the Forth railway bridge (1883–90), probably the most remarkable piece of engineering to be carried out in the nineteenth century, and one which earned Fowler his baronetcy.

For this photograph, probably taken after the opening of the Metropolitan Railway in January 1863, Baker sat to the American-born photographer, Mayall, who had once been assistant to the daguerreotypist Claudet (no. 4). A highly successful businessman, his mass-produced royal photographs did much to popularize the carte-de-visite format. In this large photograph Mayall combines a somewhat incongruous studio backdrop of a village scene with the parapet of a bridge and a length of railway track, emblems of Fowler's profession. Hand colouring was an 'extra' offered by many of the commercial photographic firms, and shows them consciously emulating the large-format portrait-miniature paintings favoured by the Victorians.

33

Sir John Frederick William Herschel, 1st Bt. 1792–1871

Julia Margaret Cameron 1815–79

Albumen print, signed and inscribed by the photographer on the mount: *From Life taken at his own residence Collingwood/Sir J.F.W. Herschel*; 1867
34 × 26.4 (13⅜ × 10⅜)
Purchased, 1982 (P213)

Sir John Herschel, son of the great astronomer Sir William Herschel, was a man of outstanding scientific and astronomical achievement, and took an interest in photography from its earliest days. He was the friend of Fox Talbot, and an early correspondent of Mrs Cameron, and invented the photographic use of sensitized paper (1839), introduced hyposulphate of soda (hypo) as a fixing agent, and coined the terms 'photograph', 'negative', 'positive' and 'snapshot'. Mrs Cameron's portrait of him, taken at his home Collingwood at Hawkhurst, Kent, is therefore not only one of the most moving images of a great intellect caught in the process of physical dissolution, but an important document in the history of photography. It is, like all her best work, distinguished by its dramatic lighting, soft focus (often ridiculed by her contemporaries), and feeling for character. But it is the *ad vivum* feel which she prized above all, and which she obtained by the use of very large glass plates from which she printed directly without enlargement or retouching. It is this quality which led her, as here, to inscribe 'From Life' on the mounts of her prints. See also no. 28.

34

Charles Robert Darwin 1809–82

Ernest Edwards 1837–1903

Albumen print, signed and inscribed by ?the photographer on the mount, *c*.1867
28.3 × 23.9 (11⅛ × 9¼)
Purchased, 1975 (X1500)

No scientist had a greater impact on Victorian attitudes than Darwin, whose theory of evolution, expressed in *The Origin of Species* (1859), destroyed the old biblical myth of creation.

He was photographed by Ernest Edwards for Edward Walford's *Representative Men in Literature, Science and Art* (1868), and is portrayed as a typical Victorian elder, lost in sober contemplation, very different from the young man who sailed on *The Beagle* to South America. For all his eminence Darwin remained modest and polite, judging himself only 'superior to the common run of men in noticing things which easily escape attention, and in observing them carefully'.

Edwards, who had a studio at 20 Baker Street, London, from 1864, specialized in portraiture and topographical work, and he published with H.B. George *The Oberland and its Glaciers Explored and Illustrated with Ice-Axe and Camera* in 1866. He developed an early form of pocket camera, and invented the heliotype (1869), a modified form of collotype reproduction. The first book to be illustrated with heliotypes was Darwin's *The Expression of the Emotions in Man and Animals* (1872). See also no. 30.

35

Queen Victoria 1819–1901 with her servant John Brown 1826–83

W. & D. Downey active c.1860–early 1900s

Albumen print, inscribed on the mount: *Downey./The Queen./Balmoral. June 1868.*
J.Brown holding the pony.; June 1868
13.7 × 9.8 (5⅜ × 3⅞)
Purchased, 1975 (P22/4)

Queen Victoria and Prince Albert acquired the lease of the Balmoral estate in 1848, and the castle which they built there on the banks of the River Dee became 'Albert's favourite resort, whence the view is very beautiful'. In her years of widowhood it therefore had special significance for the Queen, and she often suffered 'homesickness for my beloved Highlands, the air – the life, the liberty'.

This photograph, from an album of prints by various photographers of the Queen, her family and servants at Balmoral, is by William and Daniel Downey of Newcastle upon Tyne and Eaton Square, who were much patronized by the royal family, especially the Prince of Wales. The Queen is shown about to go out riding, attended by her faithful servant and companion John Brown. Two months later she was to pay her first visit to Switzerland, travelling incognito as 'the Countess of Kent'. When Brown died the Queen described him as 'my best & truest friend, – as I was his', and organized elaborate tributes to him, much to the disapproval of her family, including a statue by the leading sculptor Boehm at Balmoral, for which Tennyson (no. 21) supplied the inscription:

Friend more than servant, loyal, truthful, brave:
Self less than duty even to the grave.

Downey.

The Queen.

Balmoral. June 1868.

J. Brown holding the pony.

36

Sir Henry Morton Stanley 1841–1904

London Stereoscopic Company active 1860–early 1900s

Carbon carte-de-visite, on printed mount, *c*.1872
9 × 5.7 (3½ × 2¼)
Purchased, before 1983 (X27584)

On 16 October 1869 the proprietor of the *New York Herald* ordered his special correspondent H.M. Stanley to 'find Livingstone' (no. 29), who was lost in the interior of Africa. Two years later, on 10 November 1871, he came face to face with Livingstone at Ujiji on the shore of Lake Tanganyika, 'reduced to the lowest ebb in fortune'. Stanley returned to find himself famous; England and America resounded with the story of his adventures, which he published as *How I Found Livingstone* (1872).

This photograph, which first appeared as frontispiece to his book, shows Stanley in tropical kit, the man of action. It was probably taken shortly after his return to London, and was widely published by the London Stereoscopic Company. This carte-de-visite version was produced for promotional purposes by 'E. Moses & Son, Merchant Tailor & Outfitters for all classes' of London and Bradford, and is on the firm's printed mount.

Stanley devoted most of his later life to travel and exploration, and to publishing his experiences, but this workhouse boy from St Asaph ended his career as a Unionist Member of Parliament.

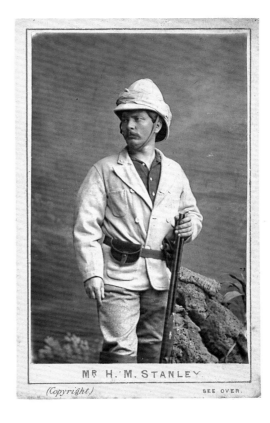

MR H. M. STANLEY

(Copyright) SEE OVER.

37

Edward Robert Bulwer Lytton, 1st Earl of Lytton 1831–91

Bourne & Shepherd active 1860s–present day

Albumen cabinet prints, on the photographers' printed mounts, 1877
13.6 × 9.9 (5$\frac{3}{8}$ × 3$\frac{7}{8}$)
Purchased from the Strachey Trust, 1979 (X13102 [left], X13100 [right])

The only son of the novelist Lord Lytton, Edward Lytton was a distinguished if flamboyant colonial administrator, and one of the century's worst and most prolific poets: 'his massed jewels glitter against no background, and the eye becomes confused and fatigued with their dazzle. Some, also, are unquestionably paste, and many are not his property' (Richard Garnett). By contrast, 'as a prose writer Lytton takes high rank; his minutes and despatches were the admiration of the India Office'.

These photographs were taken in India in 1877, in the year that Lytton as Viceroy proclaimed Queen Victoria Empress of India at Delhi. They are by the leading firm of photographers in India, founded by Samuel Bourne (1834–1912) and Charles Shepherd, which had studios in Simla, Bombay and Calcutta. They show something of Lytton's histrionic tendencies, and his love of dressing up: the one in his Viceroy's robes, the other in academical dress (by him is a cast of P.J. Mène's bronze *The Accolade*).

38

William Ewart Gladstone 1809–98

William Currey active 1870s

Carbon cabinet print, on the photographer's printed mount, 1877
14.3 × 8.5 (5½ × 3¾)
Given by the executors of the estate of Sir Cecil Beaton, 1980 (X12503)

No English politician has been more intensely loved or more fervently hated than Gladstone. A man of formidable intelligence and energy and of wide interests – he gave the same attention to everything that he put his mind to – he was a force in British politics for more than sixty years, serving as prime minister no less than four times, and equalled as an orator only by Bright (no. 41). He died, according to Lord Salisbury 'a great Christian man'.

He pursued his leisure activities with equal intensity, and his favourite pastime was cutting down trees, a taste which he acquired on the Duke of Newcastle's estate at Clumber. Here he is seen at his Welsh home, his wife's estate of Hawarden Castle, taking a brief respite from wood-chopping. It is a fitting image of a politician in opposition (he was between ministries), taken by the little-known photographer Currey of Bolton and Manchester. Its publication, along with three others from the same sitting, was noticed in *The British Journal of Photography* on 7 September 1877, as affording 'a peep behind the scenes in connection with the private life of this energetic statesman. . . . the expression on the face is . . . perhaps the finest we have ever seen of this gentleman, an immense amount of latent power being apparent, ready to be displayed at a moment's notice'.

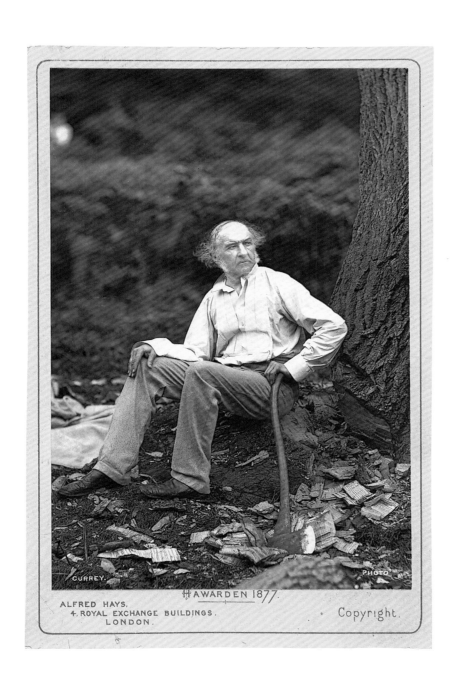

CURREY. PHOTO.

HAWARDEN 1877.

ALFRED HAYS,
4, ROYAL EXCHANGE BUILDINGS,
LONDON.

Copyright.

39

Benjamin Disraeli, 1st Earl of Beaconsfield 1804–81

(Cornelius) Jabez Hughes 1819–84

Albumen cabinet print, on the photographer's printed mount, 22 July 1878
13 × 9.3 (5⅛ × 3⅝)
Given by Mrs W.O. Manning, 1958 (X665)

Few would have predicted that the young Disraeli, restless, romantic and Jewish, was to become a great statesman. But by sheer ability he gradually asserted his influence on the Tory party, becoming Prime Minister in 1868. He guided the passage of the second Reform Bill, and his diplomatic triumphs included the purchase of the Suez Canal and the Congress of Berlin (1878). Unlike Gladstone (no. 38) he was a debator rather than an orator, possessed a sense of humour, and was, in addition, a prolific novelist, whose *Coningsby* (1844) and *Sybil, or the Two Nations* (1845) are among the earliest political novels in English, and distinguished by their concern for major social issues.

Again, unlike his rival, Disraeli was the intimate friend of Queen Victoria whom he nicknamed 'The Faery', and their relationship amounted almost to a romance. This carefully composed portrait was taken by her command at Osborne on the day that Disraeli was created a Knight of the Garter. The photographer Hughes is first recorded in 1848, as running a daguerreotype studio in Glasgow. He worked subsequently as assistant to Mayall (see no. 32), on the Strand, London, and from 1861 had his own studio at Ryde on the Isle of Wight, where he was extensively patronized by the Queen.

EARL of BEACONSFIELD, K.G.

PHOTOGRAPHED AT OSBORNE BY COMMAND OF H.M. THE QUEEN,
JULY 22ND 1878.

BY JABEZ HUGHES, RYDE, I.W.

ENTERED AT STATIONERS' HALL.

40

Sir Pierre Louis Napoleon Cavagnari 1841–79 with Afghan Chiefs

John Burke active *c*.1860–1907

Albumen print, signed and numbered 85 in the print and inscribed on the reverse: *85 Major Cavagnarie*
& Chief Sirdars with Kunar Synd, May 1879
23.5 × 28.9 (9¼ × 11⅜)
Purchased, 1987 (P330)

The son of one of Napoleon's officers, Cavagnari, a naturalized British subject, became
one of the most courageous servants of the Empire, first in India, and later in Afghanistan.
In 1879, when this photograph was taken, he negotiated and signed the Treaty of
Gandamuck with Afghanistan, and was made a KCB. He was then appointed British
Resident in Kabul, but was murdered in the citadel there along with other Europeans
on 3 September by mutinous Afghan troops. His head was split open with a blow, just
as the citadel's burning roof fell in. His body was never found. Lord Lytton (no. 37),
the Viceroy of India, heard of his death 'with unspeakable sorrow', and wrote to
Cavagnari's widow that 'every British heart in India feels for you'.

 This photograph presumably commemorates the Treaty of Gandamuck, and shows
Cavagnari surrounded by the Sirdars. The photographer worked variously in Murree,
Peshawar and Rawalpindi in India, and in the Afghan War was employed by the British
Army as 'Photographic Artist'.

41

John Bright 1811–89

Rupert Potter 1832–1914

Carbon print, September 1879
29.1 × 17.7 (11½ × 6⅞)
Acquired before 1977 (X4323)

Rupert Potter and his daughter Beatrix (better known as the writer and illustrator of the *Peter Rabbit* books) were both keen photographers. His favourite subjects were landscapes, but friendship with Sir John Everett Millais (no. 25) led him to portraiture, and, according to Beatrix, Millais thought that 'the professionals aren't fit to hold a candle to Papa'. So much so that he often used Potter's photographs as the basis for his portraits.

This was the case with the radical orator and Liberal statesman Bright. In the autumn of 1879 he and Millais were both guests of Potter in Scotland for the salmon-fishing, and this photograph was probably taken at about that time, for Millais follows it closely in his portrait of Bright exhibited at the Royal Academy in 1880 (Private Collection). The photograph conveys all those qualities which made Bright, like his associate, Cobden (with whom he led the Anti-Corn Law League), such a powerful representative of the manufacturing classes in British politics, and an advocate of reform. He was an idealist who, in all that he did, felt himself 'above the level of party', and never feared unpopularity, as, for instance, in condemning the Crimean War.

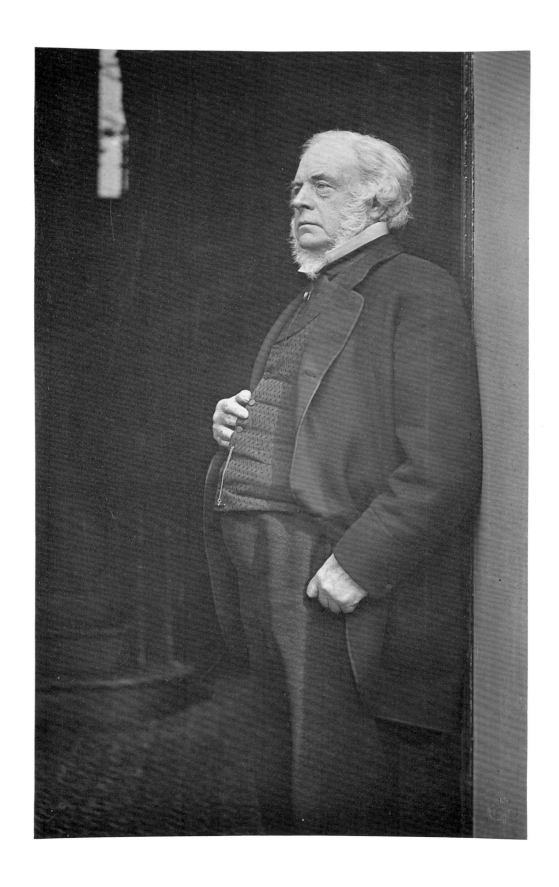

42

Queen Alexandra 1844–1925 when Princess of Wales

Symonds & Co active 1880s–90s

Carbon print, on the photographer's printed mount, August 1880
27 × 35.5 (10⅝ × 14)
Purchased, 1983 (X17460)

Queen Alexandra, 'Alix', was the eldest daughter of the future Christian IX of Denmark, and married the Prince of Wales, later Edward VII, in March 1863. 'Just think,' she said, 'my trousseau will cost more than Papa's whole annual income'. To Charles Dickens (no. 19), who saw her then, she seemed 'not simply a timid shrinking girl, but one with character distinctive of her own, prepared to act a part greatly'. She was very beautiful and had an assured sense of style, and it was inevitable, while Queen Victoria sank in the depths of widowhood, that she and the Prince should become the leaders of fashionable society. She bore her husband's habitual infidelity with stoicism, and, always excessively generous, devoted herself increasingly to charitable works, her family and her dogs. She was also a keen amateur photographer, and had trained at the London Stereoscopic School of Photography in Regent Street.

The Princess is seen here on board the Royal Yacht *Osborne*, in a photograph published by Symonds & Co of Chancery Lane, which epitomizes the elegance and informality of her style. This went unappreciated by the Queen, who thought her 'a distinguished lady of Society but nothing more!'.

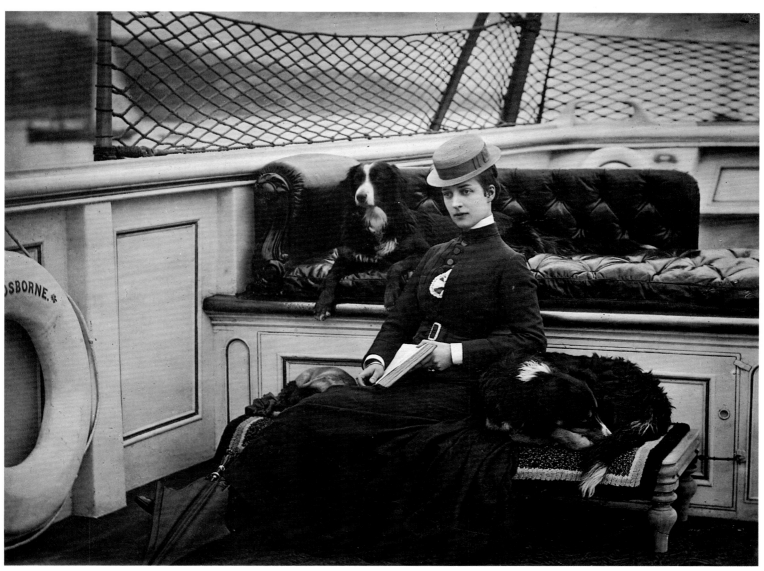

H.R.H THE. PRINCESS OF WALES

On Board the Royal Yacht "Osborne."

43

Oscar Fingal O'Flahertie Wills Wilde 1854–1900

Napoleon Sarony 1821–96

Albumen panel print, on the photographer's printed mount, January 1882
30.6 × 18.4 (12 × 7¼)
Purchased, 1976 (P24)

Oscar Wilde, playwright, wit and representative of the London aesthetic movement, arrived in New York on the steamship *Arizona* in January 1882 with 'nothing to declare but his genius'. Early on he called on the photographer Sarony at his studio on Union Square to commission publicity photographs for his series of lectures on 'Art for Art's Sake'. Sarony, who was himself one of the best known of New York's eccentrics, found in Wilde 'A picturesque subject indeed!'. He was the greatest curiosity of the New York season, and wrote home: 'Great success here; nothing like it since Dickens, they tell me'.

Like the great French photographer Nadar (see no. 26), Sarony began his career as a caricaturist, but turned to photography under the influence of his brother Oliver, who was one of England's most successful provincial photographers. He specialized in theatrical sitters, and his work, with its use of painted backdrops and carefully chosen accessories gave him a contemporary reputation as 'the father of artistic photography in America'.

OSCAR WILDE.

Copyright 1882, by N. Sarony.

NEW YORK.

44

Horatio Herbert Kitchener, 1st Earl Kitchener of Khartoum and of Broome 1850–1916

O. *Schoefft* active 1880s

Albumen cabinet print, on the photographer's printed mount, signed by the sitter on the verso four times;
between October 1884 and June 1855
$14.5 \times 10 \left(5\frac{3}{4} \times 3\frac{7}{8}\right)$
Purchased, 1982 (X15599)

The embodiment of the successful imperialist general, Kitchener served under Wolseley in the relief expedition to Gordon in Khartoum, and subsequently commanded in Egypt and the Sudan. His reputation for invincibility was enhanced by his victories in the Boer War, and at the time of the First World War it was he who converted the small British Army into one of three million men. He went down on HMS *Hampshire* off Scapa Flow.

This photograph was taken in Cairo at a much earlier stage in the Field Marshal's career, by the German photographer Schoefft, who styled himself 'photographe de la Cour au Caire'. Kitchener signed it proudly no less than four times on the verso, giving his rank as 'Major'. It therefore dates from between 8 October 1884 and 15 June 1885, for which short period Kitchener held the rank. He was at that time heavily involved in military intelligence in Egypt, and often worked in disguise. It fell to him to send the first authoritative report of the death of General Gordon on 26 January 1885.

45

Lillie Langtry (Emilie Charlotte le Breton, Mrs Edward Langtry, and later Lady de Bathe) 1852–1929

Henry van der Weyde active 1877–1901

Albumen cabinet print, on the photographer's printed mount, *c.*April 1885
14.5 × 10.3 (5¾ × 4⅛)
Acquired, 1973 (x19877)

'The Jersey Lily' was the daughter of the Dean of Jersey, and by virtue of her first marriage to a wealthy businessman and good looks she became the toast of London society, and an intimate friend of the Prince of Wales (later Edward VII). Her first appearance on stage in 1881 caused a sensation, primarily because of her social position and beauty, and she was not taken seriously as an actress. A New York critic wrote following her début there the next year: 'The difference between Madame Modjeska [the actress Helena Modjeska 1840–1909] and Lillie Langtry is that the first is a Pole and the other a stick'. In 1884 she took over the management of the Prince's Theatre, London, and this photograph shows her in the role of Lady Ormond in the revival of *Peril*, an adaptation of Sardou's *Nos Intimes*, which opened there in April 1885.

The American photographer van der Weyde came to London after the Civil War, in which he had fought, and set up his studio at 182 Regent Street. With Ralph Robinson (see no. 55) he was a founder member of the Linked Ring Brotherhood of those 'who delight in photography solely for its artistic possibilities', but he is best remembered as the creator of the first commercial studio to rely entirely on artificial light. This was provided by a Crossley gas engine which drove a Siemens dynamo, which in turn fed an arc light in a five-foot reflector, giving 4,000 candle-power illumination. This is advertised in the stamp on the mounts of his photographs: 'THE VAN DER WEYDE LIGHT'.

THE "VANDERWEYDE" LIGHT

182 REGENT ST. W.

46

James Abbott McNeill Whistler 1834–1903

Unknown photographer

Platinum print, signed by the sitter on the mount in full and with butterfly monogram; summer 1885
17.8 × 11.8 (7 × 4⅝)
Purchased, 1987 (P356)

Restless, volatile and eccentric, the American Impressionist painter Whistler, who chose as his emblem the butterfly, came to London in 1859 and settled in Chelsea in 1863. This photograph was taken in the garden of his studio in the Fulham Road in the summer of 1885, when he and his fellow-American William Merritt Chase were painting portraits of one another. Whistler's painting of Chase is lost, but it showed him 'full-length in frock coat and top hat, a cane held jauntily across his legs . . . the Masher of the Avenues'. In this photograph Whistler himself poses as a 'masher', a dandy and lady-killer, with his mahlstick under his arm, doing duty for a cane, perhaps in parody of his own painting.

In another photograph from this session Whistler appears with Chase and an artist friend, Mortimer Menpes, and it is possible that Menpes took both photographs.

J McNeill Whistler

47

John Ruskin 1819–1900

T.A. & J. Green active 1880s

Platinum print, with the photographers' imprint, c.1885
19.7 × 26 ($7\frac{3}{4}$ × $10\frac{1}{4}$)
Purchased, 1987 (P327)

Ruskin – 'the Professor', as he was habitually called – was the first great English art critic and a talented artist, whose voluminous writings greatly influenced contemporary attitudes to art and architecture. Although he once burned a set of Goya's *Caprichos* which he considered hideous, he recognized the genius of Turner and was an early champion of the Pre-Raphaelites, even after his friend Millais (no. 25) had stolen his wife Effie. In 1877 he was involved in a celebrated libel suit with Whistler (no. 46), in which the painter was awarded one farthing damages. In later life he turned to social and political problems, and was a passionate advocate of social reforms, which alienated many of his earlier admirers.

In 1871, following the death of his mother, Ruskin bought the small estate of Brantwood on Coniston Water in the Lake District, and there he spent his declining years. This photograph was 'taken during one of his daily walks' by a firm of photographers from Grasmere, about 1885, at the time that Ruskin was working on his autobiography *Praeterita*, when he was suffering from increasing mental instability, the 'monsoons and cyclones of my poor old plagued brains'.

48

Cardinal John Henry Newman 1801–90

Herbert Rose Barraud 1845–96

Carbon print, on the photographer's printed mount, *c*.1888
24.5 × 17.9 (9⅝ × 7)
Purchased, 1937 (x5406)

Newman, who as vicar of St Mary's, Oxford, was in 1833 a founder member of the Oxford Movement for the establishment of the principles of Anglo-Catholicism in the Anglican Church, came increasingly to doubt the Anglican position, and was received into the Roman Church in 1845. After ordination in Rome, he returned to England to found oratories in Birmingham (1847) and London (1850), and spent the rest of his life in Birmingham working for the revival of Catholicism in England: 'There is no help for it; we must either give up the belief in the church as a divine institution altogether, or we must recognise it in that communion of which the pope is the head . . . to believe in a church is to believe in a pope'. Newman's conversion to Catholicism shook the Church of England – Gladstone wrote that 'it has never yet been estimated at anything like the full amount of its calamitous importance' – and ensured that he remained a celebrity throughout his life. He was made Cardinal in 1879. His vivid writings include the *Apologia pro Vita Sua* (1864), *The Dream of Gerontius* (1866), and hymns, among them 'Lead, Kindly Light'.

The photographer Barraud, who had premises at 263 Oxford Street, London, is best known for his series of volumes of contemporary personalities entitled *Men and Women of the Day*, published annually between 1888 and 1891, in which his highly efficient photographs were accompanied by biographies of the sitters. This portrait of Newman appeared in the volume for 1888, and shows Barraud's ability to fix a personality by the choice of a significant gesture. About 1891 Barraud's finances failed, and he ended his days as manager of Mayall's studio at 73 Piccadilly, London (see no. 32).

49

George Bernard Shaw 1856–1950

Sir Emery Walker 1851–1933

Modern bromide print from the original half-plate glass negative, summer 1888
Given by Emery Walker Ltd, 1956 (x19646)

George Bernard Shaw quit his native Dublin for London in 1876. The next ten years were a period of momentous change for him. He wrote five novels, none of them published, but which were to provide raw materials later for his plays; he became a socialist, and joined the Fabian Society (1884); converted to vegetarianism (1881) – a diet to which he attributed his immense energy; but, above all, by sheer will-power, he conquered his own shy and nervous personality. He forced himself to speak on platforms, in public parks and on street corners, and turned himself into one of the most effective orators, debators and, indeed, wits of the day. 'The years of poverty had ended, and the years of plenty now began'.

This photograph 'at ease in Summer in Battersea Park' by Shaw's friend and fellow-socialist Emery Walker shows him standing confidently in his newly-forged persona. It was taken at about the time of his appointment as music critic of the recently-founded evening paper *The Star*. In the next two years, under the pen-name of Corno di Bassetto, he was to write some of the liveliest music-criticism ever published.

Walker, a friend of William Morris, with whom he worked in founding the Arts and Crafts Exhibition Society, was a process-engraver and typographer, who devoted his life to the improvement of the quality of book production. The Gallery owns some 10,000 of his photographic negatives, most of them reference photographs for book illustrations, but including a number of original negatives from life, like this one, of his friends and associates.

50

Mary Augusta Arnold, Mrs Humphrey Ward 1851–1920

Herbert Rose Barraud 1845–96

Carbon print, on the photographer's printed mount, *c.*1889
24.6 × 17.7 (9⅝ × 7)
Purchased, 1936 (AX5470)

The daughter of Thomas Arnold, Professor of English, for a time Newman's first classics Master at the Birmingham Oratory School (see no. 48), Mrs Humphrey Ward was the granddaughter of Dr Arnold of Rugby and niece of the poet and critic Matthew Arnold. A chronic sufferer from writer's cramp, she was a prolific author, and this photograph was taken shortly after the publication of her best known work, the novel *Robert Elsmere* (1888), an instant best-seller, which popularized her theme: the social mission of Christianity. She put her principles into practice, founding in London in 1890 a settlement for popular Bible teaching and social work which developed into the Passmore Edwards Settlement. She instituted 'children's play hours' and drew attention to the need for special educational facilities for handicapped children. Despite her own taste for politics, she was the foundress of the Women's National Anti-Suffrage League (1908), working instead to bring the views of women to bear on the legislature without the aid of the vote. In the First World War she produced pro-Allied propaganda for America.

This photograph appeared in *Men and Women of the Day* (1889) (see no. 48).

51

Marie Lloyd (Matilda Alice Victoria Wood) 1870–1922

Schloss active 1890s

Albumen panel print, on the photographer's printed mount, signed and inscribed by the sitter:
Yours Always/Marie Lloyd; 1890
18.1 × 29.5 (7⅛ × 11⅝)
Purchased, 1980 (X12456)

The eldest of the eleven children of an artificial-flower maker, Marie Lloyd formed the Fairy Bell Minstrels as a child, and performed in schoolrooms and mission halls. She first appeared on stage aged fourteen, and was in the West End of London before she was sixteen. Though she worked in pantomimes, her name will always be associated with the music hall, and with songs like 'The Boy I love sits up in the Gallery' and 'Oh, Mr Porter'. To much of her material, by look, gesture, or tone of voice, she brought a cheery vulgarity, and both Ellen Terry (no. 9) and Sarah Bernhardt praised her powers of 'significant expression'.

This photograph dates from Marie Lloyd's first visit to America in 1890, and was taken at the Schloss studio at 54 West 23rd Street, New York. The Cockney girl is portrayed as an oriental houri, among all the exotic trappings of a fashionable theatrical photographer, and with a whiff of sexual provocation which anticipates no. 136. It is curiously at odds with the singer of 'I'm one of the ruins that Cromwell knocked abaht a bit'.

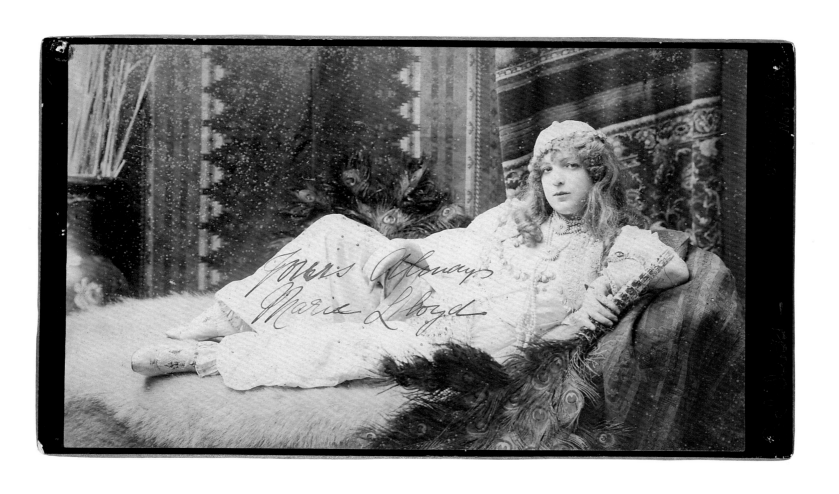

52

Sir Edward Coley Burne-Jones Bt. 1833–98

Barbara Leighton active *c*.1890

Platinum print, 27 July 1890
33.3 × 25.7 ($13\frac{1}{8}$ × $10\frac{1}{8}$)
Given by E.E. Leggatt, before 1922 (X13185)

As an undergraduate at Oxford in the early 1850s Burne-Jones met William Morris and founded with him The Brotherhood, a group of friends who worshipped the Middle Ages, visited churches, read Ruskin and Tennyson, and who in effect constituted a little 'romantic movement' of their own. While still an undergraduate Burne-Jones came to London to meet Rossetti (no. 24), who persuaded him to give up university and to learn to paint. The combined influences of medieval romance and the Pre-Raphaelites dominated the whole of his later career as artist and designer.

This photograph shows Burne-Jones towards the end of his life, when bouts of illness had convinced him that he had not long to live. He is at work in the Garden Studio of his house, The Grange, North End Lane, Fulham, on his vast watercolour *The Star of Bethlehem* (completed early 1891; Birmingham Museum and Art Gallery). Burne-Jones said of his labours on this picture: 'And a tiring thing it is, physically, to do, up my steps and down, and from right to left. I have journeyed as many miles as ever the kings travelled'.

The photographer Barbara Leighton, whose name is recorded in Lady Burne-Jones' *Memorials* of her husband (1904) is otherwise unknown. She may perhaps have been 'the young girl who', as Lady Burne-Jones recalls, 'asked him [Burne-Jones] as she watched him painting "The Star of Bethlehem", whether he believed in it, he answered: "It is too beautiful not to be true"'.

This photograph has in the past been wrongly attributed to Frederick Hollyer (see no. 59), who did however make this platinum print from Barbara Leighton's 15 × 12 inch negative. This belonged to Sir Emery Walker (see no. 49), and is now also in the Gallery's collection.

53

Dame Millicent Garrett Fawcett, Mrs Henry Fawcett 1847–1929

Walery (Stanislas Julian Walery, Count Ostrorog) active 1884–98

Carbon print, on the photographer's printed mount, with a facsimile of the sitter's signature; c.1890
25 × 18 (9¾ × 7⅛)
Acquired before 1980 (X9121)

Sister of the pioneer of women's medicine Elizabeth Garrett Anderson, and wife of the blind Liberal statesman Henry Fawcett, Dame Millicent was prominent in the women's suffrage movement from its earliest years in the late 1860s. She worked unremittingly for the cause, but as president from 1897 of the influential National Union of Women's Suffragettes she opposed the militant suffragettes (1905–14), led by Mrs Emmeline Pankhurst and her daughter Christabel. During the 1880s and 1890s, in addition to her work for women, she visited Ireland repeatedly, and was active in opposition to Home Rule, and in 1901 went to South Africa as leader of the ladies' commission of inquiry into Boer concentration camps.

This serene portrait, which appeared in Walery's monthly series *Our Celebrities* (published by Sampson Low & Co.), dates from about 1890, in which year Dame Millicent's daughter Philippa, a student at Newnham College, Cambridge, was placed above the (male) Senior Wrangler (top first class degree) in the mathematical tripos, an achievement which materially advanced the cause of higher education for women. Walery's studio was at 164 Regent Street, London. Like Barraud (see nos. 48 and 50), he was a superb technician, and his carbon prints derive much of their fascination from the great clarity of image which he obtained. So sharp indeed was the definition that they often needed cosmetic retouching, and Dame Millicent's complexion owes much of its perfection to the art of the stippler rather than to nature.

54

Thomas Henry Huxley 1825–95

Elliott & Fry active 1863–1963

Albumen cabinet print, on the photographers' printed mount, c.1890
14.8 × 10.4 (5¾ × 4)
Acquired, 1973 (X11994)

Huxley was one of the best known and most influential scientists of his day. A Darwinian, many of his ideas were in violent opposition to accepted religious teaching, and he battled throughout his career 'to promote the increase of natural knowledge and to further the application of scientific methods of investigation to all the problems of life', and to rid the world of 'the garment of make-believe, by which pious hands have hidden its uglier features'. He carried out his important researches on fish, reptiles, birds and fossils, but he is above all remembered as a scientific popularizer and spokesman.

Joseph John Elliott and Clarence Edmund Fry established the firm of Elliott & Fry at 55 Baker Street, London, in 1863, and it remained there until 1963. This portrait was taken towards the end of Huxley's life, and conveys by its considered pose and careful lighting both his intellectual curiosity and authority.

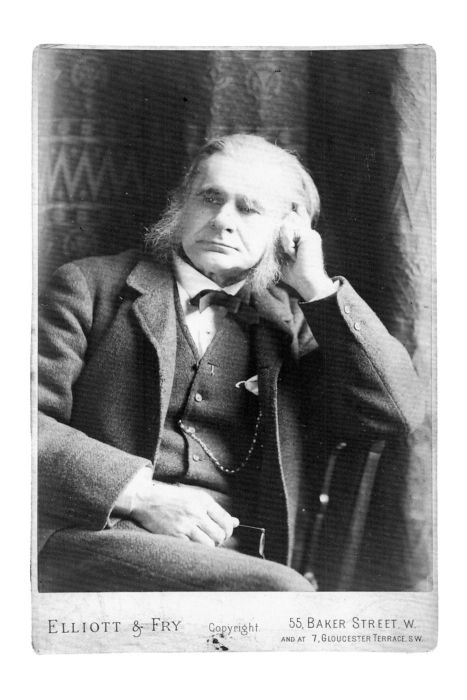

ELLIOTT & FRY Copyright. 55, BAKER STREET. W.
 AND AT 7, GLOUCESTER TERRACE. S.W.

55

Frederic, Baron Leighton of Stretton 1830–96

Ralph Winwood Robinson 1862–1942

Platinum print, with the name of the sitter printed on the mount, *c.*1891
20 × 15.4 (7¾ × 6)
Acquired, 1969 (X7373)

In 1892 Ralph Robinson, elder son of the photographer and writer on photography Henry Peach Robinson, published a volume of fifty-seven portrait photographs entitled *Members and Associates of the Royal Academy of Arts in 1891*. All show the distinguished artists at home or in their studios, rather than in the photographer's studio, an unusual procedure at the time, and this makes the book an especially valuable social document.

Robinson captures Leighton, President of the Royal Academy (1878–96) and the foremost representative of High Victorian academic painting, in the first floor studio of his house at 2 (now 12) Holland Park Road, London. By him stands a small plaster of his sculpture *The Sluggard* (*c.*1882–5); hanging on the wall (top left) is a cast of Michelangelo's 'Taddei' tondo (Royal Academy, London), alongside a group of Leighton's own oil sketches. He holds a figurine of a female torso. At about this time Leighton was working on two large canvases, *And the Sea gave up the Dead which were in it* for Sir Henry Tate (Tate Gallery, London) and *Perseus and Andromeda* (Walker Art Gallery, Liverpool), in both of which his admiration for sculptural forms is readily apparent. Both Ralph Robinson and his father were founder members of the Linked Ring (see no. 45).

56

Robert Louis Stevenson 1850–94 and his Family

J. Davis active 1890s

Albumen print, with the photographer's blind stamp, *c.*1891
19.2 × 23.4 (7½ × 9¼)
Purchased from the estate of Sir Edmund Gosse, 1919 (X4630)

The sitters are (left to right) : an unknown woman; Lloyd Osbourne, Stevenson's stepson and literary collaborator; Mrs Thomas Stevenson, his mother; Isobel Osbourne, Mrs Joseph Strong, stepdaughter and amanuensis; Stevenson; Austin Strong, the Strongs' son; Fanny van de Grift, Mrs Stevenson (formerly Mrs Osbourne), and Joseph Strong, his stepson-in-law.

Throughout his life the Scottish novelist, essayist and poet Robert Louis Stevenson led a wandering gipsy existence. This reflected his longing for the primitive, but was also stimulated by the search for a climate which suited his tuberculosis. In 1891 he settled with his family at Apia in Samoa, where the beauty of the scenery, the climate, and the charm of the native population delighted them.

This photograph was taken by the local postmaster, who also had a photography business, and shows the family on the verandah of the wooden house which Stevenson had built on his four-hundred-acre estate Vailima ('five rivers'). The carefully posed group, grave, and with an air of suspended theatricality, conveys well the atmosphere of this tightly knit community, grouped around Tusitala ('the teller of tales'), hard-working, contented and religious. Lloyd Osbourne, who was collaborating with Stevenson on *The Wreckers* at this time, wrote that

> he [Stevenson] liked too, best of all, I think, the beautiful and touchingly patriarchal aspect of family devotions; the gathering of the big, hushed household preparatory to the work of the day, and the feeling of unity and fellowship thus engendered. . . . We were the *Sa Tusitala*, the clan of Stevenson, and this was the daily enunciation of our solidarity.

The date 1891 is usually associated with this photograph, but it could be a little later. Stevenson died of a brain haemorrhage in 1894.

57

Herbert Henry Asquith, 1st Earl of Oxford and Asquith
1852–1928

Cyril Flower, Baron Battersea 1843–1907

Platinum print, *c.*1891–4
20 × 14.7 (7$\frac{7}{8}$ × 5$\frac{3}{4}$)
Purchased, 1982 (AX15687)

Cyril Flower, later Lord Battersea, Liberal MP, ardent huntsman, eccentric and passionate aesthete, took up photography in the 1880s. His friends were his favourite subject, and this portrait of the future Prime Minister Asquith comes from an album of 124 portrait photographs owned by the Gallery, which were taken at Aston Clinton, the family home of Flower's wife, Constance de Rothschild. They are redolent of the social life of the period. Asquith got to know Cyril Flower in the 1880s, and became something of a protégé. Lady Battersea writes of him in her *Reminiscences* (1922), in the chapter entitled 'Prime Ministers I have known', as

> a somewhat spare figure, carelessly dressed, a shapely head with smooth light-brown hair, a fine forehead, rather deep-set grey eyes, a pale complexion, such as one would expect in a hard-working student, a firm mouth that could break into a pleasant smile, no special charm of bearing or manner, but a low agreeable voice and a distinctly refined enunciation.

This photograph was almost certainly taken shortly after the death of Asquith's first wife in 1891, and before his marriage to Margot Tennant (no. 88) in 1894, at about the time he first entered the Cabinet as Home Secretary.

Lord Battersea died in November 1907, and his obituary in *The Times* ends with the announcement: 'In consequence of the death of Lord Battersea, Lord Rothschild's staghounds will not hunt today'.

58

Joseph Chamberlain 1836–1914

Eveleen Myers died 1937

Carbon print, early 1890s
29.1 × 23.7 (11⅜ × 9¼)
Purchased, 1983 (X19813)

The formidable political boss of Birmingham, Chamberlain entered national politics as President of the Board of Trade in Gladstone's second administration (1880). His strongly-held radical opinions made him the *enfant terrible* of the Cabinet but he appeared to many to be the natural successor to Gladstone. This prize was thrown away when he and John Bright (no. 41) voted against their party on the Irish Home Rule bill (1886). He spent nine years in the political wilderness, until in 1895 this dedicated imperialist was appointed Colonial Secretary in Lord Salisbury's coalition government.

Throughout his career Chamberlain was the delight of caricaturists, and his distinctive features and monocle were known throughout Europe. Eveleen Myers creates a likeness of great concentration – Chamberlain's intense glance fixed by his hypnotic monocle – the image of a political hard-hitter, 'alert, not without a pleasant squeeze of lemon, to add savour to the daily dish'. Born Eveleen Tennant, she was the beautiful daughter of cultivated well-to-do parents, and was painted by Watts and Millais. She married in 1880 F.W.H. Myers, poet and essayist, and a dedicated spiritualist who founded the Society for Psychical Research. In 1888 at their home, Leckhampton House, Cambridge, she set up a studio, and photographed many of her distinguished friends and contemporaries, as well as aesthetically posed genre studies. John Addington Symonds, writing in *Sun Artists* (1891), comments on 'her powers . . . so marked in the direction of humanity'. Her photograph of Chamberlain is probably a little later than this article, but before 1895. Mrs Myers' sister Dorothy Tennant was married to Sir H.M. Stanley (no. 36).

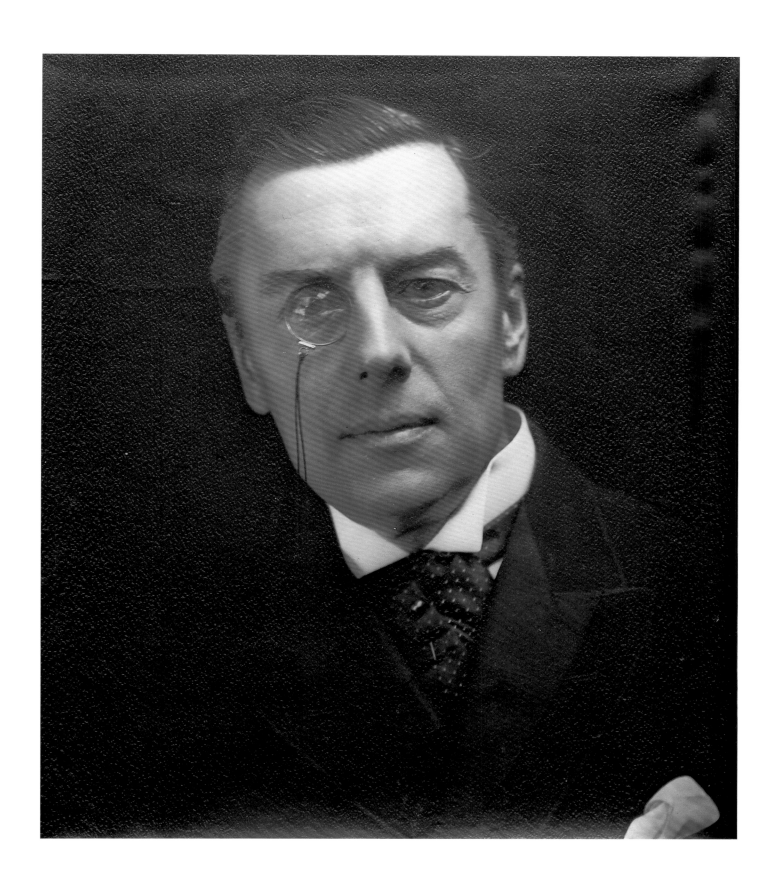

59

Beatrice Stella Tanner, Mrs Patrick Campbell 1865–1940

Frederick Hollyer 1837–1933

Platinum print, with the photographer's stamp on the reverse of the mount, 1893
14 × 8.9 (5½ × 3½)
Purchased, 1983 (P229)

One of the greatest actresses of the century, 'Mrs Pat' became on account of her tempestuous moods, devastating wit and pronounced eccentricity, a legend in her own lifetime. She made her début in 1888, and triumphed in the year of this photograph in the role of Paula Tanqueray in the first production of Pinero's *The Second Mrs Tanqueray*. She had a dark, Italian beauty and a rich expressive voice, with a gift for portraying passionate and complex women. Sir Edmund Gosse writing to her in 1895 cites 'the flash and gloom, the swirl and the eddy, of a soul torn by supposed intellectual emotion'. Later roles included Mélisande (1898) and in lighter vein Eliza Doolittle in Shaw's *Pygmalion* (1914): 'I invented a Cockney accent and created a human Eliza'.

Frederick Hollyer took up photography in about 1860, and established a business in the photographic reproduction of works of art (notably the paintings of the Pre-Raphaelites and the drawings of Burne-Jones [no. 52]). As a relaxation he photographed people, and at his studio at 9 Pembroke Square, London, Mondays were reserved for portraiture. His portrait prints, with their limited range of tone and distinctive mounts, have a rare delicacy and beauty. His sitters are unselfconsciously posed and softly lit, their characters revealed with great sympathy and understanding. Hollyer was a member of the Photographic Society and the Linked Ring (see no. 45), and his work was much admired by his contemporaries: 'From a fine Hollyer portrait you study the man as he is . . . these finely modelled heads, set so well in place as regards the decoration of a panel, are also transcripts of personalities – human documents of singular verity . . .'.

60

Queen Victoria 1819–1901 with her Indian servant Abdul Karim

Hills & Saunders active *c.*1859 to the present day

Carbon print, 17 July 1893
42.9 × 57.4 (16⅞ × 22⅝)
Purchased, 1901–2 (P51)

To her great satisfaction Queen Victoria was proclaimed Empress of India in 1876 and thereafter imported an Indian flavour to her court. There was a Durbar Room at Osborne, and, after the death of John Brown (no. 35), she employed as her personal attendant an Indian servant Abdul Karim from Agra. His airs made him, like Brown before, most unpopular in court circles, but the Queen defended him with absolute tenacity, and he remained in her service until her death. In 1888 Abdul Karim refused to continue to wait at table, because in Agra he had been a clerk or Munshi, not a menial, and in 1889 he was created Queen's Munshi. He rapidly graduated, as Prince Albert had done, from blotting the Queen's letters to helping in their composition. He looked after 'all my boxes', and gave his mistress lessons in Hindustani: 'a very strict Master' and 'a *perfect* Gentleman'. He was painted, like the Queen, by Von Angeli.

In this photograph by the Eton firm founded by Robert Hills and John Henry Saunders, the Queen is shown working at her boxes, seated in her garden-tent at Frogmore House, Windsor.

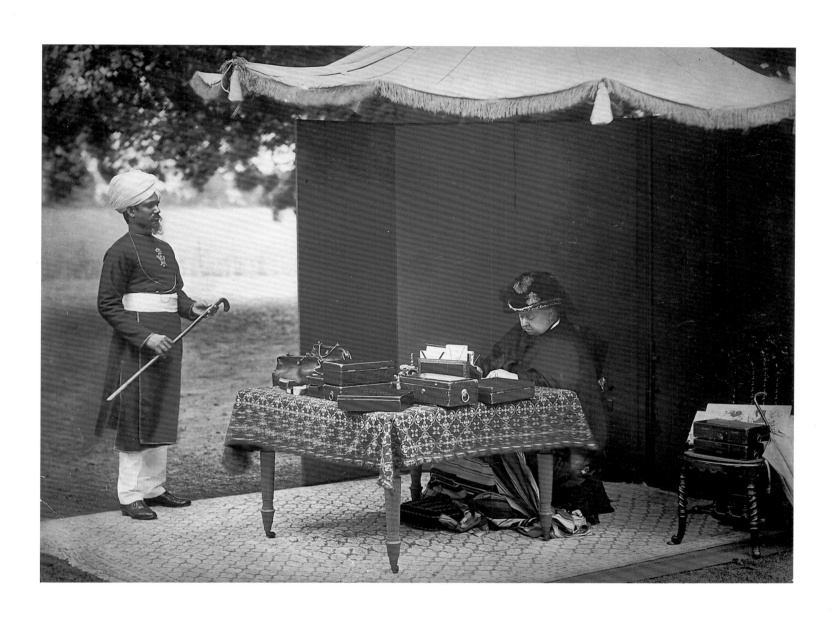

61

Sir Richard Strachey 1817–1908 and his Family

Graystone Bird active 1895–1910

Albumen print, on the photographer's printed mount, *c*.1893
19.3 × 24.1 (7½ × 9½)
Purchased from the Strachey Trust, 1979 (X13122)

The sitters are (left to right): James Beaumont Strachey 1887–1967, psycho-analyst; Giles Lytton 1880–1932, critic and biographer; Oliver 1874–1960, musician, civil servant and author; Ralph 1868–1923; Richard John 1862–1935, soldier; Sir Richard; Jane Maria Grant, Lady Strachey 1840–1928; Elinor, Mrs Rendel 1860–1945; Dorothy 1865–1960, wife of the artist Simon Bussy; Philippa 1872–1968; Joan Pernel 1876–1951, and Marjorie 1882–1962.

As soldier, engineer, botanist and administrator, Sir Richard Strachey devoted his life to the service of India, where he rose to be Head of the Public Works department (1862–5) and Inspector-General of Irrigation (1866). In retirement he pursued his prodigiously wide interests, and was for a time Chairman of the East Indian Railway, President of the Royal Geographical Society, and Chairman of the Meteorological Council. The member of a distinguished intellectual family, many of his own children played a significant part in English social and intellectual life, above all Lytton, who was a leading member of the Bloomsbury Group.

In this photograph by the obscure Bath photographer Bird, whose studio was at 38 Milsom Street, the family are displayed with characteristic eccentricity in perfect symmetry, in imitation of the reliefs of kneeling figures often found on seventeenth-century English tombs. It was probably taken at the Strachey family home of Sutton Court, Somerset, and is part of a large group of Strachey family photographs purchased from the Strachey Trust in 1979.

62

Aubrey Vincent Beardsley 1872–98

Frederick H. Evans 1853–1943

Platinum print, signed, inscribed and dated by the photographer on the mount; summer 1894
13.6 × 9.7 (5⅛ × 3⅞)
Given by Dr Robert Steele, 1939 (P114)

The bookseller and publisher Frederick Evans of Queen Street, Cheapside, London, was the friend and patron of the artist and illustrator Aubrey Beardsley, and instrumental in obtaining his earliest commissions. He was also a gifted and sensitive photographer, whose style was, like that of Hollyer (see no. 59), noted for its purity. He photographed Beardsley in the summer of 1894, perhaps at his home at 144 Cambridge Street, London. He wrote to Evans on 20 August 1894: 'I think the photos are splendid; couldn't be better. I am looking forward to getting my copies. I should like them on cabinet boards, if that's not too much trouble'. Although seriously ill, he was at this time struggling to work on his illustrations to Wagner's *Tannhäuser*:

> I have been suffering terribly from a haemorrhage of the lung which of course left me horribly weak. For the time all my work has stopped, and I sit about all day moping and worrying about my beloved Venusberg. I can think about nothing else – I am just doing a picture of Venus feeding her pet unicorns.

By this date Evans sensed that Beardsley was dying, and this photograph, with its emphasis on the delicate bird-like profile and long etiolated fingers, is a grave and fragile reminder of mortality. Evans exhibited it at the second Photographic Salon of the Linked Ring (see no. 45) in October 1894, where it was displayed mounted on a photographic copy of one of Beardsley's black and white border designs. The illustrator of the *Yellow Book* and *Savoy*, of *The Rape of the Lock* and Oscar Wilde's *Salomé*, whose work aroused such furious controversy, died less than four years later.

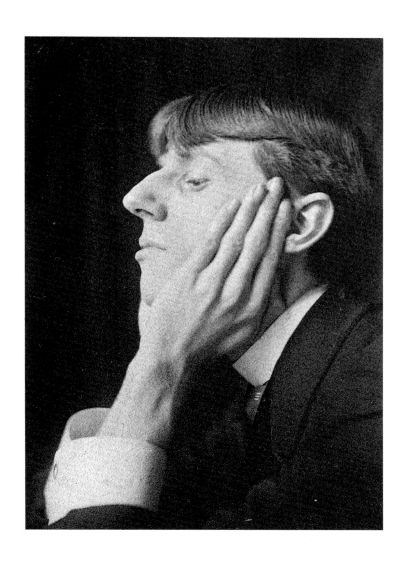

63

Queen Victoria 1819–1901 and her Descendants,
'The Four Generations'

Chancellor active 1860s–1916

Panel print, on the photographer's printed mount, 5 August 1899
28.8 × 23.9 (11⅜ × 9⅜)
Purchased, 1983 (P232)

The sitters are (left to right): Prince George, Duke of York 1865–1936, later George V; Queen Victoria; Edward, Prince of Wales 1841–1910, later Edward VII; and Prince Edward of York 1894–1974, later Edward VIII, and subsequently Duke of Windsor.

Writing to her daughter Princess Victoria, Empress Frederick of Germany, in June 1894, about the birth of Prince Edward of York, a 'fine, strong-looking child', Queen Victoria commented on the birth: 'It is a great pleasure & satisfaction, but not such a marvel'. She added, 'As it is, however, it seems that it has never happened in this Country that there shld be three direct Heirs as well as the Sovereign alive'. The Queen was evidently fond of this idea, and a number of photographs and paintings commemorate 'The Four Generations'. This group by Chancellor of Sackville Street, Dublin, was taken at Osborne House on the Isle of Wight on 5 August 1899, shortly after the Queen's eightieth birthday. Originally a firm of clock-makers, Chancellors turned to photography in the 1860s. The cartes-de-visite from this period bear the name of John Chancellor.

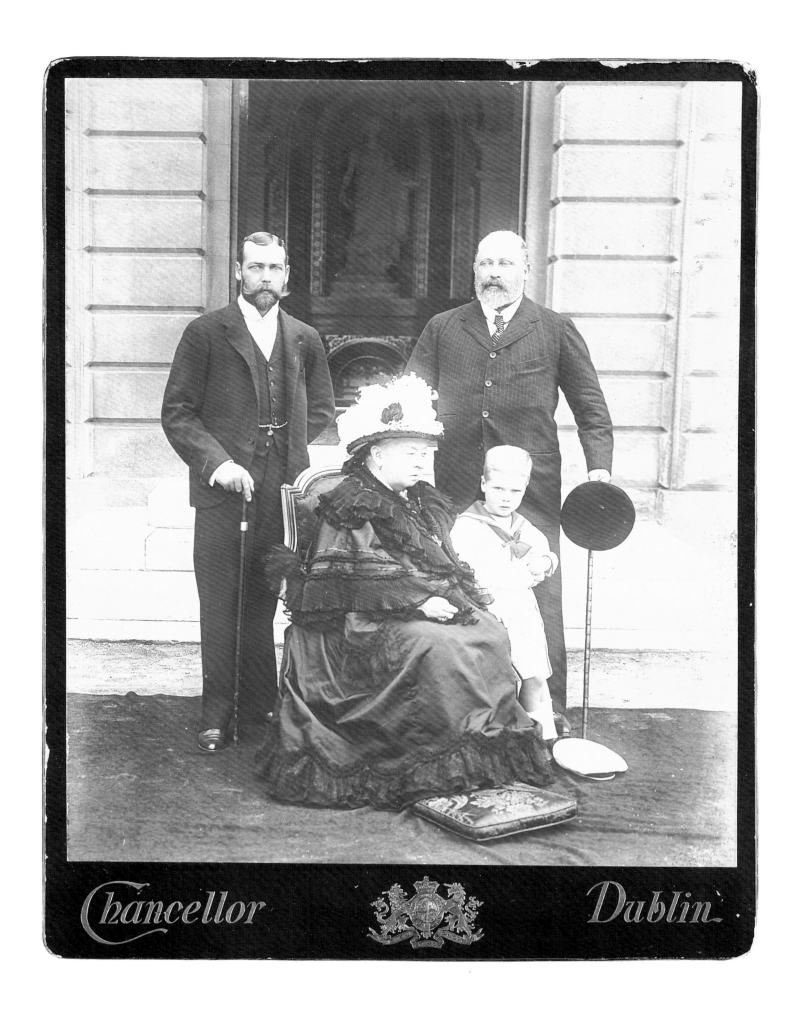

Chancellor Dublin

64

Francis Cowley Burnand 1836–1917

Unknown photographer

Albumen cabinet print, inscribed and dated by the sitter on the mount, 1899
14.2 × 10.2 (5½ × 4)
Given by the executors of the estate of Lady Partridge, 1961 (x4904)

Burnand pursued a zigzag course from Eton to Cambridge (where he founded the Amateur Dramatic Club), from Anglican theological college to Roman Catholicism, from the Bar to the stage, and finally to the editorship of *Punch* (1880–1906). As a playwright he has over a hundred popular plays and burlesques to his name, of which *Black-eyed Susan* (1866) is best known. He was co-founder of the periodical *Fun*. He joined the staff of *Punch* in 1863, and was largely responsible for transforming it into a national monument of humour. To the charge that *Punch* in his time was not as good as it used to be, he replied 'It never was'.

This cabinet photograph, an amusing composite of two poses, conveys much of Burnand's genial appearance and gentle humour. On the column (centre) stands a plaster reduction of the Venus de Milo, and the mount is inscribed in Burnand's hand: 'Discussion on the Venus of Milo/Two of a trade never agree/Yours F. C. Burnand June 2 1899'. The photograph was formerly in the collection of the cartoonist Sir Bernard Partridge, who worked for *Punch* throughout most of Burnand's editorship.

65

Virginia Woolf (Adeline Virginia Stephen, Mrs Leonard Woolf)
1882–1941

George Charles Beresford 1864–1938

Platinum print, July 1902
15.2 × 10.8 (6 × 4½)
Purchased, 1983 (P221)

The second daughter of the editor of *The Dictionary of National Biography*, Sir Leslie Stephen, Virginia Woolf possessed an ethereal beauty and a temperament of extreme sensitivity, both of which qualities seem reflected in her novels and in her exquisite historical fantasy *Orlando* (1928). In *Mrs Dalloway* (1925), *To the Lighthouse* (1927) and *The Waves* (1931) she developed the 'stream of consciousness' style which is her main contribution to the development of the English novel. Throughout her career she suffered bouts of mental illness, and eventually took her own life. Despite her apparent fragility, she made a considerable impact on her contemporaries, and could be both mordantly witty and tough. With her sister Vanessa and their brothers Adrian and Thoby, she was at the heart of the Bloomsbury Group, a coterie of intellectuals and artists who dominated English cultural life in the first decades of the twentieth century, and counted among her intimates Maynard Keynes, Lytton Strachey (no. 61), E.M. Forster (no. 120), and the political writer Leonard Woolf, whom she married in 1912.

Beresford, who was a brilliant talker and wit and also an antique dealer, is best known as the model for 'M'Turk' in his friend Rudyard Kipling's stories of *Stalky & Co*. But between 1902 and 1932 this versatile man was a respected commercial photographer with a studio in Yeoman's Row, Brompton Road, London, specializing in straightforward portraits of writers, artists and politicians, many of which were reproduced in periodicals of the time. He photographed Virginia Woolf in the summer of 1902, at a time when she was beginning her literary career, writing reviews for *The Times Literary Supplement*. In addition to prints, the Gallery also owns a large collection of Beresford's negatives.

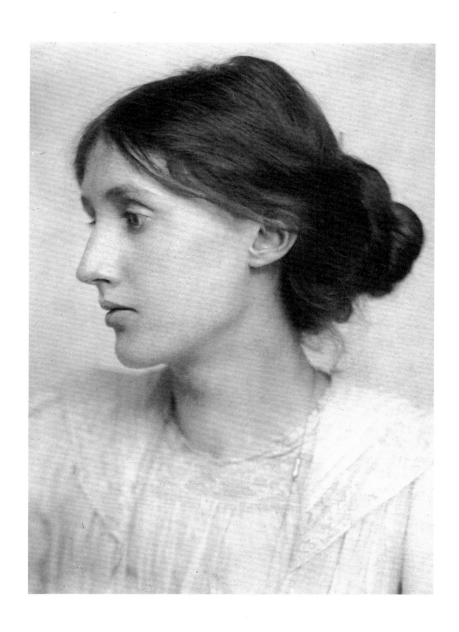

66

Sir James Dewar 1842–1923

Dr Alexander Scott active *c.*1900

Platinum print, 1902
20.1 × 15.3 (7⅞ × 6)
Given by Lady Dewar, 1926 (X5197)

Dewar was a dominant figure in experimental science in the late nineteenth and early twentieth centuries. At Cambridge and at the Royal Institution he carried out important work on the liquefaction of gases, and laid the foundations of subsequent advances in atomic physics. He invented a precursor of the 'Thermos' flask, and was, with Sir Frederick Abel, the inventor of cordite (1889). An impatient, indeed choleric man, he is shown here at work in his laboratory in an attitude of intense concentration.

This photograph was given to the Gallery in 1926 by his widow Lady Dewar. It is inscribed in an unknown hand on the back of the mount: 'Prof. Sir James Dewar./ Taken by Dr. Alexander Scott/in 1902/In the Laboratory of/The Royal Institution', but the photographer Olive Edis (see nos. 85, 90), in whose studio this print was possibly made, believed that it was taken by an associate of hers, Ethel Glazebrooke.

67

Arthur Morrison 1863–1945

Frederic G. Hodsoll active c.1900–10

Gelatin silver print, inscribed by the photographer on the mount: *Arthur Morrison by. FG. Hodsoll*, 1902
26.2 × 22 (10$\frac{3}{8}$ × 8$\frac{1}{2}$)
Purchased from St Paul's Cathedral, 1983 (AX25182)

The novelist Arthur Morrison is best known for his 'realist' stories of life in London's East End, first published in *Macmillan's Magazine*, and later collected as *Tales of Mean Streets* (1894). His most widely read work is *A Child of the Jago* (1896), an account of a slum childhood, of gang warfare and violent crime. Morrison's later life, as this portrait suggests, was devoted to collecting and writing about oriental art.

Little is known of Frederic Hodsoll; he was apparently born in England, and went to live in America. According to his own very brief account he 'returned to England from New Mexico after the flood' and 'took up journalistic work for the weekly illustrated papers in London'. He was one of the earliest photographers to use flashlight, and this gives his prints exceptional clarity of detail. It was ideally suited to his favourite subjects: writers in their homes and actors in their dressing-rooms. He worked for *The Sphere* and *The Tatler and Bystander*, where this portrait was reproduced on 24 September 1902, as part of a series called 'Authors in their Rooms'. It comes from one of two albums of Hodsoll's work owned by the Gallery. Many of Hodsoll's sitters are of considerable interest in themselves, but his photographs are especially valuable as evidence of contemporary interior decoration. The albums also contain a number of photographs of spectacular theatrical productions.

68

Sir Edward William Elgar 1857–1934

Edgar Thomas Holding 1870–1952

Platinum prints, *c.*1905
19.3 × 10.9 (7⅝ × 4½) (left); 19.4 × 11 (right)
Given by the photographer, 1934 (X11905 [left]; X11906 [right])

Less than a month after the death of Elgar, England's greatest composer, the then director of the Gallery, Sir Henry Hake, wrote to one of Elgar's closest friends, A. Troyte Griffith of Malvern, a member of the small group of intimates portrayed in music in the 'Enigma' Variations (1899; 'Troyte', the seventh Variation), to enquire about likenesses of the great man. Through Troyte Griffith's agency the Gallery acquired two of Holding's 'admirable photographs', of which Troyte Griffith wrote:

> These are 'straight' and show every detail of the dress. Two in particular – one full face the other profile – give quite different aspects of the very various Elgar. One may be said to be the Elgar of 'Gerontius' (1900) the other of the Variations or 'Cockaigne' (1901).

They were, according to another letter from Troyte Griffith, taken about the time of *The Apostles* (1903) or a little later. Nothing is recorded of Holding's work as a photographer, and he is best known as a minor landscape painter and watercolourist.

69

Edward Carpenter 1844–1929

Alvin Langdon Coburn 1882–1966

Gum platinum print, signed and dated: *Alvin Langdon Coburn 1906* on the mount; 28 November 1905
28.2 × 22.2 (11⅛ × 8¾)
Given by Dr F. Severne Mackenna, 1977 (P48)

Edward Carpenter's life was a long reaction against Victorian convention and respectability, both social and sexual. The enduring influences were Socialism and Walt Whitman. At Millthorpe in Derbyshire in 1883 Carpenter built for himself and his working-class friend, Albert Fearnehough, and his family, a cottage with an orchard and market garden. Here he lived for the next forty years, writing, and, for a time, market gardening and making sandals. In 1898 George Merrill succeeded the Fearnehoughs; gardening and sandal-making ceased, and the two men kept open house for the many followers who made the pilgrimage there to meet the prophet of 'sexual liberation', among them E.M. Forster (no. 120). He was 'touched' by Merrill: 'The sensation was unusual, and I still remember it, as I remember the position of a long vanished tooth. It was as much psychological as physical. It seemed to go straight through the small of my back into my ideas, without involving my thoughts'. This experience inspired Forster to write his novel *Maurice*.

Carpenter's own writings include *Towards Democracy* (1883–1902), *England's Ideal* (1885) and *Civilisation, its Cause and Cure* (1889).

The great American-born photographer Coburn, who had studied in New York with Gertrude Käsebier and Edward Steichen (see no. 77), was regularly in London from 1904 onwards, where George Bernard Shaw (no. 49) introduced him to many of the most celebrated and influential men of the day. He finally settled in England in 1912, and mastered the process of photogravure, which he used to illustrate the books in his well-known *Men of Mark* series. This portrait of Carpenter, taken in Bloomsbury, illustrates the emphasis in Coburn's earlier work on mood and broad effects, rather than on contrast and detail.

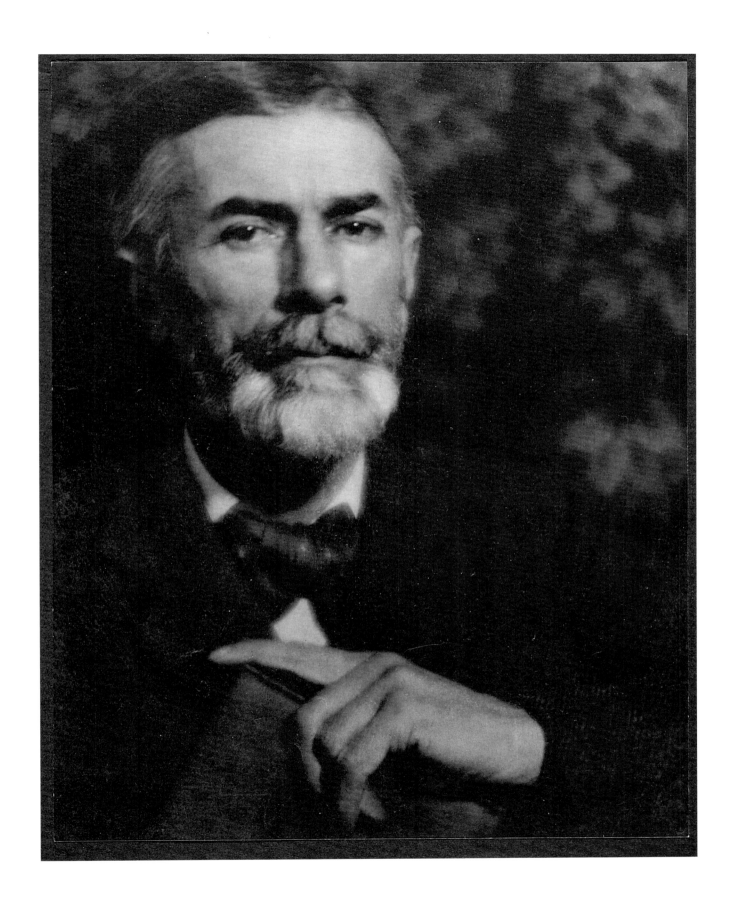

70

William Strang 1859–1921

James Craig Annan 1864–1946

Photogravure, *c*.1907
15.2 × 19.7 (6 × 7¾)
Purchased, 1988 (P357)

Born in Dumbarton, William Strang came to London to study at the Slade School under Alphonse Legros, and remained there for the rest of his life. A prolific painter of portraits, biblical and subject paintings, he is best known for his portrait drawings in a style based on Holbein, and for his 747 etchings, remarkable for their unity of vision and superb draughtsmanship.

The son of the leading Scottish photographer Thomas Annan, James Craig Annan learned in Vienna the techniques of photogravure printing, and reproduced many of his own photographs in this medium, which allows for exquisite tonal effects. This print was published in America in Alfred Stieglitz's *Camera Work* (July 1907; see no. 77), under the title *The Etching Printer – William Strang, Esq., A.R.A.* It shows Strang minutely examining an etcher's plate, with a printing press in the background, and is a fine example of Annan's ability to unite in his compositions a certain informality with a refined sense of atmosphere and design.

71

Henry James 1843–1916 and his brother William James 1842–1910

Marie Leon active *c*.1901–30

Bromide print, with the photographer's studio stamp on the reverse of the mount, ?1908
20.1 × 15 (5⅞ × 7⅞)
Given by the Royal Historical Society, 1935 (x18720)

Although sometimes said to date from one of Henry James' trips to America, this photograph by the self-styled 'artistic photographer', Marie Leon of 30 Regent Street, London, was almost certainly taken at her London studio, perhaps in 1908 when James' elder brother, William, Professor of Philosophy at Harvard, was in England to deliver the Hibbert Lectures at Oxford.

Born in New York, Henry James was in spirit a European, and settled in England in 1876. His finest novels, among them *The Portrait of a Lady* (1881), *The Wings of the Dove* (1902) and *The Golden Bowl* (1904) all date from after his arrival, and several treat the subject of the impact of European civilization upon American life. At Harvard William James set up the first American laboratory of psychology, and founded in 1884 the American Society for Psychical Research. His *Principles of Psychology* was published in 1890, and *The Varieties of Religious Experience* in 1902. In later life heart disease made him an invalid, and in 1908 he spent some weeks in convalescence with his brother at his home, Lamb House, Rye in Sussex. Henry James wrote on 3 September to Edmund Gosse:

> the summer here fairly rioted in blandness & he (my brother) got 3 or 4 weeks of tranquil recuperative days (he had come to me unwell) largely in my garden.

Although the brothers apparently got on well, there was an underlying ambivalence in their relationship. In 1905, for instance, William heard that he had been elected to the American Academy of Arts and Letters, two months after the election of his younger brother, and he wrote to refuse the honour:

> I am the more encouraged in this course by the fact that my younger and shallower & vainer brother is already in the Academy.

In Marie Leon's photograph the characters of the brothers are cleverly individualized. Neither looks at the camera: William, the philosopher and visionary, stares impassively into space, while Henry, the novelist and critic, leaning affectionately towards his brother, turns to observe what is going on around them. Little is known of Leon's career, but in the later 1920s she moved to 50 Park Road, Regent's Park, styling herself 'Madame' Leon.

159

72

Edward VII 1841–1910 in the Paddock, Epsom, on Derby Day

William Booty

Bromide print, 26 May 1909
14.8 × 10.4 (5¾ × 4)
Given by Mrs B. Clarke, the photographer's daughter, 1978 (x7802)

The sitters are (left to right): Alec March, the King's trainer; Prince Arthur, Duke of Connaught 1850–1942; the King; Lord Marcus Beresford 1848–1922, the King's racing manager; Prince Arthur of Connaught 1883–1938; the Duke of York, later George V 1865–1936; and the Earl of Athlone 1874–1957.

Taken by an amateur photographer (who is said to have been at one time manager of the Theatre Royal, Drury Lane, London), this photograph records the moments after the King's colt Minora, ridden by Herbert Jones, won the Derby by a short head. This was the first time the race had been won by a reigning sovereign, and such was the excitement on the occasion that the crowds broke spontaneously into 'God Save the King'.

73

Sir Benjamin Stone's Lunch to the Aeronauts of France and England

Sir (John) Benjamin Stone 1838–1941

Platinum print, 15 September 1909
15.4 × 20.2 (6 × 8)
Given by the Library of the House of Commons, 1974 (x32600)

The sitters are: (front row, left to right) Edward Purkis Frost 1842–1922, aviator; Louis Blériot 1872–1936, pioneer aviator; Samuel Franklin Cody 1861–1913, aviator; Alfred du Cros MP, 1868–1946; Frank Hedges Butler 1855–1928, founder of the Aeroplane Club; Col. Harry Stanley Massy 1850–1920, soldier; (back row, left to right) Sir Alliot Verdon-Roe 1877–1958, aviator; Sir George Renwick, Bt. MP, 1850–1931; John Martin 1847–1944, journalist; D. Macnamara; S. Renwick; Captain Sir Reginald Ambrose Cave-Browne-Cave, Bt. 1860–1930, Royal Navy; Thomas Power O'Connor MP, 1848–1929; the Hon. Charles Steward Rolls 1877–1910, Managing Director of Rolls-Royce; Lt.-Col. the Hon. Robert Lygon 1879–1952, soldier; William James Stuart Lockyer 1868–1936, explorer and astronomer.

On 25 July 1909 Louis Blériot became the first person to fly the English Channel, crossing in a time of twenty-seven minutes. The military significance of this feat was appreciated by both the British government and public, and the War Office became for the first time involved in the development of aircraft. On 15 September Sir Benjamin Stone MP gave a lunch party in Blériot's honour at the Houses of Parliament, and the guests included many of the pioneer aviators of the day, among them the American Cody (front row, third from left), bearing signs of a recent crash, who was there against doctor's orders: 'He told his doctor . . . that he should go if he died that night. (Cheers)', as a contemporary report of his speech that day records.

Stone was an enthusiastic amateur photographer, and, as Conservative MP for Birmingham East for fourteen years, he made it his task to photograph every MP as well as servants and visitors to the Houses of Parliament. The Gallery owns two thousand of his photographs, an invaluable record of the comings and goings about Westminster in the early years of this century.

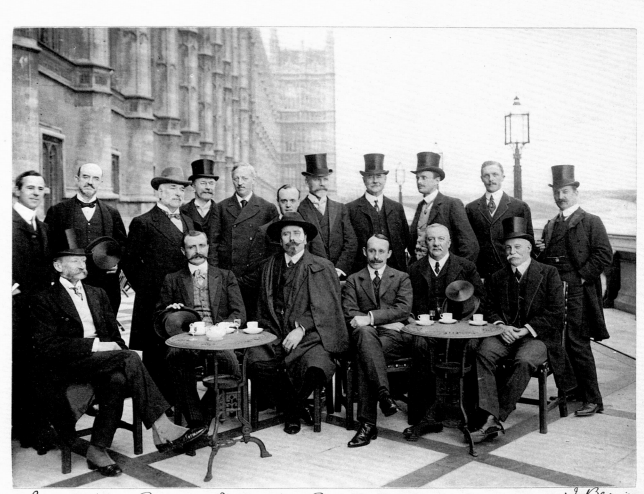

Luncheon Party to French & English Aviators
House of Commons.
Sep 15th 1909

J. Benjamin Stone

74

Hazel Martyn, Lady Lavery c.1888–1935

Baron Adolf de Meyer 1868–1949

Bromide print, after 1910
17.1 × 22.2 (6¾ × 8¾)
Purchased, 1981 (P164)

Adolf Meyer-Watson was created a baron by the King of Saxony in 1901 at the request of the King's cousin Edward VII. It was a device to allow him and his beautiful wife Olga, the god-daughter (and possibly an illegitimate child) of Edward, to attend his coronation in Westminster Abbey. The de Meyers were one of the most glamorous couples in a brilliant and chic international society, and the Baron's aesthetic photographs only made him more desirable. At the outbreak of war, however, the couple, who were suspected of being German spies, hastily left England for America. There the Baron, who was admired and encouraged by Steichen (see no. 77) and Stieglitz, was employed by Condé Nast as photographer for *Vogue* and *Vanity Fair*. He brought to magazine photography not only his social kudos and contacts, but a new sense of style and elegance.

Hazel Martyn married the successful painter Sir John Lavery as his second wife in 1910, and was one of his favourite models. As her obituarist in *The Times* noted: 'he drew her as the colleen on the modern Irish bank notes, and her features thus became as familiar as those of any film star'. In reality Lady Lavery was no 'colleen', and her social position, distinguished features and sophistication made her a natural sitter for de Meyer. This photograph dates from after her marriage, and may have been taken either in London or New York. It was purchased from the sale of de Meyer's own collection.

75

Robert Falcon Scott 1868–1912

Herbert George Ponting 1870–1935

Toned bromide print, signed and inscribed on the mount: *Captain Scott & his Diary.*
Scott's Last Expedition, 7 October 1911
35.4 × 45.5 (14 × 18)
Purchased, 1976 (P23)

When he was invited by Captain Scott to go as photographer on his ill-fated Antarctic expedition of 1910, Herbert Ponting was already the leading travel photographer of the day and had published his *In Lotus Land Japan* in that year. His work in the Antarctic was a challenge of an altogether different order. Working with the greatest skill and bravery in extremely hazardous conditions, he produced photographs and motion pictures which are both technically and aesthetically superb. He left the expedition before its tragic end because of illness, but devoted the rest of his life to the preservation of records of it.

Scott had set sail in *Terra Nova* in June 1911, and established his expedition's winter quarters at Cape Evans. This photograph shows him in his hut there, at work on his famous journal. He was to set out on his southern sledge journey three weeks later. On 16 January 1912 he arrived at the South Pole, to find the Norwegian Amundsen's flag already there. On the return journey from the Pole Scott and his companions perished, among them the legendary Captain Oates. The last entry in Scott's journal (which was found by a search party eight months later) reads: 'We shall stick it out to the end, but we are getting weaker, of course, and the end cannot be far. It seems a pity, but I do not think I can write any more'.

76

Rupert Chawner Brooke 1887–1915

Sherrill Schell 1877–1964

Glass positive, spring 1913
25.7 × 20.4 (10⅛ × 8)
Given by Emery Walker Ltd, 1956 (P101/e)

According to Henry James (no. 71) the poet Rupert Brooke was 'a creature on whom the gods had smiled their brightest', and he was famous for his great good looks, personal charm and literary promise. His early death in the First World War at Scyros only served to intensify his mythical quality. It was Francis Meynell, the son of the poet Alice Meynell, who suggested to the American photographer Schell that he photograph 'the beautiful Rupert Brooke'. Schell was amused at the idea that any man should be 'beautiful', 'visualizing in spite of myself a sort of male Gladys Cooper or a Lady Diana Manners in tweed cap and plus fours'. But he found Brooke 'a genial, wholesome fellow entirely unspoiled by all the adoration and admiration he had received . . . in short a type of all round fellow that only England seems to produce'.

In the spring of 1913 Schell was living in a flat in St George's Square, Pimlico, and there in the living room, on a foggy day and without any artificial light, he photographed Brooke, who came to him

> dressed in a suit of homespun, with a blue shirt and blue necktie. The tie was a curious affair, a long piece of silk wide enough for a muffler, tied like the ordinary four-in-hand. On any other person this costume would have seemed somewhat outré, but in spite of its carefully studied effect it gave him no touch of eccentricity. . . . His face was more remarkable for its expression and colouring than for its modelling. His complexion was not the ordinary pink and white . . . but ruddy and tanned. His hair, a golden brown with sprinklings of red. . . . The lines of his face were not faultless . . . he had narrowly escaped being snubnosed.

In all Schell took some dozen exposures of Brooke that day (each demanding 'one whole minute without the least change of expression'), and seven glass positives made by Sir Emery Walker (see no. 49) from his negatives belong to the Gallery.

77

Edward Henry Gordon Craig 1872–1966

Edward J. Steichen 1879–1973

Photogravure, 1913
20 × 16.2 ($7\frac{7}{8} \times 5\frac{5}{8}$)
Purchased, 1983 (P228)

Edward Gordon Craig was the son of the architect E.W. Godwin and the great actress Ellen Terry (no. 9), and his life was lived in or around the theatre. He had abundant natural talent as an actor, but turned early on to stage design. From the first his productions broke with popular pictorial realism, and were distinguished by brilliance, originality and economy of effect. A man of many love affairs and seemingly even more children, in 1905 he left England for good, and took up with the experimental dancer Isadora Duncan; this was the beginning of a rich period in his work, which saw him working with Eleonora Duse in Florence and Stanislavsky in Moscow. In 1911 he published *On the Art of the Theatre*, in which he put forward his concept of a unified theatrical experience controlled by one mastermind, the designer-director.

Edward Steichen was one of the greatest photographers of all time, who after the Second World War was appointed Director of the Department of Photography at the Museum of Modern Art, New York. He had a superb sense of design and, as is seen in his portrait of Craig, he delighted in capturing almost imperceptible forms as they emerged from shadow. For this theatrical subject, he creates an especially theatrical effect: Craig is caught, turning in a moment of unexplained drama, in a shaft of light – a device he used in his own productions. This gravure was published in Alfred Stieglitz's quarterly *Camera Work* in July 1913.

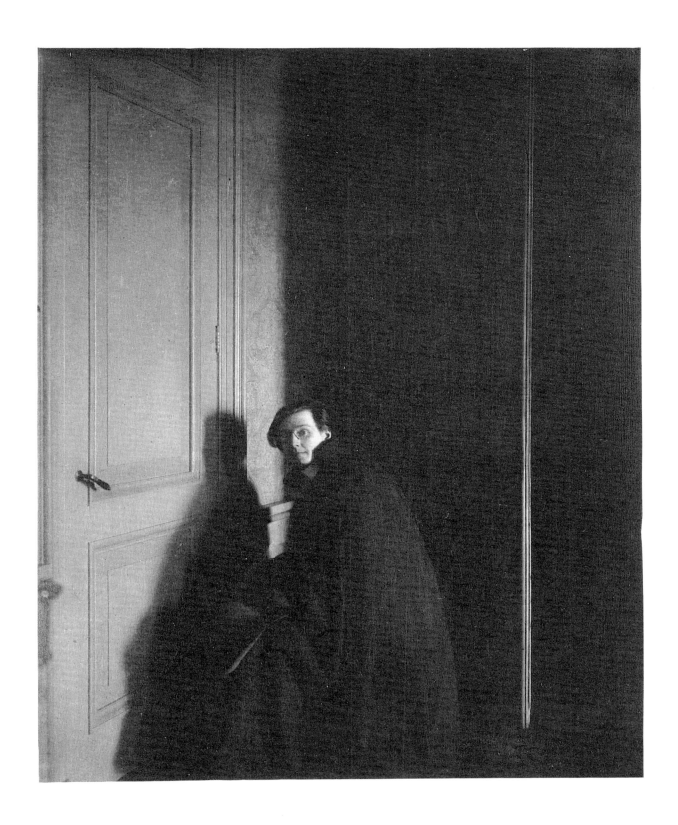

78

David Lloyd George, 1st Earl Lloyd-George of Dwyfor 1863–1945

Walton Adams 1842–1934

Bromide print, *c*.1913
20.6 × 19.4 (8$\frac{1}{8}$ × 7$\frac{5}{8}$)
Purchased from the photographer's grandson, Gilbert Adams FRPS, 1980 (P140/36)

The 'Welsh Wizard' was one of the most eloquent and dynamic figures in British politics of his day. In his twenties he established himself a reputation as a speaker on religious, temperance and political issues, and entered Parliament as the Liberal Member for Caernarvon Boroughs in 1890, a seat which he held until 1945. As Chancellor of the Exchequer he declared war on poverty in his first ('the People's') Budget of 1909, and introduced many social reforms. He succeeded Asquith (no. 57) as Prime Minister in 1916.

This photograph, taken shortly before the First World War, shows Lloyd George as Chancellor, in his prime, and conveys much of that energy and determination which he later brought both to the conduct of the war, and the pursuit of 'a short sharp peace' after it.

The photographer Walton Adams, who worked in Southampton and Reading, and was the co-inventor of the dry plate process, was the father of Marcus Adams (see no. 110).

79

Thomas Hardy 1840–1928

Emil Otto Hoppé 1878–1972

Photogravure, signed by the photographer, *c.*1913–14
28.2 × 20.3 (11⅛ × 8)
Purchased, 1986 (P310)

By the time he was photographed by Hoppé, Thomas Hardy was the doyen of English letters. His great novels – *Far from the Madding Crowd* (1874), *The Mayor of Caster-bridge* (1886), *Tess of the d'Urbervilles* (1891) – were long behind him, his epic drama *The Dynasts* (1904–8) was complete, and he was devoting his time to the writing of lyric poetry. Like his novels, his verses embody a tragic and ironic vision of life, and are written in language which is entirely idiosyncratic, at turns awkward, archaic and intensely poetic.

The photographer Hoppé was born in Munich, and moved to London in 1900, co-founding in 1909–10 the London Salon of Photography. When he photographed Hardy (at the sitter's home, Max Gate, near Dorchester) he was already one of the best known photographers in London, living at Millais' old house at 7 Cromwell Place, London, and working for *Vanity Fair*, *The Sketch*, *The Tatler*, and other periodicals. His compositions show a distinctive simplicity and comparatively restrained use of soft-focus (which must have appealed to editors), and he concentrated on the revelation of character by the most direct means.

80

Dame Adeline Genée 1848–1970

Alice Boughton 1865–1943

Platinum print, signed by the photographer, 1914
19.7 × 14.2 (7⅞ × 5⅝)
Purchased, 1982 (P206)

In her book *Photographing the Famous* (1928) the New York photographer Alice Boughton reproduces a variant of this delicate photograph of the great ballet dancer and teacher Adeline Genée, and tells how it was taken when Genée was on tour in America:

> During the first year of the war, I photographed Mlle. Genée knitting for soldiers . . . I was obliged to go to the theatre and get what I could between acts. . . I shall always remember the scene – the dancer was standing on her toes in the wings, breaking in some new ballet slippers and looking like a bit of thistle-down. She was knitting a long woolen stocking with lightning-like rapidity. There was very little light to work by, and as the picture had to be a time exposure I told her to stand on her toes as long as she could and squeak as a signal that the limit was reached. I counted 60 and got it. She then sprang over some rope, followed by her manager who in turn was followed by the Keith [vaudeville theatre] manager, and all three went round and round back of the scene . . . keeping perfect time to the refrain of 'Steamboat Bill', which was being sung by a 'gent' out front.

Born in Jutland Anina Jensen, Genée came to England in 1897 to dance what became her best known role, *Coppélia*, and soon achieved with her virtuoso footwork and impudent prettiness a reputation unrivalled in this country since Taglioni in the 1830s. Max Beerbohm (no. 82) wrote of her: 'Genée! It is a name that our grandchildren will cherish. . . And Alas! our grandchildren will never believe, will never be able to imagine, what Genée was'.

81

Commandant Mary Sophia Allen 1878–1964 with members of the Women Police

Christina Livingston, Mrs Albert Broom 1863–1939

Bromide print, with the photographer's stamp on the reverse, 1916
11 × 14.3 (4⅜ × 5⅝)
Given at the wish of the photographer, 1940 (x6075)

With Margaret Damer Dawson, Mary Allen was the founder in 1914 of the Women Police in London, and their Commandant from 1919 until 1938. She is seen here with members of her force at the British Women's Work Exhibition, held at the Princes Skating Rink, Knightsbridge, London. She later published *Pioneer Policewoman*, *Lady in Blue* and *Women at the Cross-roads*.

Mrs Albert Broom, the first woman press-photographer, was also a pioneer. A woman of indefatigable energy, she took up photography with a box camera at the age of forty to support an ailing husband, and was official photographer to the Household Brigade until her death: 'I have photographed all the king's horses and all the king's men, and I am never happier than when I am with my camera among the crack regiments of Britain'. Apart from her military work, she specialized in photographs of royalty and political meetings, and the Gallery owns a representative selection of her work, including important photographs of the Suffragettes.

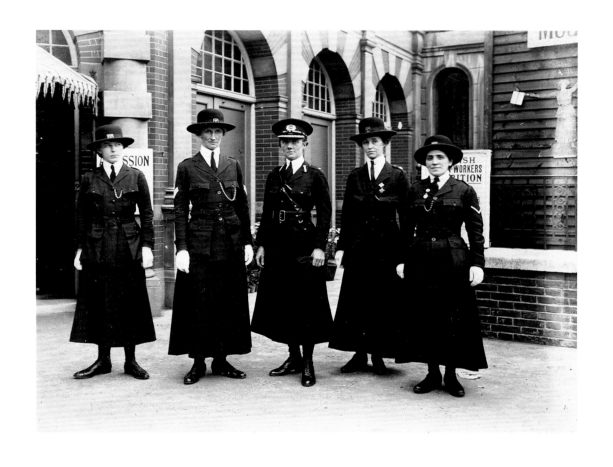

82

Sir Henry Maximillian ('Max') Beerbohm 1872–1956

(Alexander Bell) Filson Young 1876–1938

Toned bromide print, signed with monogram and inscribed by the photographer on the mount: *MAX BEERBOHM, ESQ; WITH APOLOGIES TO ALL CONCERNED FY*, 1916
29.7 × 22.4 (11¾ × 8¾)
Purchased, 1975 (X3767)

The caricaturist and humorist Beerbohm married in 1910 the American actress Florence Kahn, and thereafter the couple lived for most of their time in Italy, not least because they were poor and it was cheap. In 1915, however, following the outbreak of war, Beerbohm felt compelled to return to England, and there he remained until 1919. This photograph, taken at that time, is conceived as an *hommage à Whistler*, for Beerbohm's pose, indeed the whole composition, follows closely that painter's *Arrangement in Grey and Black, No.2: Portrait of Thomas Carlyle* (1872–3; City Art Gallery, Glasgow). Beerbohm caricatured both artist and sitter in his 'Blue China' (Tate Gallery, London), published in *Rossetti and His Circle* (1922), but, while one suspects that he had little time for the egocentric Scots historian (no. 31), Whistler (no. 46), as the first of the late nineteenth-century dandy-aesthetes, was to some extent a role-model for him.

Whether it was Beerbohm or Young who suggested the parody – the photographer's inscription implies that it was his idea – the image is the perfect vehicle for Beerbohm, urbane, aesthetic and gently facetious, and shows the author of the ironical and fantastic *Zuleika Dobson*, in the guise of the self-absorbed and deadly serious 'sage of Chelsea'.

Young worked at this time from 124 Ebury Street, London, and despite the evident distinction of the few known examples of his photographic work – mainly portraits and topography – is better known as a writer. His first published work, written under the pseudonym 'X.Ray', was *A Psychic Vigil* (1896), but he also wrote novels, poetry, and works on art, music, the Navy, motoring, famous trials (including that of Dr Crippen), and a two-volume study of Christopher Columbus. He ended his career as Adviser on Programmes to the BBC, and his last book was *Shall I Listen? Studies in the Adventure and Technique of Broadcasting* (1933). His portrait of Beerbohm was published in *Photograms of the Year* (1916), plate 11.

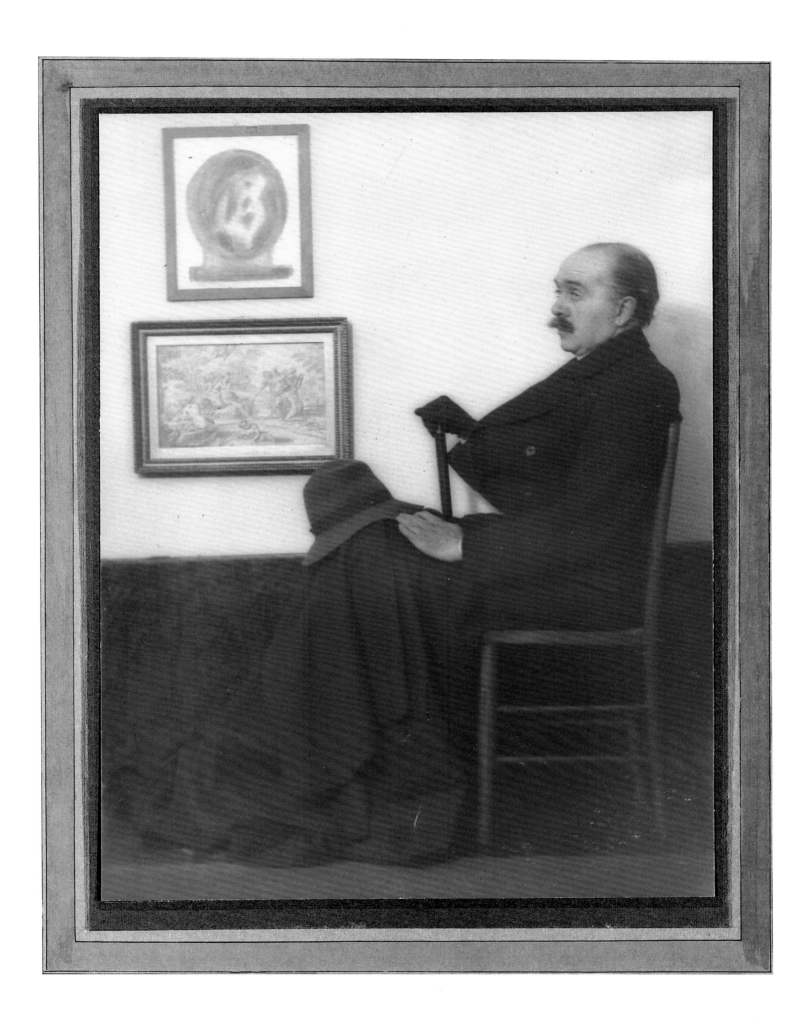

83

Isaac Rosenberg 1890–1918

London Art Studios active *c.*1915

Bromide postcard, signed and inscribed by the sitter *Kind Regards/Rosenberg/1917*, and with the studio's
blind stamp, *c.*1917
12.8 × 7.8 (5 × 2⅞)
Purchased, 1983 (P230)

The son of Jewish Russian *émigrés*, Isaac Rosenberg grew up in Whitechapel, London,
where his father worked as a pedlar and market-trader. Early on he learned to paint
and began to write poetry, and in 1911 another Jewish family paid for him to go to
the Slade School of Art, where he was a contemporary of Mark Gertler. A year later
he published at his own expense *Night and Day*, a collection of his poems, and as a
result received encouragement from the poets Ezra Pound and Gordon Bottomley.
Another volume, *Youth*, appeared in 1915. That year, in opposition to his parents' paci-
fist views, he enlisted in the army, and was killed in action in 1918. As both poet and
painter he was a figure of striking originality. His poems written in the trenches are
experimental in character, starkly realistic and coloured by his urban Jewish background.
A painted self-portrait, richly coloured and emotionally charged, belongs to the Gallery.
As a poet he was slow to gain recognition, and it was not until the publication of the
Collected Works (1937) that his importance was generally accepted.

This photographic postcard is of a type that many a soldier would have had made
while on leave to give to his family and friends, and is a notably unidealized image
of the young Private and poet who hated Rupert Brooke's 'begloried sonnets' (no. 76).

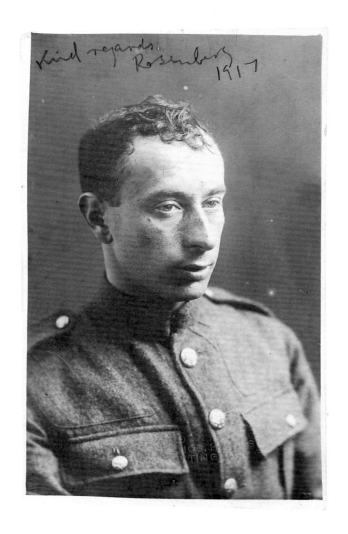

84

Yvonne Gregory, Mrs Bertram Park 1889–1970

Bertram Park 1883–1972

Bromide print, with the photographer's blind stamp, 1919
20.6 × 14.5 (8 × 5¾)
Given by Mrs June Mardall, daughter of the sitter and the photographer, 1977 (x11824)

The photographer Yvonne Gregory (see no. 97) married Bertram Park in 1916, and together they set up in business at 43 Dover Street, London, with the financial backing of Lord Carnarvon, the Egyptologist. Marcus Adams (see no. 110) trained with them and ran their Nursery Studio for children; Paul Tanqueray (see no. 96) also had premises in the same street, as did Hugh Cecil (see no. 103) and Bassano (see Introduction, fig. 1). Park was one of the most successful society photographers of the day. He was an *aficionado* of the soft-focus lens, and specialized in elegant portraits of society beauties posed against dark backgrounds, with the use of flattering back-lighting, influenced by Baron de Meyer (see no. 74).

In this photograph Yvonne Gregory attitudinizes in the 'dazzle' costume which she wore to the Dazzle Ball held in London in 1919, and is posed against a 'dazzle' background. The Ball took its theme from dazzle-painting, a form of sea-camouflage which had been developed by the British during the war. It was intended not to hide ships, but to break up their outline and bewilder the enemy by the use of bold and eccentric designs. It is ironic that after the war it should be adopted by the world of fashion.

85

Nancy Witcher Langhorne, Viscountess Astor 1879–1964

Olive Edis, Mrs E.H. Galsworthy ?1876–1955

Platinum print, with the photographer's blind stamp on the mount, 1920
20.1 × 11.4 (7⅞ × 4⅜)
Given by the photographer, 1948 (X339)

A beautiful and impetuous divorcee from Virginia, Nancy Langhorne came to London in 1904 and, rejecting several other suitors, married the immensely rich Waldorf (later 2nd Viscount) Astor. By nature religious, she was converted to Christian Science in 1914, which ever after she preached with missionary zeal. In 1919 her husband, on inheriting the peerage, was forced to vacate his seat in Parliament. She won the ensuing by-election, and was the first woman to take a seat in the Commons. She showed little reverence for proceedings there, and was a frequent interrupter; so much so that on one occasion, when she claimed to have been listening for hours before making her interjection, a member exclaimed: 'Yes, we *heard* you listening!'. This photograph was taken at the Astors' London home, 4 St James's Square, and shows Lady Astor in uncharacteristically reflective mood.

Olive Edis, one of the daughters of the architect Sir Robert Edis, took up photography in 1900, and set up her studio at Sheringham in Norfolk. She later had studios in Farnham, Surrey, and Ladbroke Grove, London, and was particularly interested in portraiture, photographing many of the leading figures of her day. In 1919 she toured the battlefields of France and Flanders to record the work of the British Women's Services for the Imperial War Museum (see Introduction, fig. 11). In 1948 she presented some 250 of her photographs – richly-toned platinum prints and autochromes – to the Gallery. See also no. 90.

86

David Herbert Lawrence 1885–1930

Nickolas Muray 1892–1965

Silver print, with the photographer's stamp on the reverse, 1920
24.1 × 19.4 (9½ × 7⅝)
Purchased, 1982 (P208)

Towards the end of 1919 the novelist D.H. Lawrence scraped together enough money for him and his wife to leave England. He was by nature hyper-sensitive, and though his early novels such as *The White Peacock* (1911) and *Sons and Lovers* (1913) had won him a certain acclaim, he felt acutely the charges of indecency against *The Rainbow* (1915). The rest of his life he spent in wandering. In 1920 he was in New York, where *Women in Love* was privately printed that year, and was photographed by the Hungarian-born Muray at his fashionable studio on MacDougal Street in Greenwich Village, for *Vanity Fair*. He was taken there 'bodily' by Mabel Dodge, heiress and eccentric, and a well-known patroness of the arts. Muray found him

> unkempt; his hair was disheveled [sic], as was his attire. The shirt he wore was three sizes larger than he needed, and he looked as if he had borrowed it from a poor uncle. Nor have I ever seen a person more shy . . . There wasn't a single smiling picture, but he wasn't the smiling type.

Muray studied photography and lithography in Budapest, and came to the United States in 1913, where he worked at first as a colour-printer and colour-print processor. He soon however made a name for himself as a leading fashion photographer, and in the 1920s was noted for his portraits of literary personalities. He was one of the great party-givers of the period, a fencing champion and an officer in the Civil Air Patrol, and he must have found Lawrence's brooding presence a shade disconcerting.

87

Augustus Edwin John 1878–1961

John Hope-Johnstone 1883–1970

Bromide print, May 1922
10.5 × 8 (4⅛ × 3⅛)
Purchased, 1979 (P134/10)

Augustus John was the best known British painter of the generation after Sickert, and combined in his work brilliant draughtsmanship with a highly personal use of colour. His genius was for landscapes and portraits, but he was always drawn to large-scale imaginative paintings which were beyond him. Addicted to beautiful women, alcohol and the gipsy life, he was a legendary bohemian, and as early as 1932 T.E. Lawrence described him as 'in ruins'.

In 1911 John took as tutor to his children Romilly and Robin, John Hope-Johnstone, an equally wayward figure who 'was very unfortunate in combining extreme poverty with the most epicurean tastes I have ever known' (Romilly John). He lived by his wits, working for a time as co-editor of *The Gramophone* with Compton Mackenzie, and editor of *The Burlington Magazine*, until sacked by Roger Fry. A brilliant conversationalist, flamboyantly dressed, he was a relentless self-improver, and his interests were omnivorous.

Not surprisingly, Hope-Johnstone parted from the John household after less than a year, absconding with some of John's paintings, but after the war he re-engaged himself as Robin John's philosopher and guide. In 1922 the pair were staying with the writer and refugee from Bloomsbury, Gerald Brenan, at his house at Ugijar in southern Spain, where it was Hope-Johnstone's 'intention to master the art of photography', importing 'several hundred weight of photographic materials'. According to Brenan, 'most of the photos he took with such care and preparation faded away at the end of a few months because he omitted to fix them properly. Even in his photographic work he was negative and self-destructive'.

This delicate but intense head of John was taken in May that year when he was visiting the household in Ugijar, and is from an album of Hope-Johnstone's photographs taken at that time, mainly of Brenan, John and his family. John wrote home that they were 'very bad ones, and he's [Hope-Johnstone] very slow about it, changing his spectacles, losing bits of his machine and tripping over the tripod continually'.

88

Emma Alice Margaret ('Margot') Tennant, Countess of Oxford and Asquith 1864–1945

Howard Instead active *c.*1918–35

Bromide print, 1920s
28.6 × 16.5 ($11\frac{1}{4} \times 6\frac{1}{2}$)
Purchased, 1983 (AX24999)

The wife of a Prime Minister (no. 57) who possessed 'a modesty amounting to deformity', Margot Asquith was a very different spirit. 'Unteachable and splendid', she was energetic, opinionated, impetuously generous, and a master of the *bon mot*. A passionate idealist, with a crusading passion to right wrongs, she once wrote: 'When I hear nonsense talked it makes me physically ill not to contradict'. It is questionable whether these qualities were entirely welcome in the wife of a Prime Minister, but they made her one of the leading personalities of the day. One of the independent group known as 'the Souls', she was also a writer on a wide range of intellectual and aesthetic themes, as exemplified by her *Lay Sermons* (1927). She also produced volumes of memoirs, including her *Autobiography* (1920), and a novel.

Margot Asquith's features were as idiosyncratic as her personality, and this portrait, though Instead worked in the prevailing soft-focus idiom of the 1920s, conveys the force of both. Seen at full length and from below, as if on stage, she looks down her formidable nose and turns as if to address an unseen audience.

This print is from an album of Instead's work, which mainly comprises portraits of theatrical figures. Little is known of his career, but, according to Cecil Beaton, 'he started life as a painter, but became a photographer instead', making 'delightful Chelsea-ish compositions'. He worked freelance for *Vogue* around 1918–20. His first studio was at 30 Conduit Street, London. He subsequently moved to 5 Vigo Street nearby, and in the 1930s to the Chenil Studios on the King's Road.

89

Eugene Arnold Dolmetsch 1858–1940

Herbert Lambert 1881–1936

Toned bromide print, lettered: *ARNOLD DOLMETSCH, c.1925*
15 × 17.6 ($5\frac{7}{8}$ × $6\frac{7}{8}$)
Given by the photographer's daughter, Mrs Barbara Hardman, 1978 (P108)

Born in France of Bohemian origin, Arnold Dolmetsch trained as a musical-instrument maker with his father, and came to England about 1883. With the encouragement of Sir George Grove (of dictionary fame), he began his investigations into early English instrumental music and the way it was played. This led to the making of lutes, virginals, clavichords, harpsichords, recorders, viols and violins, which became his life's work. In 1925, close to the time of this photograph, he founded at Haslemere, Surrey, where he lived, an annual summer festival of early music. Here he, his family and friends attempted to recreate historically authentic performances, but not for their own sake: 'This music is of absolute and not antiquarian importance; it must be played as the composer intended and on the instruments for which it was written with their correct technique; and through it personal music-making can be restored to the home, from which two centuries of professionalism have divorced it'.

Herbert Lambert worked from 32 Milsom Street, Bath, but also had a studio in Bristol, and at 125 Cheyne Walk, London, where, according to his trade label, he was 'during the early part of each month for the purpose of taking a limited number of camera portraits by appointment'. He was appointed managing director of Elliott & Fry (see no. 54) in 1926. He specialized in portraits of musicians, publishing his *Modern British Composers* in 1923. His book *Studio Portrait Lighting* is dedicated 'To my friend Marcus Adams [see no. 110]. A master of the art herein treated'. This print, which shows Dolmetsch playing one of his own lutes, is part of a collection of Lambert's work donated to the Gallery by his daughter. It shows his own mastery of lighting, and ability to create a harmonious atmosphere which is almost audible. The Holbeinesque lettering is a characteristic touch.

ARNOLD DOLMETSCH

90

James Ramsay MacDonald 1866–1937

Olive Edis, Mrs E.H. Galsworthy ?1876–1955

Autochrome, ?1926
21.5 × 16.4 (8½ × 6½)
Given by the photographer, 1948 (X7196)

The illegitimate son of a Scottish farm-girl, MacDonald, who was born in a two-roomed 'but and ben' at Lossiemouth in Morayshire, worked his way up through the Socialist ranks to become the first Labour Prime Minister of this country in 1924. His initial ministry was short-lived, and in 1929 was followed by a two-year term, which was brought to an abrupt end in August 1931 by the country's devastating financial crisis. On the fall of the Labour government, MacDonald, who was an ingenuous and dedicated man, immediately accepted the proffered premiership of a Government of National Unity, thereby alienating his former colleagues, and creating a breach with his party which was never to be healed.

This autochrome was probably taken in 1926, for it shows MacDonald wearing the robes of an LLD. of the University of Wales, an honorary degree which he was awarded in that year. As early as 1912 Olive Edis was using the Lumière autochrome plate, which had been introduced in 1907, and her work in this medium reveals a subtle sense of colour and atmosphere. She also patented her own autochrome viewer, of which there is an example in the Gallery's collection. See also no. 85.

91

Sir William Turner Walton 1902–83

Sir Cecil Beaton 1904–80

Bromide print, with the photographer's stamp on the reverse, 1926
29 × 23.9 (11⅜ × 9⅜)
Purchased, 1978 (P55)

In 1919, while still an undergraduate at Oxford, the composer Walton, a tall, shy boy from Oldham, was taken up by the aesthetes Osbert and Sacheverell Sitwell, who persuaded him to forsake academia, and to pursue the natural bent of his genius: 'If it hadn't been for them, I'd either have ended up like Stanford [the composer, Sir Charles Villiers Stanford], or would have been a clerk in some Midland bank with an interest in music'. He shared his life with them and their poetic sister Edith (no. 92) for the next fourteen years. In 1923 came the first public performance of *Façade*, his witty and satirical setting of Edith's avant-garde poems, written in metres echoing the rhythms of waltzes, polkas and foxtrots. It caused a furore, and from that time Walton was an *enfant terrible*.

The ambitious young photographer Cecil Beaton (no. 94; see also nos. 92 and 115) attended a later performance of *Façade* at the Chenil Galleries in April 1926, but 'felt too restless to settle down. . . . There were too many distractions – arty people moving about and arty people in the outer room talking loud'. Nevertheless, sensing an opportunity, he photographed the young composer at about this time, and included his portrait in his first one-man show (1927). In the introduction to the catalogue Osbert Sitwell praised Beaton as 'a photographic pioneer', adding, 'if the race of mortals were to perish from this earth, and nothing remain of the wreck except a few of Mr. Cecil Beaton's photographs, there is no doubt that those who succeed us would pronounce this past set as one of extraordinary beauty'. With his usual assured sense of design, Beaton sets Walton's angular profile against a 'Cubist' background which the photographer had himself painted, and which he used, with improvised adaptations, in other photographs of this period.

92

Dame Edith Louisa Sitwell 1887–1964

Sir Cecil Beaton 1904–80

Bromide print, 1927
22.5 × 17.6 ($8\frac{7}{8}$ × $4\frac{1}{8}$)
Given by Lawrence Whistler, 1977 (X4082)

In December 1926 Cecil Beaton (no. 94) met the poetess Edith Sitwell for the first time. He found her: 'a tall graceful scarecrow, really quite beautiful with a lovely, bell clear voice and wonderful long white hands'. She was a natural sitter, and the more exaggerated the pose the more she enjoyed it. The next year Beaton travelled to Renishaw Hall in Derbyshire to photograph the whole Sitwell family. They were delighted with the results, Edith writing: 'I simply can't tell you what excitement there is at Renishaw about the marvellous photographs – or what joy and gratitude. We are all, including mother, half off our head with excitement. . .'. This portrait dates from that time, and exemplifies that element of refined fantasy, evocative of past ages, which he brought to his portraits of this dedicated bohemian and her eccentric family.

This print was given to the Gallery by Lawrence Whistler. It had previously belonged to his brother the illustrator and mural-painter Rex, a close friend of both Beaton and the Sitwells, whose own work has affinities with the archaic, aristocratic yet pastoral tone of Beaton's photograph. For Beaton, see also nos. 91 and 115.

93

Sir Henry Malcolm Watts Sargent 1895–1967

Elsie Gordon active 1920s

Bromide print, inscribed on the reverse by the photographer: *Malcolm Sargent –/a brief (v unusual)/*
interval of repose/taken at Llandudno/in 1927; 1927
6.3 × 10.7 (2½ × 4⅛)
Given by Dr Jonathan Harvey, 1984 (x20656)

Sir Henry Wood spotted Malcolm Sargent's talent in 1921, when as pianist, composer and conductor the young man was organizing concerts in Leicestershire. He invited him to London to conduct at the Promenade Concert season of 1921, and from that time his career as a conductor accelerated rapidly. The next decade was a period of unremitting hard work and, indeed, pleasure, for Sargent liked to relax after a concert by dancing until dawn. It ended with a complete nervous breakdown in 1932, though two years later he was back at work with renewed vigour.

In his career Sargent conducted many first performances of British works, among them Walton's (no. 91) *Belshazzar's Feast* (1931) and *Troilus and Cressida* (1954), and achieved international recognition as an artist, though in England he never fully escaped charges of superficiality. He won an enduring place, however, in the public's affection, above all for his conducting of *Messiah*, for his long association with the Promenade Concerts and the Huddersfield Choral Society, and for his charm and dashing appearance.

Little is known of Elsie Gordon, an amateur photographer, who in the 1920s mixed in musical circles, and took numerous snapshots of musicians, either at rehearsal or relaxing. The Gallery owns some sixty of her prints, including a group of rare photographs of the pianist and composer Percy Grainger.

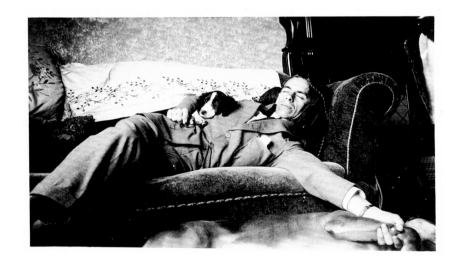

94

Sir Cecil Walter Hardy Beaton 1904–80

Curtis Moffat 1887–1949 and *Olivia Wyndham*

Bromide print, signed by both photographers on the original mount, *c*.1928
28.9 × 24 ($11\frac{3}{8}$ × $9\frac{1}{2}$)
Purchased from the executors of the estate of Sir Cecil Beaton, 1980 (x20034)

In August 1927 Cecil Beaton became a major contributor to *Vogue*, and in November of the same year his first one-man exhibition at the Cooling Galleries on Bond Street established him as a significant photographic figure. With professional recognition came social success for this socially avaricious young man. In 1928 he designed clothes for the Dream of Fair Women Ball at Claridges and the charity matinée *A Pageant of Hyde Park* at Daly's Theatre, and much of his social life and that of his set seems to have revolved around dressing-up. Noël Coward (no. 101) alludes to this in his song 'I've been to a marvellous party' which includes the couplet:

Dear Cecil arrived wearing armour
Some shells and a black feather boa.

In this photograph Beaton's improvised costume anticipates the torn clothes and sexual ambiguity of pop-music stars of the 1980s, and the prevailing tone is of self-dramatizing decadence.

The American photographer and interior designer Moffat worked with Man Ray (see no. 99) in Paris, before opening a studio at 4 Fitzroy Square, London. Beaton thought this high bohemian 'a gentle, quiet, easy-going man with velvet eyes and enormous charm', and his portrait photographs, printed on low-key papers and mounted on coloured papers, 'sensationally original'. For Moffat's assistant Olivia Wyndham, Beaton evidently had less time, for she 'was never mistress of her camera'. See also nos. 91, 92 and 115.

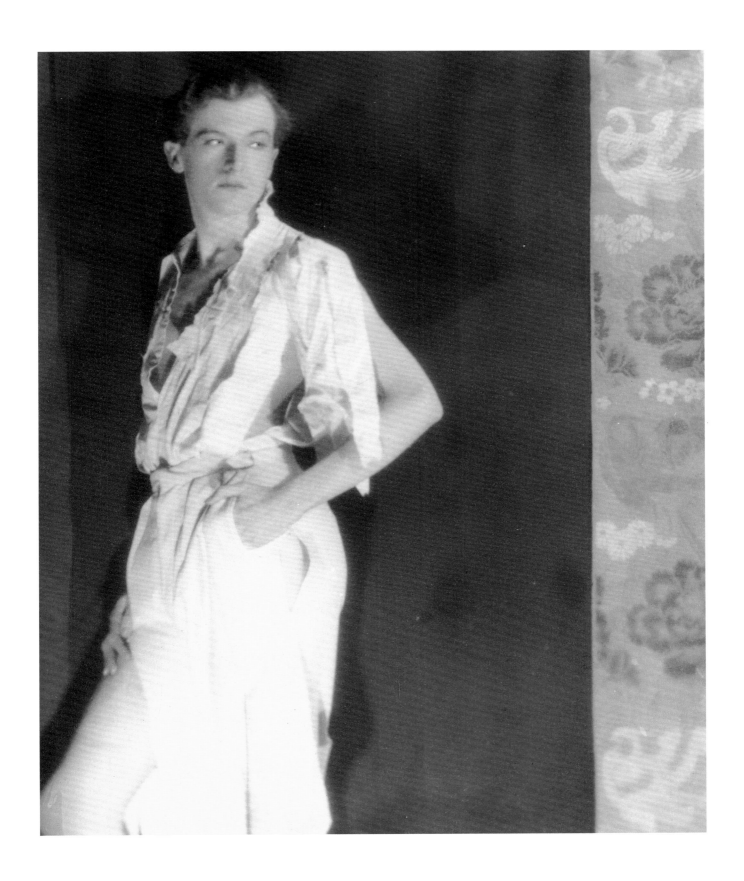

95

John Oliver Havinden 1908–87

Self-portrait

Modern bromide print from the original composition, 1930
25.4 × 20.3 (10 × 8)
Purchased from the photographer, 1987 (P350)

Brother of the designer Ashley Havinden, John Havinden began his photographic career in Australia, before returning to London in 1929, where, with the backing of Madame Yevonde (see no. 106), he set up Gretton Photographs (1930), a studio for commercial and colour photography. Until he abandoned photography in 1938, Havinden produced a considerable volume of advertising work, much of it for Crawford's Agency (of which his brother was a director), for clients such as HMV and Standard Cars. Precise, stark, with a strong feeling for underlying abstract forms, his work parallels in photography the modernist tendency in British art of the period.

This self-portrait is a characteristic blend of the figurative and abstract, in which the German word 'FOTO', is spelled out across Havinden's features, part in modernist sanserif type and part in the form of his spectacles. The allusion is to *Foto-Auge* ('photo-eye'), a book published in Germany in 1929 to mark the Stuttgart 'Film und Foto' exhibition, at which Cecil Beaton (no. 94) was the only British photographer to be exhibited.

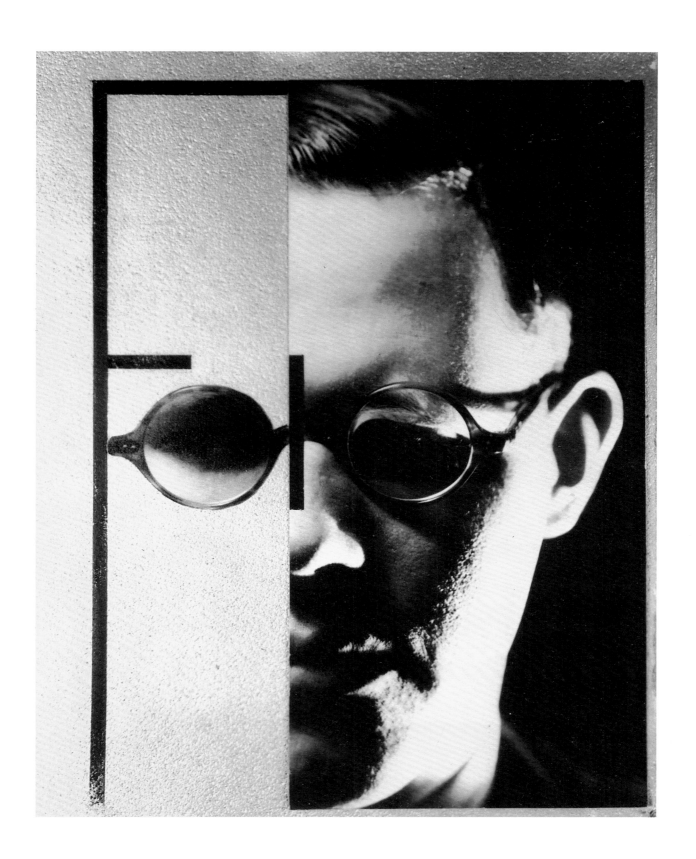

96

Gertrude Lawrence (Gertrude Alexandra Dagma Lawrence Klasen, Mrs Richard Stoddart Aldrich) 1898–1952

Paul Tanqueray born 1905

Modern bromide print from the original half-plate negative, 1932
45.7 × 35.6 (18 × 14)
Given by the photographer, 1983 (X29700)

Noël Coward (no. 101) first met the most brilliant of his leading ladies in 1913 when she was a child-performer: 'Her face was far from pretty, but tremendously alive. She was very *mondaine*, carried a handbag with a powder-puff and frequently dabbed her generously turned-up nose. . . . I loved her from then onwards'. Her first great success was in Charlot's revue *London Calling* (1923), written by Coward, and in 1929 he created *Bitter Sweet* with her in mind. They starred together in *Private Lives*, an immediate success on both sides of the Atlantic, and thereafter she spent most of her time in New York. She was appearing triumphantly on Broadway in *The King and I* at the time of her death.

Paul Tanqueray was, like Angus McBean (see no. 116), a pupil of Hugh Cecil (see no. 103), and set up his own studio in London at 139 Kensington High Street in 1924, moving to 8 Dover Street in 1930. He specialized in society and theatrical portraiture, working especially for *Theatre World*. He photographed Gertrude Lawrence against a background of skyscrapers evocative of New York, painted by his studio assistant Ida Davis, and caught both her wit and romantic allure.

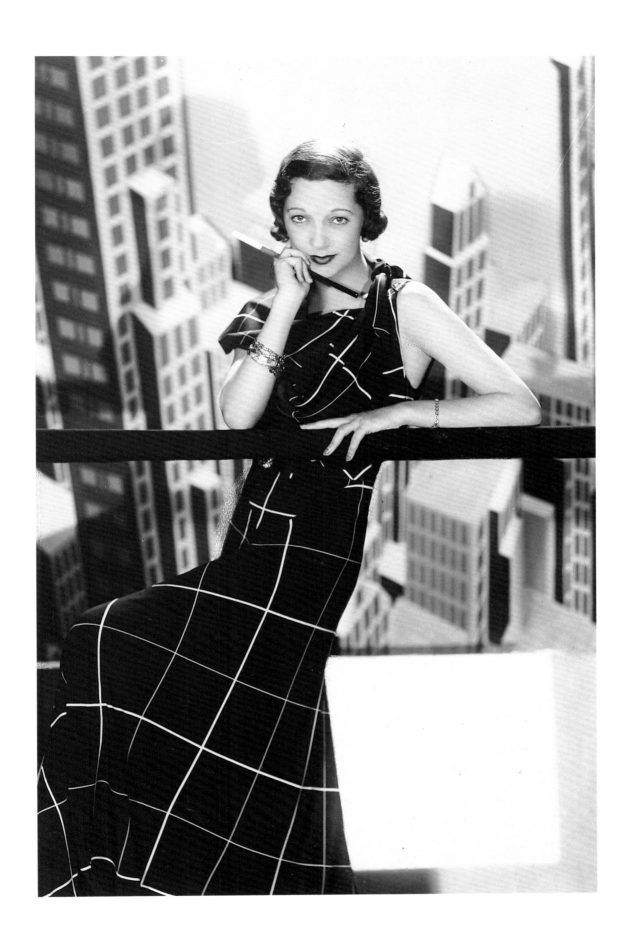

97

Sir John Gielgud born 1904

Yvonne Gregory 1889–1970

Bromide print, 20 January 1933
28.8 × 20.6 (11¼ × 8¼)
Purchased from Gilbert Adams FRPS, 1980 (P140/31)

Sir John Gielgud made his stage début at the Old Vic in 1921 as the Herald in *Henry V*. The foremost Shakespearian actor of the time, he is equally at home in Chekhov, Wilde or Pinter. Only Hollywood has shown him ill-at-ease. This photograph by Yvonne Gregory (no. 84) records his first great popular success: as Richard II in Miss Gordon Daviot's romantic comedy *Richard of Bordeaux*, which he also directed. This opened at the New Theatre, London, in February 1933, and ran for over a year. Gregory portrays him in costume, and the photograph was taken shortly before the play opened, presumably as part of the advance publicity. She stresses Richard's pride, deploying the fullness of his robes to give an effect of majestic height. Gielgud's performance was evidently more complex. According to the critic of *The Illustrated London News* he built up:

> a living character – courageous, impetuous, stubborn, impractical in his dreaming, well-intentioned, devoted, capable of blind follies and injustices, a man whose conscience is the foe of his office – that has the seeds of inevitable tragedy in his soul.

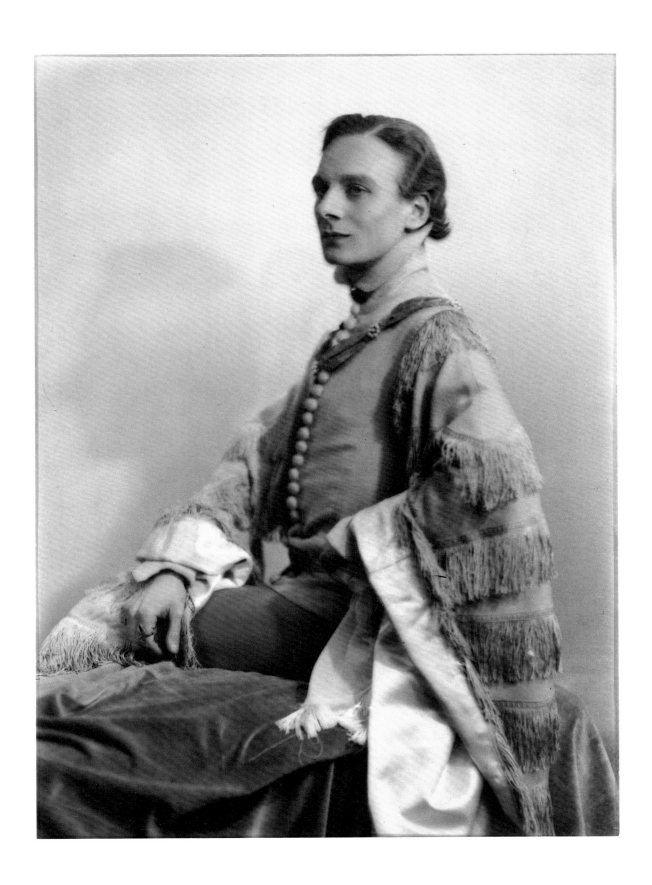

98

Amy Johnson 1903–41

J. Capstack active 1930s

Toned bromide print, signed on the print by the sitter: *Amy Mollison*, and on the mount
by the photographer; *c.*1933–5
20 × 14.6 ($7\frac{7}{8}$ × $5\frac{3}{4}$)
Purchased, 1982 (X17127)

The intrepid daughter of a Hull herring-importer, Amy Johnson trained as a secretary, but developed a consuming passion for flying. With no more experience than a flight from London to Hull, on 5 May 1930 she set out to fly solo to Australia in a tiny Gipsy Moth. She landed in Port Darwin nineteen days later. Though not a record time, her flight was an astonishing achievement, and aroused universal enthusiasm. She was awarded a CBE, the *Daily Mail* made her a gift of £10,000, and the children of Sydney raised the money for a gold cup. Other record long-distance flights followed: across Siberia to Tokyo (1931), to Cape Town (1932), and, with her husband J.A. Mollison, to New York (1933). She divorced Mollison in 1938, and in 1939 joined the Air Transport Auxiliary. She was lost, presumed dead, over the Thames estuary on 5 January 1941, when ferrying a plane with material for the Air Ministry.

In this portrait of Johnson in flying gear the Blackpool photographer Capstack attempts an effect of film-star glamour. He also photographed her in allegorical vein as a personification of 'Speed'.

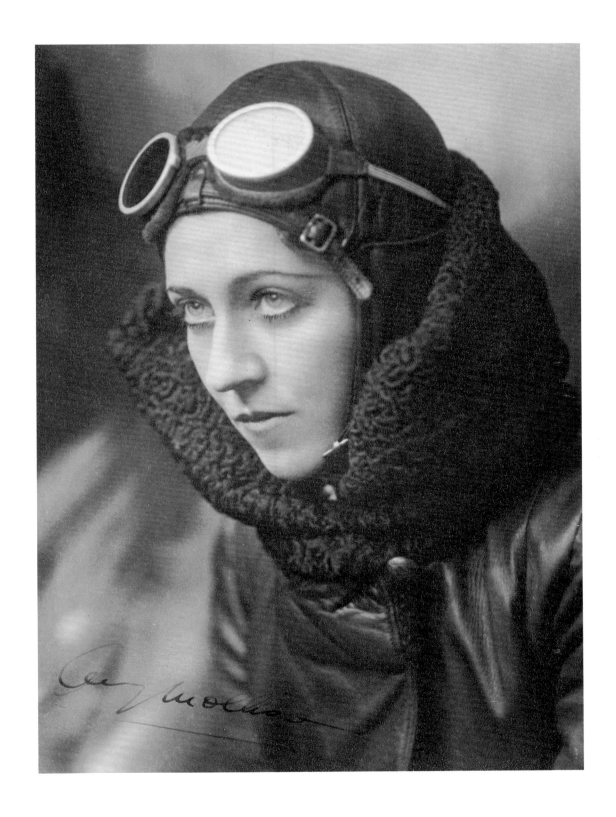

99

Aldous Leonard Huxley 1894–1963

Man Ray 1890–1976

Bromide print, signed and dated by the photographer, and signed on the reverse, with the
photographer's stamp, 1934
29.5 × 23.5 ($11\frac{5}{8}$ × $9\frac{1}{4}$)
Purchased, 1988 (P359)

Of formidable intellectual descent – he was the son of the writer Leonard Huxley, grandson of T.H. Huxley (no. 54), great-grandson of Dr Thomas Arnold, and nephew of Mrs Humphrey Ward (no. 50) – Aldous Huxley, while still an undergraduate of Balliol College, Oxford, was taken up by Philip Morrell and his wife Lady Ottoline. At their home, Garsington Manor, this virtually blind young man was introduced to the up-and-coming writers and artists of the day. In 1921 he published his first novel *Crome Yellow*, to an extent based on his experiences with the Morrells, the first of a succession which were to make him something of a hero with the young. *Point Counter Point* (1928) was a best-seller in England and America, and his utopian fantasy *Brave New World* appeared in 1932. In 1938 he settled in America, where his eye-sight improved and he published *The Art of Seeing* (1942). His later interest in psychedelic drugs such as LSD led to *The Doors of Perception* (1954), which again brought him a cult following.

The American Man Ray (born Emmanuel Rudnitsky in Philadelphia) was one of the century's leading experimental photographers. He lived for much of his career as an *émigré* in Paris, and there photographed many of the leading writers and artists of the day. He was one of the first photographers to reject 'soft focus', and, under the influence of Dadaism, laid great stress on spontaneity. According to a contemporary, Huxley was so tall that he had to 'fold himself and his legs, like some gigantic grasshopper, into a chair', and Man Ray, in this otherwise simple portrait, makes something of this effect.

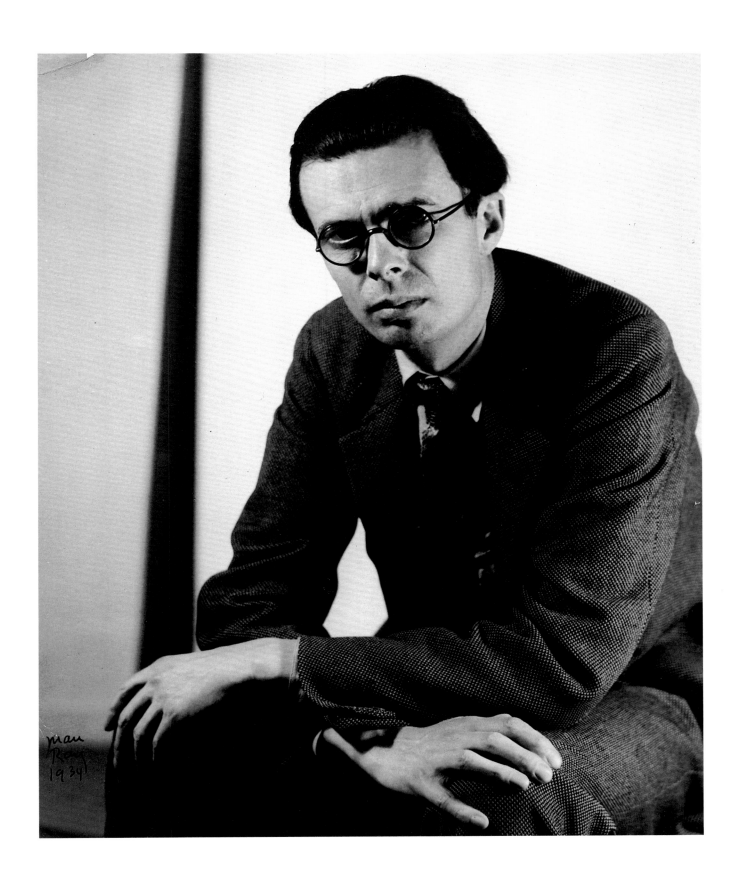

100

Ben Nicholson 1894–1982

Humphrey Spender born 1910

Bromide print, *c*.1935
20.3 × 16.2 (8 × 6⅜)
Purchased from the photographer, 1977 (P42)

Throughout his life Ben Nicholson, the son of the painter and graphic artist Sir William Nicholson, was fascinated, both as painter and sculptor, by the artistic possibilities of still-life. The 1930s were a period of exploration and experimentation for him, as his paintings edged towards sculpture: towards abstract forms and textured surfaces. In 1932 he visited the Paris studios of Brancusi, Braque and Arp, with his future wife, the sculptor Barbara Hepworth. In 1934, while a member of Unit One, which he had founded with Paul Nash (no. 113), he met Piet Mondrian, and produced the first of his series of 'white reliefs', with which his name is especially associated. In these he created a form of abstracted still-life of great purity and harmoniousness, in which basic geometrical shapes are united in subtly modulated planes.

Humphrey Spender, brother of the writer Stephen Spender, made his reputation in the 1930s working as a photo-journalist for *The Daily Mirror* and *Picture Post*, and as official photographer to Mass Observation (see no. 112). He photographed Nicholson at The Mall Studios in Hampstead in this period, though in a style which is the antithesis of reportage. His portrait is, like Nicholson's own work, a painstakingly contrived study in formal and spatial relationships, in which the artist appears in a moment's ambiguity to become part of one of his own compositions.

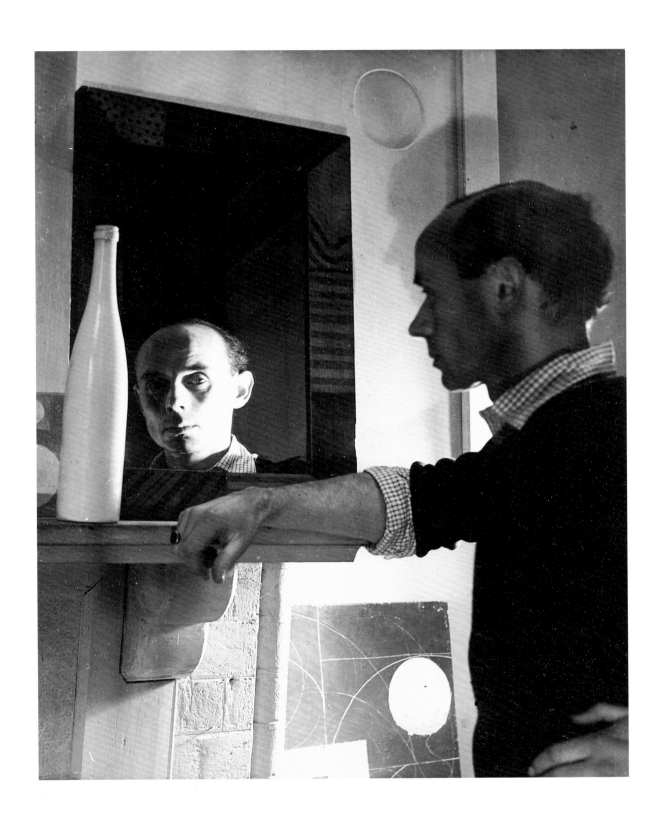

IOI

Sir Noël Peirce Coward 1899–1973

Horst P. Horst born 1906

Modern platinum/palladium print, signed by the photographer on the front
and reverse of the mount, summer 1935
45.3 × 35.4 ($17\frac{7}{8}$ × $13\frac{7}{8}$)
Given by the photographer, 1989 (P419)

Noël Coward, 'the Master', was in every sense a man of the professional theatre, an actor, playwright, lyricist, composer and producer, who began his career aged twelve, playing Prince Mussel in *The Goldfish*, as one of a 'star cast of wonder children'. In 1924 *The Vortex*, his controversial play about drug addiction, took London and New York by storm. There followed a string of successes – *Hay Fever* (1925), *This Year of Grace* (1928), *Bitter Sweet* (1929) and *Private Lives* (1933) – which established Coward as, in Arnold Bennett's phrase, 'the Congreve of our day'. As a song-writer he could be touching and witty by turns, equally at home with the sentiments of 'I'll see you again' as with 'Mad Dogs and Englishmen'. As a performer, whether of the spoken word or song, on the stage, in cabaret, or, latterly, on television, his trademarks were staccato speech, perfect diction and timing, and a brittle wit.

The American photographer Horst was born in Germany; he studied architecture in Hamburg, and with Le Corbusier in Paris. As a photographer he was the protégé of Hoyningen-Huene in the *Vogue* studios in Paris (1932–5), and since 1935 has worked with *Vogue* in New York. Between 1952 and 1970 the Horst Studio was on East 55th Street. He is known above all as a fashion photographer, but during the 1930s produced a series of portraits, which are distinguished, like Coward himself, for their perfectionist pursuit of style. Horst first met Coward in Paris on a summer morning in 1935, after an all-night session at *Vogue*:

> We talked and sat and had a drink, and I asked if I could photograph him (it was the time of *Private Lives*). The next day he came to the studio, immaculately dressed. I started to photograph him and had to tell him, 'Don't pose so much. Look at me'. Actors! Theater people always know what the best angle is and I wanted to get him out of that.

The next year he photographed Coward again, this time in New York with Gertrude Lawrence (no. 96), on the set of Coward's *Tonight at 8.30*.

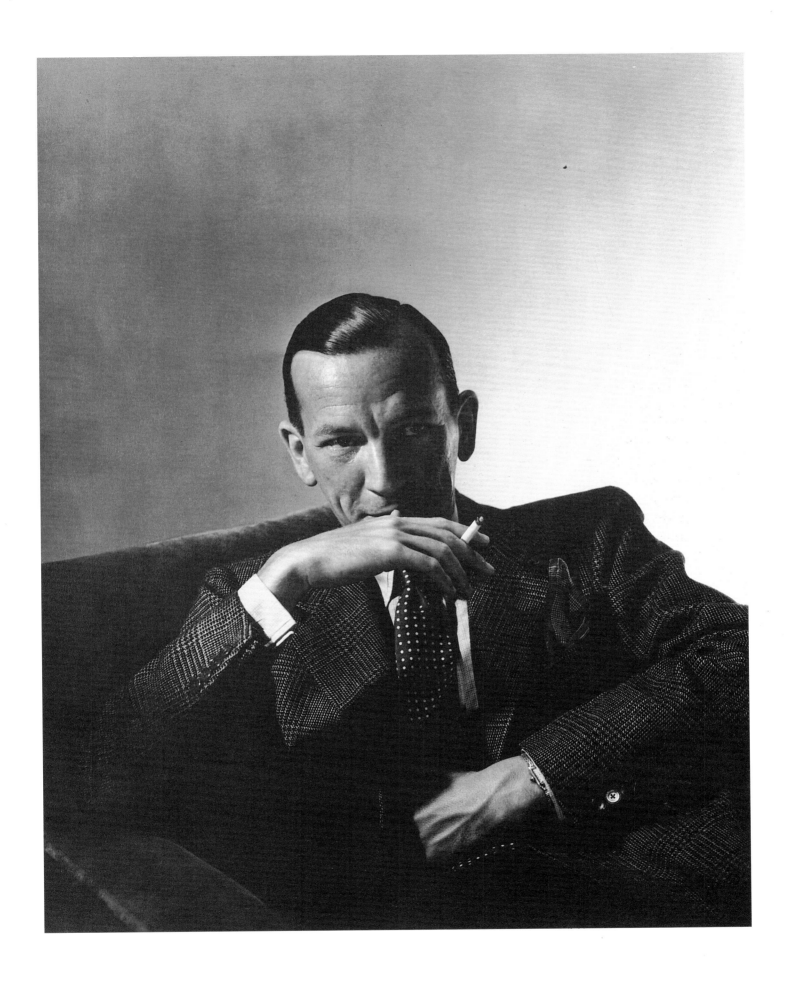

102

Bessie Wallis Warfield, Duchess of Windsor 1896–1986

Dorothy Wilding 1893–1976

Bromide print, 1935
29.1 × 20.2 ($11\frac{3}{8} \times 7\frac{7}{8}$)
Given by Mrs Susan Morton, the photographer's sister, 1976 (x25936)

When George V died on 20 January 1936 his son Edward VIII (no. 103) came to the throne with the firm hope that he could make Wallis Warfield his queen. Born in Baltimore, Maryland, an early marriage ended in divorce, and she then married an Anglo-American Ernest Simpson with a shipping business in England. He brought her to London, where her good looks, vivacity and stylishness won her a place in society, and the love of the Prince of Wales. Her husband resigned himself to a divorce, and a decree nisi was granted in October 1936. But the Prime Minister Baldwin felt that a marriage between the King and a divorcee would be impossible, and Edward, faced with a choice between the throne and Mrs Simpson, chose 'the woman I love'. He abdicated on 11 December, and the couple were married in France in June the following year. As Duke and Duchess of Windsor they lived for the rest of their lives in almost permanent exile in France – the Duchess was ostracized in England – as part of the international set, and dedicated exponents of 'the Windsor style'.

Dorothy Wilding was the most successful woman photographer of her day with studios in Bond Street, London (from 1924) and New York (from 1937), and her work is elegant and flattering. In her autobiography, appropriately entitled *In Pursuit of Perfection* (1958), she recalls that this photograph was taken when she was away from her studio 'gardening in my little country cottage at Petersham. . . . there are times when you have to let go to keep yourself fresh and at the top of your form'. The photograph was actually taken by her assistant Marion Parham who 'was like salt to my egg and butter to my bread'. When 'the four o'clock appointment – Mrs Simpson' turned up at the studio accompanied by the Prince of Wales she initially caused great consternation, but Parham was soon 'on the job'. The Prince was ordered to bring the Cairn terrier from the car, 'and, dutifully, he did so'. Ironically, Dorothy Wilding was chosen as the first woman royal photographer – for the coronation of George VI in 1937. This print is an unretouched proof.

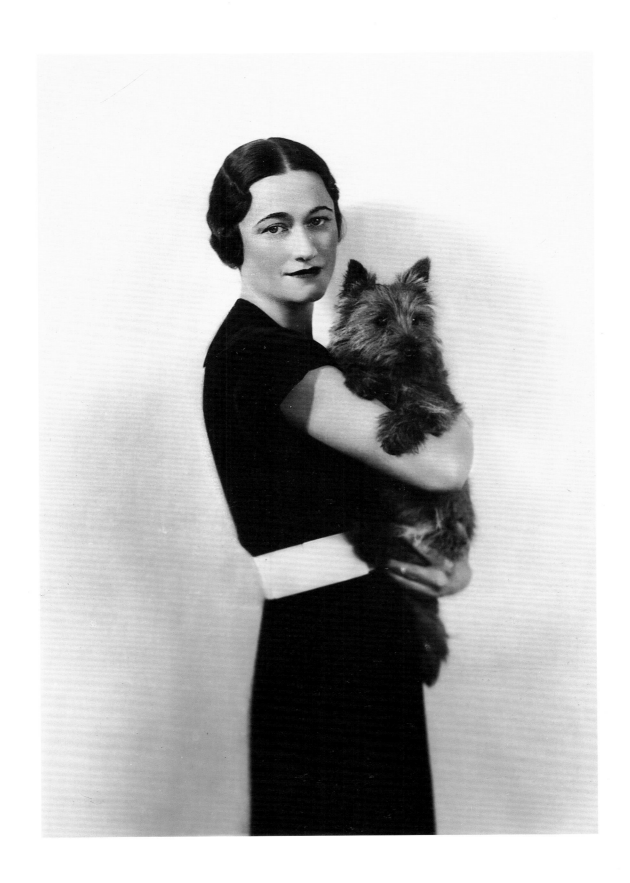

103

Edward, Duke of Windsor 1894–1972

Hugh Cecil born 1889; active 1912–40

Toned bromide print, with the photographer's imprint, 1936
37.5 × 29.8 (14¾ × 11¾)
Purchased, 1979 (P136)

Good-looking, charming, an intrepid sportsman, Edward VIII, as Prince of Wales, was the object of almost universal adulation, dubbed 'the world's most eligible bachelor'. He had however a more sensitive side. This found its most positive expression in a concern for social causes and the poor, but at other times could make him appear spoiled or rootless. A series of affairs with married women ended in his *grande passion*, Mrs Simpson (no. 102). His decision to marry her, in the face of establishment opposition, led to his abdication, only eleven months after he had succeeded to the throne.

Hugh Cecil (born Hugh Cecil Saunders) was, according to Cecil Beaton, a 'retiring and elusive personality' who became interested in photography while at Cambridge. He first set up as a professional portrait photographer in Victoria Street, London, in 1912, moving to the more fashionable Grafton Street in 1923, where his studio was decorated in the most opulent style. Though influenced by de Meyer (see no. 74), his use of light was unique: 'I believe in swamping my studio with light to secure the utmost luminosity in all directions and in this respect follow the best traditions of cinema lighting'; however, for his sitter's face he used a softer, entirely reflected, light. In 1936 Cecil was chosen to take this, the official accession photograph of Edward VIII, which was used as the basis for the short-lived issues of postage stamps. He kept his studio going until the outbreak of war, but increasingly turned his attention to his 'inventions', one of which was the 'photomaton', a forerunner of the photo-booth.

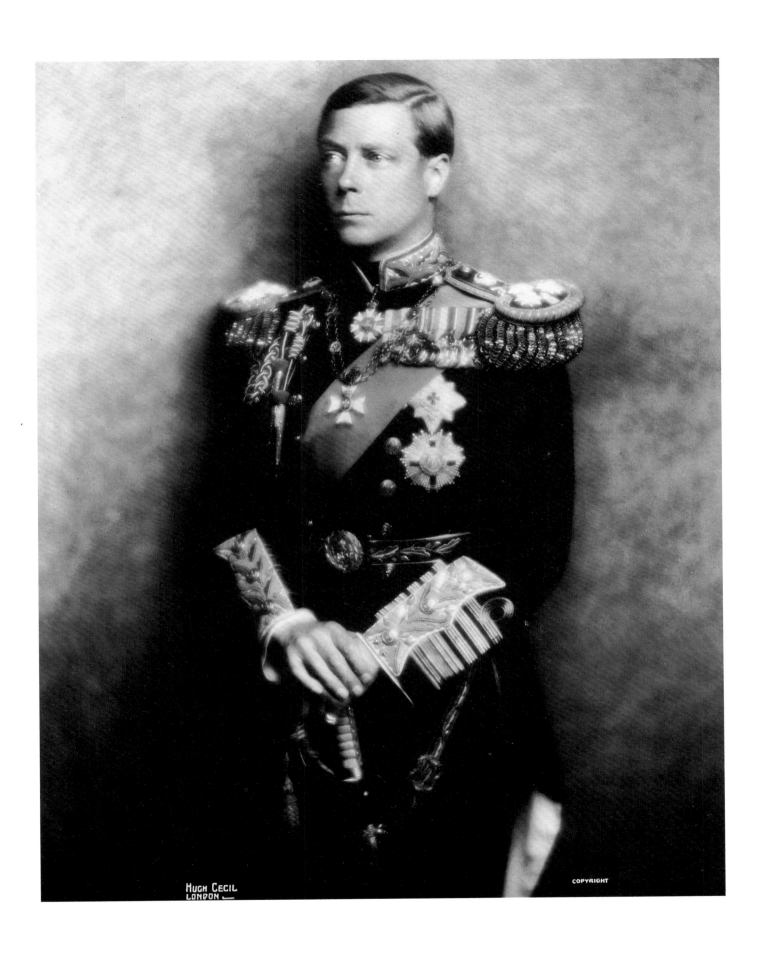

HUGH CECIL
LONDON

COPYRIGHT

104

Patrick Maynard Stuart Blackett, Baron Blackett 1897–1974

Lucia Moholy FRPS AICA born 1894

Modern bromide print, signed on the reverse, 1936
40.1 × 31 ($15\frac{3}{4}$ × $11\frac{3}{4}$)
Purchased from the photographer, 1979 (P127)

One of the greatest scientists of the century, Blackett's influence extended far beyond the laboratory into military strategy and national politics. In his early career he worked with Lord Rutherford in Cambridge on atomic theory, and photographed the first visible evidence of the disintegration of the nitrogen atom. From 1935 he served on the committee formed to advise on defence which pressed for the development of radar, and was director of naval operational research during the war. His dissentient views on the uses of atomic energy, expressed in *The Military and Political Consequences of Atomic Energy* in 1948, the year he won the Nobel Prize for physics, led to his expulsion from government circles, until in 1964 Harold Wilson appointed him scientific adviser to his newly created Ministry of Technology, with the aim of creating for the first time a scientific and technological policy for the country. At his insistence support for the computer industry was made a priority.

Born Lucia Schulz in Prague, Lucia Moholy was married in the 1920s to the Hungarian painter and photographer László Moholy-Nagy, and created with him the first experimental photograms. She moved to London in 1934, where she worked as freelance photographer and lecturer, and produced a series of portraits which are remarkable as character-readings. They are generally close-ups, unaffected in style, informal, with a minimal use of props. Blackett was a powerful, dominant personality, and much of his nervous energy and impatience is conveyed by his concentrated stare, directed away from the camera, and the urgency with which he seems to draw on his cigarette. In 1939 Lucia Moholy published with the newly-founded Penguin Books *A Hundred Years of Photography*, the first history of photography in English. She now lives in Switzerland.

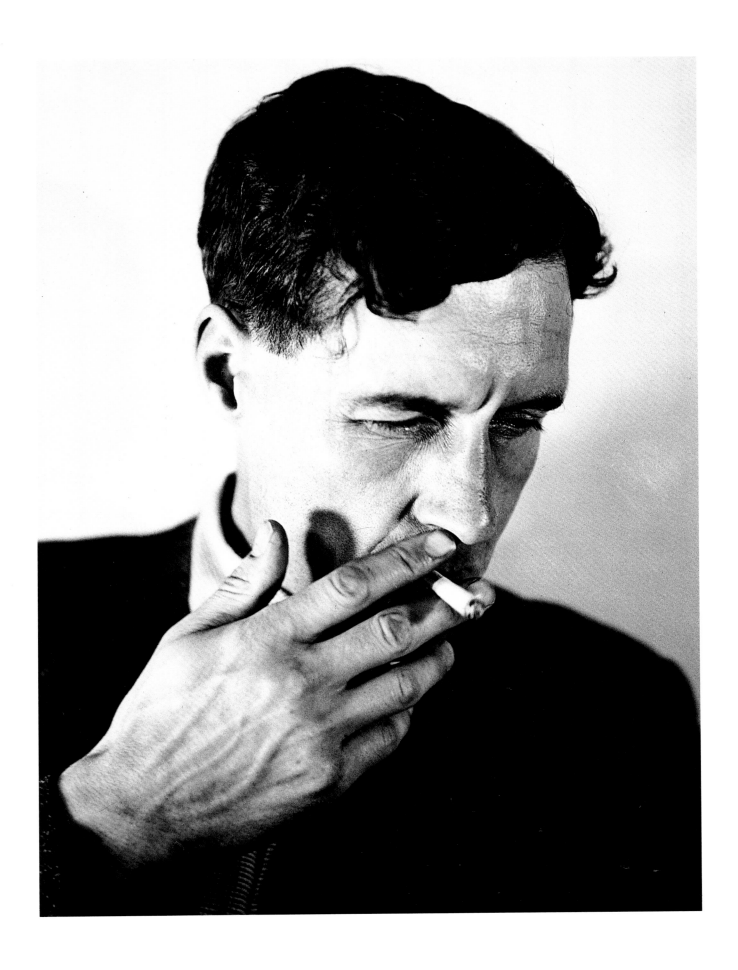

225

105

Dame Dorothy Mary Crowfoot Hodgkin born 1910

Ramsey & Muspratt active c.1930–80

Bromide print, with the photographers' imprint on the reverse of the mount, *c*.1937
37.8 × 30.1 ($9\frac{7}{8}$ × $7\frac{7}{8}$)
Given by Mrs Jane Burch, daughter of Lettice Ramsey, 1988 (P363/13)

In the 1940s Dorothy Hodgkin carried out pioneering work on the structure of penicillin, and in 1964 was awarded the Nobel Prize for chemistry for her work on the structure of Vitamin B^{12}. In 1969 she established the chemical structure of insulin, and continues to work on its description. In 1965 she was admitted to the Order of Merit, only the second woman after Florence Nightingale (no. 17) to receive this honour. In addition to her scientific work, she has been a prominent worker for international peace and understanding.

The Cambridge firm of Ramsey & Muspratt was founded by Lettice Ramsey (1898–1985) and Helen Muspratt (born 1907) in about 1930. According to Ramsey 'She [Muspratt] had the know-how, I had the connections'. From their studio came a succession of unaffected portraits of the intellectual and literary luminaries of Cambridge of the pre-war years, 'a unique chronicle of youth with its eye on futurity'. Muspratt extended the business to Oxford in 1937, while Ramsey stayed on to become a notable Cambridge character. This photograph is one of a group of prints donated to the Gallery by Lettice Ramsey's daughter. It was taken in the mid-1930s, shortly before the sitter's marriage to Thomas Hodgkin, writer on African affairs.

106

Louis Francis Albert Victor Nicholas Mountbatten, 1st Earl Mountbatten of Burma 1900–79

Madame Yevonde 1893–1975

Vivex print, signed by the photographer, *c.*1937
48 × 32.5 (18⅞ × 12¾)
Given by the photographer, 1971 (X26400)

The great-grandson of Queen Victoria and the uncle of Prince Philip, Lord Mountbatten enjoyed a meteoric naval career, which took him from midshipman at Jutland in 1916 to First Sea Lord in 1955, and included the legendary command of HMS *Kelly*, and Supreme Command of the Far East during the Second World War. In 1947 he was appointed by the Attlee government to supervise the transfer of power in India from the British Raj, and was the last Viceroy and the first Governor-General of the new dominion. He was assassinated by Irish terrorists. A patrician figure, with considerable personal magnetism, he was handsome, courageous, possessed of a powerful analytic intelligence, intensely ambitious and excessively vain. Many of these qualities are conveyed by this photograph, which shows him, against a starry background, in the robes of the Royal Victorian Order. Mountbatten had been appointed naval ADC to Edward VIII (no. 103) in 1936, and in February 1937 the new king George VI chose him for the same post, appointing him at the same time GCVO.

Madame Yevonde (Edith Plummer), who was married to the playwright Edgar Middleton, opened her first studio in 1914 at 92 Victoria Street, London, just before the outbreak of the First World War. She was an energetic exponent of the cause of women photographers. In 1933 she moved to Berkeley Square, and, unlike many of her contemporaries, enthusiastically embraced colour photography – notably the Vivex carbro colour process – which she insisted should be treated 'with proper respect'. In her autobiography *In Camera* (1940) she recalls her reaction: 'Hurrah, we are in for exciting times – red hair, uniforms, exquisite complexions and coloured finger-nails at last come into their own'. She had a vivid imagination, and her work ranges from the stylish and chic, through the ruritanian to the surreal, as exemplified in her series of 'Goddesses'. This print is one of a collection of her work donated by her to the Gallery.

107

Christopher William Bradshaw Isherwood 1904–1986 and Wystan Hugh Auden 1907–73

Louise Dahl-Wolfe born 1895

Toned bromide print, 1938
25 × 20.6 ($18\frac{7}{8}$ × $12\frac{3}{4}$)
Given by the Trustees of the Britten Estate, 1981 (X15194)

Christopher Isherwood and W.H. Auden first met at preparatory school in Surrey, and became lifelong friends, literary collaborators, and, as Stephen Spender writes, 'intermittently' lovers. In 1937 Auden was in Spain, where he had volunteered to drive an ambulance for the Republican side in the civil war, but in the following year from January to July he and Isherwood travelled together in China to report on the Sino-Japanese war. Jointly they produced *Journey to a War* (1939), in which their sympathy for the occupied Chinese is fully expressed both in prose and in some of Auden's greatest poetry. The two returned from China by way of America, and this detour changed their lives, for it was then that they decided to leave England and live in America.

It was on that visit, in the summer of 1938, the year before their removal to New York and the publication of Isherwood's *Goodbye to Berlin*, that they were photographed in Central Park by the American photographer Louise Dahl-Wolfe. Though she is best known for her fashion photography which rivals that of Beaton, Horst or Avedon, she has also produced a significant body of portraiture, and has written:

> It is easy to learn the technique of the camera by oneself, but by working in design I learned the principles of good design and composition. Drawing from the nudes in life class made me aware of the grace and flow of line, body movements, and the differences in the way a male poses from that of a female.

This print belonged to the composer Benjamin Britten (no. 120).

108

George Douglas Howard Cole 1889–1959 and his wife Dame Margaret Isabel Postgate Cole 1893–1980

Howard Coster 1885–1959

Modern bromide print from the original half-plate negative, 1938
38.4 × 24.8 (15$\frac{1}{8}$ × 9$\frac{3}{4}$)
Given by the Central Office of Information, 1974 (x10859)

Although he never played a part in parliamentary politics, the 'dark, dynamic presence' of G.D.H. Cole, author of *The World of Labour* (1913), was one of the moving spirits of British Socialism for fifty years. In 1918 he married a colleague from the Fabian Research Department, Margaret Postgate, and the couple were united in the Socialist cause, though always took pains to point out that they were not a 'partnership' on the lines of Beatrice and Sidney Webb. Together they published *The Intelligent Man's Review of Europe To-day* (1933), *Condition of Britain* (1937), and no less than twenty-nine detective stories. Independently Cole was a prolific writer producing a stream of books on social theory and labour history, and an inspiring lecturer, who, as Professor of Social and Political Theory at Oxford became the doyen of PPE (Politics, Philosophy and Economics). According to his wife he was a 'strong Tory in everything but politics'.

Howard Coster, self-styled 'Photographer of Men', opened his first London studio off the Strand in 1926, working first for *The Bookman* and then *The Bystander*. He photographed most of the leading (predominantly) male figures of the day, and the Gallery owns 8,000 of his original negatives as well as many vintage prints. This photograph was taken at the Coles' bookish house in Hendon in 1938. The armchairs are covered in an appropriately Socialist fabric designed by William Morris.

109

Edris Albert ('Eddie') Hapgood 1908–73

Fred Daniels 1892–1959

Bromide print, 1939
41.2 × 30.4 (16¼ × 12)
Purchased from Mrs Nancy Eckart, the photographer's widow, 1988 (P385)

The England full-back Eddie Hapgood, the outstanding defender of his day, joined Arsenal from Kettering at the age of nineteen. Between 1927 and 1944 he played 396 times for the first team; he won five League championship medals and two FA cup winners' medals. He played for England 43 times (including 13 war-time internationals), captaining the side on 34 occasions. When his playing days were over he managed Blackburn and Watford.

Fred Daniels was a film-stills photographer at Elstree Studios, and later at Pinewood and Denham, where he did much work for Michael Powell and Emeric Pressburger, on such films as *49th Parallel* (1941), *The Life and Death of Colonel Blimp* (1943) and *Black Narcissus* (1946). This portrait was taken in connection with Hapgood's role in the film *The Arsenal Stadium Mystery* (1939), directed by Thorold Dickinson.

110

George VI 1895–1952 and his Family

Marcus Adams 1879–1959

Toned bromide print, 1939
34.9 × 26 (14 × 10¼)
Purchased from Gilbert Adams FRPS, the photographer's son, 1980 (P140/13)

The sitters are (left to right): Her Majesty The Queen born 1926, when Princess Elizabeth; George VI; Queen Elizabeth, later Queen Elizabeth The Queen Mother born 1900; Princess Margaret, later Countess of Snowdon born 1930.

The shy and sensitive younger brother of Edward VIII (no. 103), George VI had been prepared from birth for a life of public service, but not for the throne. Undoubtedly the abdication of his brother was both a shock and a blow to him, and he came to the throne a man who had 'never seen a State Paper'. The whole of his reign was overshadowed by the Second World War, and the after-effects of it, and he brought to the monarchy at a crucial time innate good sense, great courage, and an unswerving sense of duty. In this he was supported by his wife and children, and the Royal Family became in the war years a powerful symbol of national unity and stability.

Marcus Adams first trained as an artist, but soon turned to photography, serving his apprenticeship with his father Walton Adams (see no. 78). In 1919 he was invited by Bertram Park (see no. 84) to join his studio in Dover Street, London. There he specialized in child photography, which Park found uncongenial, creating the Nursery Studio. All his work, whether of children or adults, proclaims his perfectionism, and is characterized by a feeling of harmonious informality. This royal group, taken at Buckingham Palace shortly before the outbreak of war, posed considerable technical problems for Adams. It had to be photographed with a very wide aperture, which put the background out of focus. He therefore took a second photograph of the background alone, bleached out the background in the first negative, bound the two negatives together, and printed from his double negative. The recalcitrant corgi Dookie was lured into the composition with a biscuit placed on the king's shoe. According to Adams, 'It took a day to do the job. Reproductions of this picture ran into millions'.

III

Sir Winston Leonard Spencer Churchill 1874–1965

Walter Stoneman 1876–1958

Bromide print, 1 April 1941, 3 p.m.
27.5 × 20.9 ($10\frac{7}{8}$ × $8\frac{1}{4}$)
Given by the photographer, 1942 (X6140)

From Omdurman and the Boer War to his state funeral in 1965, Winston Churchill's life is virtually synonymous with the major events in modern British history. The son of Lord Randolph Churchill, he naturally gravitated to politics, after brief but eventful episodes as a soldier and then as a journalist, and for the next fifty years was one of the dominant figures in the House of Commons. A vociferous and eloquent enemy of appeasement, he succeeded Chamberlain as Prime Minister in 1940, and became Britain's leader and inspiration in her 'darkest hour'.

Walter Stoneman took up photography in the 1890s and was still working at his studio in Baker Street, London, at the time of his death. As chief photographer and eventually chairman of J. Russell & Sons Ltd, photographers to the Gallery's National Photographic Record (see Introduction), he photographed some 7,000 distinguished sitters on the Gallery's behalf. Stoneman styled himself 'the Man's Photographer', explaining that, 'Women do not make beautiful photographs. Men have more character in their faces', and was himself something of a character. His work for the Record – mainly head-and-shoulders portraits taken in the studio – rarely goes beyond the documentary, but this portrait of Churchill at three-quarter-length in the historic surroundings of the Cabinet Room at 10 Downing Street, shows Stoneman rising for once above the mediocre, his latent talent stirred by a man who was, to use Churchill's own phrase, 'walking with destiny'. This photograph was not commissioned as part of the National Photographic Record but presented to the Gallery by Stoneman. Sensing its historical significance, he recorded not just the date but the hour it was taken.

112

Humphrey Jennings 1907–50

Lee Miller 1907–77

Bromide print, *c*.1942
39 × 37.1 (15⅜ × 14⅝)
Purchased from Miss Charlotte Jennings, the sitter's daughter, 1980 (P156)

One who 'survived the theatre and English literature at Cambridge', Jennings seems very much the 1930s intellectual dilettante, dabbling in poetry, radical politics, theatre design and painting. In 1936, with Roland Penrose and André Breton, he set up the International Surrealist Exhibition in London, and in the following year helped to found Mass Observation, an organization dedicated to exploring the unconscious collective life of England, researching such subjects as the 'shouts and gestures of motorists' and the 'anthropology of football pools'. But it is as a maker of short documentary films that he is best remembered, first working for the GPO Film Unit in the early 1930s, and later the Crown Film Unit. The war acted as a catalyst on his talent, and in films such as *London Can Take It* (1940), *Listen to Britain* (1942), *A Diary for Timothy* (1944–5), but above all *Fires Were Started* (1943), he evolved a symbolic film language which was both popular and extraordinarily powerful.

The beautiful American Lee Miller came to London in 1937 with an impeccable pedigree. In New York she had modelled for Steichen (see no. 77); in Paris she was the assistant and mistress of Man Ray (see no. 99), and modelled for Hoyningen-Huene and Horst (see no. 101); with her brother she had her own photographic studio in New York, numbering among its clients *Vogue*, Helena Rubenstein and Saks of Fifth Avenue. Between 1940 and 1945 she was head of *Vogue*'s London studio, and took many of her most distinguished photographs as its war correspondent in France, Germany and Russia. In 1947 she married the painter and art critic Roland Penrose.

This portrait, which appeared in *Vogue* in 1942 is a typically sophisticated arrangement of light and shade, of velvety textures, all treated with a cool sensuousness.

113

Paul Nash 1889–1946

Felix H. Man 1893–1985

Bromide print, 1943
19.1 × 23.3 (7½ × 9⅛)
Given by the photographer, 1980 (X11807)

Poised between European Modernism and a profound devotion to nature, Paul Nash's work as a painter, watercolourist and engraver has a symbolic quality which evokes the rhythms and forms that lie beyond local time and place. At the Slade School (1910–11) he made friends with Ben Nicholson (no. 100), but, unlike Nicholson, with whom he was later to found Unit One (1933), he never adopted pure abstraction, preferring 'a different angle of vision', based on the dramatic possibilities of the deep space and distorted perspectives of Surrealism. Some of his most powerful work was produced as an official war artist in both world wars.

Felix H. Man (born Hans Baumann in Freiburg im Breisgau) began his photographic career working as a photojournalist in Munich and Berlin in the 1920s. In 1934 he emigrated to England, bringing with him the latest technique and equipment – cameras with ultra-fast lenses, the most light-sensitive film – which gave him an ability to seize the possibilities of 'available light'. Working for *The Daily Mirror*, *Lilliput*, and as chief photographer of *Picture Post* (1938–45), he made an art of what he called 'the live-portrait', unposed, in which

> the sitter was made to feel at ease and comfortable in his own surroundings, by not giving him any direction nor interfering with his normal activities, but preserving the atmosphere of his normal way of life. At the same time a personal contact had to be established and the photograph had to be taken at the critical moment reached through long and close observation with the utmost concentration.

Man photographed Nash at work at 106 Banbury Road, Oxford, where he had moved in 1939. He holds his *Landscape of the Vernal Equinox* (collection of HM Queen Elizabeth The Queen Mother), painted in the first half of 1943: a view of Boars Hill, Oxford, overlooking Bagley Woods, with Wittenham Clumps in the distance. Of this painting Nash wrote, 'Call it, if you like, a transcendental conception; a landscape of the imagination which has evolved in two ways: on the one hand through a personal interpretation of the phenomenon of the equinox, on the other through the inspiration derived from an actual place'. Nash painted this view on numerous occasions about this time; another treatment can be seen in the background. This photograph is one of a group of Man's work, presented to the Gallery by the photographer in 1980.

114

Richard Howard Stafford Crossman 1907–74

Bill Brandt 1904–83

Bromide print, 1945
23.5 × 19.1 (9¼ × 7½)
Purchased from the photographer, 1982 (P188)

Intelligent, energetic and inconsistent, Richard Crossman was not an easy colleague. He lacked team spirit and defied regulations, whether at the Ministry of Economic Warfare (1940–5), where he organized the British propaganda effort against Hitler; or as Harold Wilson's Minister of Housing and Local Government (1964–6) and Lord President of the Council (1966–8), or as editor of the *New Statesman* (1970–2). Throughout his life, however, he fought for open government, that parliamentary democracy should not be 'a sham, a gaily-painted hoarding behind which are kept hidden the government and the machinery of the state'. Appropriately, at the very end of his life he succeeded in publishing – against opposition from the then Labour government – his *Diaries of a Cabinet Minister*, which gave an unidealized behind-the-scenes view of politics.

Bill Brandt studied in Paris with Man Ray (see no. 99) before returning to London in 1931, where he began to document in photographs the manners and mores of inter-war society, at a time when photographic reportage was almost unknown in England. Towards the end of the war, however, his style changed completely, and he adopted a more self-consciously formal and aesthetic manner (see no. 117). This portrait of Crossman, working at this desk in the last year of the war, when he was assistant head of the Psychological Warfare Division, is one of Brandt's last works in the early style. It was published in *Harper's Bazaar* in September 1945.

115

Quintin McGarel Hogg, Baron Hailsham of St Marylebone
born 1907

Sir Cecil Beaton 1904–80

Bromide print, 1945
24.6 × 19.6 (9⅝ × 7⅝)
Given by the photographer, 1970 (X14094)

Lord Hailsham is the son of the 1st Viscount Hailsham, Lord Chancellor (1928–9 and 1935–8), and grandson of the philanthropist Quintin Hogg, pioneer of the polytechnic movement. He first entered Parliament as MP for Oxford City in 1938, in the year his father ended his second period of office as Chancellor, and has himself been Lord Chancellor for two periods (1970–74 and 1979–87), in the second of which he saw his own son enter Parliament.

He was photographed by Cecil Beaton as 'a leader of the Tory Reform Group' in 1945, at the collapse of what had seemed a promising ministerial career. In April that year he had been appointed Joint Parliamentary Under-Secretary of State for Air, but the appointment lasted only a matter of months, for Churchill (no. 111) resigned as leader of the wartime coalition government in May, and was defeated by Atlee in the July general election. This photograph was published in American *Vogue* on 1 September that year, accompanying an article by Harold Nicolson on Hogg (as he then was), Aneurin Bevan and Peter Thorneycroft (now Lord Thorneycroft), beginning: 'These three men are ones to watch, since theirs are among the more forceful and rebellious younger minds in the defeated Conservative and the victorious Labour Parties'.

Beaton's compositions often seem inspired theatrical improvisations on hastily-gathered materials, remote in place and time. For the politician, however, at the moment of defeat, he adopts a different solution. The bare table, trunk, the cupboard doors, have a stubborn presence, indifferent to the sensitive young man, his hat by his side, who is about to get up and leave the room. The great American photographer Irving Penn credits this image as a major influence on his work.

116

Hughes Griffiths ('Binkie') Beaumont 1908–73 with Angela Baddeley 1904–76 and George Emlyn Williams 1905–87, in Terence Rattigan's *The Winslow Boy* ('Binkie Pulls the Strings')

Angus McBean born 1904

Bromide print, signed by the photographer on the mount, 1947
38 × 29.7 (15 × 11¾)
Purchased from the photographer, 1977 (P59)

At the age of twenty-eight 'Binkie' Beaumont founded with his associate H.M. Tennent the firm of theatrical producers H.M. Tennent Ltd. Beaumont was from the beginning the moving spirit behind the company, but, even after Tennent's death in 1941, he did nothing to publicize his own name. His firm, however, dominated the West End theatre for almost twenty years, and during that period Beaumont had the power to make or break the career of almost any actor. From the start he had the friendship and support of John Gielgud (no. 97) and Noël Coward (no. 101), and this, combined with his exceptional managerial skills and perfectionism, resulted in a run of highly successful productions. Above all, the firm of Tennents became a byword for superbly dressed comedies with starry casts.

Angus McBean began his career in the theatre as an odd-job man, making masks and building scenery, but turned to full-time theatre photography in 1936, and, as 'one-shot' McBean, was virtually official photographer to Tennents. His work is characterized by its wit and imagination, and, as he himself puts it, 'the use of surrealism for its fun value'. In this characteristically inventive photograph Beaumont is shown as puppeteer, manipulating Angela Baddeley as Catherine Winslow and Emlyn Williams as Sir Robert Morton, in the first production of Rattigan's *The Winslow Boy*, which had opened at the Lyric Theatre, Hammersmith, in May 1946. It is the perfect image of Beaumont who all his life cultivated anonymity, and yet was a domineering personality, one in whom, according to Tyrone Guthrie, 'the iron fist was wrapped in fifteen pastel-shaded velvet gloves'. It was published in *The Tatler and Bystander* in August 1947.

117

Graham Greene born 1904

Bill Brandt 1904–83

Bromide print, with the photographer's stamp on the reverse of the mount, 1948
34.2 × 29.1 ($13\frac{1}{2} \times 11\frac{5}{8}$)
Given by the photographer, 1982 (x22429)

The novelist Graham Greene, who was awarded the Order of Merit in 1986, sees his work as divided into two distinct streams: the serious novels, works of moral and religious enquiry, such as *Brighton Rock* (1938), *The Power and the Glory* (1940), and *The Heart of the Matter* (1948), and 'entertainments', fast-moving psychological thrillers including *Stamboul Train* (1932), *A Gun for Sale* (1936), *The Confidential Agent* (1939), *The Third Man* (1950), and, in lighter vein, *Our Man in Havana* (1958). To his readers the distinction is less material, for both styles of work are recognizably facets of the same personality. As a youth Greene habitually played Russian roulette; later on he was converted to Roman Catholicism, and his whole *œuvre* seems to constitute a meditation on the meaning and purpose of life in a mind which is both intensely religious and profoundly sceptical.

Greene was photographed by Brandt at about the time of the publication of *The Heart of the Matter*, in which the central character, the well-meaning, ineffectual colonial administrator (and Roman Catholic) Major Scobie destroys himself. The act itself is violent and apparently meaningless, but Greene draws from it a profound spiritual truth. The photograph shows the author, against a background of skylights, in his flat in St James's, London. Brandt, working in his later analytical manner (see no. 114), draws from the architecture of this most sociable area of London – the home of so many gentlemen's clubs – a more anguished landscape of the mind. The photograph was first published in *Lilliput* in November 1949, and later in *Harper's Bazaar* in March 1950.

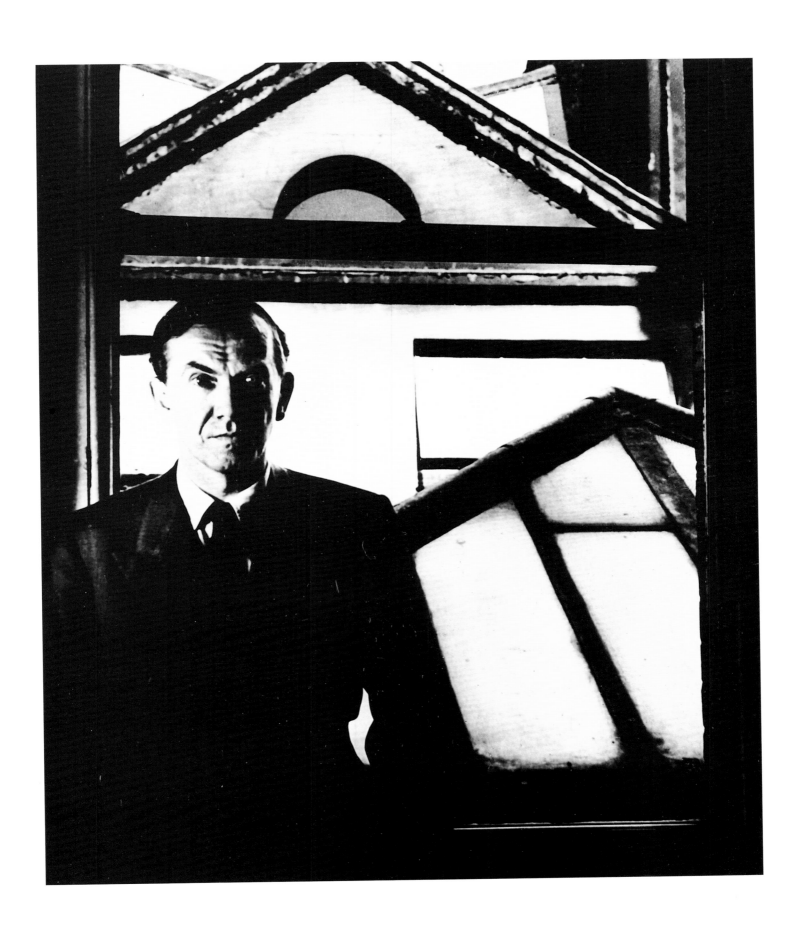

118

John Desmond Bernal 1901–71

Wolfgang Suschitzky born 1912

Bromide print, 14 April 1949
29.5 × 24.8 ($11\frac{5}{8} \times 9\frac{3}{4}$)
Purchased from the photographer, 1985 (P304)

From his days as an undergraduate the physicist Desmond Bernal was nicknamed 'Sage', and he was a polymath, with an infectious delight in new ideas. Before the war he played a major role in the development of crystallography, and was one of the founders of molecular biology, working on the structures of sex hormones, water, proteins (with Dorothy Hodgkin, no. 105), and viruses. During the war he worked as adviser to Lord Mountbatten (no. 106) at Combined Operations, on the development of artificial icebergs as aircraft carriers, and on the scientific planning for the invasion of Europe. Afterwards, as professor at Birkbeck College, London, he had a vision of his laboratory as an 'Institute for the Study of Things', but it never fully materialized. Bernal's extreme left-wing views made him unpopular in the climate of the cold war, and he was largely deprived of the necessary funds for his research. A frequent visitor to the Soviet Union, he was a friend of Khruschev, and, most controversially, a supporter of the agriculturist Lysenko. He was awarded the Lenin Prize for peace in 1953.

Wolf Suschitzky was born in Vienna, where his father had opened the first Socialist bookshop in 1900, and studied at the Austrian State School for Photography. Like many of his contemporaries, he was deeply influenced by the *Foto-Auge* exhibition of 1929 (see no. 95). He came to London in the 1930s, where he produced a series of documentary photographs of the West End, and worked as a photo-journalist. From the late 1930s onwards he has worked as a film cameraman on documentary and feature films, and, increasingly, commercials. Shortly after the war he was a founder member of DATA, the first film co-operative. He photographed Bernal at his microscope in his laboratory at Birkbeck College, in the cold war years when he was fighting against diminishing resources and for world peace.

119

Henry Moore 1898–1986

Yousuf Karsh born 1908

Bromide print, signed by the photographer on the mount, 1949
99 × 74.9 (39 × 29½)
Given by the photographer, 1984 (P251)

Universally recognized as one of the greatest sculptors of the century, Henry Moore is above all renowned for his monumental seated and reclining figures – predominantly female – usually benevolent in character and lyrical in mood. In them he reveals a remarkable feeling for the relationship between the human form and the forms of landscape, and has said: 'I would rather have a piece of my sculpture put in a landscape, almost any landscape, than in the most beautiful of buildings'.

The photographer Karsh was born in Turkish Armenia, and emigrated to Canada in 1924. He opened his studio in Ottawa – the city which is inextricably associated with his name – in 1932, and from that time specialized in portraiture. At the request of the Canadian government he has photographed many of the most important and celebrated figures in the world. He is equally at home with royalty, politicians, writers, artists, and religious leaders, and he approaches each of his sitters in a spirit of enquiry, but also, it seems, of veneration. He photographed Moore 'on a bitterly cold and rainy morning in 1949' in the sculptor's studio at Hoglands, his home in Perry Green, Hertfordshire, at a moment of transition in Moore's career.

In the background of the portrait is the full-size plaster model for Moore's *Family Group* (1948–9), the first of his large works to be conceived as a bronze, in other words, not carved directly from the material. It was made for a school in the New Town of Stevenage in Hertfordshire (later casts are in the Tate Gallery, London, and the Museum of Modern Art, New York). Installed in September 1950, it caused considerable local and national controversy, Moore's old adversary Sir Alfred Munnings commenting: 'Distorted figures and knobs instead of heads get a man talked about these foolish days'. Moore's sculptures, and especially his expressive use of 'holes', were frequently the butt of anti-Modernist mockery. He said to Karsh: 'The first hole made through a piece of stone . . . is a revelation. A hole can have as much shape and meaning as a solid mass.' The photographer adds: 'I glanced up at the family group, here pictured, and began to understand a little better what he meant'.

120

Edward Morgan Forster 1879–1970, Edward Benjamin Britten, Baron Britten of Aldeburgh 1913–76, and Eric Crozier born 1914, at work on the libretto of *Billy Budd*

Kurt Hutton 1893–1960

Bromide print, with the stamp of *Picture Post* and Kurt Hutton on the reverse, 1950
19.5 × 14.2 (5$\frac{1}{2}$ × 7$\frac{5}{8}$)
Given by the Trustees of the Britten Estate, 1981 (X1522)

In 1948 at the first Aldeburgh Festival Benjamin Britten heard E.M. Forster lecture in the Baptist Chapel there on the poet George Crabbe whose tale of Peter Grimes formed the basis of Britten's first opera (1945). In his talk Forster reflected on how he might have treated the libretto for the opera had it been his to write. This was not wasted on Britten, and when he was commissioned to write an opera for the Festival of Britain (1951), he turned to Forster. The novelist was then in his seventies, with virtually no dramatic experience. Together they decided to make an opera of Herman Melville's story *Billy Budd, Foretopman* and, in collaboration with the producer and experienced librettist Eric Crozier, they created one of the best (and most faithful) librettos ever to be based on a literary masterpiece. Britten's score itself is a work of great psychological subtlety, and when the opera was first performed at Covent Garden in December 1951, the drama of the 'handsome sailor' destroyed by evil was recognized as a work of tragic insight.

Born Kurt Hubschmann in Strasbourg, the photographer emigrated to Britain in 1934, adopting the name 'Hutton' in 1937. As a photo-journalist he had worked under Felix H. Man (see no. 113) in Berlin, and in London he was soon adopted by *Weekly Illustrated* and later by *Picture Post*. His secret lay in his sympathy with his subjects, and it is possible to feel in this photograph of the three men entirely absorbed in their project, all the excitements and frustrations of collective literary composition. It was taken at Britten's home, Crag House, overlooking the seafront at Aldeburgh, in the early part of 1950, when Forster's friendship with Britten was at its most excited. Later, relations were less easy, and Forster confided to his diary in December that year: 'I am rather a fierce old man at the moment, and he is rather a spoilt boy, and certainly a busy one'. This print is one of a group of 108 photographs of, and relating to, Benjamin Britten presented to the Gallery in 1981.

121

John Christie 1882–1962

Cornell Capa born 1918

Bromide print, with the stamp of *Life* magazine and the photographer on the reverse,
and inscribed and dated; 23 July 1951
34 × 26.3 (13$\frac{3}{8}$ × 10$\frac{3}{8}$)
Purchased, 1988 (P358)

John Christie could seem impossibly eccentric, but in reality he had an extraordinary ability, by virtue of his energy and enthusiasm, to reconcile the ideal with the practical. In the 1920s at Glyndebourne, his house in Sussex, he installed a cathedral organ (buying up an organ company in the process), and began to give concerts, and when in 1931 he married the operatic soprano Audrey Mildmay he decided to build an opera house there. Thus Glyndebourne Opera was founded. Public reaction was incredulous, but, with his conductor Fritz Busch and the producer Carl Ebert, the opening season (1934) proved a triumphant success. The years which followed had many ups and downs, and it was not until 1950, the year before this photograph, that support from the John Lewis Partnership ensured the future of Glyndebourne and its festival. Its name is now known internationally as the home of country-house opera, and above all for productions of Mozart.

Cornell Capa (born Kornel Friedmann in Budapest), brother of the photographer of war Robert Capa, emigrated to the United States in 1937, and spent most of his career as a photo-journalist working for *Life* magazine. His subject is people, and he tackles them with directness and vitality, so that, as in the case of Christie, they almost burst from the picture space. This photograph, taken as part of a session for *Life* magazine, shows Christie teasing a favourite pug. His son Sir George Christie, the present Chairman of Glyndebourne, has described it as 'extremely characteristic. He liked to bring the worst out of his pugs and he achieved this unfailingly'.

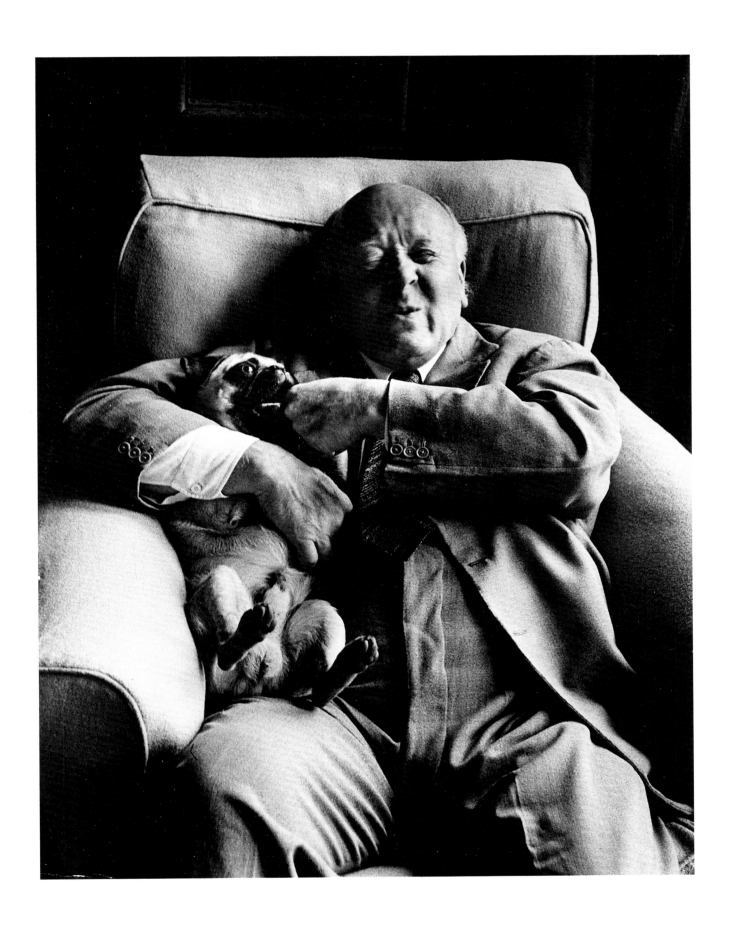

122

Joan Collins born 1933

Cornel Lucas born 1923

Modern c-type colour print from the original transparency, 1951
39 × 31 (15⅜ × 12½)
Given by Pinewood Studios, 1986 (x27871)

The daughter of a theatrical agent, Joan Collins went into show-business in her teens, and her good looks and good sense have carried her triumphantly through the vicissitudes of a long career. From the 1950s to the 1970s her sultry charms made her a popular leading lady in a variety of British and international films, and from 1981 she has acted in the television soap-opera *Dynasty*, which has made her the most famous, and imitated, actress in America. Her autobiography *Past Imperfect* appeared in 1978. In the same year she produced and starred in the film of her sister Jackie's novel *The Stud*, and *The Bitch* followed in 1979. She has recently herself written a best-selling novel. With her indomitable glamour, voice like 'a pout made audible', and the ability to laugh at herself, she has become a cult figure on both sides of the Atlantic.

Cornel Lucas, after studying photography at the Regent Street and Northern Polytechnics, went into the film industry in 1937 as a laboratory technician, and turned to full-time photography in 1942. From 1946 to 1959 (when he left films to concentrate on fashion and advertising photography), he worked for Rank, Columbia and Universal Studios as a stills photographer, in a period when the 'star' system dominated the industry. To the British film studios and their stars he brought the glamour of Hollywood, and his female subjects have an aura of utopian gorgeousness. His portrait of Joan Collins, which was commissioned by Pinewood Studios, was taken at the very beginning of her film career.

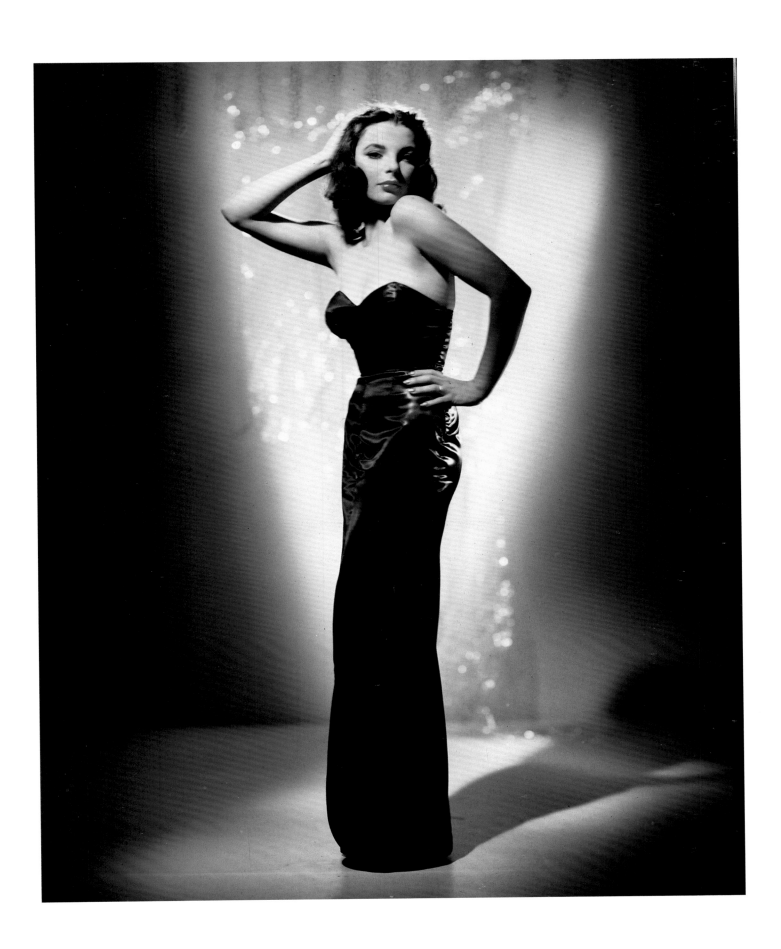

123

Sir Eduardo Luigi Paolozzi born 1924

John Deakin 1912–72

Bromide print, signed and inscribed on the reverse, 24 September 1952
30.1 × 26 ($11\frac{7}{8}$ × $10\frac{1}{4}$)
Purchased, 1985 (P296)

Eduardo Paolozzi, born in Scotland of Italian parents, is recognized as one of the leading British print-makers and sculptors. For him 'all human experience is one big collage', and his work is infused with a fascination with popular culture – he was a prominent member of the Pop Art movement – as well as modern industrial technology. A recent exhibition at the Gallery, based around new portrait sculptures of the architect Richard Rogers (no. 140), however, conclusively revealed another strain in his work: his debt to, and veneration for, the academic tradition of Western art, and, in his own words, 'that form of teaching scathingly dismissed by more recent generations as Ecole des Beaux Arts'. This latest synthesis finds its most majestic expression in his monumental self-portrait bronze *The Artist as Hephaestus* (1987), which stands at 34–36 High Holborn, and which portrays the artist in his complex role as man, machine and myth. The Gallery owns a smaller version of this entitled *Self-portrait with Strange Machine*.

John Deakin was from 1948 until his death a familiar Soho character, and, according to George Melly, 'a vicious little drunk', a liability to his friends, who included Francis Bacon (no. 141) and Daniel Farson (see no. 124). He was, nevertheless, an inspired photographer, whose work has an unflinching documentary quality, stripped of any trace of sentiment or humour. Until his behaviour became intolerable, he worked for *Vogue*, where his portrait of Paolozzi was published in March 1953. It shows the sculptor when a member of the Independent Group of young artists, architects and critics, 'who were more interested in discussing helicopters and proteins than prospects for the Royal Academy', and illustrates Deakin's understanding that a close-up, though it may well show more detail, also lends emphasis to broad sculptural forms.

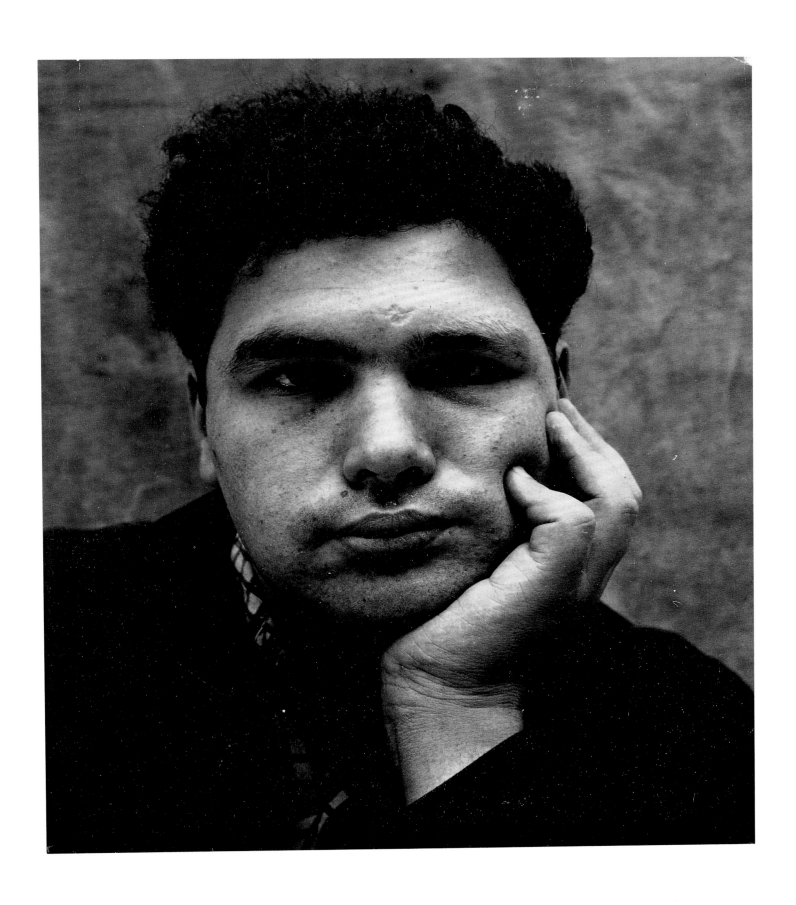

124

Cyril Vernon Connolly 1903–74 and Lady Caroline Blackwood born 1931

Daniel Farson born 1927

Bromide print, inscribed on the reverse: *Outside Wheelers*, early 1950s
17.8 × 17.8 (7 × 7)
Purchased from the photographer, 1985 (P290)

Daniel Farson's photographic career began immediately after the Second World War in Germany, when he was posted to the American Air Corps newsletter *Stars and Stripes*, and later at Cambridge he ran and illustrated his own magazine *Panorama*. In the 1950s he worked for *Picture Post* and *Harper's Bazaar*, and in 1951 discovered Soho. There, while pursuing a career as a journalist and as one of the first British television personalities, in an atmosphere of perpetual hangover, he took a series of photographs of the denizens of this bohemian haunt – forties diehards and some brilliant newcomers – which are redolent of the period. Cecil Beaton designated his photographs 'anti-artistic', and certainly their style is generally spare and documentary, though to this double portrait of two writers he brings a faintly sinister note of unspecified drama. It was taken outside the fish-restaurant Wheeler's in Old Compton Street, described by Farson in his *Soho in the Fifties* (1987). In the post-war years it represented luxury, and to the artistic set of Francis Bacon (no. 141) and Lucian Freud it became both dining-room and club. According to Farson: 'Over the years the staff shared our triumphs and disasters, observed our high spirits and furious arguments, and became our friends. In return, we provided a sort of cabaret'.

Connolly, who is best known for his *bon mot* 'imprisoned in every fat man a thin one is wildly signalling to be let out', was an unsparing observer of the literary scene and of himself. He wrote in *The Unquiet Grave* (1944) that 'the true function of a writer is to produce a masterpiece and that no other task is of any consequence', and his whole life can seem like a commentary on his failure to produce that masterpiece. He was nevertheless a distinguished editor of *Horizon*, and as a leading book reviewer for *The Sunday Times* his opinions had a lasting influence on a younger generation. The novelist and critic Lady Caroline Blackwood is the daughter of the 4th Marquess of Dufferin and Ava. She was a favourite model, and at the time of this photograph the wife of the painter Lucian Freud. She subsequently married the American poet Robert Lowell, who wrote of her 'moon-eyes', 'bulge-eyes bigger than your man's fist', eyes which are familiar from the hypnotic portraits of her by Freud.

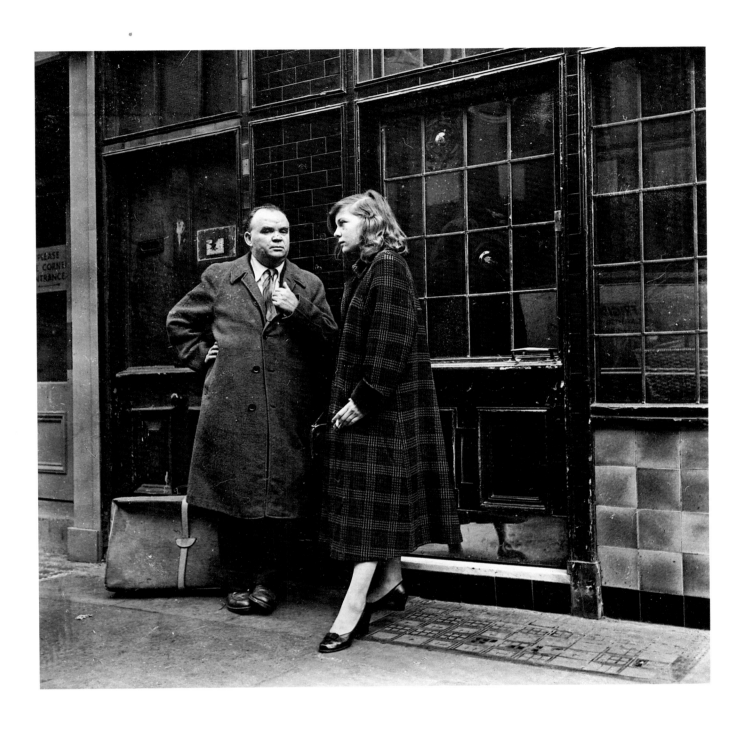

125

Bertrand Arthur William Russell, 3rd Earl Russell 1872–1970

Ida Kar 1907–74

Toned bromide print, with the photographer's studio stamp on the reverse, 1953
24.1 × 19.4 (9½ × 7⅝)
Purchased from Victor Musgrave, the photographer's widower, 1981 (X13796)

Both as philosopher and social reformer Russell was indisputably one of this century's major intellects. He was closely associated with the Bloomsbury Group, and early on established his reputation as a philosopher with the *Principia Mathematica* (1910–13). As a writer and lecturer he was an ardent pacifist, and the first president of the Campaign for Nuclear Disarmament (1958), which he split in 1960, to form the more militant Committee of 100, dedicated to civil disobedience in pursuit of its ends. He lived for nearly a hundred years, retaining his mental vigour to the end. His high-pitched voice, precise and pedantic delivery and whinnying laugh were much parodied. He won the Nobel Prize for literature in 1950.

Born in Armenia, educated in Egypt and Paris, Ida Kar had her first studio in Cairo in the war years, and there experimented with Surrealism. In 1944 she married Victor Musgrave, director of the avant-garde Gallery One, and came to London, where she worked as a portrait photographer, contributing to numerous newspapers and magazines, including *The Sunday Times*, *The Tatler*, and *Vogue*. Her photographs, all taken by natural light, are marked by what Colin MacInnes described as her 'gift . . . to woo and win intimacy without any loss of courteous deference. . . . an Ida Kar portrait is at once identifiable by its purity and distinction'. She photographed Russell, as he made notes in his diary, in the studio of the sculptor Epstein (no. 128), where he was sitting for his bust. In the background is the plaster of what is probably the sculptor's bust of the actor Terence O'Regan, also dating from 1953.

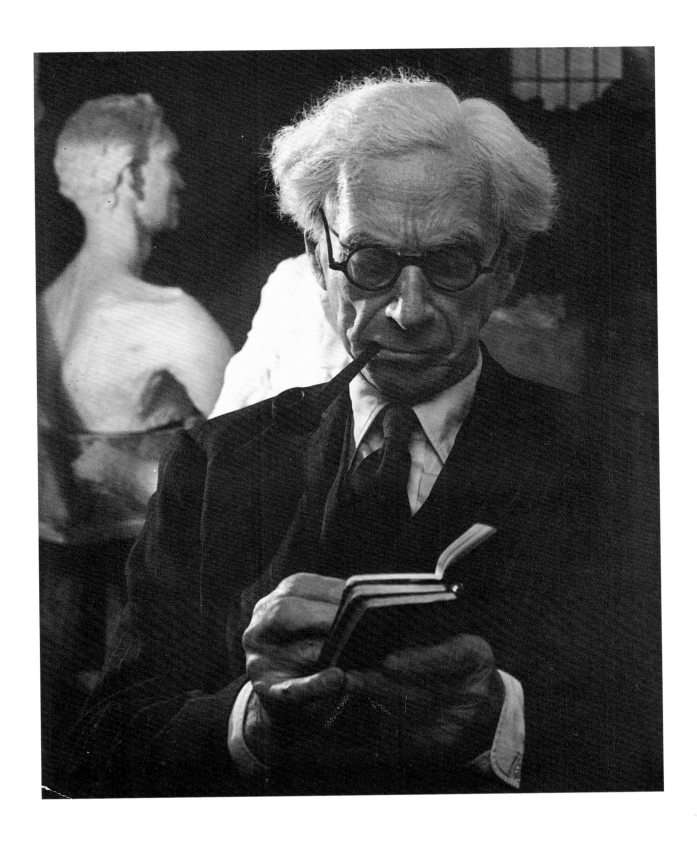

126

Maurice Harold Macmillan, 1st Earl of Stockton 1894–1986

Arnold Newman born 1918

Bromide print, signed, inscribed and dated: *MP. and Minister Harold McMillan, London 1954*; 1954
33.6 × 26.3 (13$\frac{1}{4}$ × 10$\frac{3}{8}$)
Purchased, 1976 (P44)

Born into the family publishing house, Harold Macmillan first entered Parliament as MP for Stockton-on-Tees in 1924. He was something of a rebel, and had to wait sixteen years for a government job – until Churchill, another rebel, recognized his qualities. Elected leader of the Conservative Party in succession to Anthony Eden in 1957 in the aftermath of the Suez crisis, 'Supermac', as he came to be known, set about restoring confidence both in his party and the country. A hatred of poverty drew him to policies of economic expansion and social benefits; he restored the relationship between Britain and America, strove for *détente* between the West and the Soviet Union, felt the 'wind of change' blowing in Africa and the need for decolonisation, and attempted to forge a new relationship with Europe. Behind a studied 'Edwardian' manner lay a subtle and, when necessary, ruthless intelligence, which enlivened his later role as distinguished elder statesman.

Arnold Newman was born in New York, studied at the University of Miami, and trained as a photographer in Philadelphia. He opened his first studio in Miami Beach in 1942, moving to New York in 1946, and has established himself as one of America's leading portraitists. His exhibition *The Great British* was shown at the Gallery in 1979, and revealed a style which though restrained is none the less inventive. He studies his sitters in advance, and depicts them in a setting which is not just symbolic, but also symptomatic, of their life and work. Macmillan is photographed as Minister of Housing, and Newman makes great play with the impedimenta of office which surround the successful minister, who had just achieved his target of 300,000 new houses in a year.

127

Thomas Stearns Eliot 1888–1965

Kay Bell Reynal 1905–77

Bromide print, signed on the reverse, 1955
34 × 26.7 (13⅜ × 10½)
Purchased, 1982 (P205)

Kay Bell took up photography as the result of a dare in 1943. She was working as an associate editor for *Vogue* in New York, and was given a camera by the then art director. Two years later she set up a studio in an Eastside townhouse, and there, working with a hand-held camera by natural light, she produced fashion photographs and portraits which are marked by their elegance and informality. In 1947 she married the publisher Eugene Reynal, and through him came into contact with many of the leading writers of the day, often photographing them 'after lunch', as she put it, in relaxed and less guarded moments.

The poet, playwright and critic T.S. Eliot sat to her in May or June 1955, when staying with his American publisher Robert Giroux, on his way to Boston to visit his two ailing sisters. He was by that time the 'elder statesman' of British letters, in whose work can be traced a spiritual quest which leads from the apparently despairing *Waste Land* (1922) to the religious fulfilment of the *Four Quartets* (1935–42). With characteristic prudence he gave three poetry readings on the trip – just enough to pay for it – and, with less circumspection, went to see his old friend Ezra Pound, 'il miglior fabbro' who had revised *The Waste Land*, and who was incarcerated in an asylum in Washington. On a visit the previous year Pound had criticized Eliot's Christianity as 'lousy', but this year things went better, and Pound wrote to Ernest Hemingway: 'Possum [Eliot] more relaxed this year . . . last year rather edgy'.

128

Sir Jacob Epstein 1880–1959

Geoffrey Ireland born 1923

Silver print, with the photographer's stamp on the reverse of the mount, February 1956
43.7 × 40.4 (17⅜ × 15⅞)
Purchased from the photographer, 1980 (x8496)

Jacob Epstein was born in New York of well-to-do Jewish *émigré* parents, and first studied sculpture there. In his early twenties he travelled to Europe in search of new influences, and settled in London, in Camden Town, in 1905. His career could seem to be a long series of public scandals, for his major works reveal a fascination with primitive art and themes of sexuality and procreation which were certain to shock. His nude figures symbolizing the stages of human life on the British Medical Association building in the Strand (1907–8) were later emasculated; his tomb of Oscar Wilde (1909–12; Père Lachaise Cemetery, Paris) wreathed in plaster, straw and tarpaulin by the cemetery authorities; later works like his monumental sculpture *Genesis* (1929–30) became side-show attractions. By contrast, his expressive portrait busts were always in demand.

The photographer Geoffrey Ireland was born in Lancaster, and studied at the Royal College of Art, London, where in 1953 he was appointed tutor in graphic design. He was later Head of Photography at the Central School of Art and Design. In 1953 he began work with Epstein on a book on his recent sculpture (published in 1958 as *Epstein: A Camera Study of the Sculptor at Work*), and this photograph is reproduced there with the caption 'more work still to do'.

In his introduction to Ireland's book, Laurie Lee writes of Epstein: 'he haunts these photographs; a broad-boned working figure, homely as a riveter, untouched by the professional vanities of dress or posture, almost unnoticeable except for his tough absorption in his work and the profound enquiry of that unforgettable face'. This photograph shows the sculptor, who was already in failing health, in a setting of operatic grandeur confronting for the first time the massive block of Roman stone from which he was to carve his Trades Union Congress War Memorial. This was commissioned for Congress House, Great Russell Street, which was then under construction. The block was lowered into place in February 1956, and Epstein began work shortly after on his figure of a mother cradling in her arms her dead son. It was 'devilish hard work as this particular block is as hard as granite and tools just break on it', with 'terrific noise of building going on all about me'. It was finished by Christmas that year, but the building was not formally opened until 1958.

129

John Osborne born 1929

Mark Gerson born 1921

Bromide print, signed and inscribed on the mount, 1957
43.2 × 38 (17 × 15)
Purchased from the photographer, 1989 (x32734)

One of the original 'Angry Young Men', John Osborne made his name with his play *Look Back in Anger*, which opened at the Royal Court Theatre in May 1956. It was set in a one-room flat in a Midlands town, and centred on the marital conflict between Jimmy Porter, from a 'white tile' university, working on a market stall, and his wife Alison, a colonel's daughter. A landmark in British theatre, this 'kitchen sink' drama was a focus for reaction against the work of a previous generation – the middle-class comedies of Coward (no. 101) and Rattigan and the portentous verse-plays of T.S. Eliot (no. 127) and Christopher Fry. In the plays which followed Osborne presented a series of tormented or tragic heroes, Archie Rice in *The Entertainer* (1957), *Luther* (1961) and Colonel Redl in *A Patriot for Me* (1965). Later works such as *A Sense of Detachment* (1972) and indeed his autobiography *A Better Class of Person* (1981), have proved that his anger has not diminished over the years, even if the viewpoint has become more conservative.

Mark Gerson took up professional photography in 1947, working from a studio near Marble Arch for magazines such as *John O'London's Weekly* and *Books and Bookmen*. He has made a speciality of portraits of writers, photographed informally in their gardens or homes, and he believes that the photographer's role should be as neutral as possible. His study of Osborne is therefore untypical. Gerson first photographed him at his house in Woodfall Street, Chelsea, on 22 February 1957 for *The Tatler*, and afterwards Osborne asked him to take a photograph of the front of the Royal Court Theatre with his name up in lights for his own use. It was Gerson's idea to make a montage of the two photographs in one image. He writes: 'I did it for fun and presented it to John, who was very impressed and ordered masses of postcard size prints for his fans'.

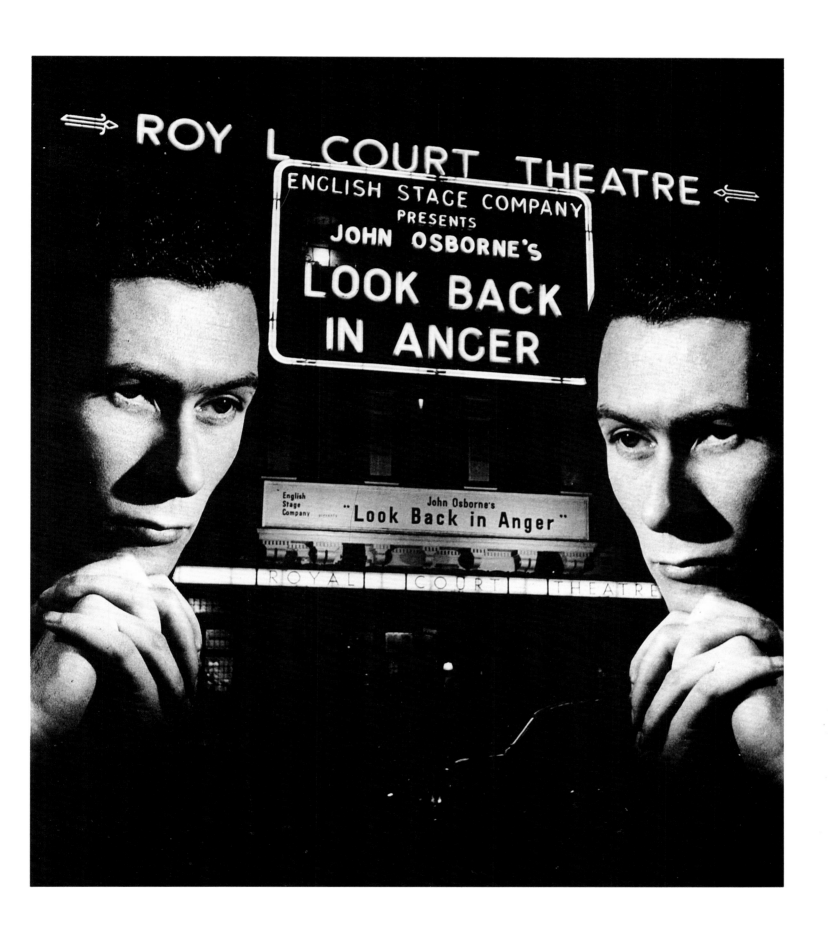

130

Her Majesty Queen Elizabeth II born 1926 and her Family

Lord Snowdon born 1930

Bromide print, with the photographer's stamp on the reverse, 10 October 1957
28.6 × 23 (11¼ × 9)
Purchased, 1985 (x32733)

The sitters are (left to right): The Princess Royal, Mrs Mark Phillips born 1950; Charles, Prince of Wales born 1948; The Queen; Prince Philip, Duke of Edinburgh born 1921.

As Tony Armstrong-Jones, Lord Snowdon began his professional career in 1951 as assistant to the society photographer Baron, and opened his own studio on the Pimlico Road, London, in 1953. He has worked as a freelance photographer for many magazines, among them *Vogue*, *The Tatler*, and *Harper's Bazaar*, and in 1962 was appointed artistic adviser to *The Sunday Times*. He acknowledges the influence of his uncle, the stage-designer Oliver Messel, on his life and work, and his early photographs especially show an ingenuity of presentation which can be theatrical. His later work, especially his studies of the old, disabled or handicapped, for whom he feels a special concern – he designed a chairmobile for the disabled (1972) – though it is more documentary in character, is filled with compassion.

He photographed The Queen, Prince Philip and their two eldest children in the gardens of Buckingham Palace in 1957, three years before his own marriage to Princess Margaret. Only twenty minutes were available for the sitting, so he planned it carefully in advance, submitting a sketch of the composition for approval. He intended to base the photograph on eighteenth-century paintings, and the royal children were to be shown fishing. For this purpose he hired a rod, and bought two trout from the fishmonger. He records that

> on the morning of the assignment, Mrs Peabody, who looked after me in Pimlico, came in with breakfast. 'I thought you needed a good start to the day today', she said; and I took off the lid to find she had grilled the trout quite beautifully.

The royal children were therefore shown reading a book.

131

The Reverend Martin Cyril D'Arcy 1888–1976

Richard Avedon born 1923

Bromide print, New York City, 1 October 1959, edition number 3/15
15.2 × 15.2 (6 × 6)
Purchased from the photographer, 1983 (P235)

As lecturer and tutor at Oxford in the 1920s and 1930s Father D'Arcy became the fore-most English apologist for Roman Catholicism, and brought into that church a stream of notable converts, of whom the most celebrated was Evelyn Waugh. So much so that Muriel Spark in one of her novels described the process of conversion as 'doing a D'Arcy'. Both in his writing and preaching he worked with all the force of his magnetic personality to stir the emotions; he was a brilliant conversationalist, and in appearance strikingly idiosyncratic. In 1945 he left his beloved Oxford to become head of the English Jesuit province, but in 1950 was relieved of this post. The rest of his life was clouded by this humiliation. He was out of step with post-war England, and spent much of his later years in America, where he felt he was better understood and appreciated.

Richard Avedon was born in New York City, and studied photography at the New School for Social Research. He set up his own studio in 1946, and worked freelance for numerous periodicals, including *Life* and *Harper's Bazaar*. He has been staff photo-grapher for *Theatre Arts* and *Vogue*, and is one of America's most distinguished portrait-ists, whose style can be dramatic but is always clinical. He has written of his work – and his remarks illuminate this portrait of D'Arcy – 'A photographic portrait is a picture of someone who knows he's being photographed, and what he does with this knowledge is as much a part of the photograph as what he's wearing or how he looks . . . We all perform . . . I trust performances'.

132

The Cast of *Beyond the Fringe*

Lewis Morley born 1925

Bromide print, 1961
38.3 × 29.4 (15 × 11½)
Given by the photographer, 1989 (X32732)

The sitters are (left to right): Peter Cook born 1937; Jonathan Miller born 1934; Dudley Moore born 1935 and Alan Bennett born 1934.

In 1961 a precociously clever satirical revue, which was created for the Edinburgh Festival in the previous year, opened at the Fortune Theatre in London. *Beyond the Fringe* was a triumphant success on both sides of the Atlantic, and seemed to signal a new era in satirical theatre. In reality it was the death-knell of revue on stage, but had a revolutionary impact on television comedy, and inspired satirical programmes including *That Was The Week That Was* and Rowan and Martin's *Laugh-in*. Of the four stars only Peter Cook has not ventured beyond comedy but is the main shareholder of *Private Eye*. Dudley Moore now has a career as a film actor and jazz musician; Jonathan Miller is one of the most distinguished of theatre and opera producers, and Alan Bennett a leading playwright.

Lewis Morley was born in Hong Kong, and became interested in photography while serving in the RAF. He studied painting at Twickenham College of Art, London, but moved into professional photography in the late 1950s. In 1961 he moved into a studio above Peter Cook's Establishment Club in Greek Street, Soho. His work in the 1960s – portraits and photo-journalism – is absolutely in tune with the times: informal, irreverent, with a gently anarchic sense of humour. This photograph was taken in Regent's Park, as one of the front-of-house photographs for the original production of *Beyond the Fringe*.

133

The Beatles

Norman Parkinson born 1913

Bromide print, 12 September 1963
39.5 × 59.4 ($15\frac{1}{2}$ × $23\frac{3}{8}$)
Given by the photographer, 1981 (X27128)

The sitters are (left to right): George Harrison born 1943; Paul McCartney born 1942; Ringo Starr born 1940 and John Lennon 1940–80.

In 1963 Beatlemania swept Britain (it was to sweep America in the following year). With the release of their hit single 'She Loves You' the 'Fab Four' from Liverpool and their 'Mersey Sound' created a popular music phenomenon. They were the first group to write, sing and play their own material, and, skilfully produced, they revolutionized the sales of long-playing records throughout the world. Their services to music (and to the balance of payments) were recognized by the award of MBEs in 1965. Two years later they released *Sergeant Pepper's Lonely Hearts Club Band*, often considered the finest rock music album ever made. The group split up in 1970.

Norman Parkinson, who trained with the society photographers Speaight & Sons of Bond Street, opened his first studio at 1 Dover Street, Piccadilly, London, and rapidly established a reputation as one of the top portrait photographers, with a modern and creative approach to portraiture based on imaginative film-lighting effects. After the war he began a long association with the Condé Nast organization, working for *Vogue*, and is now recognized as the doyen of British fashion photographers. He photographed The Beatles in their hotel room in Russell Square, when they were in London to record tracks for their LP *With the Beatles* on the eve of their first tour of America, under the initial impact of fame: a frieze of smiling faces.

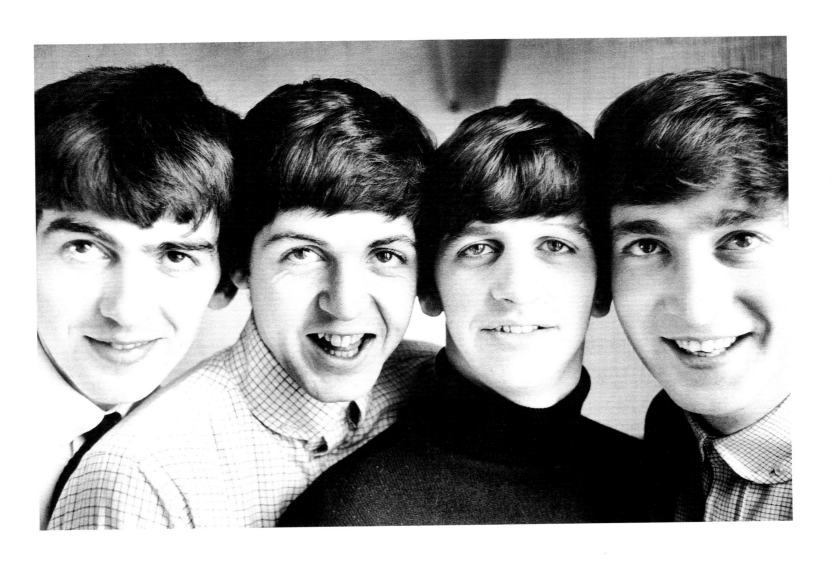

134

David Hockney born 1937

Jorge Lewinski born 1921

Bromide print, signed and dated 1969 on the reverse of the mount, 1968
37.7 × 29.1 (8 × 5⅜)
Purchased from the photographer, 1970 (X13726)

Already famous before he left the Royal College of Art, London, in 1961, Hockney has acquired an international celebrity which tends to obscure his achievement. He is nevertheless one of the most accomplished and continuously inventive of contemporary artists, whether working as a painter, printmaker, photographer (see no. 144) or theatre designer (for instance, his highly original designs for *The Rake's Progress* for Glyndebourne). His line-drawings, classically composed portraits, and mesmeric swimming-pool paintings, are readily approachable, and have spawned many imitators, but his language remains entirely personal.

Jorge Lewinski was born in Poland, and came to Britain in 1942. He turned professional photographer in 1967, making a speciality of portraits of artists in their habitats, and studies of landscape. He is married to the photographer Mayotte Magnus (see no. 138). He portrays Hockney seated in front of his *A Neat Lawn* (1967; private collection, West Germany), in a composition of Hockneyesque neatness, the artist playfully juxtaposed with a lawn sprinkler. It is a disarming image of a disarming personality, which, like Hockney's paintings, dares the spectator to search below the carefully ordered surface.

135

Vanessa Redgrave born 1937 and Tariq Ali born 1943 at the Grosvenor Square Demonstration

John Walmsley born 1947

Bromide print, 27 October 1968
45.1 × 35 (17¾ × 12)
Purchased from the photographer, 1978 (x6394)

The daughter of two distinguished actors, Sir Michael Redgrave and Rachel Kempson, Vanessa Redgrave is thought by many to be the leading British actress of her generation. She made her London début in *A Touch of the Sun* in 1958; soon after, she became a principal with the Royal Shakespeare Company, and, were it not for other commitments, she would never be out of the West End. At the same time she has had a prolific career in films, which include *Morgan – A Suitable Case for Treatment* (1966; Best Actress award at Cannes), *Camelot* (1967), *Isadora* (1968), *Julia* (1977; Academy award), *Yanks* (1979), *Wetherby* (1987) and *Prick Up Your Ears* (1987). She has said 'I choose all my roles very carefully so that when my career is finished I will have covered all our recent history of oppression', and she brings to politics, which since the early 1960s have become an increasingly important part of her life, the same passion and intensity which she shows in her acting. With her brother Corin she helped to found the Workers' Revolutionary Party, and has stood for Parliament. She has taken part in anti-nuclear demonstrations, and was once arrested. On 27 October 1968, six months after the student riots in Paris, she led the anti-Vietnam War march on the United States Embassy in Grosvenor Square, and she is shown here on that march, with (left) the revolutionary student-leader Tariq Ali, about to present a letter to the United States ambassador. Born in Lahore, Ali studied politics and philosophy at Oxford, and became the first Pakistani to be elected President of the Oxford Union. He is the author of books on world history and politics, most recently *Street Fighting Years: An Autobiography of the Sixties* and *Revolution from Above: Where is the Soviet Union Going?* He has also written plays for television, and was a founder director of Bandung Productions.

Since leaving art school John Walmsley has been a freelance photojournalist, working for *The Listener*, *New Society* and *The Sunday Times*, among others. He has had one-man shows in London and Vienna, and has published books on the child psychologist and educationalist A.S. Neill. This photograph was taken while he was still at art school: 'I'd hitched up to London (with a borrowed college camera), took my pictures, and then hitched home again'. It is in essence a piece of reportage, but by careful cropping, he captures the full force of Redgrave's idealism, giving it a histrionic turn, setting her head high in the frame, in a way which recalls the revolutionary posters of Eastern Europe. According to Walmsley, 'The white headband is a Vietnamese sign of mourning'.

136

Charlotte Rampling born 1945

Helmut Newton born 1920

Bromide print, 19 October 1973
46.2 × 31.3 (18⅜ × 12¼)
Purchased, 1985 (X32395)

The daughter of an army officer and Olympic gold medallist, Charlotte Rampling first made a name in the early 1960s as a fashion model, but soon moved into films, playing in the quintessentially sixties pieces *The Knack and How To Get It* (1965) and *Georgy Girl* (1966). Over the years, in films such as *The Damned* (1969), *The Night Porter* (1974), *Farewell My Lovely* (1975) and *Paris by Night* (1989), her screen persona has become increasingly cool and sophisticated, a spellbinding *femme fatale* with almond eyes. She lives in France with her husband, the musician and composer Jean-Michel Jarre.

Helmut Newton was born in Berlin and trained there with the fashion and theatre photographer Yva. He left Germany in 1938, first for Singapore, and later Australia, where he worked as a freelance photographer, and met his wife June, the photographer Alice Springs. In 1955 the couple left Australia for Europe, and settled in Paris. They now live in Monaco. Newton is one of the world's best known fashion photographers, but since the late 1970s portraiture has been his main interest. His habitual subject is the international jet-set, on which he casts an ironic eye. His work has appeared in numerous magazines, in recent years particularly *Vanity Fair*, and he has published several books, including *47 Nudes* (1982), *World Without Men* (1984) and *Helmut Newton: Portraits* (1987). In 1988 the National Portrait Gallery held a retrospective exhibition of his portrait works. His photograph of Charlotte Rampling at the Hôtel Nord Pinus, Arles, is one of his earliest portraits, but entirely characteristic in its use of an elaborate *mise-en-scène* and tone of sexual audacity. The point of view is voyeuristic, suggesting an unspoken drama between photographer and subject.

137

Philip Arthur Larkin 1922–85

Fay Godwin born 1931

Bromide print, 1974
29.9 × 21 (11⅝ × 8¼)
Purchased from the photographer, 1980 (X12937)

'Deprivation is for me what daffodils were for Wordsworth': a typically ironic, melancholic remark of the man who at the time of his death was the most widely read and admired contemporary English poet. Born in Coventry, the son of the city treasurer, he went up to St John's College, Oxford, with Kingsley Amis. He assumed his mature persona when in 1955 he became librarian of the Brymor Jones Library at the University of Hull and published his second volume of verse, *The Less Deceived*. Ever self-conscious, he fancied he was seen as 'one of those old-type *natural* fouled-up guys', and in his gentle and retiring way did nothing to counteract the image. His poetry, which is direct and highly memorable, takes the rhythms of contemporary speech and coaxes them into unobtrusive metrical elegance. In *The Whitsun Weddings* (1964) and *High Windows* (1974) he ranges over sad urban and suburban landscapes, and the preoccupations of their inhabitants, but above all he writes of his own preoccupation with transience and death. He produced verse sparingly, but also wrote two novels, and quantities of jazz criticism in which he revealed an otherwise latent hedonism.

Fay Godwin first took up photography in 1966, when she began to photograph her young children. Despite the lack of any formal training, she has made a reputation for herself as a photographer of writers and, above all, of landscape, and has collaborated among others with John Fowles on *Islands* (1978), Ted Hughes on *Remains of Elmet* (1979), and with Alan Sillitoe on *The Saxon Shore Way* (1983). She photographed Larkin in wry mood at the library in Hull, looking, as he described himself in later life, 'like a bald salmon'.

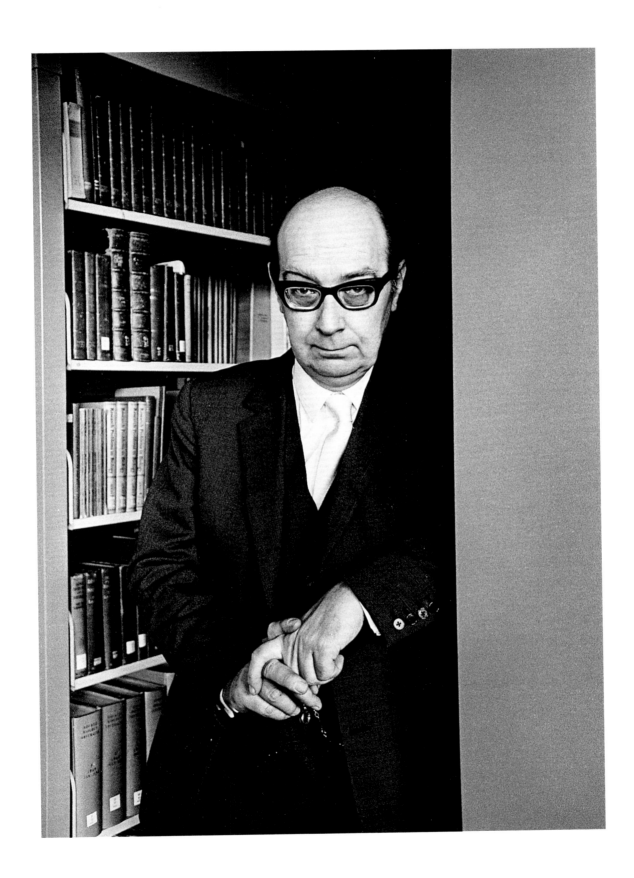

138

Elisabeth Agnes Lutyens, Mrs Edward Clarke 1906–83

Mayotte Magnus

Bromide print, with the photographer's stamp on the reverse, August 1976
40 × 29.7 (15¾ × 11⅝)
Purchased from the photographer, 1977 (X18622)

Elisabeth Lutyens, one of the first and most important English composers to adopt 12-note techniques, was the daughter of the architect Sir Edwin Lutyens. She studied composition at the Royal College of Music and the Paris Conservatoire. Though at first she worked in a late romantic style, she soon realized that her true idiom lay in serialism, and with typical decisiveness discarded fifty of her early works. An abrasive character, she dismissed the prevalent fashions in English composition as 'cow-pat music', and spent much of her time until the late 1950s in artistic isolation. Her works include six chamber concertos (1939–45), more than two hundred radio scores (including collaborations with Dylan Thomas and Louis MacNeice), and an opera *Time Off? Not the Ghost of a Chance* (1972), a virtuoso collage of music, pre-recorded tapes, dance and speech. But her greatest gifts were as a miniaturist in the manner of Webern and in the setting of words (usually for small choirs), tackling texts which range from Chaucer to Stevie Smith, and include African poems, letters by Flaubert, Japanese haiku and the writings of Wittgenstein.

Mayotte Magnus is the French-born wife of Jorge Lewinski (no. 134). She took up photography in 1970, winning a major Ilford photographic prize two years later. In recent years she has collaborated with her husband on a series of photographically illustrated books, and has worked for magazines including *Harpers & Queen* and *Fortune*. This portrait was taken for her exhibition 'Women' at the National Portrait Gallery in 1977, and shows Lutyens at her home in North London in the year of the first production of the ritualistic drama *Isis and Osiris*, in a composition of hieratic stylization.

139

Samuel Beckett born 1906

Paul Joyce born 1944

Platinum print, signed, inscribed and dated on the mount, 1979
24.4 × 24.1 (9⅝ × 9½)
Purchased from the photographer, 1980 (P157)

The leading protagonist of the Theatre of the Absurd and dramatic minimalism, Beckett was born in Foxrock near Dublin, but has lived in France since the 1930s. He was the friend and, to an extent, spiritual heir of James Joyce. Much of his work – novels, short stories and plays – was first written in French, but he is one of the most controversial figures on the English literary scene. His trilogy of novels *Molloy* (1951), *Malone Dies* (1958) and *The Unnameable* (1960) are all desolate interior monologues, occasionally relieved by flashes of last-ditch humour. This mood of tentative despair had its first and fullest dramatic expression in *Waiting for Godot* (1955), in which the two tramps Estragon and Vladimir endlessly wait for the mysterious Godot. Each act ends with the interchange: 'Well, shall we go?' 'Yes, let's go', and the stage direction 'They do not move'. Late plays have shown an increasing minimalism: *Come and Go* (1966) is a 'dramaticule' of 121 words; *Breath* (1969) lasts only 30 seconds, and begins with the cry of a newborn baby and ends with the final gasp of a dying man; in *Not I* (1973) only a disembodied mouth is illuminated on stage, to deliver its fragmentary monologue.

Paul Joyce had his first exhibition in Nottingham in 1974, and this was followed by 'Elders' at the National Portrait Gallery in 1978. He has also written and directed stage plays and several film profiles, among them studies of the film-makers John Huston and Nicolas Roeg (no. 144). In his portraits his usual habit is to place his sitters in their natural environment, without any attempt at symbolism. However, in the case of Beckett, whom he photographed during a lunch break from rehearsals of his own production of his *Happy Days* at the Royal Court Theatre, London, he has chosen a location generally evocative of his work, and perhaps more specifically of the play *Endgame* (1958), in which the blind man Hamm sits in an empty room flanked by two old people, his 'accursed progenitors', who spend the action in dustbins.

140

Richard Rogers born 1933

Michael Birt born 1953

Bromide print, signed, inscribed and dated, 15 October 1982
25.4 × 25.8 (10 × 10⅛)
Purchased from the photographer, 1984 (X23476)

Born in Florence of British parents, the architect Richard Rogers studied in London and at Yale. In the 1960s he worked for a time with Norman Foster, and in 1970 formed a partnership with Renzo Piano, with offices in London, Paris and Genoa. His name is pre-eminently associated with the Hi-Tech style, and, though he has created some of the most visually exciting buildings in the world, he rightly sees advanced technology not as a stylistic end in itself, but, rather, as a way of 'solving long-term social and ecological problems'. This ideal is embodied in the calculated functionalism of his buildings. A charismatic figure, who can charm clients and motivate a team with little apparent effort, his Centre Georges Pompidou, Paris (completed 1977) and the headquarters building for Lloyds of London (1986) have proved that modernist architecture is capable of catching and holding the imagination of the general public.

Michael Birt, was born in Merseyside, studied in Bournemouth, and since 1976 has worked in London as a freelance portrait photographer. 'A serious photographer who is prepared to concentrate on clear and quiet portraits' (Norman Parkinson), Birt has been employed by a wide range of magazines, including *The Tatler*, *New Society*, *Ritz*, and *Woman's Journal*. *Famed*, an anthology of his work, appeared in 1988. He photographed Richard Rogers at his former offices in Princes Place, Holland Park. The sitter considers this portrait 'a refreshingly straightforward, unmannered study, full of shadows and wrinkles', but technically it is something of a *tour-de-force* in the way in which Birt overcomes the problems posed by double back-lighting.

141

Francis Bacon born 1909

Bruce Bernard born 1928

Bromide print, 1984
45.1 × 30.7 (17¾ × 12)
Given by the photographer, 1986 (x27588)

In speaking of himself Bacon uses the phrase 'exhilarated despair. . . . one's basic nature is totally without hope, and yet the nervous system is made out of optimistic stuff'. Undoubtedly the paintings which have brought him international recognition use a vocabulary of despair – mutilated bodies, agonized faces, stripped interiors – but the tone is vital: vibrant colour, intense physicality, and, at times, an illusion of silvery, glittering movement which comes from the cinema. In his reworking of a great portrait by Velázquez, Pope Innocent X takes on the wounded mask of the nurse in Eisenstein's *Battleship Potemkin*. Bacon was brought up in Ireland, and, after a brief period in Paris and Berlin, came to London and worked in the 1930s as an interior designer. Although he had no formal training, he turned increasingly to painting, and from 1944 and the completion of *Three Studies for a Crucifixion* (Tate Gallery, London), it became his exclusive *métier*.

Like his friend Bacon, Bruce Bernard, journalist, writer on art and photography, and occasional photographer, is no stranger to the bars and clubs of Soho. Both men were close friends of the legendary John Deakin (see no. 123), who taught Bernard not only 'how to use a Rolleiflex' but 'more importantly . . . that photography is a black and white business and not a grey affair'. Bernard photographed Bacon in his studio, melancholy, the available surfaces daubed with paint, behind him a bare room and a familiar motif from his paintings, a naked light-bulb hanging on its despairing flex.

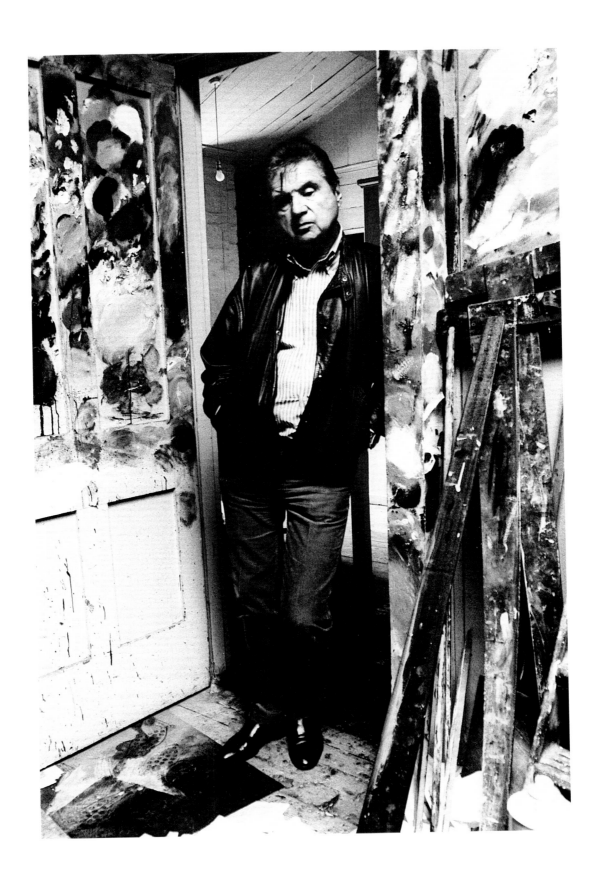

142

John Davan Sainsbury, Baron Sainsbury of Preston Candover
born 1927

Denis Waugh born 1942

C-type colour print, signed by the photographer, 1984
30.4 × 39.4 (12 × 15½)
Given by the photographer, 1986 (X32372)

Lord Sainsbury, eldest son of Lord Sainsbury of Drury Lane, has been chairman of the family firm of J. Sainsbury PLC (whose supermarkets occupy a commanding position in British retail trading) since 1969. He married the ballerina Anya Linden in 1963, and together they have been notable supporters of the arts in Britain. Lord Sainsbury is chairman of the Royal Opera House, London, with which he has long been associated, and has served as a Trustee of the Tate Gallery, the Westminster Abbey Trust, and the National Gallery, to which, with his brothers Simon and Timothy, he has donated a new wing, designed by the American architect Robert Venturi.

Denis Waugh came to London from New Zealand in 1967 to take up a job as art director and photographer, but in 1968 he was chosen as one of the first two students on the Royal College of Art's new course in still photography. Since leaving the College he has travelled, taught at several London colleges, and undertaken an increasing number of commissions. He photographed Lord Sainsbury for *Fortune* magazine at Stamford House, the headquarters of Sainsbury's, with (left) Bridget Riley's painting *Persephone* (1969) and (right) Brendan Neiland's *Building Projection* (1977). Both these works were later given by Lord and Lady Sainsbury's Linbury Trust to the Contemporary Art Society, and are now in the Grundy Art Gallery, Blackpool.

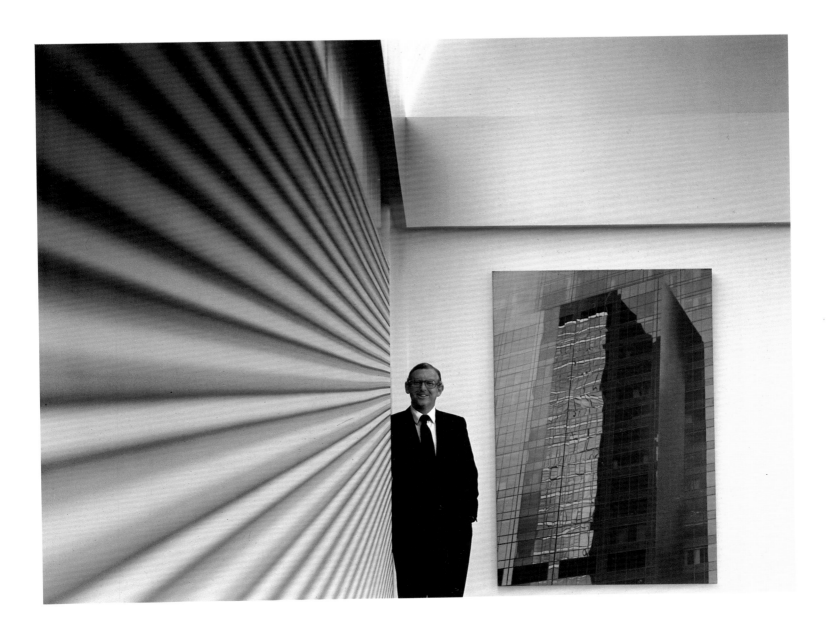

143

Sting born 1951

Terry O'Neill born 1938

Bromide print, 1984
35.5 × 35.7 (14 × 14)
Given by the photographer, 1985 (x322001)

The son of a Geordie milkman, Gordon Sumner took the nickname Sting, which was to become his stage name, from a wasp-striped tee-shirt which he once wore. After dropping out of the University of Warwick he became a primary school teacher, playing in bands in his spare time. In 1977 he became lead singer of the phenomenally successful group Police, writing all their hit songs. The album *Synchronicity* (1983), influenced by the works of Arthur Koestler and Jung, sold over seven million copies. He made his film début in *Quadrophenia* (1978), and has subsequently appeared in *Brimstone and Treacle* (1982), *Dune* (1984), and *Plenty* (1985). He is teetotal with a keep-fit mentality and social conscience. A proportion of the earnings of Police went to help youth clubs, and most recently he has been working with all the resources at the command of an international star to save the rain forests of Brazil.

Terry O'Neill was born in East London, and was a professional jazz musician by the age of fourteen. He took up photography at the age of twenty, and within nine months began working for *The Daily Sketch*. Three years later he became a freelance, and has since ranged the world photographing celebrities. He was for a time married to the American film actress Faye Dunaway. His work has appeared in many magazines, including *Life*, *Time*, *The Observer*, *The Sunday Times* and *Première*, and he published a collection of his work, 'Legends', in 1985. Many of his portraits are coloured by the instinctive spontaneity of the reportage photographer, but he portrays Sting posed in self-consciously pugnacious guise.

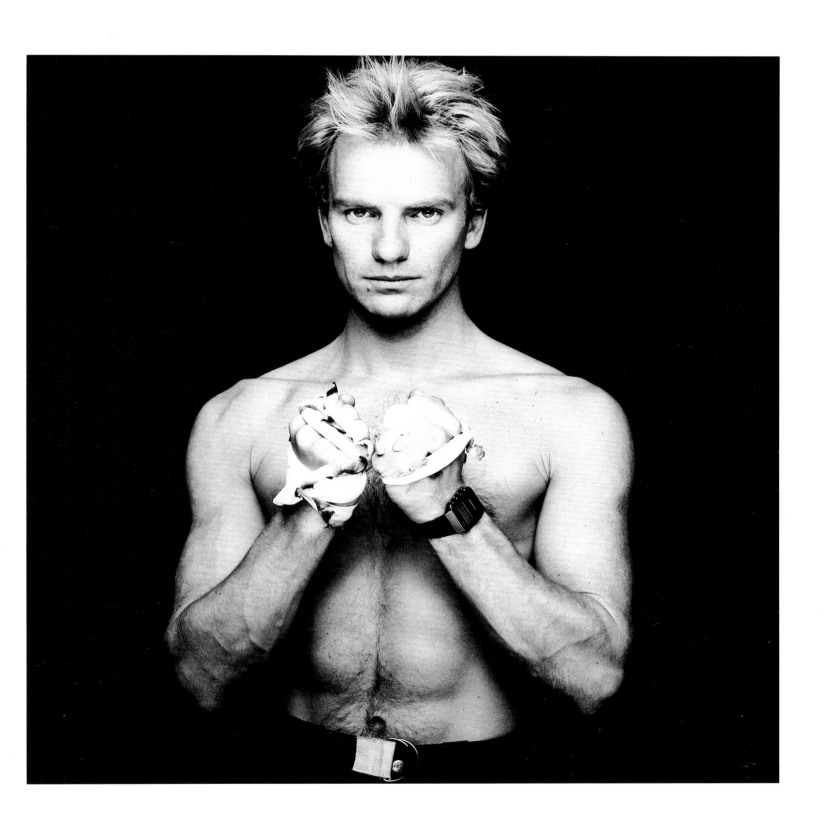

144

Nicolas Roeg born 1928

Dudley Reed born 1946

Bromide print, signed and dated, 1985
31.6 × 26.5 (12⅜ × 10⅜)
Purchased from the photographer, 1989 (x32172)

Nic Roeg began his film career as a cinematographer, working on *The System* (1963), *The Caretaker* (1966), *Far from the Madding Crowd* (1968), and many other films. He is now recognized as one of Britain's leading modernist directors, whose enigmatic, shocking and highly original films are always controversial and rarely commercial. His first was *Performance* (1970), starring Mick Jagger, which he co-directed with Donald Cammell. This was followed by *Walkabout*, set in Australia (1971), the psychological thriller *Don't Look Now* (1973) and *The Man Who Fell to Earth* (1976). Recent works include *Castaway*, *Track 29* and a section of *Aria*. He is a meticulous craftsman, with a cameraman's eye for a sumptuous shot, who has done much to establish the acting careers of Jenny Agutter, Donald Sutherland and David Bowie. He has also made some of the most inventive of commercials – 'when I do a commercial, it's not just a technical exercise done for the money. Interesting things happen' – including *Tombstone*, the first to publicize the threat of AIDS.

Dudley Reed studied at Guildford School of Art (1968–71), before working as assistant to Adrian Flowers and Lester Bookbinder. He began freelancing in 1974, and has worked for *The Tatler*, American *Vogue*, *GQ*, and *The Sunday Times*. He had his first one-man show in 1985, and his work was included in 'Twenty for Today' (1986) at the National Portrait Gallery. He photographed Roeg in company with David Hockney's photographic collage ('joiner') *Nude 17th June 1984*. This is a portrait of Roeg's second wife the actress Theresa Russell, and consciously imitates Tom Kelly's pin-up portrait photographs of Marilyn Monroe. It was commissioned by Roeg for his film *Insignificance* (1985), in which his wife plays the leading role of Monroe.

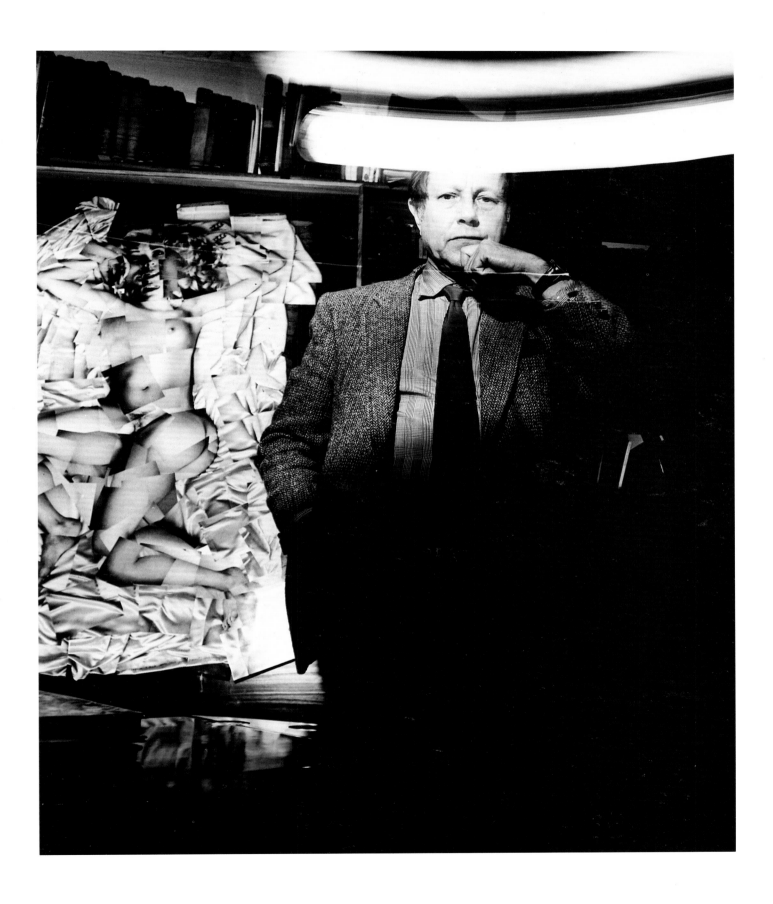

145

Bruce Oldfield born 1950

John Swannell born 1946

Bromide print, 1985
38.4 × 30.4 (15 × 11⅞)
Given by the photographer, 1986 (X27936)

One of Britain's leading fashion designers, and a favourite of the Princess of Wales (no. 149), Oldfield's reputation is based on his ability to create glamorous, sophisticated clothes which are also practical. He was brought up in a Dr Barnardo's children's home, and after a spell at teacher-training college, went to St Martin's College of Art, London. After an unsuccessful début in New York, he worked freelance, with assignments in Paris designing shoes for Yves St Laurent and furs for Dior. He opened his own salon in Knightsbridge in 1975 with a bank loan of £1,000. There he produced designer collections of high fashion clothes for the United Kingdom and overseas market. Six years later he began making couture clothes for individual clients, who now include members of the Royal Family, Joan Collins (no. 122), Charlotte Rampling (no. 136) and Bianca Jagger. He opened the first Bruce Oldfield retail shop selling ready-to-wear and couture in 1984.

John Swannell left school at sixteen, and worked as a messenger with Keystone Press, as an assistant at Vogue Studios, and subsequently with David Bailey (see no. 149). He went freelance in 1973, and has travelled widely, mainly for fashion magazines, including *Vogue*. His work has appeared in *Harper's & Queen*, *The Tatler*, *The Sunday Telegraph*, *The Sunday Times*, *Interview* and *Ritz*. He has published *Fine Lines* (1982) and *The Naked Landscape* (1986). In this cool and elegant portrait of Oldfield the strong diagonal of the sitter's back and the cropping at the hairline concentrate attention on Oldfield's frankly assessing stare.

146

Sir Clive Marles Sinclair born 1940

Simon Lewis born 1957

Bromide print, signed, inscribed and dated on the mount, 1985
41 × 28 (16⅛ × 11)
Purchased, 1988 (P365)

Latest in the line of great British inventors, Sir Clive Sinclair is a retiring mathematical genius, whose creations – the pocket calculator, the low-cost digital watch, the miniature television set, and the cheap home computer – have revolutionized popular attitudes to technology, and changed the lives of millions. The son of a mechanical engineer, he worked first as a technical journalist, and in 1962 founded his own company selling build-your-own-radio kits by mail order. He is now chairman of Sinclair Research Ltd, with a multi-million-pound turnover, and also Chairman of MENSA. Only his electric car, the Sinclair C5, has so far proved a failure, and Sir Clive has quickly moved on, to the problems of improving the silicon chip.

The London-based Simon Lewis first studied graphic design, before becoming a freelance photographer in 1983. He photographed Sir Clive for his series *The Essential Britain*, on which he is working with the writer Tadgh O'Seaghdha. In a portrait of steely brilliance Sir Clive holds his favourite circular slide rule – hardly high technology – but used here emblematically as the index of a numerate mind.

147

The Rt. Hon. Margaret Hilda Roberts, Mrs Denis Thatcher
born 1925

Brian Griffin born 1948

Bromide print, 1986
22.8 × 22.8 (9 × 9)
Purchased from the photographer, 1989 (P415)

Member of Parliament for Finchley since 1959, Margaret Thatcher was elected Leader of the Conservative Party in 1975, in succession to Edward Heath, and has been Prime Minister since 1979. She has now spent a third of her parliamentary career as premier. Born in Grantham, Lincolnshire, the daughter of a grocer, she read chemistry at Oxford, and, after four years as a research chemist, was called to the Bar in 1954. She first achieved government office in 1961, and between 1970 and 1974 was Secretary of State for Education and Science. A conviction politician of the greatest energy and determination, she is the most controversial figure in modern British politics. With her faith in the free-market economy and the enterprise of the individual, she has brought about wide-ranging social and economic changes, the full significance of which remains to be assessed.

Brian Griffin, photographer, poet, performance-artist and self-publicist, was born in Birmingham, and, after working for some years in the engineering industry, studied photography at Manchester Polytechnic (1969–72). Highly prolific, his work has been seen in many exhibitions in Britain and abroad, including 'Twenty for Today' (1986) and a one-man show 'Work' (1989) at the National Portrait Gallery, and in numerous magazines. Above all, however, he is associated with *Management Today*, and his series of portraits of businessmen. The best of these have a surreal, almost subversive quality, which is, however, shrewdly managed, and never allowed to undermine his subjects. This portrait of the Prime Minister in hard hat is characteristic. It was commissioned by Rosehaugh Stanhope Developments PLC as part of a series of photographs of management and workers commemorating their massive Broadgate development scheme in London.

148

Harold Evans born 1928 and Tina Brown born 1953, 'The Editors'

David Buckland born 1949

Cibachrome print, signed, inscribed and dated on the reverse by the photographer:
The Editors Buckland. Aug 87/$\frac{1}{10}$ *Printed August 88*; 1987
99.1 × 76.2 (39 × 30)
Purchased from the photographer, 1988 (P380)

Harold Evans and his wife Tina Brown are two of the most successful and original editors today. Evans made his reputation on northern newspapers, before moving south to *The Sunday Times* in 1966. He was editor there from 1967–81, in arguably its greatest days, moving to *The Times* in 1981. Tina Brown won the Catherine Pakenham Prize for most promising female journalist in 1973, and was Young Journalist of the Year for 1978. As editor of *The Tatler* (1979–83) she was a triumphant success, bringing wit and bite to a tired favourite, and tripling its circulation in the process. In 1981 she married Harold Evans, and the pair now work in New York, he as editor-in-chief of *Traveler Magazine* and vice-president of Weidenfeld and Nicolson, she as editor-in-chief of *Vanity Fair*, where she has again worked the *Tatler* miracle.

David Buckland studied at the London College of Printing (1967–70) and held a Northern Arts fellowship in photography (1971–3). He has taught at the Royal College of Art in London, and in addition to his photographic work, has designed sets and costumes for Ballet Rambert and the London Contemporary Dance Theatre. He has had numerous one-man shows in England and abroad, and his work was included in 'Twenty for Today' (1986) at the National Portrait Gallery. His large portraits have a mythic quality, and he undoubtedly sees his sitters as types in a pageant of contemporary society. For Evans and Brown he creates a glowing image of international celebrity, and he has spoken of the photograph's 'Hollywood colour'. It was taken in a New York studio, the back-drop of the Manhattan skyline supplied by front-projection, a film technique which he uses to dramatic effect in his still photography.

149

Her Royal Highness The Princess of Wales born 1961

David Bailey born 1938

Bromide print, 1988
50.4 × 37.3 (19⅞ × 14¾)
Commissioned by the Trustees and given by the photographer, 1988 (P397)

Lady Diana Spencer, daughter of the 8th Earl Spencer, married The Prince of Wales in July 1981. The couple have two children, Prince William (born 1982) and Prince Henry (born 1984). Fun-loving, elegant and goodlooking, she makes the perfect foil to her husband. The Princess has been increasingly involved in work for charity, and shows particular interest in children, and in drugs- and AIDS-related causes. In Britain and on her many tours abroad, in private and in public life, she has become a leader of fashion with an assured style of her own.

David Bailey was born in East London, left school aged fifteen, and, after national service in Singapore and Malaya, began work as assistant to the fashion photographer John French and produced his first work for *Vogue* in 1960. He starred in a series of television advertisements for Olympus, and as a result he is is now the most famous living British photographer. To both fashion and portrait photography he has brought qualities of fantasy and invention, which can make him seem eclectic. In his non-commissioned work he has revealed an endless creative fascination with the female body. He has published numerous books of his work, including *David Bailey's Box of Pin-ups* (1965), *Goodbye Baby & Amen* (1969), *Beady Minces* (1973) and *Trouble and Strife* (1980), which appeared in America as *Mrs David Bailey*. For his portrait of the Princess he takes an uncharacteristically straightforward approach, and produces a classically elegant study in black and white.

150

Anita Roddick born 1942

Trevor Leighton born 1957

C-type colour print, signed, 1989
(39.4 × 39.4 (15½ × 15½)
Given by the photographer, 1989 (X33001)

Anita Roddick presides over a cottage-industry which has grown into a multi-million pound business. The daughter of Italian immigrant parents who ran a café in Little-hampton, Anita Parella campaigned as a teenager for CND and Freedom from Hunger, and later worked on a kibbutz, a period which she describes as 'the benchmark of my life'. While working for an international charity she noticed that the peoples of the Third World countries used natural products on their skin. From this sprang the idea of the first Body Shop, which opened in Brighton in 1975, selling cosmetics made only from natural ingredients, involving no suffering to animals, packed in refillable containers and wrapped in recycled paper. With the help of her husband Gordon Roddick, the Body Shops have now grown into a franchised chain, and are the retail flagship of the environmentalist movement, in which she takes a leading role.

Trevor Leighton studied at Carlisle College of Art and Design, and for two years played guitar in a punk rock band. He worked first as a photographer in Newcastle, and opened a studio in London in 1981. He specializes in fashion and portraits, and his work has appeared in *The Tatler*, *Woman's Journal*, *The Observer* and *The Independent* magazine. He exhibited in 'Twenty for Today' (1986) at the National Portrait Gallery. For portraits he generally favours tight-cropped head shots, but he occasionally, as here, works at three-quarter-length; a format which allows greater scope for his evident fantasy. He portrays Anita Roddick in the clothes she wears for her expeditions to find new products, cradling in her hands a pat of mud, in witty allusion to her concern for all things natural, a 'friend of the earth'.

GLOSSARY

● **Albumen print** A print made using albumen paper, an improvement on salted paper (see *Salt print*), introduced by L.D. Blanquart-Evrard in 1850, which became the main medium for photographic printing throughout the nineteenth century. It was a very thin paper coated with a layer of egg white containing salt, and sensitized with silver nitrate solution. Prints made with it have a slight surface sheen, and were often toned with a gold solution, giving a rich purplish-brown colour to the image. The whites tend to yellow with age.

● **Ambrotype** A collodion positive. In 1851 Frederick Scott Archer published the first account of the wet collodion process, which revolutionized photography. In this a glass plate was coated with prepared collodion (pyroxyline dissolved in a mixture of alcohol and ether), and then immersed in silver nitrate solution. This was then exposed in the camera, and the negative developed while the plate was still wet. Between the mid-1850s and the 1880s wet collodion negatives were virtually the only type in use. Around 1852 it was found that such negatives, developed and bleached, appeared as positives when set against a dark ground and seen in reflected light. They were very rapidly taken up by commercial studios as cheap imitations of daguerreotypes (*q.v.*), and known as ambrotypes.

● **Autochrome** The product of the first commercially available colour process, invented by Auguste and Louis Lumière, patented in 1904, and first marketed in 1907. A glass plate was covered with microscopic grains of potato starch, dyed red, green and blue, producing a random pattern of coloured dots, and then coated with a pan-chromatic gelatin-silver emulsion. This plate was exposed in the camera, with the glass side towards the lens, so that the grains of starch acted as a colour filter on the light before it reached the emulsion. There followed a complex reversal development process to produce a positive image on the plate, which was then covered with another piece of glass to protect it. The resulting transparency had a grainy texture which made the technique popular with photographers seeking an Impressionistic effect. Autochromes were viewed either by projection or in a special viewer. Lumière Autochrome plates went out of production in the 1930s.

● **Bromide print** A print made with paper sensitized with silver bromide. Bromide paper was invented by Peter Mawdesley in 1873, and first produced commercially c.1880. It became the most popular and widely used photographic paper in the twentieth century, produced in a variety of finishes – matt, semi-matt and glossy. In bromide prints the blacks have a cold, green-grey quality.

● **Cabinet print** A format, introduced in 1865 and surviving until c.1910, similar to the carte-de-visite (*q.v.*), but larger in size, measuring 16.5 × 10.8cm. (6½ × 4¼in.). It was originally devised for landscape subjects, but soon taken up by portrait photographers for a market which was satiated with cartes-de-visite.

● **Calotype** A process discovered by W.H. Fox Talbot in 1840, and patented by him in the following year. Strictly speaking it is a paper negative process, but the name was soon applied to the positives produced by its means. High-quality writing paper was sensitized with potassium iodide and silver nitrate solutions and exposed in the camera. Exposure took between 10 and 60 seconds in sunlight. After exposure the negative was developed, fixed, washed, and dried, and waxed to give translucency. It was then used to print on to salted paper (see *Salt print*), and many prints could be made from the one negative. The calotype formed the basis of later photographic developments, but in its time it never attained the commercial success of the daguerreotype. It was, however, popular with amateur photographers, who favoured the process for architectural and landscape subjects.

● **Carbon print** The product of a photo-mechanical process invented by A.L. Poitevin in 1855, and popularized in the 1860s. In this a sheet of paper, coated with gelatin containing pigment (usually carbon black) and potassium bichromate, was exposed by daylight under a negative. To the extent that light was admitted to the surface by the negative the gelatin hardened. After exposure the paper was washed, removing the more soluble gelatin, and the hardened residue thus produced the image. Carbon prints are permanent, showing no signs of fading, and were very popular for commercial editions of photographs and for book illustrations. They may be either matt or glossy, and, when viewed in raking light, the surface has a relief effect.

● **Carte-de-visite** A format of photograph which became hugely popular around 1860, and which remained in use until c.1900. It consisted of a print mounted on a sturdy card measuring about 10.1 × 6.3cm (4 × 2½in.), and usually printed on the reverse with the photographer's or publisher's name and address. Cartes were cheap, since up to six exposures could be obtained from a single large-format negative measuring 25.4 × 20.3cm. (10 × 8in.).

● **Daguerreotype** The first photographic process to be publicly announced, invented in 1839 by the Frenchman L.J.M. Daguerre. It comprised a copper plate with a highly polished silver surface sensitized by iodine fumes, exposed in a camera, and the image developed by fuming over warmed mercury. The resulting image is, of course, reversed, and unique. Easily damaged by touching, daguerreotypes were mounted behind glass in decorative cases. As the image is formed from a whitish deposit on a shiny silver surface, the daguerreotype, if it is to be seen properly, must be held so as to reflect a dark ground. As a medium it was especially favoured by portrait photographers.

● **Gum platinum print** A print produced by a combination of two processes. A light platinum print (*q.v.*), was made first, and this was then sensitized with a gum bichromate mixture, and re-exposed under the same negative. This method enriched the blacks of the platinum print, and gave great tonal density.

● **Panel print** A format similar to the carte-de-visite (*q.v.*) and the cabinet print (*q.v.*), but measuring c.30 × 18.5cm. (11¾ × 7¼in.).

● **Photogravure** The product of a photo-mechanical printing process invented by W.H. Fox Talbot in 1858, and which came into commercial use c.1880. It was in essence an etching process with affinities with the carbon process (see *Carbon print*), and was used for high quality reproduction of art photographs in the 1890s and 1900s.

● **Platinum print** A print made with paper sensitized with iron-salts (but no silver) and a platinum compound (a process invented by William Willis in 1873). The exposed print was developed in a solution of potassium oxalate, and the resulting image formed from platinum deposited on the paper. Prints produced in this way (sometimes known as platinotypes) are permanent and have a matt surface. They are especially rich and velvety in tone, with intense blacks and silvery-grey middle tones. The popularity of the process declined with the dramatic rise in the price of platinum after 1918.

● **Salt print** A print made using salted paper: high quality writing paper sensitized by immersion in a solution of common salt, and then floated on a bath of silver nitrate. Paper thus treated was used by W.H. Fox Talbot for his 'photogenic drawings' as early as 1834, and later to print from calotype and other negatives. Salt prints were superseded in the 1850s by albumen prints (*q.v.*) but had something of a revival in the 1890s and early 1900s. They have a matt surface, and may be toned with a gold solution to give a rich purple-brown image. Though stable to light, they are susceptible to attack by airborne pollutants, and are often faded to yellow at the margins.

● **Silver print or gelatin silver print** Although strictly the term silver print may be applied to any photographic print made with paper in which the emulsion is sensitized with one of the silver compounds, the term now denotes prints made with gelatin silver halide papers, in use from the 1880s to the present day.

INDEX OF SITTERS

INDEX OF PHOTOGRAPHERS

Contents

SIGNS AND MEANING
IN THE CINEMA

 Publishing

This edition first published in 1998
by the British Film Institute,
21 Stephen St, London W1P 2LN

The British Film Institute exists to promote appreciation, enjoyment, protection
and development of moving image culture in and throughout the whole of the
United Kingdom. Its activities include the National Film and Television Archive;
the National Film Theatre; the Museum of the Moving Image; the London Film
Festival; the production and distribution of film and video; funding and sup-
port for regional activities; Library and Information Services; Stills, Posters and
Designs; Research; Publishing and Education; and the monthly *Sight and Sound*
magazine.

First published by Secker & Warburg in association
with the British Film Institute 1969
third edition, revised and enlarged 1972
fourth edition, revised and enlarged 1998

Cover design: Swerlybird Art & Design

Typeset by Fakenham Photosetting Limited, Fakenham, Norfolk

Printed in Great Britain by St Edmundsbury Press, Bury St Edmunds

British Library Cataloguing-in-Publication Data
A catalogue record for this book is available from the British Library
ISBN 0–85170–646–0 hbk
ISBN 0–85170–647–9 pbk

Introduction

The general purpose of this book is to suggest a number of avenues by which the outstanding problems of film aesthetics might be fruitfully approached. My guiding principle has been that the study of film does not necessarily have to take place in a world of its own, a closed and idiosyncratic universe of discourse from which all alien concepts and methods are expelled. The study of film must keep pace with and be responsive to changes and developments in the study of other media, other arts, other modes of communication and expression. For much too long film aesthetics and film criticism, in the Anglo-Saxon countries at least, have been privileged zones, private reserves in which thought has developed along its own lines, haphazardly, irrespective of what goes on in the larger realm of ideas. Writers about the cinema have felt free to talk about film language as if linguists did not exist and to discuss Eisenstein's theory of montage in blissful ignorance of the Marxist concept of dialectic.

Breadth of view is all the more important because, by right, film aesthetics occupies a central place in the study of aesthetics in general. In the first place, the cinema is an entirely new art, not yet so much as a hundred years old. This is an unprecedented challenge to aesthetics; it is difficult to think of an event so momentous as the emergence of a new art: an unprecedented challenge and an astonishing opportunity. Lumière and Méliès achieved, almost within our lifetime, what Orpheus and Tubal-Cain have been revered for throughout the millennia, the mythical founders of the art of music, ancient, remote and awe-inspiring. Secondly, the cinema is not simply a new art; it is also an art which combines and incorporates others, which operates on different sensory bands, different channels, using different codes and modes of expression. It poses in the most acute form the problem of the relationship between the different arts, their similarities and differences, the possibilities of translation and transcription: all the questions asked of aesthetics by the Wagnerian notion of the *Gesamtkunstwerk* and the Brechtian critique of Wagner, questions which send us back to the theory of synesthesia, to Lessing's *Laocoön* and Baudelaire's *correspondances*.

Yet the impact of the cinema on aesthetics has been almost nil. Universities still continue to parade a derelict phantom of aesthetics, robbed of immediacy and failing in energy, paralysed by the enormity of the challenge which has been thrown down. Many writers on aesthetics have gone so far as to refuse the cinema any status whatever; they have averted their gaze and returned to their customary pursuits. Various attempts have been made to renovate aesthetics, but these have sprung mostly from contact with other academic disciplines – psychological testing, statistical sociology, linguistic philosophy – rather than from developments in

1

Lumière poster.

Georges Méliès.

the arts themselves. It is incredible that writers on aesthetics have not seized on the cinema with enthusiasm. Perhaps, at times, Pudovkin, Eisenstein or Welles may be mentioned but, on the whole, there is a depressing ignorance, even unconcern.

In the 1920s the Russians – Kuleshov, Pudovkin, Eisenstein – managed to force themselves on the attention. The situation in which they worked, of course, was unique. The Bolshevik Revolution had swept away and destroyed the old order in education as in everything else; academic conservatism was in full-scale retreat. Experts on aesthetics came into close contact with the artistic avant-garde; this was the heyday of Russian Formalism: the collaboration between poets and novelists on the one hand, and literary critics and theorists on the other, is now well known. Indeed, many of the leading critics were also poets and novelists. The cinema was obviously affected by this. Many of the Formalists – the novelist and literary theorist Tynyanov, for instance – also worked in the cinema as scriptwriters. With the breakdown of the old academic system, there was not a slackening of intellectual pace, but actually an intensification. There was the crystallisation of an authentic intelligentsia, rather than an academic hierarchy: like all intelligentsias, it was built round a revival of serious journalism and polemic. Literary theorists, such as Victor Shklovsky in particular, issued manifestos, wrote broadsides, collaborated enthusiastically on magazines like *Lef.* This was, of course, only an interim period: a new kind of heavy academicism soon descended.

It is possible to dismiss Eisenstein as an auto-didact, to slight him for his lack of serious academic training – or rather training in the wrong subject – but few are now willing to take this risk. It is quite clear that, despite his own lack of rigour and the difficult circumstances in which he worked, Eisenstein was the first, and probably still the most important, major theorist of the cinema. The main task now is to reassess his voluminous writings, to insert them into a critical frame of reference and to sift the central problematic and conceptual apparatus from the alarms and diversions. Of course, the first wave of popular works on film aesthetics, in almost every country, shows the very powerful influence Eisenstein exerted, in part, evidently, because of his prestige as a director. The key idea, which seized the imagination, was the concept of montage. There are any number of pedestrian expositions of Eisenstein's views about this. And, of course, a counter-current has reacted against this orthodoxy, stressing the sequence instead of the shot and the moving as against the stationary camera. It seems to me that what is needed now is not an outright rejection of Eisenstein's theories but a critical reinvestigation of them, a recognition of their value, but an attempt to see them in a new light, not as the tablets of the law, but as situated in a complex movement of thought, both that of Eisenstein himself and that of the cultural milieu in which he worked.

It is not possible to be definitive about Eisenstein at this stage. The 1920s in the Soviet Union is an extraordinarily complex period – not only complex but startlingly and breathtakingly original. The huge political and social upheavals of the period produced an unprecedented situation in the arts, in culture in general, in the movement of thought and ideology. In the section on Eisenstein in this book, I have tried to shift the terrain of discussion and to indicate, in broad outlines, what I take to be the main drift of Eisenstein's thought and to locate it in its setting. But all this is necessarily very provisional.

3

Russian and American bourgeoisie: (top) October, *(above)* All that Heaven Allows.

4

Italian peplum and Japanese science fiction: (top) Maciste the Mighty, *(above)* Rodan.

Vienna in Hollywood: Wilder's The Emperor Waltz.

The main stumbling-block for film aesthetics, however, has not been Eisenstein, but Hollywood. Eisenstein, as we have seen, was part of a general movement which included not only film directors, but also poets, painters and architects. It is relatively easy to assimilate the Russian cinema of the 1920s into the normal frame of reference of art history. Hollywood, on the other hand, is a completely different kind of phenomenon, much more forbidding, much more challenging. There is no difficulty in talking about Eisenstein in the same breath as a poet like Mayakovsky, a painter like Malevich, or a theatre director like Stanislavsky. But John Ford or Raoul Walsh? The initial reaction, as we well know, was to damn Hollywood completely, to see it as a threat to civilised values and sensibilities. The extent of the panic can be seen by the way in which the most bourgeois critics and theorists manage to find *Battleship Potemkin* far preferable to any Metro-Goldwyn-Mayer musical or Warner Bros. thriller. They actually prefer the depiction of the bourgeoisie in *Strike* or *October*, hideous, bloated and cruel, to its depiction in the movies of Vincente Minnelli or Douglas Sirk, which appals them much more. This attitude seems to have very strong roots. It is not surprising that Jean Domarchi gave as his title to a review of *Brigadoon*: 'Marx would have liked Minnelli.' (It is possible to doubt whether *Brigadoon* is the most apposite choice, but it is not hard to see Domarchi's point.)

Of course, the reaction to Hollywood was always exaggerated. There are two points which need to be separated out. Firstly, Hollywood is by no means monolithically different; the American cinema is not utterly and irretrievably other. To begin with, all cinemas are commercial; producers and financiers act

6

Terence Fisher's The Mummy.

from the same motives everywhere. The main difference about American films is that they have succeeded in capturing the foreign as well as the home market. We only see the tip of the French, Italian or Japanese cinema, or East European too, for that matter, but we see a much more broad slab of Hollywood. When we do see more of a foreign cinema, it is usually dismissed in just the same way as American movies: Italian peplums or Japanese science fiction, for example. Then, a very large number of American directors actually worked in Europe first: Hitchcock is the most obvious example, but we should also consider Sirk, Siodmak, Lang, Ulmer. Tourneur studied in Paris, Welles in Ireland, Siegel in England. There is a whole 'Viennese' school of Hollywood directors. One of the more extraordinary convergences of Viennese culture was that between Sternberg

and Neutra, the architect of the Sternberg house in San Fernando Valley. The whole battle for and against ornament, which exploded in Vienna, is expressed in the work of these two Viennese in exile.

In the section of this book on the auteur theory, I have tried to outline the theoretical basis for a critical investigation and assessment of the American cinema, as a model of the commercial cinema. I have restricted myself to American examples – Ford and Hawks – but I cannot see any reason in principle why the auteur theory should not be applied to the European cinema. The British cinema, for instance, is in obvious need of reinvestigation; we can see the beginnings of a reassessment in the French studies of Terence Fisher and O. O. Green's *Movie* article on Michael Powell. The same is true for the Italian and French cinema. It is very striking, for instance, how Godard and Truffaut are still treated with widespread critical respect, even indulgence, whereas we hear very little today about Chabrol, who seems to have evaporated in the same magical way that was once presumed to have overcome Hitchcock and Lang. Our ideas about the Japanese cinema must be extraordinarily distorted and blinkered.

I do not in any way want to suggest that it is only possible to be an auteur in the popular cinema. It is simply that working for a mass audience has its advantages as well as its drawbacks, in the same way, *mutatis mutandis*, that working for a limited audience of *cognoscenti* does. Erwin Panofsky put the point very forcefully:

> While it is true that commercial art is always in danger of ending up as a prostitute, it is equally true that non-commercial art is always in danger of ending up as an old maid. Non-commercial art has given us Seurat's *Grande Jatte* and Shakespeare's sonnets, but also much that is esoteric to the point of incommunicability. Conversely, commercial art has given us much that is vulgar or snobbish (two aspects of the same thing) to the point of loathsomeness, but also Dürer's prints and Shakespeare's plays.

I would not myself use *esoteric* and *vulgar* as the pertinent pair of contraries, but the main gist is clear enough. The reason for constantly stressing the auteur theory is that there is an equally constant, and spontaneous, tendency to exaggerate the significance and value of the art film. Despite all that is fashionable about a taste for horror movies, it is still much less unquestioned than a taste for East European art movies. What has happened is that a determined assault on the citadels of taste has managed to establish the American work of Hitchcock, Hawks, perhaps Fuller, Boetticher, Nicholas Ray. But the main principles of the auteur theory, as opposed to its isolated achievements, have not been established, certainly not outside a very restricted circle.

However, there are even more difficult problems for film aesthetics than those raised by the popular cinema, by Hollywood and Hawks. In Chapter 3 of this book I try to set out some guidelines for a semiology of the cinema, the study of the cinema as a system of signs. The underlying object of this is to force a reinvestigation of what is meant when we talk about the language of film; in what sense is film a language at all. A great deal of work in this field has already been done on the continent of Europe, in France, Italy, Poland, the former Soviet Union. The Anglo-Saxon countries are still comparatively innocent of this. I have tried to combine

an introductory account of the main issues, the main problems which have been found to arise, with an original intervention in the European debate. The problems which semiologists confront can quickly become complex; I fear it is true to say over-complex and pedantic. The important thing is to remember that pedantry is a necessary by-product at a certain stage of any scientific advance; pedantry becomes dangerous when it is conservative.

There are two reasons why semiology is a vital area of study for the aesthetics of film. Firstly, any criticism necessarily depends upon knowing what a text means, being able to read it. Unless we understand the code or mode of expression which permits meaning to exist in the cinema, we are condemned to massive imprecision and nebulosity in film criticism, an unfounded reliance on intuition and momentary impressions. Secondly, it is becoming increasingly evident that any definition of art must be made as part of a theory of semiology. Forty years ago the Russian Formalist critics insisted that the task of literary critics was to study not literature but 'literariness'. This still holds good. The whole drift of modern thought about the arts has been to submerge them in general theories of communication, whether psychological or sociological, to treat works of art like any other text or message and to deny them any specific aesthetic qualities by which they can be distinguished, except of the most banal kind, like primacy of the expressive over the instrumental or simply institutionalisation as art. The great breakthrough in literary theory came with Jakobson's insistence that poetics was a province of linguistics, that there was a poetic function, together with an emotive, conative, phatic function and so on. The same vision of aesthetics as a province of semiology is to be found in the Prague school in general and in the work of Hjelmslev and the Copenhagen school. We must persevere along this road.

Two and a half centuries ago Shaftesbury (1671–1713), the greatest English writer on aesthetics and the semiology of the visual arts, wrote as follows, in his preliminary notes for a treatise on Plastics:

> Remember here [as prefatory] to anticipate the nauseating, the puking, the delicate, tender-stomached, squeamish reader [pseudo- or counter-critic], *delicatulus*. 'Why all this?' and 'can't one taste or relish a picture without this ado?' Thus kicking, spurning at the speculation, investigating, discussion of the *je ne sais quoy*.
> Euge tuum et belle: nam belle hoc excute totum,
> Quid non intus habet?
> So the 'I like,' 'you like,' who can forbear? who does forbear?
> Therefore. Have patience. Wait the tale. Let me unfold etc.

I confidently hope that the '*je ne sais quoy*' is not so deeply entrenched today as it was in Shaftesbury's time and that there is less resistance, more awareness of the importance of speculation, investigation and discussion.

1
Eisenstein's Aesthetics

Even today the Bolshevik Revolution reverberates through our lives. During those heroic days Eisenstein was a student at the Institute of Civil Engineering in Petrograd. He was nineteen years old. He was not prepared for the overthrow of the existing order of society, the collapse of his culture and ideology and the dissolution of his family as his parents departed into exile. The Revolution destroyed him, smashed the co-ordinates of his life, but it also gave him the opportunity to produce himself anew. It swept aside the dismal prospect of a career in engineering, his father's profession, and opened up fresh vistas. In the span of ten years, as we know, Eisenstein was to win world fame, first in the theatre, then in the cinema. In order to achieve this, he was compelled to become an intellectual, to construct for himself a new world-view, a new ideological conception both of society and of art. He had to become a student of aesthetics in order to work in the cinema; he could take nothing for granted. And, of course, we cannot separate the ideas which he developed from the matrix in which they were formed, the matrix of the Bolshevik Revolution.

The ideology of the new order of society was proclaimed as political, revolutionary and scientific, and it was in this image that Eisenstein sought to construct his art and his aesthetics. When, through a chance meeting with a childhood friend, he became a scenery-painter and set-designer at the Proletcult Theatre in Moscow, he quickly recognised that the theatre should be a vehicle for political propaganda, a laboratory for avant-garde experiment and, in the words of his mentor, the actor and director Vsevolod Meyerhold, a machine for acting, manned by technicians, rather than a temple with a priesthood. In this, of course, he was not alone. He identified himself with the artistic avant-garde which he found, a dynamic avant-garde whose ideas were forged, among others, by Meyerhold, the poet and playwright Mayakovsky, the painters Kasimir Malevich and Vladimir Tatlin. Under their leadership the pre-Revolutionary movements of Futurism and Symbolism were reassessed and transformed. Art was to be a branch of production, in the service of the Revolution. Thus Constructivism was born.

Eisenstein's first production in the theatre took place in 1923. The play, an adaptation of a nineteenth-century work by Ostrovsky, was organised not into acts and scenes but as a programme of attractions, as in the music-hall or the circus. The stage was laid out like a gymnasium, with a tightrope, vaulting-horses and parallel bars. Caricatures of Lord Curzon, Marshal Joffre, Fascists and other political figures were lampooned in satirical sketches. There was a parody of a religious procession, with placards reading 'Religion is the opium of the people'.

S. M. Eisenstein.

Clowns and 'noise bands' assaulted the audience, under whose seats fireworks exploded. At one point a screen was unrolled and a film diary projected. It was this travesty of Ostrovsky, produced incongruously enough in the ballroom of the ex-Villa Morossov, which was the occasion for Eisenstein's first theoretical writing, published in the magazine *Lef*. In this manifesto he outlined his concept of the montage of attractions.

At this point the greatest influence exerted on Eisenstein was that of Meyerhold. Meyerhold, already a successful theatre director before the Revolution, emerged after it as a leader of the avant-garde. He was motivated by a deep distaste for the

(Above and opposite) Eisenstein's production of The Wise Man.

methods of Stanislavsky and the Moscow Arts Theatre, later, of course, to be enshrined as the apogee of Stalinist art. Meyerhold's original antipathy sprang from his hostility to Naturalism, part of his inheritance from Symbolism, which until Futurists such as Mayakovsky burst upon the scene was the leading foreign, imported counter-trend to the dominant domestic insistence on civic and social themes, going back from Tolstoy to Belinsky. In 1910 Meyerhold had set up an experimental studio where he worked under the pseudonym Dr Dapertutto, a name taken from the *Tales* of Hoffmann. Hoffmann, and German Romanticism in general, had an enormous influence on Meyerhold and on the whole Russian intelligentsia of the time. (Adaptations of Hoffmann's *Tales* were put on in the theatre by almost every leading Russian director, they were made into ballets, they provided the name for the Serapion Brotherhood, they are alluded to in Mayakovsky's *The Backbone Flute*, they were among the favourite works not only of Meyerhold but also of Fokine and, indeed, Eisenstein.) In particular, Meyerhold drew from Hoffmann (especially *The Princess Brambilla*) an enhanced interest in the *commedia dell'arte*, which he saw as the main element in a theatrical anti-tradition comprising the fantastic, the marvellous, the popular, the folkloric: a non-verbal, stylised, conventional theatre which he could use as a weapon against Stanislavsky's Naturalism and psychologism. The links with the Futurists' adoption of the circus are quite evident: the two trends, towards pantomime and towards acrobatics, quickly merged.

Later a second fault, more obvious to a Constructivist than a Symbolist, was detected in Stanislavsky: his mysticism. Stanislavsky's closest collaborators, Mikhail Chekhov and Sullerzhitsky, were both absorbed in the Russian mystical tradition. Sullerzhitsky had been a 'Wrestler of God' who helped move his religious sect from the Caucasus to Canada, then returned to Russia where he was given a job as a stage-hand by Stanislavsky. He came to influence Stanislavsky enormously, infecting him with a naïve infatuation with Tolstoy, Hindu philosophy and yoga.

13

Stanislavsky's production of Armoured Train 14–69.

Stanislavsky with Max Reinhardt.

Chekhov too developed the yogic strain in the Stanislavsky system, what he called its 'Pythian quality'. One student actor has described how 'we indulged in *prana*, stretching out our hands and emitting rays from the tips of our fingers. The idea was to get the person at whom your fingers pointed to feel the radiation.' These antics were out of key with the epoch of the machine, the mass, urbanism and Americanism. Meyerhold attacked them.

His own system, bio-mechanics, he conceived as a combination of military drill with algebra. The human body was seen almost as a robot, whose muscles and tendons were like pistons and rods. The key to success as an actor lay in rigorous physical training. This system was given a psychological underpinning by Pavlovian reflexology: 'The actor must be able to respond to stimuli.' The good actor – and anybody physically fit could become a good actor – was one with a 'minimum of reaction time'. There were other important ingredients in Meyerhold's system: Taylorism, the study of workers' physical movements, invented in America to increase production and popularised after the Revolution in Russia, with Lenin's approval ('Let us take the storm of the Revolution in Soviet Russia, unite it to the pulse of American life and do our work like a chronometer!' read one slogan of the time); Dalcroze's eurhythmics, influential on Massine's choreography; the *commedia dell'arte*; Douglas Fairbanks; the German Romantic cult of the marionette (Kleist, Hoffmann); the Oriental theatre (during his Dr Dapertutto period Meyerhold had invited Japanese jugglers to his studio). Further ammunition was provided by the psychology of William James; another anti-Stanislavskian, Evreinov, was struck by James's examples of how when we count up to ten, anger disappears, and how whistling brings courage in its train; Eisenstein cites James's dictum that 'we weep not because we are sad; we are sad because we weep' – which was taken to prove the primacy of physiological gesture over psychological emotion.

A Russian journalist described the work of the Proletcult Theatre in 1923, the year *The Wise Man* was produced:

> A big training of proletarian actors is taking place. In the first place, it is a physical training, embracing sport, boxing, light athletics, collective games, fencing and bio-mechanics. Next it includes special voice training and beyond this there is education in the history of the class struggle. Training is carried on from ten in the morning till nine at night. The head of the training workshop is Eisenstein, the inventor of the new circus stage.

Eisenstein's debt to Meyerhold even extended to paying particular attention to the movements of cats and tigers, which in Meyerhold's view exemplified the secrets of bodily plasticity.

Besides working for Meyerhold, Eisenstein had also collaborated for a spell with Forregger, in his studio of satirical theatre, where he designed Picasso-influenced sets and costumes and gleaned the idea of the 'noise band', which expressed the sounds of a mechanical, industrial epoch rather than those of the decadent artisanal orchestra, and also went to Petrograd with the film director Sergei Yutkevich where he did some designing for FEKS (Factory of the Eccentric Actor), run by Kozintsev, Trauberg and Krijitsky. The idea of 'American eccentricism' can, like so

The set for Meyerhold's production of Dawns.

much else, be traced back to the Futurist Manifesto; the FEKS group were fascinated with what Radlov, another Petrograd director, ex-pupil of Dr Dapertutto, called 'a new aspect of the comic outlook on life, created by Anglo-American genius': all kinds of slapstick, comic policemen, rooftop chases, rescues by rope from aeroplanes, underground hatchways, etc. Radlov introduced contortionists into his plays and replaced Pantaloon in the *commedia dell'arte* by Morgan, the Wall Street banker. Eisenstein and Yutkevich worked with FEKS on what was billed as 'Electrification of Gogol, Music Hall, Americanism and Grand Guignol'. 'The tempo of the revolution', believed Kozintsev, 'is that of scandal and publicity.' For Forregger they did sets based on the 'urbanistic' *Parade*; Yutkevich has described the main influences on Forregger at this time as being *commedia dell'arte*, French cancan, ragtime, jazz, Mistinguett. (Jazz was also seen as 'urbanistic' as well as exotic; this was the time when Bechet and Ladnier received a tumultuous welcome in the Soviet Union, only exceeded by that given to Douglas Fairbanks and Mary Pickford.)

Eisenstein, with considerable bravado, attempted in his *Lef* manifesto to give theoretical coherence to all these fantastic and bizarre influences which lay behind his production of 'Ostrovsky's' *The Wise Man*. He chose as his slogan the idea of 'Montage of Attractions'. Some years later he described how he invented this phrase:

> Don't forget it was a young engineer who was bent on finding a scientific approach to the secrets and mysteries of art. The disciplines he had studied had taught him one thing: in every scientific investigation there must be a unit of measurement. So he set out in search of the unit of impression produced by art! Science knows 'ions', 'electrons' and 'neutrons'. Let there be 'attraction' in art. Everyday language borrowed from industry a word denoting the assembling of machinery, pipes, machine

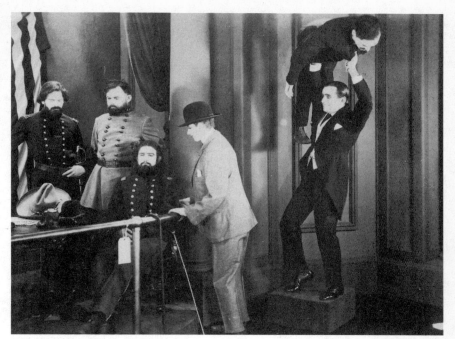

Douglas Fairbanks in The Nut.

Clown drawn by Eisenstein.

tools. This striking word is 'montage' which means assembling, and though it is not yet in vogue, it has every qualification to become fashionable. Very well! Let units of impression combined into one whole be expressed through a dual term, half-industrial and half-music-hall. Thus was the term 'montage of attractions' coined.

Some more information can be added to this: Yutkevich suggests that the word 'attraction' may well have been suggested to Eisenstein by the roller-coaster in the Petrograd Luna Park, which carried that name. Probably the idea of montage was suggested by the photomontages of Rodchenko, another of the *Lef* group, and George Grosz and John Heartfield in Berlin. But this would only take things back one step: Raoul Hausmann, speaking of Berlin Dadaism, explained, 'We called this process photomontage because it embodied our refusal to play the part of the artist. We regarded ourselves as engineers and our work as construction: we *assembled* [in French *monter*] our work, like a fitter.' Of course contacts between Berlin and Russia, between Dadaism and Constructivism, were very close at that time.

Half-industrial and half-music-hall: this expresses perfectly the curious artistic admixture of the time. Eisenstein, it will be seen, was very much swept along by the currents of the epoch. This is hardly surprising: only nineteen at the time of the Bolshevik Revolution, he had been impelled into a vortex for which he was not prepared, an epoch of overwhelming force and change, unprecedented, unpredictable. It was not until this molten magma hardened into the lava of Stalinism that Eisenstein had time really to take stock of his situation. However, already there were some original traits to be seen. In particular, there was his quite idiosyncratic approach to the emotional structure of works of art. Looking back, he was to describe his project in *The Wise Man* in these typical words: 'A gesture expanded into gymnastics, rage is expressed through a somersault, exaltation through a *salto mortale*, lyricism on "the mast of death".' He wrote that he dreamed of a theatre 'of such emotional saturation that the wrath of a man would be expressed in a backward somersault from a trapeze'. This dream of emotional saturation was to stay with Eisenstein all his life. It became a preoccupation with the idea of ecstasy.

Eisenstein was influenced by two powerful, but in many ways incompatible, teachers of psychology: Freud and Pavlov. In his *Lef* manifesto we can see plainly Freud's influence in his observations on the difficulty of fixing 'the boundary line where religious pathos moves into sadist satisfaction during the torture scenes of the miracle plays'. This interest in the overlapping of sexual and religious ecstasy is a recurrent feature in Eisenstein's work. Pera Attasheva recounts how Eisenstein was delighted to find at Mont-Saint-Michel two postcards in which the same model posed as Ste Thérèse de Lisieux and, heavily made up, in the arms of a sailor. In Mexico he wrote of 'The Virgin of Guadelupe worshipped by wild dances and bloody bullfights. By tower-high Indian hair-dresses, and Spanish mantillas. By exhausting hours-long dances in sunshine and dust, by miles of knee-creeping penitence, and the golden ballets of bullfighting cuadrillas.' One theme of the unfinished *Que Viva Mexico!* seems to have been this intermingling of sexual, religious and sadistic ecstasy.

However, during the 1920s, Pavlov became of even greater importance to

Ecstacy: two drawings by Eisenstein and a shot from Que Viva Mexico!

Eisenstein. As the idea of montage developed in his mind, he tended to replace the idea of attractions by that of stimuli, or shocks. This merged with two other currents: the extremist assault on the spectator and the demands of political agitation; after *The Wise Man* Eisenstein's next production, *Listen Moscow*, was called an 'agit-guignol'. Eisenstein had always been concerned with the agitational aspects of his work: during the Civil War of 1921 he had worked on an agit-train as a poster-artist, drawing political cartoons and caricatures, decorating banners and so on. This attitude to art was one of the dominating trends of the time; Mayakovsky boasted that his slogans urging people to shop at Mosselprom were poetry of the highest calibre and he designed and wrote jingles for countless posters and publicity displays; it led eventually to Mayakovsky's doctrine of the social command. The problem of art became that of the production of agitational verse: 'I want the pen to equal the gun, to be listed with iron in industry. And the Politburo's agenda: Item I to be Stalin's report on "The Output of Poetry".' In a curious way this was a return of the Russian intelligentsia to its old civic preoccupations: though of course those who had been through Futurism *en route* did not see eye to eye with those who had just kept trudging along with naturalistic writers like Chernyshevsky and Dobrolyubov.

Before he embarked on his first film, *Strike*, Eisenstein directed one more play, *Gasmasks*, devised by Tretyakov. For this production he abandoned the mock-Spanish ex-Villa Morossov for the Moscow Gas Factory, a setting suitable for the modern age, comparable with Mayakovsky's Brooklyn Bridge or Tatlin's

21

October: *reflexes of struggle.*

Monument to the Third International. (Tatlin, taking his view that the artist was an engineer worker to its logical conclusion, actually went to work in a metallurgical factory near Petrograd.) Also relevant here was Tretyakov's preference for 'factography', as it came to be known, for which he propagandised in *Lef*. Literature became seen as a matter of diaries, travelogues, memories and so on, dealing with the raw material of life itself. Tretyakov developed the 'bio-interview', a technique like that of Oscar Lewis's *Children of Sanchez*; he wrote angrily, 'There is no need for us to wait for Tolstoys, because we have our own epics. Our epics are the newspapers.' It seemed only logical that if the theatre was to become a factory the factory should become a theatre. The stage first broke through the proscenium arch, then outburst the brick-and-mortar integument of the theatre itself. Already the theatre had taken to the streets in great mass pageants, reminiscent of the *fêtes* of the French Revolution. Next they must enter the factory itself. Unfortunately, the experiment was not a great success. As Eisenstein ruefully described, the giant turbo-generators dwarfed the actors. However, it prepared the way for the next step: out of the drama altogether and into the cinema.

Strike was made in 1924; Eisenstein was then twenty-six. *Strike*, like *Listen Moscow*, was to be an agit-guignol. He planned to produce a chain of shocks: 'Maximum intensification of aggressive reflexes of social protest is seen in *Strike*, in mounting reflexes without opportunity for release or satisfaction or, in other words, concentration of reflexes of struggle, and heightening of the potential expression of class feeling.' Thus the concept of montage was retained, but that of attractions dropped, except in the reductive sense of shocks or provocations. The film was made up in effect of poster-like, often caricatural vignettes, planned for maximum emotional impact. The next year, Eisenstein wrote that:

> The science of shocks and their 'montage' in relation to these concepts should suggest their form. Content, as I see it, is a series of connecting shocks arranged in a certain sequence and directed at the audience. ... All this material must be arranged and organised in relation to principles which would lead to the desired reaction in correction proportion.

The dominant influence of Pavlov is manifest.

In order to transpose his system of montage from theatre to cinema Eisenstein made use of the discoveries that had been made by Kuleshov and Vertov. Before the Revolution Kuleshov had been a designer at the Khanzhankov Studio, where he already began writing theoretical articles stressing the visual aspects of film. In 1920, after a period in the Red Army, he became a teacher at the State Film School, where he set up his own workshop; Eisenstein studied there for three months in 1923. It was there that he carried out his famous experiments in editing. The first was a demonstration of creative geography or 'artificial landscape', placing the White House in Moscow. The second was a synthetic composition of a woman out of the lips of one, the legs of another, the back of a third, the eyes of a fourth and so on. The third showed how the expression perceived on an actor's face – grief, joy, etc. – is determined by the shots which precede and follow it. For Kuleshov the third demonstration was, of course, a blow against Stanislavsky; he insisted, when he made his film *Mr West in the Land of the Bolsheviks* in 1923–24, that 'the most

Vertov's Kino-Pravda.

difficult task was to show that new actors, specifically trained for film work, were far better than the psychological-theatrical film-stars'. He hated Naturalism and always referred to actors as 'models'. The importance of Kuleshov's experiments was that they showed how, by editing, the anti-Naturalist, anti-psychologist trend in the theatre could also be introduced into cinema, using scientific, laboratory-tested and specifically cinematic methods. The second major influence was Dziga Vertov, the leading film documentarist of the period who, like Eisenstein, was a contributor to *Lef*, where he had developed his theories of 'kino-pravda' and the 'kino-eye'. However, perhaps more important was Vertov's use of editing. Eisenstein was to tell Hans Richter a few years later that Vertov should be credited with the invention of musical rhythm in the cinema, governing the tempo of the film by the measured pace of the cutting, and hence with a decisive breakthrough in montage principles. Moreover, Vertov (or rather Rodchenko, who collaborated with him) was the first to realise the importance of the titles and to integrate them into the film as an element in its construction, rather than as troublesome inter-ruptions. In *Battleship Potemkin* especially, the titles, on which Tretyakov worked, played an important role. The documentary tendency Eisenstein was hostile to-wards; he liked to repeat: 'I don't believe in kino-eye, I believe in kino-fist.'

During his work on *Strike* Eisenstein also elaborated his theory of 'typage' in the choice of actors. Like Kuleshov, like the whole theatrical tradition in which he worked, he rejected orthodox stage acting. Instead he preferred to cast his films simply by the physiological, particularly facial, characteristics he felt suited the part. He would often spend months looking for the right person. A man who he saw shovelling coal in the hotel at Sevastopol where they were shooting was

The General Line: *typage. On the left, Chukhmarev as the kulak.*

Strike: *lumpenproletarians jumping out of their barrels.*

Strike: *the dwarfs.*

drafted into the cast to play the surgeon in *Battleship Potemkin*. For *The General Line* his cameraman Tissé recalls:

> The kulak's role was played by Chukhmarev, a Moslem and former meat contractor for the army. Father Matvei was found in Leningrad; before the war he had played the cello at the Marinsky Theatre, was drafted into the army and later joined the Red Army and suffered concussion in the fighting at Kronstadt. The lovely sad wife in the scene of the divided hut was found in Neveshkovo, a village of Old Believers.

The heroine was found on a State Farm at Konstantinovka. Eisenstein has described how he developed the idea of typage from his thoughts about the *commedia dell'arte* with its stock types who are immediately recognised by the audience. He wanted faces which would immediately give the impression of the role. Later he became interested in Lavater's system of physiognomics; probably Leonardo da Vinci had an influence too.

However, *Strike* still retained important elements from Eisenstein's past in the theatre. The guignol strain played a key part, particularly in the closing sequence, where the subjection of the workers is paralleled by the slaughter of cattle in an abattoir. The film is suffused with parody, a cartoonist's approach, squibs, lampoons, and so on, in the eccentric music-hall tradition. The critic Victor Shklovsky commented on the similarities to Keaton, both the fascination with machinery and the effective use of 'the eccentricity of his material and the sharpness of the contrasts'. A kind of Hoffmannesque grotesque is evident in *Strike* with the police spies who are metamorphosed into animals: monkey, bulldog, fox and owl. The lumpenproletarian strike-breakers jumping out of their barrels, as Shklovsky comments, are like devils jumping out of hell in a mystery play. The pe-

Strike: *the police spy as an owl.*

Battleship Potemkin: *agit-guignol, and beautifully composed photography.*

culiar dwarfs who appear reveal a theatrical, almost Gothic, outlook, far from what was regarded as Realism. But as Eisenstein became more engrossed in the cinema this residue from the theatrical past began to fall away. *October* was the last film to have a very strong theatrical flavour, where the scenes of the storming of the Winter Palace were evidently echoes of the enormous pageants which had taken place in Petrograd, when tens of thousands had swarmed through the street and squares, re-enacting the events of the October Revolution. In a quite different way *Ivan the Terrible* looks back to the theatre, but no longer to the theatre of FEKS or the Proletcult. Yet I think that these three films – *Strike, October* and *Ivan the Terrible* – are certainly Eisenstein's best, most extraordinary achievements. He was at his strongest when he was working within the theatrical tradition which exerted such influence on him in the 1920s: his more purely cinematic work lacks the bite, the lampooning edge which was his strength. In *Battleship Potemkin*, the most successful sequence, the famous massacre on the Odessa Steps, is really an extension of the agit-guignol he had worked at in the Proletcult Theatre; other sequences of the film, beautifully composed photography, heroic postures, etc., look forward to the artistic disaster of *Alexander Nevsky*.

During the years from 1924 to 1929, when Eisenstein left Russia for a tour abroad, he worked more intensively than at any time during his career, and also made a great effort to elaborate his aesthetic theories more systematically, in particular his theory of montage. It is popularly believed that Eisenstein conceived of montage as the basis of a film language, a cinematic rather than a verbal code, with its own appropriate, even necessary, syntax. In fact, at this stage, Eisenstein was rather sparing in his remarks on film language and usually very vague. At a later date, as we shall see, he delved into linguistic theory, but throughout the 1920s his ideas of language and linguistics seem to have been extremely sketchy, though through *Lef* he was in contact with a number of the Formalist linguists.

What did interest Eisenstein, however, was the dialectic. He constantly stresses that montage is a dialectical principle. Eisenstein seems to have absorbed his notion of the dialectic in rather a haphazard manner. Certainly, the dominant influence must have been Deborin, the editor of *Under the Banner of Marxism*, the leading philosophical magazine of the time in the Soviet Union. Deborin was a militant Hegelian, engaged during the second half of the 1920s in a fierce controversy with the Mechanist school, militant materialists, whose hard core were leaders in the campaign of the godless against religion. Inclined towards Positivism, they regarded the dialectic as so much mumbo-jumbo. Deborin was able to counter their attacks by pointing to Engels's *The Dialectics of Nature* and Lenin's *Philosophical Notebooks*, first published in Russia during the 1920s, in part on Deborin's initiative. Eisenstein frequently quotes from these two works; he seems to have been particularly fond of an excerpt from Lenin's *Philosophical Notebooks*, 'On The Question of Dialectics', first published in *Bolshevik* in 1925. One sentence struck him forcefully: 'In any proposition we can (and must) disclose as in a "nucleus" ("cell") the germs of all the elements of dialectics.' Eisenstein was able to link this to his concept of the shot as the cell, or later, as his views grew more complex, the molecule of montage.

Clearly there were some difficulties in Eisenstein's position, of which he began to grow uncomfortably aware. The problem was to reconcile his 'idealist' preoc-

cupation with the dialectic with the materialist inheritance he carried with him from the Proletcult Theatre: the stress on the machine, on gymnastics and eurhythmics, on Pavlovian reflexology. The dialectic, Lenin stressed, was knowledge: 'the living tree of vital, fertile, genuine, powerful omnipotent, objective, absolute human knowledge'. In the past Eisenstein described how cinema was 'confronted with the task of straining to the utmost the aggressive emotions in a definite direction' (that is, an agitational task whose ideological roots lay in reflexology), but 'the new cinema must include deep reflective processes'. At first Eisenstein's ideas on this subject were rather abstract and vague. He criticised Kuleshov and Pudovkin for seeing the unit of the shot as being like a brick; making a film was like laying bricks end to end. Pudovkin, wrote Eisenstein, 'loudly defends an understanding of montage as a *linkage* of pieces. Into a chain. Again "bricks". Bricks arranged in a series to *expound* an idea.' He goes on: 'I confronted him with my viewpoint on montage as a *collision*. A view that from the collision of two given factors *arises* a concept. ... So montage is conflict. As the basis of every art is conflict (an "imagist" transformation of the dialectical principle).'

But how did a concept arise from a collision? Neither Pavlov nor Deborin were very helpful on this subject. Marxism did not have a satisfactory aesthetics. Its most clamorous aestheticians were particularly hostile to the background from which Eisenstein had emerged, Futurism and Constructivism, and to which he still adhered. In fact, Eisenstein proved unable to solve the problems confronting him and eventually tacitly abandoned them. Primarily, a work of art remained for him 'a structure of pathos', which produced emotional effects in the spectator. The

Battleship Potemkin: *gymnastics.*

October: *conflict within the frame.*

problem was to get the maximum effect. 'If we want the spectator to experience a maximum emotional upsurge, to send him into ecstasy, we must offer him a suitable "formula" which will eventually excite the desirable emotions in him.' This was a simple physiological approach; conflict, on various levels and dimensions, on the screen excited emotions in the spectator, which would either strengthen his political and social consciousness or jolt him out of his ideological preconceptions to look at the world anew. What baffled Eisenstein was how *new* concepts could be precisely conveyed. He built up a model, first with four and then with five levels of montage (metric, rhythmic, tonal, overtonal, intellectual), in which, in each case, every level except the last could be described as 'purely physiological'. The last (intellectual montage) was to direct not only the emotions but 'the whole thought process as well'. Eisenstein conceded that his method might be 'more suitable for the expression of ideologically pointed theses', but explained that this was only a 'first embryonic step'. Ahead lay 'the synthesis of art and science' and the dream of a film of *Capital*, the summit of Eisenstein's ambitions.

This search for the synthesis of art and science led Eisenstein into a line of argument to which there could be no satisfactory conclusion. He became increasingly interested in the idea that verbal speech is a kind of secondary process and that the primary, underlying level of thought is sensuous and imagistic. He was impressed by the notion that the origins of language were in metaphor and in conjunction with magic and mystic rituals. He came to believe that the language of primitive peoples was more imagistic and metaphoric than the tongues of advanced nations. He saturated himself in the writings of anthropologists such as Frazer, Lévy-Bruhl and Malinowsky, and regarded myth as the primary function of thought; logical thought, in the more usual sense, came to be seen as a kind of shrivelled myth. It was in myth that the synthesis of art and science could be seen. This idea, of course, is at the root of *Que Viva Mexico!* Eisenstein also became

October: *sequence in the Czarina's bedroom.*

interested in the concept of 'affective logic', based on the observation that most people, in colloquial speech, did not utter complex and logically formed sentences so much as bursts of disjointed phrases which the hearer was able to connect. Finally, he was deeply impressed by the work of James Joyce and was persuaded that inner speech was closer to sensuous and imagistic thought than externalised, verbal speech. In some sense, the cinema might correspond to interior monologue; the drift of Joyce's literary innovations was towards a kind of cinematisation of language. Of course, it is easy now to point out how many of his mentors have been discredited, how our concepts of myth and of the syntax of colloquial speech have been transformed, how it has been shown that inner speech is not less but more sophisticated and advanced than externalised speech. But at the time Eisenstein was working, and in the isolated conditions in which he worked, there was nothing abnormal about his line of thought. It did, however, bring him into error and confusion.

An important moment in the development of his ideas occurred when the Kabuki troupe of Ichikawa Sadanji visited Russia in 1928. Eisenstein, who had long been interested in Japan, was enormously impressed. He felt that there was a kinship of principle between Kabuki acting, the Japanese written ideogram, and his great discovery of montage.

> How grateful I was to fate for having subjected me to the ordeal of learning an Oriental language [while in the army], opening before me that strange way of thinking and teaching me word pictography. It was precisely this 'unusual' way of thinking that later helped me to master the nature of montage, and still later, when I came to recognise this 'unusual', 'emotional' way of thinking, different from our common 'logical' way, this helped me to comprehend the most recondite methods of art.

Under the influence of the Kabuki theatre Eisenstein began to see montage as an activity of mental fusion or synthesis, through which particular details were united at a higher level of thought, rather than a series of explosions as in a combustion engine, as it had once seemed. Eisenstein was fascinated by the use of conventions, masks and symbolic costumes in Oriental theatre. He became interested in Japanese ideas of picture composition. Under the spell of the East, montage was defused for Eisenstein. Finally, the Japanese theatre suggested to Eisenstein the concept of a 'monistic ensemble' which came to dominate his thought more and more, culminating in the Wagnerian excesses of his stage production of the *Valkyrie*. He was struck by the way sound and gesture were correlated in the Kabuki theatre; this was a subject which became more and more crucial to him as it became clear that the sound film was to be the form of the future. Again, quite in the tradition of Meyerhold, he reacted against the idea that the sound film must mean the dominance of the spoken word and looked for a different way of combining the visual and aural components of the cinema. In the Kabuki theatre Eisenstein felt that the line of one sense did not simply accompany the other, the two were totally interchangeable, inseparable elements of a monistic ensemble.

This interest in the relationships between the different senses converged with

Kabuki theatre.

Eisenstein's growing proneness to use musical analogies and terminology to explain what he was trying to achieve in the cinema. Thus, while pondering over the editing of *The General Line*, he came to the conclusion that his montage should concentrate not on the dominant in each shot (tonal montage) but on the overtones. At the same time he put increased stress on finding the correct rhythm. And, when he discussed the relationships between the different senses and different lines of development, he introduced the idea of counterpoint and later of polyphony (noise bands, which in a way survived until *Battleship Potemkin*, with the 'music of the machines' passage in Meisel's score, now disappeared entirely). This stress on the 'synchronisation of the senses', and on analogies with music, set the stage for the full-scale reflux of Symbolism which overwhelmed Eisenstein's thought during the 1930s.

Eisenstein's visit to Western Europe, the United States and Mexico had a shattering effect on his life. Firstly, there was the terrible catastrophe of *Que Viva Mexico!*, a film to which he became obsessively attached, which he was unable to finish and over which he lost all control. Secondly, there was the completely changed political and cultural atmosphere which greeted him when he returned to the Soviet Union, suspicious of Eisenstein for his enthusiasm for Western culture and hostile to the drift of his ideas about cinema and aesthetics in general. Eisenstein had left Russia during 'the spinal year' of 1929, when the collectivisation of the peasants had reached the vital point of no return, when the first Five Year Plan had reached the moment of fate. Russia was thrown into a frenzy to reach production goals, to destroy the kulaks, to enforce collectivisation. At the time Eisenstein left the shock waves had not yet broken with their full force upon the intelligentsia. By the time he returned, party control had been made rigid, a standard and requisite ideology introduced and many of the artistic and academic stars of 1929 quenched and discredited. Eisenstein took up a post at the Institute of Cinematographic Studies where he conducted a series of lecture courses, read voluminously and worked in isolation at a projected *magnum opus* of film aesthetics.

Eisenstein had continual problems even in this relative isolation: indeed, in part because of it. He was accused of withdrawing into an ivory tower, charges which he countered by describing himself as at work in a laboratory on the theoretical problems without whose solution practice would be premature, unoriented. Quite clearly, however, the tendency of his theoretical work ran counter to the main lines of Stalinist aesthetics. His views on Joyce, for instance, were well known. He had met Joyce, and Joyce had once said that if *Ulysses* were to be filmed it should be by either Eisenstein or Ruttmann. Consequently, when in 1933 Vsevolod Vishnevsky made a defence of Joyce in an article entitled 'We Must Know the West', he cited Eisenstein as a great Soviet artist who recognised the importance of Joyce. Vishnevsky's defence unleashed a controversy which raged until the 1934 Congress of Soviet Writers. Radek there gave his notorious report, one section of which was entitled 'James Joyce or Socialist Realism?' It was not hard to guess the answer: a taste for Joyce was denounced as a craving to flee from Magnetogorsk. Eisenstein, however, refused to submit. In his lectures at the Institute he observed:

For two years there were discussions about translating Joyce for scientific purposes, but this plan was abandoned after the speech by Radek. Because of this the mass of

36

Russian writers will lose a great deal. I was furious at Radek's speech. When I analysed it I found it to be a quite conventional interpretation of Joyce.

Joyce, concluded Eistenstein hopefully, 'extends the line commenced by Balzac'.

The main onslaught on Eisenstein, however, was to come over his films of the 1920s and the issue of Realism. Perhaps the strangest feature of the Stalinist attack is the way in which it has echoed down the years:

> The artist takes the village outside of its real relations, outside of its living connections. He thinks in terms of things. He disintegrates reality into disconnected, un-related pieces. This makes quite illusory Eisenstein's construction which is proclaimed in principle as arch-realistic. This film, arising from the desire to express a most urgent page of living reality, full of throbbing interest, proves to be a production torn away from reality itself.

Ivan Anisimov's denunciation of *The General Line* prefigures in an eerie and uncanny way a whole series of criticisms still to come, from Robert Warshow and, more seriously, from Charles Barr and Christian Metz. Anisimov even joins Warshow in attacking Eisenstein for 'collectivism', for making films without in-dividual characters. It is strange to see how the philistinism of the Stalinist regime in the 1930s finds its belated double in the United States of the Cold War two decades later. 'Realism' has always been the refuge of the conservative in the arts, together with a preference for propaganda of a comforting rather than dis-turbing kind. Thus *Alexander Nevsky*, Eisenstein's worst film, made during the 1930s under the impact of Stalinist criticism, was his most successful propaganda film. Film, Charles Barr has written, 'cannot show the essence, but it can suggest the essence by showing the substance'. Undeformed, undisintegrated, merely suggestive versions of 'reality' are always the best propaganda for the *status quo*.

Meanwhile, however, Eisenstein was pursuing his researches. The dominant strand throughout the rest of his life was to be the investigation of the 'synchro-nisation of the senses', a return to the Symbolist infatuation with Baudelaire's *correspondances*, a frequent subject for debate in Russia in the two decades before the Revolution.

> Comme de longs échos qui de loin se confondent
> Dans une ténébreuse et profonde unité,
> Vaste comme la nuit et comme la clarté,
> Les parfums, les couleurs et les sons se répondent.
> Il est des parfums frais comme des chairs d'enfants,
> Doux comme les hautbois, verts comme les prairies ...

Eisenstein went even further than Baudelaire by including taste. In his discussion of the Kabuki theatre he wrote:

> Not even what is eaten in this theatre is accidental! I had no opportunity to dis-cover if it is ritual food eaten. Do they eat whatever happens to be there or is there

a definite menu? If the latter, we must also include in the ensemble the sense of taste.

Eisenstein allowed no scientific scruples to stand in his way; indeed, by an astute reading of Pavlovian reflexology, he was able to validate his ideas scientifically to his own satisfaction. The *Laocoön* was summarily dismissed:

> And yet we cannot reduce aural and visual perceptions to a common denominator. They are values of different dimensions. But the visual overtone and the sound overtone are values of a single measured substance. Because, if the frame is a visual perception and the tone is an aural perception, visual as well as aural overtones are a totally physiological sensation. And consequently they are of one and the same kind ... for both, a new uniform formula must enter our vocabulary: 'I feel'.

After this, however clumsily it may have been expressed, the way was open for every kind of interpenetration and admixture of categories.

Eisenstein's writings on synaesthesia are of great erudition and considerable interest, despite their fundamentally unscientific nature. For example, he quotes numerous Baroque and Romantic authorities, who speculated about the colour symbolism of the vowels long before Rimbaud. He sees himself in the tradition of Wagner and the *Gesamtkunstwerk* and quotes copiously from the French Symbolists. In particular, we can detect the influence of René Ghil, a close friend of V. Y. Bryusov, the poet and evangel of Russian Symbolism, and a frequent and respected contributor to Bryusov's review *Scales*. Another source for Eisenstein's

Battleship Potemkin: *'I feel'*.

speculations on colour symbolism is Kandinsky. Though he explicitly dissociates himself from Kandinsky's mysticism and spiritualism, his general tone and the trend of his investigations vividly recalls Kandinsky's programme for the Inkhuk (Institute of Artistic Culture). Clinging as hard as he can to the anchor of reflexology, Eisenstein explains that the colour stimulus acts 'as in a conditioned reflex which recalls a whole complex, in which it had once played a part, to the memory and the senses'. He also finds a crumb of scientific comfort in the theory of vibrations.

Another important forerunner whom Eisenstein cites is Scriabin, who wrote a colour score alongside the sound score for his *The Poem of Fire*. Scriabin also planned a stupendous *Mystery* with gestures, colours, perfumes, etc. Eisenstein used Scriabin, together with Debussy, to justify his theory of overtonal montage and also saw himself as the vector of Scriabin's dream of a synthesis of the arts. (He does not discuss the occult and peculiarly Russian brand of Theosophy which underlay this dream.) The idea of synthetic theatre was one much voiced during the 1920s. Eisenstein adopted it and went so far as to write that the cinema was destined to fulfil the prophecies of Edward Gordon Craig and Adolphe Appia, the great Symbolist and Wagnerian theoreticians of the pre-Revolutionary theatre. The logical extension of this, of course, was his production of the *Valkyrie* at the Bolshoi Opera in 1940. (In defence of Eisenstein it should be said that he was not entirely dominated by Symbolist and Wagnerian thought; he also hailed Walt Disney as a master of synaesthesia.) The *Valkyrie*, according to Eisenstein's painstaking biographer, Marie Seton, had this aim: 'Men, music, light, landscape, colour and motion brought into one integral whole by a single piercing emotion, by a single theme and idea.' He himself wrote of his efforts to achieve 'a fusion between the elements of Wagner's score and the wash of colours on the stage'. This led directly on to *Ivan the Terrible*.

Walt Disney's first Silly Symphony.

39

Eisenstein and Daumier

The result of this overwhelming Symbolist reflux was that the monistic ensemble gradually became no more than an organic whole and the dialectic was reduced to the interconnection of the parts. At the same time Eisenstein became interested in ideas of harmony, mathematical proportion, and the golden section as part of a search for Classicism. As far back as *The General Line* his cameraman Tissé recalls, 'we resolved to get away from all trick-camerawork and to use simple methods of direct filming, with the most severe attention to the composition of each shot'. (For the Odessa Steps sequence of *Battleship Potemkin*, Eisenstein had strapped a camera to a somersaulting acrobat.) This interest in geometry was not that of the Constructivist, derived from the machine, but re-

The operatic splendour of Ivan the Terrible.

Ivan the Terrible.

lied on insights into the nature of art. Eisenstein was especially fond of citing the geometry of the works of Leonardo da Vinci. It seems at times a component of that obsession with science which he was never able to control, reminiscent almost of René Ghil. 'In his attempt to create the logarithmic tables of art there is something akin to alchemy,' observed one critic, and it is hard not to see much of Eisenstein's later writing as an attempt to shore up, scientifically and intellectually, an art increasingly preoccupied with emotional saturation, ecstasy, the synchronisation of the senses, myth and primitive thought ('Folk images equal human knowledge,' he said, apropos of *Que Viva Mexico!*). Indeed, there is something essentially Symbolist in his whole view of the near-identity of art and philosophy, though in his case philosophy was a bizarre mixture of Hegel with Pavlov.

One final strand in Eisenstein's aesthetics should be noted: his lifelong interest in caricature, in lampoon, in the grotesque. This derives in part from Meyerhold, Hoffmann, and the seventeenth-century French etcher Callot. The artists Eisenstein revered were Daumier, Toulouse-Lautrec and Sharaku ('the Japanese Daumier'). In Mexico he added Posada to this pantheon: the Dance of Death sequence which was to close the film owes its provenance to Posada as well as Hoffmann and Callot. Later he became obsessed by El Greco, about whom he planned to write a book. This reflects both an interest in caricature, or at least hyperbole, and the fascination of the strange sado-spiritual atmosphere of the Toledo of the Inquisition, similar to that that he felt in Mexico. (Hence too his series of semi-caricatural drawings of the Stigmata and his admiration for Lawrence.) Eisenstein began his artistic career as a caricaturist on an agit-train; he ended it de-

A print by Sharaku.

Ivan the Terrible: *(left) a sketch by Eisenstein and (right) Cherkassov.*

Ivan the Terrible: *Cherkassov.*

Berthold Brecht.

signing the strange, distorted costumes for *Ivan the Terrible*, twisting the actor Cherkassov out of shape till he collapsed from exhaustion. (In more than one way *Ivan the Terrible* returns, in a different form, to the ideas of the 1920s: there is even the gigantic Mayakovskian theme of the battle with God, strangely distended.)

It is instructive to compare Eisenstein with Brecht. They both started out in the same cultural milieu, with the same kind of orientation: the influence of Meyerhold (relayed to Brecht through Piscator), the interest in Oriental art, in music-hall, in sport; their commitment to Marxism and the Bolshevik Revolution; their Americanism, Behaviourism, hatred of Naturalism. Brecht might have echoed Eisenstein's words:

> The Moscow Art Theatre is my deadly enemy. It is the exact antithesis of all I am trying to do. They string their emotions together to give a continuous illusion of reality. I take photographs of reality and then cut them up so as to produce emotions. ... I am not a realist, I am a materialist. I believe that material things, that matter gives us the basis of all our sensations. I get away from realism by going to reality.

There are friendships in common. They both sought the same goal: the elusive unity of science with art. But at the end of the 1920s they took different paths. Brecht protested to Tretyakov against the idea of 'pathetic overtones'; he devoted himself to attacking Wagner, to insisting that the senses, as the *Laocoön* had showed, must be clearly differentiated, that the different components in a work of art should be specified and be kept clearly apart. Brecht tried to find an artistic form for rational argument; Eisenstein repeatedly tried to cram and squeeze concepts into an artistic form he had already semi-intuitively (even 'ecstatically') elab-

Brecht's production of Dreigroschenoper.

orated: in the end, he decided thought and image were at one in myth and inner speech, abandoning rational argument for 'affective logic'. But it would be too easy simply to praise Brecht at Eisenstein's expense. Brecht always stayed with words, with verbal discourse, and was never compelled to face the problems of working in a predominantly non-verbal, iconic rather than symbolic medium.

Scientific concepts can, in fact, only be expressed within a symbolic code. Eisenstein's whole orientation, however, prevented him from pursuing the search for a symbolic language. In so far as he was interested in semiology his kinship is not so much with Saussure and structural linguistics, as Christian Metz supposes, as with Charles Morris and his Behaviourist semiotic. Eisenstein soon disowned his early experiments with non-diegetic metaphor, the necessary beginning for any movement towards the establishment of paradigmatic sets, such as the Gods sequence in *October*, though, as Godard has since shown in *Une Femme Mariée* and *La Chinoise*, this was not a dead-end street at all. Probably too he underestimated the importance of the support verbal discourse can and must give on the soundtrack. (Strangely, he was much more aware of the importance of subtitles during the silent era.) His emphasis on the emotional impact of the cinema tended all the time to draw him away from the symbolic.

Paradoxically, it was his conviction of the scientific basis of art which in the end led him into a full-scale retreat from the expression of scientific concepts through film. His acceptance of Pavlovian reflexology was unquestioning and rigid. (While he was in the United States he even felt moved to contrast Rin-Tin-Tin unfavourably with Pavlov's laboratory-trained dogs.) At an epistemological level, he was never able to resolve clearly what he intended by the Marxism to which he was fervently committed. It fell into two unrelated shells, and lacked a binding core. On the one hand was a 'scientistic' materialism, which sought physiological explanations for all human activity. On the other hand, there was a purely formal and abstract concept of the Hegelian dialectic, mechanically applied and eventually degenerating into an empty stereotype.

Eisenstein liked to compare himself with Leonardo da Vinci, as a great artist who saw his art as scientific and became, in time, more interested in aesthetic theory than in art itself. (He even compared his failure to complete *Que Viva Mexico!* with the catastrophe of the Sforza Monument.) His aspirations were greater than his achievement. Nevertheless, he was one of the few writers on aesthetics in this century to show any awareness of the cataclysmic reassessment of aesthetics which must take place. He was an original, unrelenting, and comprehensive thinker. The fact that he fell short of his own gigantic appreciation of his worth should not lead us to forget that he towers above his contemporaries. He still has an enormous amount to teach us.

Rin-Tin-Tin on set.

2
The Auteur Theory

The *politique des auteurs* – the auteur theory, as Andrew Sarris calls it – was developed by the loosely knit group of critics who wrote for *Cahiers du Cinéma* and made it the leading film magazine in the world. It sprang from the conviction that the American cinema was worth studying in depth, that masterpieces were made not only by a small upper crust of directors, the cultured gilt on the commercial gingerbread, but by a whole range of authors, whose work had previously been dismissed and consigned to oblivion. There were special conditions in Paris which made this conviction possible. Firstly, there was the fact that American films were banned from France under the Vichy government and the German Occupation. Consequently, when they reappeared after the Liberation they came with a force – and an emotional impact – which was necessarily missing in the Anglo-Saxon countries themselves. And, secondly, there was a thriving ciné-club movement, due in part to the close connections there had always been in France between the cinema and the intelligentsia: witness the example of Jean Cocteau or André Malraux. Connected with this ciné-club movement was the magnificent Paris *Cinémathèque*, the work of Henri Langlois, a great auteur, as Jean-Luc Godard described him. The policy of the *Cinémathèque* was to show the maximum number of films, to plough back the production of the past in order to produce the culture in which the cinema of the future could thrive. It gave French *cinéphiles* an unmatched perception of the historical dimensions of Hollywood and the careers of individual directors. The auteur theory grew up rather haphazardly; it was never elaborated in programmatic terms, in a manifesto or collective statement. As a result, it could be interpreted and applied on rather broad lines; different critics developed somewhat different methods within a loose framework of common attitudes. This looseness and diffuseness of the theory has allowed flagrant misunderstandings to take root, particularly among critics in Britain and the United States. Ignorance has been compounded by a vein of hostility to foreign ideas and a taste for travesty and caricature. However, the fruitfulness of the auteur approach has been such that it has made headway even on the most unfavourable terrain. A straw poll of British critics, conducted in conjunction with a Don Siegel Retrospective at the National Film Theatre, revealed that, among American directors most admired, a group consisting of Budd Boetticher, Samuel Fuller and Howard Hawks ran immediately behind Ford, Hitchcock and Welles, who topped the poll, but ahead of Billy Wilder, Josef von Sternberg and Preston Sturges.

Of course, some individual directors have always been recognised as outstanding: Charles Chaplin, John Ford, Orson Welles. The auteur theory does not limit

Fritz Lang's Scarlet Street *and (right) Alfred Hitchcock's* Vertigo.

itself to acclaiming the director as the main author of a film. It implies an operation of decipherment; it reveals authors where none had been seen before. For years, the model of an author in the cinema was that of the European director, with open artistic aspirations and full control over his films. This model still lingers on; it lies behind the existential distinction between art films and popular films. Directors who built their reputations in Europe were dismissed after they crossed the Atlantic, reduced to anonymity. American Hitchcock was contrasted unfavourably with English Hitchcock, American Renoir with French Renoir, American Fritz Lang with German Fritz Lang. The auteur theory has led to the revaluation of the second, Hollywood careers of these and other European directors; without it, masterpieces such as *Scarlet Street* or *Vertigo* would never have been perceived. Conversely, the auteur theory has been sceptical when offered an American director whose salvation has been exile to Europe. It is difficult now to argue that *Brute Force* has ever been excelled by Jules Dassin or that Joseph Losey's later work is markedly superior to, say, *The Prowler*.

In time, owing to the diffuseness of the original theory, two main schools of auteur critics grew up: those who insisted on revealing a core of meanings, of thematic motifs, and those who stressed style and *mise en scène*. There is an important distinction here, which I shall return to later. The work of the auteur has a semantic dimension, it is not purely formal; the work of the *metteur en scène*, on the other hand, does not go beyond the realm of performance, of transposing into the special complex of cinematic codes and channels a pre-existing text: a scenario, a book or a play. As we shall see, the meaning of the films of an auteur is constructed *a posteriori*; the meaning – semantic, rather than stylistic or expressive – of the films of a *metteur en scène* exists *a priori*. In concrete cases, of course, this distinction is not always clear-cut. There is controversy over whether some directors should be seen as auteurs or *metteurs en scène*. For example, though it is

51

Jules Dassin's Brute Force.

Joseph Losey's The Prowler.

possible to make intuitive ascriptions there have been no really persuasive accounts as yet of Raoul Walsh or William Wyler as auteurs, to take two very different directors. Opinions might differ about Don Siegel or George Cukor. Because of the difficulty of fixing the distinction in these concrete cases, it has often become blurred; indeed, some French critics have tended to value the *metteur en scène* above the auteur. MacMahonism sprang up, with its cult of Walsh, Lang, Losey and Preminger, its fascination with violence and its notorious text: 'Charlton Heston is an axiom of the cinema.' What André Bazin called 'aesthetic cults of personality' began to be formed. Minor directors were acclaimed before they had, in any real sense, been identified and defined.

Yet the auteur theory has survived despite all the hallucinating critical extravaganzas which it has fathered. It has survived because it is indispensable. Geoffrey Nowell-Smith has summed up the auteur theory as it is normally presented today:

> One essential corollary of the theory as it has been developed is the discovery that the defining characteristics of an author's work are not necessarily those which are most readily apparent. The purpose of criticism thus becomes to uncover behind the superficial contrasts of subject and treatment a hard core of basic and often recondite motifs. The pattern formed by these motifs ... is what gives an author's work its particular structure, both defining it internally and distinguishing one body of work from another.

It is this 'structural approach', as Nowell-Smith calls it, which is indispensable for the critic.

The test case for the auteur theory is provided by the work of Howard Hawks. Why Hawks, rather than, say, Frank Borzage or King Vidor? Firstly, Hawks is a director who has worked for years within the Hollywood system. His first film, *Road to Glory*, was made in 1926. Yet throughout his long career he has only once received general critical acclaim, for his wartime film, *Sergeant York*, which closer inspection reveals to be eccentric and atypical of the main *corpus* of Hawks's films. Secondly, Hawks has worked in almost every genre. He has made Westerns (*Rio Bravo*), gangsters (*Scarface*), war films (*Air Force*), thrillers (*The Big Sleep*), science fiction (*The Thing from Another World*), musicals (*Gentlemen Prefer Blondes*), comedies (*Bringing up Baby*), even a Biblical epic (*Land of the Pharaohs*). Yet all these films (except perhaps *Land of the Pharaohs*, which he himself was not happy about) exhibit the same thematic preoccupations, the same recurring motifs and incidents, the same visual style and tempo. In the same way that Roland Barthes constructed a species of *homo racinianus*, the critic can construct a *homo hawksianus*, the protagonist of Hawksian values in the problematic Hawksian world.

Hawks achieved this by reducing the genres to two basic types: the adventure drama and the crazy comedy. These two types express inverse views of the world, the positive and negative poles of the Hawksian vision. Hawks stands opposed, on the one hand, to John Ford and, on the other hand, to Budd Boetticher. All these directors are concerned with the problem of heroism. For the hero, as an individual, death is an absolute limit which cannot be transcended: it renders the life which preceded it meaningless, absurd. How then can there be any meaningful individual action during life? How can individual action have any value – be heroic

Budd Boetticher's The Bullfighter and the Lady.

– if it cannot have transcendent value, because of the absolutely devaluing limit of death? John Ford finds the answer to this question by placing and situating the individual within society and within history, specifically within American history. Ford finds transcendent values in the historic vocation of America as a nation, to bring civilisation to a savage land, the garden to the wilderness. At the same time, Ford also sees these values themselves as problematic; he begins to question the movement of American history itself.

Boetticher, on the contrary, insists on a radical individualism. 'I am not interested in making films about mass feelings. I am for the individual.' He looks for values in the encounter with death itself: the underlying metaphor is always that of the bullfighter in the arena. The hero enters a group of companions, but there is no possibility of group solidarity. Boetticher's hero acts by dissolving groups and collectivities of any kind into their constituent individuals, so that he confronts each person face to face; the films develop, in Andrew Sarris's words, into 'floating poker games, where every character takes turns at bluffing about his hand until the final showdown'. Hawks, unlike Boetticher, seeks transcendent values beyond the individual, in solidarity with others. But, unlike Ford, he does not give his heroes any historical dimension, any destiny in time.

For Hawks the highest human emotion is the camaraderie of the exclusive, self-sufficient, all-male group. Hawks's heroes are cattlemen, marlin-fishermen, racing-drivers, pilots, big-game hunters, habituated to danger and living apart from society, actually cut off from it physically by dense forest, sea, snow or desert. Their aerodromes are fog-bound; the radio has cracked up; the next mail-coach or

Only Angels have Wings: *The communal sing-song.*

packet-boat does not leave for a week. The élite group strictly preserves its exclusivity. It is necessary to pass a test of ability and courage to win admittance. The group's only internal tensions come when one member lets the others down (the drunk deputy in *Rio Bravo*, the panicky pilot in *Only Angels Have Wings*) and must redeem himself by some act of exceptional bravery, or occasionally when too much 'individualism' threatens to disrupt the close-knit circle (the rivalry between drivers in *Red Line 7000*, the fighter pilot among the bomber crew in *Air Force*). The group's security is the first commandment: 'You get a stunt team in acrobatics in the air – if one of them is no good, then they're all in trouble. If someone loses his nerve catching animals, then the whole bunch can be in trouble.' The group members are bound together by rituals (in *Hatari!* blood is exchanged by transfusion) and express themselves univocally in communal sing-songs. There is a famous example of this in *Rio Bravo*. In *Dawn Patrol* the camaraderie of the pilots stretches even across the enemy lines: a captured German ace is immediately drafted into the group and joins in the sing-song; in *Hatari!* hunters of different nationality and in different places join together in a song over an intercom radio system.

Hawks's heroes pride themselves on their professionalism. They ask: 'How good is he? He'd better be good.' They expect no praise for doing their job well. Indeed, none is given except: 'The boys did all right.' When they die, they leave behind them only the most meagre personal belongings, perhaps a handful of medals. Hawks himself has summed up this desolate and barren view of life:

> It's just a calm acceptance of a fact. In *Only Angels Have Wings*, after Joe dies, Cary
> Grant says: 'He just wasn't good enough.' Well, that's the only thing that keeps

55

John Ford's The Searchers: *a funeral service.*

people going. They just have to say: 'Joe wasn't good enough, and I'm better than Joe, so I go ahead and do it.' And they find out they're not any better than Joe, but then it's too late, you see.

In Ford films, death is celebrated by funeral services, an impromptu prayer, a few staves of 'Shall we gather at the river?' – it is inserted into an ongoing system of ritual institutions along with the wedding, the dance, the parade. But for Hawks it is enough that the routine of the group's life goes on, a routine whose only relieving features are 'danger' (*Hatari!*) and 'fun'. Danger gives existence pungency: 'Every time you get real action, then you have danger. And the question, "Are you living or not living?" is probably the biggest drama we have.' This nihilism, in which 'living' means no more than being in danger of losing your life – danger entered into quite gratuitously – is augmented by the Hawksian concept of having 'fun'. The word 'fun' crops up constantly in Hawks's interviews and scripts. It masks his despair.

When one of Hawks's élite is asked, usually by a woman, why he risks his life, he replies: 'No reason I can think of makes any sense. I guess we're just crazy.' Or Feathers, sardonically, to Colorado in *Rio Bravo*: 'You haven't even the excuse I have. We're all fools.' By 'crazy' Hawks does not mean psychopathic: none of his characters are like Turkey in Peckinpah's *The Deadly Companions* or Billy the Kid in Penn's *The Left-Handed Gun*. Nor is there the sense of the absurdity of life which we sometimes find in Boetticher's films: death, as we have seen, is for Hawks simply a routine occurrence, not a *grotesquerie*, as in *The Tall T* ('Pretty soon that well's going to be chock-a-block') or *The Rise and Fall of Legs Diamond*. For Hawks 'craziness' implies difference, a sense of apartness from the ordinary, everyday, social world. At the same time, Hawks sees the ordinary world as being 'crazy' in a much more fundamental sense, because devoid of any meaning or

The Rise and Fall of Legs Diamond: *death as a grotesquerie.*

Land of the Pharaohs: *the dehumanised crowd.*

values. 'I mean crazy reactions – I don't think they're crazy, I think they're normal – but according to bad habits we've fallen into they seemed crazy.' Which is the normal, which the abnormal? Hawks recognises, inchoately, that to most people his heroes, far from embodying rational values, are only a dwindling band of eccentrics. Hawks's 'kind of men' have no place in the world.

The Hawksian heroes, who exclude others from their own élite group, are themselves excluded from society, exiled to the African bush or to the Arctic. Outsiders, other people in general, are perceived by the group as an undifferentiated crowd. Their role is to gape at the deeds of the heroes whom, at the same

His Girl Friday, *the tormented insurance salesman.*

time, they hate. The crowd assembles to watch the showdown in *Rio Bravo*, to see the cars spin off the track in *The Crowd Roars*. The gulf between the outsider and the heroes transcends enmities among the élite: witness *Dawn Patrol* or Nelse in *El Dorado*. Most dehumanised of all is the crowd in *Land of the Pharaohs*, employed in building the Pyramids. Originally the film was to have been about Chinese labourers building a 'magnificent airfield' for the American army, but the victory of the Chinese Revolution forced Hawks to change his plans. ('Then I thought of the building of the Pyramids; I thought it was the same kind of story.') But the presence of the crowd, of external society, is a constant covert threat to the Hawksian élite, who retaliate by having 'fun'. In the crazy comedies ordinary citizens are turned into comic butts, lampooned and tormented: the most obvious target is the insurance salesman in *His Girl Friday*. Often Hawks's revenge becomes grim and macabre. In *Sergeant York* it is 'fun' to shoot Germans 'like turkeys'; in *Air Force* it is 'fun' to blow up the Japanese fleet. In *Rio Bravo* the geligniting of the badmen 'was very funny'. It is at these moments that the élite turns against the world outside and takes the opportunity to be brutal and destructive.

Besides the covert pressure of the crowd outside, there is also an overt force which threatens: woman. Man is woman's 'prey'. Women are admitted to the male group only after much disquiet and a long ritual courtship, phased round the offering, lighting and exchange of cigarettes, during which they prove themselves worthy of entry. Often they perform minor feats of valour. Even then though they are never really full members. A typical dialogue sums up their position:

Woman: You love him, don't you?
Man (embarrassed): Yes ... I guess so. ...
Woman: How can I love him like you?
Man: Just stick around.

The undercurrent of homosexuality in Hawks's films is never crystallised, though in *The Big Sky*, for example, it runs very close to the surface. And he himself described *A Girl in Every Port* as 'really a love story between two men'. For Hawks men are equals, within the group at least, whereas there is a clear identification between women and the animal world, most explicit in *Bringing Up Baby, Gentlemen Prefer Blondes* and *Hatari!* Man must strive to maintain his mastery. It is also worth noting that, in Hawks's adventure dramas and even in many of his comedies, there is no married life. Often the heroes were married or at least intimately committed, to a woman at some time in the distant past but have suffered an unspecified trauma, with the result that they have been suspicious of women ever since. Their attitude is 'Once bitten, twice shy'. This is in contrast to the films of Ford, which almost always include domestic scenes. Woman is not a threat to Ford's heroes; she falls into her allotted social place as wife and mother, bringing up the children, cooking, sewing, a life of service, drudgery and subordination. She is repaid for this by being sentimentalised. Boetticher, on the other hand, has no obvious place for women at all; they are phantoms, who provoke action, are pretexts for male modes of conduct, but have no authentic significance in themselves. 'In herself, the woman has not the slightest importance.'

Hawks sees the all-male community as an ultimate; obviously it is very retrograde. His Spartan heroes are, in fact, cruelly stunted. Hawks would be a lesser director if he was unaffected by this, if his adventure dramas were the sum total of his work. His real claim as an author lies in the presence, together with the dramas, of their inverse, the crazy comedies. They are the agonised exposure of the underlying tensions of the heroic dramas. There are two principal themes, zones of tension. The first is the theme of regression: of regression to childhood, infantilism, as in *Monkey Business*, or regression to savagery: witness the repeated scene of the adult about to be scalped by painted children, in *Monkey Business* and in *The Ransom of Red Chief*. With brilliant insight, Robin Wood has shown how *Scarface* should be categorised among the comedies rather than the dramas: Camonte is perceived as savage, child-like, subhuman. The second principal comedy theme is that of sex reversal and role reversal. *I Was a Male War Bride* is the most extreme example. Many of Hawks's comedies are centred round domineering women and timid, pliable men: *Bringing Up Baby* and *Man's Favorite Sport?* for example. There are often scenes of male sexual humiliation, such as the trousers being pulled off the hapless private eye in *Gentlemen Prefer Blondes*. In the same film the Olympic team of athletes are reduced to passive objects in an extraordinary Jane Russell song number; big-game hunting is lampooned, like fishing in *Man's Favorite Sport?* the theme of infantilism crops up again: 'The child was the most mature one on board the ship, and I think he was a lot of fun.'

Whereas the dramas show the mastery of man over nature, over woman, over the animal and childish, the comedies show his humiliation, his regression. The heroes become victims; society, instead of being excluded and despised, breaks in with irruptions of monstrous farce. It could well be argued that Hawks's outlook, the alternative world which he constructs in the cinema, the Hawksian heterocosm, is not one imbued with particular intellectual subtlety or sophistication. This does not detract from its force. Hawks first attracted attention because he was regarded naïvely as an action director. Later, the thematic content which I have outlined was

Women and the animal world: Hatari! *and (opposite)* Gentlemen Prefer Blondes.

detected and revealed. Beyond the stylemes, semantemes were found to exist; the films were anchored in an objective stratum of meaning, a plerematic stratum, as the Danish linguist Hjelmslev would put it. Thus the stylistic expressiveness of Hawks's films was shown to be not purely contingent, but grounded in significance.

Something further needs to be said about the theoretical basis of the kind of schematic exposition of Hawks's work which I have outlined. The 'structural approach' which underlies it, the definition of a core of repeated motifs, has evident affinities with methods which have been developed for the study of folklore and mythology. In the work of Olrik and others, it was noted that in different folk-tales the same motifs reappeared time and time again. It became possible to build up a lexicon of these motifs. Eventually Propp showed how a whole cycle of Russian fairy tales could be analysed into variations of a very limited set of basic motifs (or moves, as he called them). Underlying the different, individual tales was an archi-tale, of which they were all variants. One important point needs to be made about this type of structural analysis. There is a danger, as Lévi-Strauss has pointed out, that by simply noting and mapping resemblances, all the texts which are studied (whether Russian fairy tales or American movies) will be reduced to one, abstract and impoverished. There must be a moment of synthesis as well as a moment of analysis: otherwise, the method is Formalist, rather than truly Structuralist. Structuralist criticism cannot rest at the perception of resemblances or repetitions (redundancies, in fact), but must also comprehend a system of differences and oppositions. In this way, texts can be studied not only in their universality (what they all have in common) but also in their singularity (what differentiates them from each other). This means, of course,

that the test of a structural analysis lies not in the orthodox canon of a director's work, where resemblances are clustered, but in films which at first sight may seem eccentricities.

In the films of Howard Hawks a systematic series of oppositions can be seen very near the surface, in the contrast between the adventure dramas and the crazy comedies. If we take the adventure dramas alone it would seem that Hawks's work is flaccid, lacking in dynamism; it is only when we consider the crazy comedies that it becomes rich, begins to ferment: alongside every dramatic hero we are aware of a phantom, stripped of mastery, humiliated, inverted. With other directors, the system of oppositions is much more complex: instead of there being two broad strata of films there are a whole series of shifting variations. In these cases, we need to analyse the roles of the protagonists themselves, rather than simply the worlds in which they operate. The protagonists of fairy tales or myths, as Lévi-

Scarface: *Camonte with monkey.*

Gentlemen Prefer Blondes: *Jane Russell and the 'passive' Olympic team.*

My Darling Clementine: *Wyatt Earp at the barber's.*

The Searchers: *Ethan Edwards returns to the wilderness.*

Strauss has pointed out, can be dissolved into bundles of differential elements, pairs of opposites. Thus the difference between the prince and the goose-girl can be reduced to two antinomic pairs: one natural, male versus female, and the other cultural, high versus low. We can proceed with the same kind of operation in the study of films, though, as we shall see, we shall find them more complex than fairy tales.

It is instructive, for example, to consider three films of John Ford and compare their heroes: Wyatt Earp in *My Darling Clementine*, Ethan Edwards in *The Searchers* and Tom Doniphon in *The Man Who Shot Liberty Valance*. They all act within the recognisable Ford world, governed by a set of oppositions, but their *loci* within that world are very different. The relevant pairs of opposites overlap; different pairs are foregrounded in different movies. The most relevant are garden versus wilderness, ploughshare versus sabre, settler versus nomad, European versus Indian, civilised versus savage, book versus gun, married versus unmarried, East versus West. These antinomies can often be broken down further. The East, for instance, can be defined either as Boston or Washington and, in *The Last Hurrah*, Boston itself is broken down into the antipodes of Irish immigrants versus Plymouth Club, themselves bundles of such differential elements as Celtic versus Anglo-Saxon, poor versus rich, Catholic versus Protestant, Democrat versus Republican, and so on. At first sight, it might seem that the oppositions listed above overlap to the extent that they become practically synonymous, but this is by no means the case. As we shall see, part of the development of Ford's career has been the shift from an identity between civilised versus savage and European versus Indian to their separation and final reversal, so that in *Cheyenne Autumn* it is the Europeans who are savage, the victims who are heroes.

The master antinomy in Ford's films is that between the wilderness and the garden. As Henry Nash Smith has demonstrated, in his magisterial book *Virgin Land*, the contrast between the image of America as a desert and as a garden is one which has dominated American thought and literature, recurring in countless novels, tracts, political speeches and magazine stories. In Ford's films it is crystallised in a number of striking images. *The Man Who Shot Liberty Valance*, for instance, contains the image of the cactus rose, which encapsulates the antinomy between desert and garden which pervades the whole film. Compare with this the famous scene in *My Darling Clementine*, after Wyatt Earp has gone to the barber (who civilises the unkempt), where the scent of honeysuckle is twice remarked upon: an artificial perfume, cultural rather than natural. This moment marks the turning-point in Wyatt Earp's transition from wandering cowboy, nomadic, savage, bent on personal revenge, unmarried, to married man, settled, civilised, the sheriff who administers the law.

Earp, in *My Darling Clementine*, is structurally the most simple of the three protagonists I have mentioned: his progress is an uncomplicated passage from nature to culture, from the wilderness left in the past to the garden anticipated in the future. Ethan Edwards, in *The Searchers*, is more complex. He must be defined not in terms of past versus future or wilderness versus garden compounded in himself, but in relation to two other protagonists: Scar, the Indian chief, and the family of homesteaders. Ethan Edwards, unlike Earp, remains a nomad throughout the film. At the start, he rides in from the desert to enter the log-house; at the

end, with perfect symmetry, he leaves the house again to return to the desert, to vagrancy. In many respects, he is similar to Scar; he is a wanderer, a savage, outside the law: he scalps his enemy. But, like the homesteaders, of course, he is a European, the mortal foe of the Indian. Thus Edwards is ambiguous; the antinomies invade the personality of the protagonist himself. The oppositions tear Edwards in two; he is a tragic hero. His companion, Martin Pawley, however, is able to resolve the duality; for him, the period of nomadism is only an episode, which has meaning as the restitution of the family, a necessary link between his old home and his new home.

Ethan Edwards's wandering is, like that of many other Ford protagonists, a quest, a search. A number of Ford films are built round the theme of the quest for the Promised Land, an American re-enactment of the biblical Exodus, the journey through the desert to the land of milk and honey, the New Jerusalem. This theme is built on the combination of the two pairs: wilderness versus garden and nomad versus settler; the first pair precedes the second in time. Thus, in *Wagonmaster*, the Mormons cross the desert in search of their future home; in *How Green Was My Valley* and *The Informer*, the protagonists want to cross the Atlantic to a future home in the United States. But, during Ford's career, the situation of home is reversed in time. In *Cheyenne Autumn* the Indians journey in search of the home they once had in the past; in *The Quiet Man*, the American Sean Thornton returns to his ancestral home in Ireland. Ethan Edwards's journey is a kind of parody of this theme: his object is not constructive, to found a home, but destructive, to find and scalp Scar. Nevertheless, the weight of the film remains oriented to the future: Scar has burned down the home of the settlers, but it is replaced and we are confident that the homesteader's wife, Mrs Jorgensen, is right when she says: 'Some day this country's going to be a fine place to live.' The wilderness will, in the end, be turned into a garden.

The Man Who Shot Liberty Valance has many similarities with *The Searchers*. We may note three: the wilderness becomes a garden – this is made quite explicit, for Senator Stoddart has wrung from Washington the funds necessary to build a dam which will irrigate the desert and bring real roses, not cactus roses; Tom Doniphon shoots Liberty Valance as Ethan Edwards scalped Scar; a log-home is burned to the ground. But the differences are equally clear: the log-home is burned after the death of Liberty Valance; it is destroyed by Doniphon himself; it is his own home. The burning marks the realisation that he will never enter the Promised Land, that to him it means nothing; that he has doomed himself to be a creature of the past, insignificant in the world of the future. By shooting Liberty Valance he has destroyed the only world in which he himself can exist, the world of the gun rather than the book; it is as though Ethan Edwards had perceived that by scalping Scar, he was in reality committing suicide. It might be mentioned too that, in *The Man Who Shot Liberty Valance*, the woman who loves Doniphon marries Senator Stoddart. Doniphon when he destroys his log-house (his last words before doing so are 'Home, sweet home!') also destroys the possibility of marriage.

The themes of *The Man Who Shot Liberty Valance* can be expressed in another way. Ransom Stoddart represents rational–legal authority, Tom Doniphon represents charismatic authority. Doniphon abandons his charisma and cedes it, under what amounts to false pretences, to Stoddart. In this way charismatic and

The Man Who Shot Liberty Valance:
the showdown.

The Man Who Shot Liberty Valance.

Donovan's Reef: *the Polynesians.*

Cheyenne Autumn: *the Indians.*

rational–legal authority are combined in the person of Stoddart and stability thus assured. In *The Searchers* this transfer does not take place; the two kinds of authority remain separated. In *My Darling Clementine* they are combined naturally in Wyatt Earp, without any transfer being necessary. In many of Ford's late films – *The Quiet Man, Cheyenne Autumn, Donovan's Reef* – the accent is placed on traditional authority. The island of Ailakaowa, in *Donovan's Reef*, a kind of Valhalla for the homeless heroes of *The Man Who Shot Liberty Valance*, is actually a monarchy, though complete with the Boston girl, wooden church and saloon, made familiar by *My Darling Clementine*. In fact, the character of Chihuahua, Doc Holliday's girl in *My Darling Clementine*, is spilt into two: Miss Lafleur and Lelani, the native princess. One represents the saloon entertainer, the other the non-American in opposition to the respectable Bostonians, Amelia Sarah Dedham and Clementine Carter. In a broad sense, this is a part of a general movement which can be detected in Ford's work to equate the Irish, Indians and Polynesians as traditional communities, set in the past, counterposed to the march forward to the American future, as it has turned out in reality, but assimilating the values of the American future as it was once dreamed.

It would be possible, I have no doubt, to elaborate on Ford's career, as defined by pairs of contrasts and similarities, in very great detail, though – as always with film criticism – the impossibility of quotation is a severe handicap. My own view is that Ford's work is much richer than that of Hawks and that this is revealed by a structural analysis; it is the richness of the shifting relations between antinomies in Ford's work that makes him a great artist, beyond being simply an undoubted auteur. Moreover, the auteur theory enables us to reveal a whole complex of meaning in films such as *Donovan's Reef*, which a recent filmography sums up as just 'a couple of Navy men who have retired to a South Sea island now spend most of their time raising hell'. Similarly, it throws a completely new light on a film like *Wings of Eagles*, which revolves, like *The Searchers*, round the vagrancy-versus-home antinomy, with the difference that when the hero does come home, after flying round the world, he trips over a child's toy, falls down the stairs and is completely paralysed so that he cannot move at all, not even his toes. This is the macabre *reductio ad absurdum* of the settled.

Perhaps it would be true to say that it is the lesser auteurs who can be defined, as Nowell-Smith put it, by a core of basic motifs which remain constant, without variation. The great directors must be defined in terms of shifting relations, in their singularity as well as their uniformity. Renoir once remarked that a director spends his whole life making one film; this film, which it is the task of the critic to construct, consists not only of the typical features of its variants, which are merely its redundancies, but of the principle of variation which governs it, that is its esoteric structure, which can only manifest itself or 'seep to the surface', in Lévi-Strauss's phrase, 'through the repetition process'. Thus Renoir's 'film' is in reality a 'kind of permutation group, the two variants placed at the far ends being in a symmetrical, though inverted, relationship to each other'. In practice, we will not find perfect symmetry, though as we have seen, in the case of Ford, some antinomies are completely reversed. Instead, there will be a kind of torsion within the permutation group, within the matrix, a kind of exploration of certain possibilities, in which some antinomies are foregrounded, discarded or even inverted,

whereas others remain stable and constant. The important thing to stress, however, is that it is only the analysis of the whole *corpus* which permits the moment of synthesis when the critic returns to the individual film.

Of course, the director does not have full control over his work; this explains why the auteur theory involves a kind of decipherment, decryptment. A great many features of the films analysed have to be dismissed as indecipherable because of 'noise' from the producer, the cameraman or even the actors. This concept of 'noise' needs further elaboration. It is often said that film is the result of a multiplicity of factors, the sum total of a number of different contributions. The contribution of the director – the 'directorial factor', as it were – is only one of these, though perhaps the one which carries the most weight. I do not need to emphasise that this view is quite the contrary of the auteur theory and has nothing in common with it at all. What the auteur theory does is to take a group of films – the work of one director – and analyse their structure. Everything irrelevant to this, everything non-pertinent, is considered logically secondary, contingent, to be discarded. Of course, it is possible to approach films by studying some other feature; by an effort of critical ascesis we could see films, as Sternberg sometimes urged, as abstract light-show or as histrionic feasts. Sometimes these separate texts – those of the cameraman or the actors – may force themselves into prominence so that the film becomes an indecipherable palimpsest. This does not mean, of course, that it ceases to exist or to sway us or please us or intrigue us; it simply means that it is inaccessible to criticism. We can merely record our momentary and subjective impressions.

Myths, as Lévi-Strauss has pointed out, exist independently of style, the syntax of the sentence or musical sound, euphony or cacophony. The myth functions 'on an especially high level where meaning succeeds practically in "taking off" from the linguistic ground on which it keeps rolling'. *Mutatis mutandis*, the same is true of the auteur film. 'When a mythical schema is transmitted from one population to another, and there exist differences of language, social organisation or way of life which make the myth difficult to communicate, it begins to become impoverished and confused.' The same kind of impoverishment and confusion takes place in the film studio, where difficulties of communication abound. But none the less the film can usually be discerned, even if it was a quickie made in a fortnight without the actors or the crews that the director might have liked, with an intrusive producer and even, perhaps, a censor's scissors cutting away vital sequences. It is as though a film is a musical composition rather than a musical performance, although, whereas a musical composition exists *a priori* (like a scenario), an auteur film is constructed *a posteriori*. Imagine the situation if the critic had to construct a musical composition from a number of fragmentary, distorted versions of it, all with improvised passages or passages missing.

The distinction between composition and performance is vital to aesthetics. The score, or text, is constant and durable; the performance is occasional and transient. The score is unique, integrally itself; the performance is a particular among a number of variants. The score, in music, consists partly of a message to be translated from one channel to another (from 'the stream of ink' to the 'stream of air') and partly of a set of instructions. In some modern scores, by Lamonte Young or George Brecht, there are only instructions; others, by Cornelius Cardew,

for instance, are literary texts, which have to be translated between codes (verbal and musical) as well as between channels. But the principle remains the same. Both messages and instructions must necessarily refer back to a common code, so that they are intelligible to the performer. The performance itself, however, is not coded; hence its ungeneralised particularity. The distinctive marks of a performance, like those of somebody's accent or tone of voice, are facultative variants. A coded text consists of discrete units; a performance is continuous, graded rather than coded. It works more like an analog computer than a digital one; it is similar to a clock rather than a calendar, a slide-rule rather than an abacus. The intelligibility of a performance of a piece of music is of a different kind to the intelligibility of a score. Here we confront the distinction made by Galvano della Volpe, referred to elsewhere in this book, between the realm in which *de jure* criticism is possible and the realm in which criticism can only be *de facto*, 'the kingdom of more or less', as Nicholas Ruwet has called it in his study of the semiology of music.

Linguists have often striven to restrict their field of study to the coded aspects of texts and to expel graded features, such as accents, grunts, rasps, chuckles, wails and so on. Charles F. Hockett, for example, has written that:

> the embedding medium of linguistic messages ... shows a continuous scale of dynamics, organised to some extent in any given culture; one may speak softly, or more loudly, or more loudly still, or anywhere in between – with no theoretic limit to the fineness of gradation. But ... in general ... if we find continuous-scale contrasts in the vicinity of what we are sure is language, we exclude them from language (though not from culture).

Other linguists have contested this epistemological asceticism. Thomas A. Sebeok, for instance, has argued against Hockett and others, and demanded a radical rethinking of the relationship between coded and graded features of language. His own work in zoo-linguistics, communication among animals, has led him to the conclusion that discrete units cannot be absolutely separated from their 'embedding medium'; if linguists expel continuous phenomena from their field of study they cannot then account, for instance, for linguistic change. Similar conclusions could be reached by considering the relations between composition and performance. There is no unbridged abyss between the two.

Painting provides a particularly interesting example. At one time, during the Renaissance and Mannerist periods, many paintings were initially composed and designed by an iconographic programmer, expert in mythology or biblical studies, and then executed by the painter. Some of these programmes have survived. Thus, for example, the marvellous Farnese Palace at Caprarola was decorated throughout according to a scheme elaborated by three humanist scholars, Annibale Caro, Onophrio Panvinio and Fulvio Orsini. The scheme was extremely detailed. For the ceiling of the study, the Stanza della Solitudine, Caro outlined the following programme, in a letter to Panvinio:

> Thus in one of the large pictures of the middle I would show the solitude of Christians: and in the middle of this I would represent Christ Our Lord, and then on

the sides in the following order, St Paul the Apostle, St John the Baptist, St Jerome, St Francis, and others if it can contain more, who would come out from the desert at different places and would go and meet the people to preach the evangelical doctrine, showing the desert on one side of the painting and the people on the other. In the opposite picture, I would show, as a contrast, the solitude of the pagans . . .

and so on. A letter also survives from Caro to Taddeo Zuccaro, the painter. Evidently, this kind of iconographic programming has its similarities with a scenario.

Gradually, however, the painter emancipated himself from the iconographic programmer. We can see the beginnings of this, indeed, even in the case of Caprarola; Caro complained to Panvinio that either the programme 'must be adapted to the disposition of the painter, or his disposition to your subjects, and since it is obvious that he has refused to adapt himself to you, we must, perforce, adapt ourselves to him to avoid disorder and confusion'. That was in 1575. Fourteen years later, in 1589, the sculptor Giambologna proved even more headstrong: he sent a bronze to his patron which, he remarked, 'might represent the Rape of Helen, or perhaps of Proserpine, or even one of the Sabines'. According to a contemporary he made sculptures 'solely to show his excellence in art and without having any subject in mind'. This was unusual at the time. Most painters submitted to some kind of iconographical programming for many years after Giambologna made his break for freedom. During the seventeenth century, it was still widely felt that verbal language and Alciati's 'syntax of symbols' were mutually translatable. Shaftesbury, as late as 1712, was programming a complicated allegorical 'draught or tablature' of the Judgement of Hercules. This was to be painted by Paulo de Matthaeis, but it was made perfectly clear that he was to be the subordinate partner in the enterprise.

Shaftesbury came down clearly on the side of design and repeatedly diminished the importance of colouring, which he regarded as 'false relish, which is governed rather by what immediately strikes the sense, than by what consequentially and by reflection pleases the mind, and satisfies the thought and reason'. Painting, as such, gave no more pleasure than 'the rich stuffs and coloured silks worn by our ladies'. Elsewhere he wrote that:

the good painter (quatenus painter) begins by working first within. Here the imagery! Here the plastic work! First makes forms, fashions, corrects, amplifies, contracts, unites, modifies, assimilates, adapts, conforms, polishes, refines etc., forms his ideas: then his hand: his strokes.

Shaftesbury was trying to hold back a tide much too strong for him. Painting succumbed to

the je ne sais quoi to which idiots and the ignorant of the art would reduce everything. 'Tis not the dokei, the I like and you like. But why do I like? And if not with reason and truth I will refuse to like, dislike my fancy, condemn the form, search it, discover its deformity and reject it.

Shaftesbury's platonising and allegorising were swept away by the full flood of Romanticism.

Yet even during the nineteenth century we can still see traces of the old attitudes. The Pre-Raphaelites worked from extremely detailed programmes; even Courbet painted what he called a 'real allegory'. Gauguin programmed his paintings but according to a system effectively opaque to anybody but himself. And, at the beginning of this century, Marcel Duchamp rebelled against what he called 'retinal' painting and the validation of the painter's touch – *la patte*, his 'paw'. The *Large Glass* was based upon the complicated notes and diagrams which Duchamp later published in the *Green Box*: 'It had to be planned and drawn as an architect would do it.' In a similar spirit, László Moholy-Nagy produced paintings by telephone, dictating instructions about the use of graph paper and standardised colours. Thus the wheel came full circle. The painter, after the long and successful struggle to emancipate himself from the iconographer, reacted against the outcome and strove to turn himself into a designer in his own right. One dimension of the history of painting lies in this shifting interaction between composition and performance.

However, it is not only in painting that the performer has made efforts to emancipate himself from the designer. Even in music, which seems the most stable art in this respect, there have been intermittent periods in which improvisation has been highly valued. And, of course, jazz provides a striking example. To begin with, jazz musicians improvised on tunes which they took from a repertory: march tunes, popular songs. Later they began to write their own tunes and use these as a basis for improvisation. Finally, they began to become primarily composers and only secondarily performers. The legal battle over whether Ornette Coleman should be categorised as a classical or a popular musician recalls the very similar battles which took place during the Renaissance over the disputed status of the painter, whether he was an artist or an artificer. Conversely, an opposite movement has taken place within legitimate music, allowing the performers much greater freedom to interpret and improvise. Thus the score of Cornelius Cardew's *Treatise* only partially and sporadically refers back to a common code; it oscillates between a discrete and continuous notation, between the coded and the graded.

Closer to the cinema has been the experience of the theatre. The polemic of Ben Jonson against Inigo Jones might well be that of a scriptwriter against a director more concerned with visual values:

> ... O Showes! Showes! Mighty Showes!
> The Eloquence of Masques! What need of prose
> Or Verse, or Sense t'express Immortall you?
> You are the Spectacles of State! 'Tis true
> Court Hieroglyphicks! and all Artes affoord
> In the mere perspective of an Inch board!
> You aske noe more then certeyne politique Eyes,
> Eyes that can pierce into the Misteryes
> Of many Coulors! read them! and reveale
> Mythology there painted on slit deale!
> Oh, to make Boardes to speake! There is a taske!
> Painting and Carpentry are the Soule of Masque!
> Pack with your pedling Poetry to the State!
> This is the money-gett, Mechanick Age!

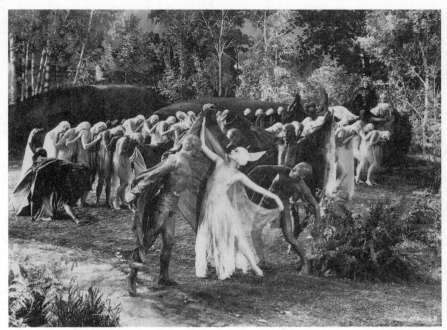

Reinhardt and Dieterle's A Midsummer Night's Dream.

The accusation of commercialism and mechanicality is all too familiar. Ben Jonson's complaint is based on an assumption of the superiority of verbal language, the inadequacy of emblems and images. The theatre has oscillated between two modes of communication. A very similar impulse to that which motivated masque, a downgrading of the literary text, made itself felt at the end of the nineteenth and the beginning of the twentieth centuries, springing in part from the theory and practice of Wagner, developed at Bayreuth. Edward Gordon Craig stressed the non-verbal dimensions of the theatre and the sovereignty of the director; his theories made a particular impact in Germany and in Russia, where he was invited to work. In Russia, we can trace a direct link from Craig, through Meyerhold to the work of Eisenstein, first at the Proletcult Theatre, then in the cinema. In Germany, Max Reinhardt was the analogue to Meyerhold; he had an equivalent kind of effect on the German Expressionist cinema: even Sternberg has acknowledged his admiration of Reinhardt. For Meyerhold, words were no longer sacrosanct: plays were ruthlessly altered and adapted. There was a counter-stress on the specifically theatrical modes of expression: mime, *commedia dell'arte*, set design, costume, acrobatics and the circus, the performing art *par excellence*. Meyerhold and Reinhardt insisted on full control. Ironically, when Reinhardt did make a film, *A Midsummer Night's Dream* in Hollywood, he was made to share the direction with an established cinema director, William Dieterle. None the less his work in theatre pointed forward to the cinema.

Even in literature, it should be said, the relationship between composition and performance occasionally varies. Most literary works used to be spoken aloud and

this persisted, even with prose, until quite recently: Benjamin Constant read *Adolphe* aloud numerous times before it ever saw print; Dickens had immensely successful recital tours. There is still a strong movement in favour of reading poetry aloud. Of course, literacy and printing have diminished the social importance of this kind of performance. Ever since St Ambrose achieved the feat of reading to himself, the performance of literary works has been doomed to be secondary. Yet, during the nineteenth century, as literacy rose, the fall of public readings was accompanied by its converse, a rising interest in typography. The typographer has become, potentially, a kind of interpreter of a text, like a musician. Early instances of creative typography can be seen in *Tristram Shandy* and the work of Baroque poets such as Quarles and Herbert. But the modern movement springs from the convergence of Morris's concern over typography and book design, spread through the Arts and Crafts guilds and Art Nouveau, with the innovations of Mallarmé. In the first decades of the century there was a great upsurge of interest in typography – Pound, Apollinaire, Marinetti, El Lissitsky, Picabia, *De Stijl*, the Bauhaus – which is still bearing fruit today. A worldwide Concrete Poetry movement has grown up, in which poets collaborate with typographers.

The cinema, like all these other arts, has a composition side and a performance side. On the one hand there is the original story, novel or play and the shootingscript or scenario. Hitchcock and Eisenstein draw sequences in advance in a kind of strip-cartoon form. On the other hand, there are the various levels of execution: acting, photography, editing. The director's position is shifting and ambiguous. He both forms a link between design and performance and can command or participate in both. Different directors, of course, lean in different directions. Partly this is the result of their backgrounds: Mankiewicz and Fuller, for instance, began as scriptwriters; Sirk as a set-designer; Cukor as a theatre director; Siegel as an editor and montage director; Chaplin as an actor; Klein and Kubrick as photographers. Partly too it depends on their collaborators: Cukor works on colour design with Hoyningen-Huene because he respects his judgement. And most directors, within limits, can choose who they work with.

What the auteur theory demonstrates is that the director is not simply in command of a performance of a pre-existing text; he is not, or need not be, only a *metteur en scène*. Don Siegel was asked on television what he took from Hemingway's short story for his film, *The Killers*; Siegel replied that 'the only thing taken from it was the catalyst that a man has been killed by somebody and he did not try to run away'. The word Siegel chose – 'catalyst' – could not be bettered. Incidents and episodes in the original screenplay or novel can act as catalysts; they are the agents which are introduced into the mind (conscious or unconscious) of the auteur and react there with the motifs and themes characteristic of his work. The director does not subordinate himself to another author; his source is only a pretext, which provides catalysts, scenes which fuse with his own preoccupations to produce a radically new work. Thus the manifest process of performance, the treatment of a subject, conceals the latent production of a quite new text, the production of the director as an auteur.

Of course, it is possible to value performances as such, to agree with André Bazin that Olivier's *Henry V* was a great film, a great rendering, transposition into the

Laurence Olivier's Henry V.

cinema, of Shakespeare's original play. The great *metteurs en scène* should not be discounted simply because they are not auteurs: Vincente Minnelli, perhaps, or Stanley Donen. And, further than that, the same kind of process can take place that occurred in painting: the director can deliberately concentrate entirely on the stylistic and expressive dimensions of the cinema. He can say, as Josef von Sternberg did about *Morocco*, that he purposely chose a fatuous story so that people would not be distracted from the play of light and shade in the photography. Some of Busby Berkeley's extraordinary sequences are equally detached from any kind of dependence on the screenplay: indeed, more often than not, some other director was entrusted with the job of putting the actors through the plot and dialogue.

Busby Berkeley sequence in Gold-Diggers of 1933.

Moreover, there is no doubt that the greatest films will be not simply auteur films but marvellous expressively and stylistically as well: *Lola Montès, Shinheike Monogatari, La Règle du jeu, La signora di Tutti, Sansho Dayu, Le Carrosse d'or.*

The auteur theory leaves us, as every theory does, with possibilities and questions. We need to develop much further a theory of performance, of the stylistic, of graded rather than coded modes of communication. We need to investigate and define, to construct critically the work of enormous numbers of directors who until now have only been incompletely comprehended. We need to begin the task of comparing author with author. There are any number of specific problems which stand out: Donen's relationship to Kelly and Arthur Freed, Boetticher's films outside the Ranown cycle, Welles's relationship to Toland (and – perhaps more important – Wyler's), Sirk's films outside the Ross Hunter cycle, the exact identity of Walsh or Wellman, the decipherment of Anthony Mann. Moreover, there is no reason why the auteur theory should not be applied to the English cinema, which is still utterly amorphous, unclassified, unperceived. We need not two or three books on Hitchcock and Ford, but many, many more. We need comparisons with authors in the other arts: Ford with Fenimore Cooper, for example, or Hawks with Faulkner. The task which the critics of *Cahiers du Cinéma* embarked on is still far from completed.

3
The Semiology of the Cinema

In recent years a considerable degree of interest has developed in the semiology of the cinema, in the question of whether it is possible to dissolve cinema criticism and cinema aesthetics into a special province of the general science of signs. It has become increasingly clear that traditional heroes of film language and film grammar, which grew up spontaneously over the years, need to be re-examined and related to the established discipline of linguistics. If the concept of 'language' is to be used it must be used scientifically and not simply as a loose, though suggestive, metaphor. The debate which has arisen in France and Italy, round the work of Roland Barthes, Christian Metz, Pier Paolo Pasolini and Umberto Eco, points in this direction.

The main impulse behind the work of these critics and semiologists springs from Ferdinand de Saussure's *Course in General Linguistics*. After Saussure's death in 1913 his former pupils at the University of Geneva collected and collated his lecture outlines and their own notes and synthesised these into a systematic presentation, which was published in Geneva in 1915. In the *Course* Saussure predicted a new science, the science of semiology.

> A science that studies the life of signs within society is conceivable; it would be part of social psychology and consequently of general psychology; I shall call it semiology (from Greek *semeion*, 'sign'). Semiology would show what constitutes signs, what laws govern them. Since the science does not yet exist, no one can say what it would be; but it has a right to existence, a place staked out in advance. Linguistics is only a part of the general science of semiology; the laws discovered by semiology will be applicable to linguistics, and the latter will circumscribe a well-defined area within the mass of anthropological facts.

Saussure, who was impressed by the work of Emile Durkheim (1858–1917) in sociology, emphasised that signs must be studied from a social viewpoint, that language was a social institution which eluded the individual will. The linguistic system – what might nowadays be called the 'code' – pre-existed the individual act of speech, the 'message'. Study of the system therefore had logical priority.

Saussure stressed, as his first principle, the arbitrary nature of the sign. The signifier (the sound-image *o-k-s* or *b-ö-f*, for example) has no natural connection with the signified (the concept 'ox'). To use Saussure's term, the sign is 'unmotivated'. Saussure was not certain what the full implications of the arbitrary nature of the linguistic sign were for semiology:

When semiology becomes organised as a science, the question will arise whether or not it properly includes modes of expression based on complete natural signs, such as pantomime. Supposing the new science welcomes them, its main concern will still be the whole group of systems grounded on the arbitrariness of the sign. In fact, every means of expression used in society is based, in principle, on collective behaviour or – what amounts to the same thing – on convention. Polite formulas, for instance, although often imbued with a certain natural expressiveness (as in the case of a Chinese who greets his emperor by bowing down to the ground nine times), are none the less fixed by rule; it is this rule and not the intrinsic value of the gestures that obliges one to use them. Signs that are wholly arbitrary realise better than the others the ideal of the semiological process; that is why language, the most complex and universal of all systems of expression, is also the most characteristic; in this sense linguistics can become the master-pattern for all branches of semiology although language is only one particular semiological system.

Linguistics was to be both a special province of semiology and, at the same time, the master-pattern ('le patron général') for the various other provinces. All the provinces, however – or, at least, the central ones – were to have as their object systems 'grounded on the arbitrariness of the sign'. These systems, in the event, proved hard to find. Would-be semiologists found themselves limited to such micro-languages as the language of traffic-signs, the language of fans, ships' signalling systems, the language of gesture among Trappist monks, various kinds of semaphore and so on. These micro-languages proved extremely restricted cases, capable of articulating a very sparse semantic range. Many of them were parasitic on verbal language proper. Roland Barthes, as a result of his researches into the language of costume, concluded that it was impossible to escape the pervasive presence of verbal language. Words enter into discourse of another order either to fix an ambiguous meaning, like a label or a title, or to contribute to the meaning that cannot otherwise be communicated, like the words in the bubbles in a strip-cartoon. Words either anchor meaning or convey it.

It is only in very rare cases that non-verbal systems can exist without auxiliary support from the verbal code. Even highly developed and intellectualised systems like painting and music constantly have recourse to words, particularly at a popular level: songs, cartoons, posters. Indeed, it would be possible to write the history of painting as a function of the shifting relation between words and images. One of the main achievements of the Renaissance was to banish words from the picture space. Yet words repeatedly forced themselves back; they reappear in the paintings of El Greco, for instance, in Dürer, in Hogarth: one could give countless examples. In the twentieth century words have returned with a vengeance. In music, words were not banished until the beginning of the seventeenth century; they have asserted themselves in opera, in oratorio, in *Lieder*. The cinema is another obvious case in point. Few silent films were made without intertitles. Erwin Panofsky has recollected his cinema-going days in Berlin around 1910:

The producers employed means of clarification similar to those we find in medieval art. One of these was printed titles or letters, striking equivalents of the medieval *tituli* and scrolls (at a still earlier date there even used to be explainers who

Hogarth's Industry and Idleness: *words in the visual arts.*

would say, *viva voce*, 'Now he thinks his wife is dead but she isn't' or 'I don't wish to offend the ladies in the audience but I doubt that any of them would have done that much for her child').

In Japan, 'explainers' of this kind formed themselves into a guild, which proved strong enough to delay the advent of the talkie.

In the end Barthes reached the conclusion that semiology might be better seen as a branch of linguistics, rather than the other way round. This seems a desperate conclusion. The province turns out to be so much 'the most complex and universal' that it engulfs the whole. Yet our experience of cinema suggests that great complexity of meaning can be expressed through images. Thus, to take an obvious example, the most trivial and banal book can be made into an extremely interesting and, to all appearances, significant film; reading a screenplay is usually a barren and arid experience, intellectually as well as emotionally. The implication of this is that it is not only systems exclusively 'grounded on the arbitrariness of the sign' which are expressive and meaningful. 'Natural signs' cannot be as readily dismissed as Saussure imagined. It is this demand for the reintegration of the natural sign into semiology which led Christian Metz, a disciple of Barthes, to declare that cinema is indeed a language, but language without a code (without a *langue*, to use Saussure's term). It is a language because it has texts; there is a meaningful discourse. But, unlike verbal language, it cannot be referred back to a pre-existent code. Metz's position involves him in a considerable number of problems which he never satisfactorily surmounts; he is forced back to the concept of 'a "logic of implication" by which the image becomes language'; he quotes with approval Béla Balázs's contention that it is through a 'current of induction' that we make sense of a film. It is not made clear whether we have to learn this logic or

The poster: words in painting. Toulouse Lautrec's Jane Avril.

whether it is natural. And it is difficult to see how concepts like 'logic of impli-
cation' and 'current of induction' can be integrated into the theory of semiology.

What is needed is a more precise discussion of what we mean by a 'natural sign'
and by the series of words such as 'analogous', 'continuous', 'motivated', which are
used to describe such signs, by Barthes, Metz and others. Fortunately the ground-
work necessary for further precision has already been accomplished by Charles
Sanders Peirce, the American logician. Peirce was a contemporary of Saussure; like
Saussure his papers were collected and published posthumously, between 1931

and 1935, twenty years after his death in 1914. Peirce was the most original American thinker there has been, so original, as Roman Jakobson has pointed out, that for a great part of his working life he was unable to obtain a university post. His reputation now rests principally on his more accessible work, mainly his teachings on pragmatism. His work on semiology (or 'semiotic' as he himself called it) has been sadly neglected. Unfortunately, his most influential disciple, Charles Morris, travestied his position by coupling it with a virulent form of Behaviourism. Severe criticisms of Behaviourism in relation to linguistics and aesthetics, from writers such as E. H. Gombrich and Noam Chomsky, have naturally tended to damage Peirce by association with Morris. However, in recent years, Roman Jakobson has done a great deal to reawaken interest in Peirce's semiology, a revival of enthusiasm long overdue.

The main texts which concern us here are his *Speculative Grammar*, the letters to Lady Welby and *Existential Graphs* (subtitled 'my *chef d'œuvre*' by Peirce). These books contain Peirce's taxonomy of different classes of sign, which he regarded as the essential semiological foundation for a subsequent logic and rhetoric. The classification which is important to the present argument is that which Peirce called 'the second trichotomy of signs', their division into icons, indices and symbols. 'A sign is either an *icon*, an *index* or a *symbol*.'

An icon, according to Peirce, is a sign which represents its object mainly by its similarity to it; the relationship between signifier and signified is not arbitrary but is one of resemblances or likeness. Thus, for instance, the portrait of a man resembles him. Icons can, however, be divided into two sub-classes: images and diagrams. In the case of images 'simple qualities' are alike; in the case of diagrams the 'relations between the parts'. Many diagrams, of course, contain symboloid features; Peirce readily admitted this, for it was the dominant aspect or dimension of the sign which concerned him.

An index is a sign by virtue of an existential bond between itself and its object. Peirce gave several examples.

> I see a man with a rolling gait. This is a probable indication that he is a sailor. I see a bowlegged man in corduroys, gaiters and a jacket. These are probable indications that he is a jockey or something of the sort. A sundial or clock indicates the time of day.

Other examples cited by Peirce are the weathercock, a sign of the direction of the wind which physically moves it, the barometer, the spirit-level. Roman Jakobson cites Man Friday's footprint in the sand and medical symptoms, such as pulse rates, rashes and so on. Symptomatology is a branch of the study of the indexical sign.

The third category of sign, the symbol, corresponds to Saussure's arbitrary sign. Like Saussure, Peirce speaks of a 'contract' by virtue of which the symbol is a sign. The symbolic sign eludes the individual will. 'You can write down the word "star", but that does not make you the creator of the word, nor if you erase it have you destroyed the word. The word lives in the minds of those who use it.' A symbolic sign demands neither resemblance to its object nor an existential bond with it. It is conventional and has the force of a law. Peirce was concerned about the appropriateness of calling this kind of sign a 'symbol', a possibility which Saussure also

considered but rejected because of the danger of confusion. However, it seems certain that Saussure over-restricted the notion of sign by limiting it to Peirce's 'symbolic'; moreover, Peirce's trichotomy is elegant and exhaustive. The principal remaining problem, the categorisation of such so-called 'symbols' as the scales of justice or the Christian cross, is one that is soluble within Peirce's system, as I shall show later.

Peirce's categories are the foundation for any advance in semiology. It is important to note, however, that Peirce did not consider them to be mutually exclusive. On the contrary, all three aspects frequently – or, he sometimes suggests, invariably – overlap and are co-present. It is this awareness of overlapping which enabled Peirce to make some particularly relevant remarks about photography.

> Photographs, especially instantaneous photographs, are very instructive, because we know that in certain respects they are exactly like the objects they represent. But this resemblance is due to the photographs having been produced under such circumstances that they were physically forced to correspond point by point to nature. In that aspect, then, they belong to the second class of signs, those by physical connection.

That is, to the indexical class. Elsewhere he describes a photographic print as a 'quasi-predicate', of which the light rays are the 'quasi-subject'.

Among European writers on semiology Roland Barthes reaches somewhat similar conclusions, though he does not use the category 'indexical', but sees the photographic print simply as 'iconic'. However, he describes how the photographic icon represents 'a kind of natural *being-there* of the object'. There is no human intervention, no transformation, no code, between the object and the sign; hence the paradox that a photograph is a message without a code. Christian Metz makes the transition from photography to cinema. Indeed, Metz verges upon using Peirce's concepts, mediated to him through the work of André Martinet.

> A close-up of a revolver does not signify 'revolver' (a purely potential lexical unit) – but signifies *as a minimum*, leaving aside its connotations, 'Here is a revolver.' It carries with it is own actualisation, a kind of 'Here is' ('*Voici*': the very word which André Martinet considers to be a pure index of actualisation).

It is curious that Metz, in his voluminous writings, does not lay much greater stress on the analysis of this aspect of the cinema, since he is extremely hostile to any attempt to see the cinema as a symbolic process which refers back to a code. In fact, obscured beneath his semiological analysis is a very definite and frequently overt aesthetic *parti pris*. For, like Barthes and Saussure, he perceives only two modes of existence for the sign, natural and cultural. Moreover, he is inclined to see these as mutually exclusive, so that a language must be either natural or cultural, uncoded or coded. It cannot be both. Hence Metz's view of the cinema turns out like a curious inverted mirror image of Noam Chomsky's view of verbal language; whereas Chomsky banishes the ungrammatical into outer darkness, Metz banishes the grammatical. The work of Roman Jakobson, influenced by Peirce, is, as we shall see, a corrective to both these views. The cinema contains all three modes of the sign:

indexical, iconic and symbolic. What has always happened is that theorists of the cinema have seized on one or other of these dimensions and used it as the ground for an aesthetic firman. Metz is no exception.

In his aesthetic preferences, Metz is quite clearly indebted to André Bazin, the most forceful and intelligent protagonist of 'realism' in the cinema. Bazin was one of the founders of *Cahiers du Cinéma* and wrote frequently in *Esprit*, the review founded by Emmanuel Mounier, the Catholic philosopher, originator of Personalism and the most important intellectual influence on Bazin. Many people have commented on the way in which Bazin modelled his style, somewhat

Fritz Lang's Nibelungen.

abstruse, unafraid of plunging into the problems and terminology of philosophy, on that of Mounier. Bazin became interested in the cinema during his military service at Bordeaux in 1939. After his return to Paris he organised, in collaboration with friends from *Esprit*, clandestine film shows; during the German Occupation he showed films such as Fritz Lang's *Metropolis* and the banned works of Chaplin. Then, after the Liberation, he became one of the dominant figures in orienting the fantastic efflorescence of cinema culture which grew up in the clubs, in Henri Langlois's magnificent *Cinémathèque*, in the commercial cinemas, where American films once again reappeared. During this time, perhaps most important of all, Bazin developed his aesthetics of the cinema, an aesthetics antithetical to the 'pure cinema' of Delluc and the 'montage' theory of Malraux's celebrated article in *Verve*. A new direction was taken.

Bazin's starting-point is an ontology of the photographic image. His conclusions are remarkably close to those of Peirce. Time and again Bazin speaks of photography in terms of a mould, a death-mask, a Veronica, the Holy Shroud of Turin, a relic, an imprint. Thus Bazin speaks of 'the lesser plastic arts, the moulding of death-masks for example, which likewise involves a certain automatic process. One might consider photography in this sense as a moulding, the taking of an impression, by the manipulation of light.' Thus Bazin repeatedly stresses the existential bond between sign and object which, for Peirce, was the determining characteristic of the indexical sign. But whereas Peirce made his observation in order to found a logic, Bazin wished to found an aesthetic. 'Photography affects us like a phenomenon in nature, like a flower or a snowflake whose vegetable or earthly origins are an inseparable part of their beauty.' Bazin's aesthetic asserted the primacy of the object over the image, the primacy of the

The Cabinet of Dr. Caligari.

natural world over the world of signs. 'Nature is always photogenic': this was Bazin's watchword.

Bazin developed a bi-polar view of the cinema. On the one hand was Realism ('The good, the true, the just', as Godard was later to say of the work of Rossellini); on the other hand was Expressionism, the deforming intervention of human agency. Fidelity to nature was the necessary touchstone of judgement. Those who transgressed, Bazin denounced: Fritz Lang's *Nibelungen, The Cabinet of Dr Caligari*. He recognised the Wagnerian ambitions of Eisenstein's *Ivan the Terrible* and wrote: 'One can detest opera, believe it to be a doomed musical genre, while still recognising the value of Wagner's music.' Similarly, we may admire Eisenstein, while still condemning his project as 'an aggressive return of a dangerous aes-theticism'. Bazin found the constant falsification in *The Third Man* exasperating. In a brilliant article he compared Hollywood to the court at Versailles and asked where was its *Phèdre*? He found the answer, justly, in Charles Vidor's *Gilda*. Yet even this masterpiece was stripped of all 'natural accident'; an aesthetic cannot be founded on an 'existential void'.

In counterposition to these recurrent regressions into Expressionism, Bazin postulated a triumphal tradition of Realism. This tradition began with Feuillade, spontaneously, naïvely, and then developed in the 1920s in the films of Flaherty, Stroheim and Murnau, whom Bazin contrasted with Eisenstein, Kuleshov and Gance. In the 1930s the tradition was kept alive principally by Jean Renoir. Bazin saw Renoir stemming from the tradition of his father, that of French Im-pressionism. Just as the French Impressionists – Manet, Degas, Bonnard – had re-formulated the place of the picture frame in pictorial composition, under the influence of the snapshot, so Renoir *fils* had reformulated the place of the frame in cinematic composition. In contrast to Eisenstein's principle of montage, based on the sacrosanct close-up, the significant image centred in the frame, he had de-veloped what Bazin called *re-cadrage* ('re-framing'): lateral camera movements deserted and recaptured a continuous reality. The blackness surrounding the screen masked off the world rather than framed the image. In the 1930s Jean Renoir alone

> forced himself to look back beyond the resources provided by montage and so un-cover the secret of a film form that would permit everything to be said without chopping the world up into little fragments, that would reveal the hidden mean-ings in people and things without disturbing the unity natural to them.

In the 1940s the Realist tradition reasserted itself, though divided between two different currents. The first of these was inaugurated by *Citizen Kane* and con-tinued in the later films of Welles and Wyler. Its characteristic feature was the use of deep focus. By this means, the spatial unity of scenes could be maintained, episodes could be presented in their physical entirety. The second current was that of Italian Neo-realism, whose cause Bazin espoused with especial fervour. Above all, he admired Rossellini. In Neo-realism Bazin recognised fidelity to nature, to things as they were. Fiction was reduced to a minimum. Acting, location, incident: all were as natural as possible. Of *Bicycle Thieves* Bazin wrote that it was the first example of pure cinema. No more actors, no more plot, no more *mise en scène*:

Pre-war realism: (top) Von Stroheim's Greed, *(above) Murnau's* City Girl, *and (opposite) Renoir's* La Règle du Jeu.

the perfect aesthetic illusion of reality. In fact, no more cinema. Thus the film could obtain radical purity only through its own annihilation. The mystical tone of this kind of argument reflects, of course, the curious admixture of Catholicism and Existentialism which had formed Bazin. Yet it also develops logically from an aesthetic which stresses the passivity of the natural world rather than the agency of the human mind.

Bazin hoped that the two currents of the Realist tradition – Welles and Rossellini – would one day reconverge. He felt that their separation was due only to technical limitations: deep focus required more powerful lighting than could be used on natural locations. But when Visconti's *La terra trema* appeared, a film whose style was for the first time the same 'both *intra* and *extra muros*', the most Wellesian of Neo-realist films, nevertheless Bazin was disappointed. The synthesis, though achieved, lacked fire and 'affective eloquence'. Probably Visconti was too

Deep focus: (top) Orson Welles's Citizen Kane *and (above) William Wyler's* Mrs. Miniver.

close to the opera, to Expressionism, to be able to satisfy Bazin. But in the late 1940s and 1950s his concept of Realism did develop a step further, towards what, in a review of *La strada*, he was to call 'realism of the person' ('de la personne'). The echo of Mounier was not by chance. Bazin was deeply influenced by Mounier's insistence that the interior and the exterior, the spiritual and the physical, the ideal and the material, were indissolubly linked. He reoriented the philosophical and socio-political ideas of Mounier and applied them to the cinema. Bazin broke with many of the Italian protagonists of Neo-realism when he

Post-war realism: (top) Rossellini's Viva L'Italia *and (above) De Sica's* Bicycle Thieves.

asserted that 'Visconti is Neo-realist in *La terra trema* when he calls for social re-volt and Rossellini is Neo-realist in the *Fioretti*, which illustrates a purely spiritual reality'. In Bresson's films Bazin saw 'the outward revelation of an interior density', in those of Rossellini 'the presence of the spiritual' is expressed with 'breath-taking obviousness'. The exterior, through the transparence of images stripped of all inessentials, reveals the interior. Bazin emphasised the importance of physiog-nomy, upon which – as in the films of Dreyer – the interior spiritual life was etched and printed.

Bazin believed that films should be made, not according to some *a priori* method or plan, but, like those of Rossellini, from 'fragments of raw reality, mul-tiple and equivocal in themselves, whose meaning can only emerge *a posteriori* thanks to other facts, between which the mind is able to see relations'. Realism was the vocation of the cinema, not to signify but to reveal. Realism, for Bazin, had little to do with mimesis. He felt that cinema was closer to the art of the Egyptians which existed, in Panofsky's words, 'in a sphere of magical reality' than to that of the Greeks 'in a sphere of aesthetic ideality'. It was the existential bond between fact and image, world and film, which counted for most in Bazin's aesthetic, rather than any quality of similitude or resemblance. Hence the possibility – even the necessity – of an art which could reveal spiritual states. There was for Bazin a double movement of impression, of moulding and imprinting: first, the interior spiritual suffering was stamped upon the exterior physiognomy; then the exterior physiognomy was stamped and printed upon the sensitive film.

It would be difficult to overestimate the impact of Bazin's aesthetic. His influ-ence can be seen in the critical writing of Andrew Sarris in the United States, in the theories of Pier Paolo Pasolini in Italy, in Charles Barr's lucid article on CinemaScope (published in *Film Quarterly*, Summer 1963, but written in England), in Christian Metz's articles in *Communications* and *Cahiers du Cinéma*. That is to say, all the most important writing on cinema in the last ten or twenty years has, by and large, charted out the course first set by Bazin. For all these writers Rossellini occupies a central place in film history. 'Things are there. Why manipulate them?' For Metz, Rossellini's question serves as a kind of motto; Rossellini, through his experience as a film-maker, had struck upon the same truth that the semiologist achieved by dint of scholarship. Both Metz and Barr contrast Rossellini with Eisenstein, the villain of the piece. They even fall into the same metaphors. Thus Barr, writing of Pudovkin, who is used interchangeably with Eisenstein, describes how he

> reminds one of the bakers who first extract the nourishing parts of the flour, process it, and then put back some as 'extra goodness': the result may be eatable, but it is hardly the only way to make bread, and one can criticise it for being un-necessary and 'synthetic'. Indeed, one could extend the culinary analogy and say that the experience put over by the traditional aesthetic is essentially a *predigested* one.

And Metz: 'Prosthesis is to the leg as the cybernetic message is to the human phrase. And why not also mention – to introduce a lighter note and a change from Meccano – powdered milk and Nescafé? And all the various kinds of robot?' Thus

Rossellini's Flowers of St Francis.

Rossellini becomes a natural wholemeal director while Eisenstein is an *ersatz*, artificial, predigested. Behind these judgements stands the whole force of Romantic aesthetics: natural versus artificial, organic versus mechanical, imagination versus fancy.

But the Rossellini versus Eisenstein antinomy is not so clear-cut as might appear. First, we should remember that for Bazin it was Expressionism that was the mortal foe: *The Cabinet of Dr Caligari* rather than *Battleship Potemkin* or *October*. And, then, what of a director like Sternberg, clearly in the Expressionist tradition? 'It is remarkable that Sternberg managed to stylise performances as late into the talkies as he did.' Andrew Sarris's observation immediately suggests that Sternberg must be arrayed against Rossellini. Yet, in the same paragraph, Sarris comments upon Sternberg's eschewal of 'pointless cutting within scenes', his achievements as a 'non-montage director'. This is the same kind of problem that Bazin met with Dreyer, whose work he much admired, including its studio sequences. 'The case of Dreyer's *Jeanne d'Arc* is a little more subtle since at first sight nature plays a non-existent role.' Bazin found a way out of the dilemma through the absence of make-up. 'It is a documentary of faces. . . . The whole of nature palpitates beneath every pore.' But his dyadic model had been dangerously shaken.

The truth is that a triadic model is necessary, following Peirce's trichotomy of the sign. Bazin, as we have seen, developed an aesthetic which was founded upon the indexical character of the photographic image. Metz contrasts this with an aesthetic which assumes that cinema, to be meaningful, must refer back to a code, to a grammar of some kind, that the language of cinema must be primarily symbolic. But there is a third alternative. Sternberg was virulently opposed to any kind

Falconetti in Dreyer's La Passion de Jeanne d'Arc.

of Realism. He sought, as far as possible, to disown and destroy the existential bond between the natural world and the film image. But this did not mean that he turned to the symbolic. Instead, he stressed the pictorial character of the cinema; he saw cinema in the light, not of the natural world or of verbal language, but of painting. 'The white canvas on to which the images are thrown is a two-dimensional flat surface. It is not startlingly new, the painter has used it for centuries.' The film director must create his own images, not by slavishly following nature, by bowing to 'the fetish of authenticity', but by imposing his own style, his own interpretation. 'The painter's power over his subject is unlimited, his control over the human form and face despotic.' But 'the director is at the mercy of his camera'; the dilemma of the film director is there, in the mechanical contraption he is compelled to use. Unless he controls it, he abdicates. For 'verisimilitude, whatever its virtue, is in opposition to every approach to art'. Sternberg created a completely artificial realm, from which nature was rigorously excluded (the main thing wrong with *The Saga of Anatahan*, he once said, is that it contained shots of the real sea, whereas everything else was false) but which depended, not on any common code, but on the individual imagination of the artist. It was the iconic aspect of the sign which Sternberg stressed, detached from the indexical in order to conjure up a world, comprehensible by virtue of resemblances to the natural world, yet other than it, a kind of dream world, a heterocosm.

The contrast with Rossellini is striking. Rossellini preferred to shoot on location; Sternberg always used a set. Rossellini averred that he never used a shooting-script and never knew how a film would end when he began it; Sternberg cut every sequence in his head before shooting it and never hesitated while editing.

The Saga of Anatahan: *fronds and creepers.*

Max Ophuls's Lola Montès.

Rossellini's films have a rough-and-ready, sketch-like look; Sternberg evidently paid meticulous attention to every detail. Rossellini used amateur actors, without make-up; Sternberg took the star system to its ultimate limit with Marlene Dietrich and revelled in hieratic masks and costumes. Rossellini spoke of the director being patient, waiting humbly and following the actors until they revealed themselves: Sternberg, rather than wishing humbly to reveal the essence, sought to exert autocratic control: he festooned the set with nets, veils, fronds, creepers, lattices, streamers, gauze, in order, as he himself put it, 'to conceal the actors', to mask their very existence.

Yet even Sternberg is not the extreme: this lies in animated film, usually left to one side by theorists of the cinema. But the separation is not clear-cut. Sternberg has recounted how the aircraft in *The Saga of Anatahan* was drawn with pen and ink. He also sprayed trees and sets with aluminium paint, a kind of extension of make-up to cover the whole of nature, rather than the human face alone. In the same way, Max Ophuls painted trees gold and the road red in his masterpiece *Lola Montès*. Alain Jessua, who worked with Ophuls, has described how he took the logical next step forward and, in *Comic Strip Hero*, tinted the film. John Huston made similar experiments. And Jessua also introduced the comic-strip into the cinema. There is no reason at all why the photographic image should not be combined with the artificial image, tinted or drawn. This is common practice outside the cinema, in advertising and in the work of artists such as El Lissitsky, George Grosz and Robert Rauschenberg.

Semiologists have been surprisingly silent on the subject of iconic signs. They suffer from two prejudices: firstly, in favour of the arbitrary and the symbolic, secondly in favour of the spoken and the acoustic. Both these prejudices are to be found in the work of Saussure, for whom language was a symbolic system which operated in one privileged sensory band. Even writing has persistently been assigned an inferior place by linguists who have seen in the alphabet and in the

Kon-Tiki.

written letter only 'the sign of a sign', a secondary, artificial, exterior sub-system. These prejudices must be broken down. What is needed is a revival of the seventeenth-century science of characters, comprising the study of the whole range of communication within the visual sensory band, from writing, numbers and algebra through to the images of photography and the cinema. Within this band it will be found that signs range from those in which the symbolic aspect is clearly dominant, such as letters and numbers, arbitrary and discrete, through to signs in which the indexical aspect is dominant, such as the documentary photograph. Between these extremes, in the centre of the range, there is a considerable degree of overlap, of the co-existence of different aspects without any evident predominance of any one of them.

In the cinema, it is quite clear, indexical and iconic aspects are by far the most powerful. The symbolic is limited and secondary. But from the early days of film there has been a persistent, though understandable, tendency to exaggerate the importance of analogies with verbal language. The main reason for this, there seems little doubt, has been the desire to validate cinema as an art.

Clearly, a great deal of the influence which Bazin has exerted has been due to his ability to see the indexical aspect of the cinema as its essence – in the same way as its detractors – yet, at the same time, celebrate its artistic status. In fact, Bazin never argued the distinction between art and non-art within the cinema; his inclination was to be able to accept anything as art: thus, for example, his praise of documentary films such as *Kon-Tiki* and *Annapurna* which struck him forcefully. Christian Metz has attempted to fill this gap in Bazin's argument, but by no means with striking success. 'In the final analysis, it is on account of its wealth of connotations that a novel of Proust can be distinguished from a cookbook or a film of Visconti from a medical documentary.' Connotations, however, are uncoded, imprecise and nebulous: he does not believe that it would be possible to dissolve them into a rhetoric. In the last resort, the problem of art is the problem of style, of the author, of an idiolect. For Metz aesthetic value is purely a matter of 'expressiveness'; it has nothing to do with conceptual thought. Here again Metz reveals the basic Romanticism of his outlook. In fact, the aesthetic richness of the cinema springs from the fact that it comprises all three dimensions of the sign: indexical, iconic and symbolic. The great weakness of almost all those who have written about the cinema is that they have taken one of these dimensions, made it the ground of their aesthetic, the 'essential' dimension of the cinematic sign, and discarded the rest. This is to impoverish the cinema. Moreover, none of these dimensions can be discounted: they are co-present. The great merit of Peirce's analysis of signs is that he did not see the different aspects as mutually exclusive. Unlike Saussure he did not show any particular prejudice in favour of one or the other. Indeed, he wanted a logic and a rhetoric which would be based on all three aspects. It is only by considering the interaction of the three different dimensions of the cinema that we can understand its aesthetic effect.

Exactly the same is true of verbal language which is, of course, predominantly a symbolic system. This is the dimension which Saussure illuminated so brilliantly, but to the exclusion of every other. He gave short shrift, for instance, to onomatopoeia. 'Onomatopoeia might be used to prove that the choice of signifier is not always arbitrary. But onomatopoeic formations are never organic elements

Good and bad cowboys: Randolph Scott and Jack La Rue in Henry Hathaway's To the Last Man.

of a linguistic system. Besides, their number is much smaller than is generally supposed.' In recent years, the balance has been somewhat redressed by Roman Jakobson, who has made persistent efforts to focus attention once again on the work of Peirce. Jakobson has pointed out that, whereas Saussure held that 'signs that are wholly arbitrary realise better than the others the ideal of the semiological process', Peirce believed that in the most perfect of signs the iconic, the indexical and the symbolic would be amalgamated as nearly as possible in equal proportions.

Jakobson has written on several occasions about the iconic and indexical aspects of verbal language. The iconic, for instance, is manifest not only in onomatopoeia, but also in the syntactic structure of language. Thus a sentence like 'Veni, vidi, vici' reflects in its own temporal sequence that of the events which it describes. There is a resemblance, a similitude, between the syntactic order of the sentence and the historic order of the world. Again, Jakobson points out that there is no known language in which the plural is represented by the subtraction of a morpheme whereas, of course, in very many a morpheme is added. He also investigates the role of synaesthesia in language. In a brilliant article, 'Shifters, verbal categories, and the Russian verb', Jakobson discusses the indexical dimensions of language. He focuses particular attention on pronouns, whose meaning – at one level – varies from message to message. This is because it is determined by the particular existential context. Thus when I say 'I', there is an existential bond between this utterance and myself, of which the hearer must be aware to grasp the signifi-

The Vamp, Theda Bara.

Sam Taylor's My Best Girl, *with Mary Pickford and Buddy Rogers – chequered table-cloth and breakfast coffee.*

cance of what is being said. Pronouns also have a symbolic aspect – they denote the 'source' of an utterance, in general terms – which makes them comprehensible on one level, at least, even when the actual identity of the source is unknown. The indexical aspect also comes to the fore in words such as 'here,' 'there', 'this', 'that', and so on. Tenses are also indexical; they depend for full intelligibility on knowledge of the point in time at which a message was uttered.

Jakobson has also pointed out how these submerged dimensions of language become particularly important in literature and in poetry. He quotes with approval Pope's 'alliterative precept' to poets that 'the sound must seem an Echo of the sense' and stresses that poetry 'is a province where the internal nexus between sound and meaning changes from latent into patent and manifests itself most intensely and palpably'. The same is surely true, *mutatus mutandis*, of the cinema. Unlike verbal language, primarily symbolic, the cinema is, as we have seen, primarily indexical and iconic. It is the symbolic which is the submerged dimension. We should therefore expect that in the 'poetry' of the cinema, this aspect will be manifested more palpably.

In this respect, the iconography of the cinema (which, in Peirce's terms, is not the same as the iconic) is particularly interesting. Metz has minimised the importance of iconography. He discusses the epoch in which good cowboys wore whites shirts and bad cowboys black shirts, only in order to dismiss this incursion of the symbolic as unstable and fragile. Panofsky has also doubted the importance of iconography in the cinema.

The straight girl, Mary Pickford.

There arose, identifiable by standardised appearance, behaviour and attributes, the well-remembered types of the Vamp and the Straight Girl (perhaps the most convincing modern equivalents of the medieval personifications of the Vices and Virtues), the Family Man and the Villain, the latter marked by a black moustache and walking-stick. Nocturnal scenes were printed on blue or green film. A checkered tablecloth meant, once for all, a 'poor but honest' milieu, a happy marriage, soon to be endangered by the shadows from the past, was symbolised by the young wife's pouring the breakfast coffee for her husband; the first kiss was invariably announced by the lady's gently playing with her partner's necktie and was invariably accompanied by her kicking out her left foot.

But as audiences grew more sophisticated, and particularly after the invention of the talking film, these devices 'became gradually less necessary'. Nevertheless, 'primitive symbolism' does survive, to Panofsky's pleasure, 'in such amusing details as the last sequence of *Casablanca* where the delightfully crooked and right-minded *préfet de police* casts an empty bottle of Vichy water into the waste-paper basket'.

In fact, I think, both Metz and Panofsky vastly underestimate the extent to which 'primitive symbolism' does survive, if indeed that is the right word at all, with its hardly muffled condemnation to death. Counter to the old post-Eisenstein overvaluation of the symbolic there has developed an equally strong prejudice *against* symbols. Barthes, for example, has commented on the 'peripheral zone' in which a kernel of rhetoric persists. He cites, as an instance, calendar pages torn away to show the passage of time. But recourse to rhetoric, he feels, means to welcome mediocrity. It is possible to convey 'Pigalle-ness' or 'Paris-ness' with shots of neon, cigarette-girls and so on, or with boulevard cafés and the Eiffel Tower, but for us rhetoric of this kind is discredited. It may still hold good in the Chinese theatre where a complicated code is used to express, say, weeping, but in

New York-ness: Stanley Donen's On The Town.

Europe 'to show one is weeping, one must weep'. And, of course, 'the rejection of convention entails a no less draconian respect for nature'. We are back in familiar territory: cinema is *pseudo-physis*, not *techne*.

Thus Roland Barthes sweeps away the American musical, *It's Always Fair Weather* and *On the Town*, condemned to mediocrity by their recourse to rhetoric to convey 'New York-ness'. And what about Hitchcock: *The Birds* or *Vertigo*? The symbolic structure of the ascent and fall in *Lola Montès* or *La Ronde*? Welles? The sharks, the wheelchair, the hall of mirrors in *Lady from Shanghai*? Buñuel? *The Man Who Shot Liberty Valance*? The extraordinary symbolic scenes in the films of Douglas Sirk, *Imitation of Life* or *Written on the Wind*? Eisenstein's peacock is by no means the length and breadth of symbolism in the cinema. It is impossible to neglect this whole rich domain of meaning. Finally, Rossellini: what are we to say of the Vesuvian lovers in *Voyage to Italy*, the record of Hitler's voice playing among the ruins in *Germany Year Zero*, the man-eating tiger in *India*?

At this point, however, we must go forward with caution. Words such as *symbol* carry with them the risk of confusion. We have seen how Saussure's usage is not compatible with Peirce's. For Peirce the linguistic sign is a symbol, in a narrow and scientific sense. For Saussure, the linguistic sign is arbitrary, whereas

> one characteristic of the symbol is that it is never wholly arbitrary; it is not empty, for there is the rudiment of a natural bond between the signifier and the signified. The symbol of justice, a pair of scales, could not be replaced by just any other symbol, such as a chariot.

Hall of mirrors in Orson Welles's Lady from Shanghai.

The confusion has been increased still further by Hjelmslev and the Copenhagen school:

> From the linguistic side there have been some misgivings about applying the term *symbol* to entities that stand in a purely arbitrary relationship to their interpretation. From this point of view, *symbol* should be used only of entities that are isomorphic with their interpretation, entities that are depictions or emblems, like Thorwaldsen's *Christ* as a symbol for compassion, the hammer and sickle as a symbol for Communism, scales as a symbol for justice, or the onomatopoetica in the sphere of language.

Hjelmslev, however, chose to use the term in a far broader application; as he put it, games such as chess, and perhaps music and mathematics, are symbolic systems, as opposed to semiotics. He suggested that there was an affinity between isomorphic symbols, such as the hammer and sickle, and the pieces in a game, pawns or bishops. Barthes complicated the issue still more by stressing that symbols had no adequate or exact meaning: 'Christianity "outruns" the cross.'

What should we say about the hammer and sickle, the Christian cross, the scales of justice? First, unlike Hjelmslev, we must distinguish clearly between a depiction or image, as Peirce would say, and an emblem. An image is predominantly iconic. An emblem, however, is a mixed sign, partially iconic, partially symbolic. Moreover, this dual character of the emblematic or allegorical sign can be overtly exploited: Panofsky cites the examples of Dürer's portrait of Lucas Paumgartner as St George, Titian's Andrea Doria as Neptune, Reynolds's Lady Stanhope as

Contemplation. Emblems are unstable, labile: they may develop into predominantly symbolic signs or fall back into the iconic. Lessing, in the *Laocoön*, saw the problem with great clarity. The symbolic or allegorical, he held, are necessary to painters but redundant to poets, for verbal language, which has priority, is symbolic in itself.

> Urania is for the poets the Muse of Astronomy; from her name, from her functions, we recognise her office. The artist in order to make it distinguishable must exhibit her with a pointer and celestial globe, this attitude of hers provides his alphabet from which he helps us to put together the name Urania. But when the poet would say that Urania has long ago foretold his death by the stars – 'Ipsa diu positis letum praedixerat astris Urania' – why should he, thinking of the painter, add thereto, Urania, the pointer in her hand, the celestial globe before her? Would it not be as if a man who can and may speak aloud should at the same time still make use of the signs which the mutes in the Turk's seraglio have invented for lack of utterance?

Lessing described a scale of representations between the purely iconic and the purely symbolic. The bridle in the hand of Temperance and the pillar on which Steadfastness leans are clearly allegorical.

> The scales in the hand of Justice are certainly less purely allegorical, because the right use of the scales is really a part of justice. But the lyre or flute in the hand of a Muse, the spear in the hand of Mars, the hammer and tongs in the hand of Vulcan, are not symbols at all, but mere instruments.

Painters should minimise the symbolic – the extreme case, 'the inscribed labels which issue from the mouths of the persons in ancient Gothic pictures', Lessing disapproved of entirely. He looked forward to an art which would be more purely iconic, much more than he ever anticipated: Courbet, the *plein air* painters, the Impressionists. In fact, what happened is that, as the symbolic was ousted, the indexical began to make itself felt. Painters began to be interested in optics and the psychology of perception. Indeed, Courbet sounds strangely like Bazin:

> I maintain, in addition, that painting is an essentially concrete art and can only consist of the representation of real and existing things. It is a completely physical language, the words of which consist of all visible objects; an object which is abstract, not visible, non-existent, is not within the realm of painting. . . . The beautiful exists in nature and may be encountered in the midst of reality under the most diverse aspects. As soon as it is found there, it belongs to art, or rather, to the artist who knows how to see it there. As soon as beauty is real and visible, it has its artistic expression from these very qualities. Artifice has no right to amplify this expression; by meddling with it, one only runs the risk of perverting and, consequently, of weakening it. The beauty provided by nature is superior to all the conventions of the artist.

One current in the history of art has been the abandonment of the lexicon of emblems and the turn to nature itself, to the existential contiguity of painter and

object which Courbet demanded. At the end of this road lay photography; under its impact painting began to oscillate violently.

The iconic sign is the most labile; it observes neither the norms of convention nor the physical laws which govern the index, neither *thesis* nor *nomos*. Depiction is pulled towards the antinomic poles of photography and emblematics. Both these undercurrents are co-present in the iconic sign; neither can be conclusively suppressed. Nor is it true, as Barthes avers, that the symbolic dimension of the iconic sign is not adequate, not conceptually fixed. To say that 'Christianity "outruns" the cross' is no different in order from saying that Christianity outruns the word Christianity or divinity outruns the mere name of *God*. To see transcendent meaning is the task of the mystic, not the scientist. Barthes is dangerously close to Barth, with his 'impenetrable incognito' of Jesus Christ. There is no doubt that the cross can serve as a phatic signal and as a degenerate index, triggering off an effusive and devout meditation, but this should be radically distinguished from the conceptual content articulated by the symbolic sign.

It is particularly important to admit the presence of the symbolic – hence conceptual – dimension of the cinema because this is a necessary guarantee of objective criticism. The iconic is shifting and elusive; it defies capture by the critic. We can see the problem very clearly if we consider a concrete example: Christian Metz's interpretation of a famous shot from Eisenstein's *Que Viva Mexico!* Metz describes the heads of three peasants who have been buried in the sand, their tormented yet peaceful faces, after they have been trampled upon by the hooves of their oppressors' horses. At the denotative level the image means that they have suffered, they are dead. But there is also a connotative level: the nobility of the landscape, the beautiful, typically Eisensteinian, triangular composition of the shot. At this second level the image expressed 'the grandeur of the Mexican people, the certainty of final victory, a kind of passionate love which the northerner feels for the sun-drenched splendour of the scene'. The Italian writer on aesthetics, Galvano della Volpe, has argued that this kind of interpretation has no objective validity, that it could never be established and argued like the paraphrasable meaning of a verbal text. There is no objective code; therefore there can only be subjective impressions. Cinema criticism, della Volpe concludes, may exist *de facto*, but it cannot exist *de jure*.

There is no way of telling what an image *connotes* in the sense in which Metz uses the word, even less accurate than its sense in what Peirce called 'J. S. Mills' objectionable terminology.' Della Volpe is right about this. But, like Metz, he too underestimates the possibility of a symbolic dimension in the cinematic message, the possibility, if not of arriving at a *de jure* criticism, at least of approaching it, maximising lucidity, minimising ambiguity. For the cinematic sign, the language or semiotic of cinema, like the verbal language, comprises not only the indexical and the iconic, but also the symbolic. Indeed, if we consider the origins of the cinema, strikingly mixed and impure, it would be astonishing if it were otherwise. Cinema did not only develop technically out of the magic lantern, the daguerreotype, the phenakistoscope and similar devices – its history of Realism – but also out of strip-cartoons, Wild West shows, automata, pulp novels, barnstorming melodramas, magic – its history of the narrative and the marvellous. Lumière and Méliès are not like Cain and Abel; there is no need for one to eliminate the other. It is quite misleading to validate one dimension of the cinema

Jean-Luc Godard: Made in U.S.A.

unilaterally at the expense of all the others. There is no pure cinema, grounded on a single essence, hermetically sealed from contamination.

This explains the value of a director like Jean-Luc Godard, who is unafraid to mix Hollywood with Kant and Hegel, Eisensteinian montage with Rossellinian Realism, words with images, professional actors with historical people, Lumière with Méliès, the documentary with the iconographic. More than anybody else Godard has realised the fantastic possibilities of the cinema as a medium of communication and expression. In his hands, as in Peirce's perfect sign, the cinema has become an almost equal amalgam of the symbolic, the iconic and the indexical. His films have conceptual meaning, pictorial beauty and documentary truth. It is no surprise that his influence should proliferate among directors throughout the world. The film-maker is fortunate to be working in the most semiologically complex of all media, the most aesthetically rich. We can repeat today Abel Gance's words four decades ago: 'The time of the image has come.'

Conclusion (1972)

Looking back over this book, even after a short distance of time, it strikes me that it was written at the beginning of a transitional period which is not yet over. What marks this period, I think, is the delayed encounter of the cinema with the 'modern movement' in the arts. The great breakthroughs in literature, painting and music, the hammer-blows which smashed (or should have smashed) traditional aesthetics, took place in the years before the First World War, at a time when the cinema was in its infancy, a novelty in the world of vaudeville, peepshows and nickelodeons. This was the period of the first abstract paintings, the first sound poems, the first noise bands. It was also the period when the idea of semiology was launched by Saussure in his Geneva Course and when Freud was making the most important of his discoveries. Precisely because the cinema was a new art, it took time for any of this to have an effect on it.

The first impact of the 'modern movement' on the cinema took place in the 20s. The clearest example of this, of course, is Eisenstein. At the same time there was the work of the Parisian avant-garde – Léger, Man Ray, Buñuel – and of abstract film-makers like Eggeling and Richter. In Germany Expressionism fed into the cinema in the form of 'Caligarism', mainly under Eric Pommer's patronage. But looking back on it, we can see how superficial this first contact was and how it was completely obliterated during the 30s. In Russia, socialist realism was launched and the avant-garde cinema of the 20s cut short. In Germany, Pommer lost control of UFA after the financial disaster of *Metropolis* and soon, in any case, the Nazi regime was in power. The early experiments of Léger or Richter petered out. Buñuel went his own way. Fischinger was working for Disney in the 30s; Moholy-Nagy for Korda. If there was any kind of avant-garde in this period, it was to be found in the documentary movement, certainly the most conservative avant-garde imaginable.

The rise of the sound film and the rapid expansion of American economic and political power after the war led to the domination of Hollywood throughout most of the world. It is in this context that a director like Orson Welles could appear as an innovator, a dangerous experimentalist, Rossellini as a revolutionary, Humphrey Jennings a poet. Today these estimations seem absurd. There has been a complete change, a revaluation, a shift of focus which had made cinema history into something different. Eisenstein or Vertov look contemporary instead of antique. Welles or Jennings look hopelessly old-fashioned and dated. Yet this change has been very recent and its full effects are still to be felt. All the old landmarks are disappearing in the mists of time.

What has happened? Really, two things. First, the rise of the underground, particularly in America. This was a product of three factors: poets and painters taking

up film-making, the arrival of European avant-garde artists like Richter as refugees, the peeling off of mavericks from Hollywood. There was also a crucial economic pre-condition: the availability of equipment and money to buy it. In the context of the underground, film-making was seen as an extension of the other arts. There was no attempt to compete with Hollywood by making feature films (except, as with Curtis Harrington, by becoming a Hollywood director). It took some time before the underground began to get into the cinemas, in fact only in the last few years when Warhol films began to bite into the sexploitation field. But it was more and more obvious that it was there to stay.

The second key development was the way that the French New Wave evolved, pushing back the conventional frontiers of the 'art' cinema. Godard has had an incalculable effect, and it was only right that this book should have built up towards a paean of praise for his films and an eager anticipation of what was to come. At the time I was writing, *Weekend* was the last Godard movie I had seen. It is now much clearer what the effect of May 1968 was on Godard. His films have increasingly been, so to speak, both politicised and semiologised. It is difficult not to think of directors like Makavejev, Skolimowski, Bertolucci, Kluge, Glauber Rocha and so on, simply as post-Godard directors. Yet none of them have gone the whole way with him, and some have tended to retreat from the adventurousness of their own early 'Godardian' work.

It seems to me now that I was wrong in what I expected of Godard. 'More than anybody else Godard has realised the fantastic possibilities of the cinema as a medium of communication and expression. In his hands, as in Peirce's perfect sign, the cinema has become an almost equal amalgam of the symbolic, the iconic and the indexical. His films have conceptual meaning, pictorial beauty and documentary truth.' In a sense, the programme I was outlining has been fulfilled, but more by others than by Godard. A film like Makavejev's *WR – Mysteries of the Organism* exploits the full semiological possibilities of film in its blend of documentary, *vérité*, library clips, Hollywood, montage, etc. But thinking back on it, credit for this should go to Kenneth Anger's *Scorpio Rising*, rather than to Godard. Anger was the first film-magician in this sense (*WR* can almost be read out of *Scorpio Rising* by substituting Crowley for Reich and Jesus Christ for Stalin). It is obvious now that what concerned Godard was an interrogation of the cinema rather than a fulfilment of its potential.

It is necessary at this point to make a digression, to sketch in the background against which Godard is working and against which the 'modern movement' in the other arts also emerged. The twentieth century witnessed an assault on traditional art and aesthetics which laid the foundations for a revolutionary art which has not yet been consolidated. It is possible that this consolidation cannot take place independently, apart from the movement of society and of politics. The heroic first phase of the avant-garde in the arts coincided, after all, with the political phase which led from 1905 to the October Revolution; Godard's films are clearly linked with the political upheavals which reached a climax in Europe in May 1968. But it is nevertheless possible, on a theoretical level, to try to explain what this potential break with the past involved, would involve if it were to be carried through. This raises problems about the nature of art, its place in intellectual production, the ideology and philosophy which underpin it.

Signs and meanings: contemporary western thought, like its forerunners, sees the problem predominantly one way. Signs are used to communicate meanings between individuals. An individual constructs a message in his mind, a complex of meaning, an idea or thought process, which he wishes to convey to someone else. Both individuals possess a common code or grammar which they have learned. Through the agency of this code, the first individual, the source, maps his message on to, for instance, its verbal representation, a sequence. He then re-maps this sentence on to a signal, a sequence of sounds which give it a physical form, and transmits this signal through a channel. It is picked up by the second individual, the receiver, who then decodes the signal and thus obtains the original message. An idea has been transferred from one mind to another. There is some disagreement among scholars about whether the original message is articulated in words or in some kind of non-articulated thought process (the problem of semantics) but, given this reservation, the model outlined above holds good for most contemporary linguistics and semiotics: Weaver and Shannon, Jakobson, Chomsky, Prieto and their followers.

The common assumption of all these various views is that language, or any other system of transmitted signals, is an instrument, a tool. This assumption is quite explicit in Jakobson, for instance: 'These efforts [of the Prague School] proceed from a universally recognised view of language as a tool of communication.' Or the British linguist, Halliday: 'Language serves for the expression of "content": that is, of the speaker's expression of the real world, including the inner world of his own consciousness. We may call this the ideational function.' And Prieto: 'the instruments which are called signals and whose function consists of the transmission of messages. . . . These instruments permit man to exercise an influence on his environment: in this case, this involves the transmission of messages to other members of the social group.' Or, to strike out in a different direction, Stalin:

> Language is a medium, an instrument with the help of which people communicate with one another, exchange thoughts and understand each other. Being directly connected with thought, language registers and fixes in words, and in words combined into sentences, the result of thought and man's successes in his quest for knowledge, and thus makes possible the exchange of ideas in human society.

Both Jakobson and Halliday note additional functions of language, but both regard themselves primarily as 'functionalist' in approach. Prieto uses the term 'utilitarian' rather than 'functional' but the drift is the same.

Clearly this model of language rests on the notion of the thinking mind or consciousness which controls the material world. Matter belongs to the realm of instrumentality; thus, the consciousness makes use of the material signal as a tool. Behind every material signal is an ideal message, a kind of archi-signal. In essence, this view is a humanised version of the old theological belief that the material world as a whole comprised a signal which, when decoded, would reveal the message of the divine Logos. Like verbal language the material world was inadequate to express the Logos fully (it remained ineffable) but it could give a partial idea of the deity, who was, so to speak, pure Message. At the time of the Enlightenment, God was no longer envisaged as the author of the great book of the world, but the

same semiotic model was transferred to human communication. Artists, in particular, were seen as quasi-divine authors who created a world in their imagination which they then expressed externally. Within a Romantic aesthetic, the signals were taken as symbols, to be decoded not by applying a common code but by intuition and empathy, projection into the artist's inner world. Porphyry's 'wise Theology wherein man indicated God and Divine Powers by images akin to sense and sketched invisible things in visible forms' was echoed in Coleridge's description of a symbol as characterised 'above all, by the translucence of the eternal through and in the temporal'. Within Classical aesthetics signals remained made up of conventional counters or tokens, as the Romantics contemptuously dubbed them.

In criticism, it was the Classical view which prevailed, not surprisingly, since Romanticism saw no need for critics. The function of criticism was seen as clarifying the decoding of signals in order to restore the original message as fully as possible. This was necessary because artistic messages were usually very complex, the signals were often ambiguous and a knowledge of the situation of the source, culturally and socially, could be helpful towards deciding on the most satisfactory decoding. Criticism thus comes to posit a 'content' of works of art, not immediately obvious from a rapid perusal of the work itself. Much might be missed by the casual or unsophisticated reader, which the critic could point out. Basically, there was one correct decoding, as though the work of art was the Rosetta Stone. Within a Romantic or symbolic aesthetic, on the other hand, decoded intuitively, there could be no 'right answer'; it was all a matter of sensitivity, of spiritual attunement, so that criticism ended up with Walter Pater's mood-recreations. Within the Classical model, as Positivism gained strength, the 'content' of the work was interpreted not as a body of ideas or experiences, but as the expression of the artist's racial or geographical or social situation. Thus Taine's 'milieu' or the 'class background' of Positivist Marxists. Another tradition saw content in terms of moral stance. Of course, a number of critics have always confused the different positions, switching from technical expertise to mystical intuition at will.

One of the main effects of the 'modern movement' was to discredit the ideas of 'intention' and of 'content'. An artist like Duchamp for example stressed the impersonality of the work, the role of chance and parody, and even left works deliberately unfinished. The Surrealists produced automatic writing; any number of modern artists stressed the importance of 'form'. The really important breakthrough, however, came in the rejection of the traditional idea of a work as primarily a representation of something else, whether an idea or the real world, and the concentration of attention on the text of the work itself and on the signs from which it was constructed. This was not exactly the same thing as 'abstraction' or 'formalism' though it was easily confused with it. An 'abstract' artist like Kandinsky for example saw himself as expressing spiritual realities, which could be grasped only through pure form. Kandinsky was really the end-product of Symbolism. The same kind of aesthetic was developed by Hulme in England, who saw abstract art as representing timeless, supra-historical values, in contrast with the history-bound, man-centred figurative art of the Renaissance and Romanticism.

The 'modern movement' made it possible for the artist to interrogate his own work for the first time, to see it as problematic; to put in the forefront the material

character of the work. Again, this could easily slide into a kind of mystical naturalism, in which an artefact was equated with a natural object like a tree, thus seeking to eradicate its status as a sign entirely. Or, on the other hand, it could lead towards technicians, concentrating on the material aspects of art simply to perfect the work as an instrument. In a sense, modern art was searching for a semiology which would enable it to break with the Renaissance tradition, but which had still to be elaborated, and perhaps could not be elaborated until the need for it was felt. The aesthetic and 'philosophical' background to most of the works of the avant-garde was a dismal mixture of theosophy, Worringer, Frazer, bits of Bergson, even Bradley, and so on. The only exception to this is to be found in the early collaboration between the Russian linguists and Futurist poets. And later, of course, the Surrealists made an effort to understand Freud.

What was (and still is) needed was a semiology which reversed and transformed the usual terms of its problematic, which stopped seeing the signal, the text, as a means, a medium existing between human beings and the truth or meaning, whether the idealist transcendent truth of the Romantics or the immanent intentional meaning of the Classical aesthetic. Thus a text is a material object whose significance is determined not by a code external to it, mechanically, nor organically as a symbolic whole, but through its own interrogation of its own code. It is only through such an interrogation, through such an interior dialogue between signal and code, that a text can produce spaces within meaning, within the otherwise rigid straitjacket of the message, to produce a meaning of a new kind, generated within the text itself. To point out a parallel: this would be as if the dialogue of Freudian psychoanalysis, segregated as it is between the space of the signal (analysand) and that of the code (analyst), were to be compressed and condensed within one single space, that of the text.

The ideological effects of such a recasting of the semiological foundations of art would be of the utmost importance. It would situate the consciousness of the reader or spectator no longer outside the work as receiver, consumer and judge, but force him to put his consciousness at risk within the text itself, so that he is forced to interrogate his own codes, his own method of interpretation, in the course of reading, and thus to produce fissures and gaps in the space of his own consciousness (fissures and gaps which exist in reality but which are repressed by an ideology, characteristic of bourgeois society, which insists on the 'wholeness' and integrity of each individual consciousness). All previous aesthetics have accepted the universality of art founded either in the universality of 'truth' or of 'reality' or of 'God'. The modern movement for the first time broke this universality into pieces and insisted on the singularity of every act of reading a text, a process of multiple decodings, in which a shift of code meant going back over signals previously 'deciphered' and vice versa, so that each reading was an open process, existing in a topological rather than a flat space, controlled yet inconclusive.

Classical aesthetics always posited an essential unity and coherence to every work, which permitted a uniform and exhaustive decoding. Modernism disrupts this unity; it opens the work up, both internally and externally, outwards. Thus there are no longer separate works, monads, each enclosed in its own individuality, a perfect globe, a whole. It produces works which are no longer centripetal,

held together by their own centres, but centrifugal, throwing the reader out of the work to other works.

Thus, in the past, the difficulty of reading was simply to find the correct code, to clear up ambiguities or areas of ignorance. Once the code was known reading became automatic, the simultaneous access to the mind of signal and 'content', that magical process whereby ideas shone through marks on paper to enter the skull through the windows of the eyes. But Modernism makes reading difficult in another sense, not to find the code or to grasp the ideas, the 'content', but to make the process of decoding itself difficult, so that to read is to work. Reading becomes problematic; the 'content' is not attached to the signal (so closely attached as to be inseparable from it) by any bond; it is deliberately, so to speak, detached, held in suspension, so that the reader has to play his own part in its production. And, at the same time, the text, through imposing this practice of reading, disrupts the myth of the reader's own receptive consciousness. No longer an empty treasure house waiting to receive its treasure, the mind becomes productive. It works. Just as the author no longer 'finds' the words, but must 'produce' a text, so the reader too must work within the text. The old image of the reader as consumer is broken.

The text is thus no longer a transparent medium; it is a material object which provides the conditions for the production of meaning, within constraints which it sets itself. It is open rather than closed; multiple rather than single; productive rather than exhaustive. Although it is produced by an individual, the author, it does not simply represent or express the author's ideas, but exists in its own right. It is not an instrument of communication but a challenge to the mystification that communication can exist. For inter-personal communication, it substitutes the idea of collective production; writer and reader are indifferently critics of the text and it is through their collaboration that meanings are collectively produced. At the same time, these 'meanings' have effects; just as the text, by introducing its own decoding procedures, interrogates itself, so the reader too must interrogate himself, puncture the bubble of his consciousness and introduce into it the rifts, contradictions and questions which are the problematic of the text.

The text then becomes the location of thought, rather than the mind. The text is the factory where thought is at work, rather than the transport system which conveys the finished product. Hence the danger of the myths of clarity and transparency and of the receptive mind; they present thought as a pre-packaged, available, given, from the point of view of the consumer. Whereas the producer of thought is then envisaged as the traditional philosopher, whose thought is the function of a pure consciousness, pure mental activity, externalised for others only when completed. It is to preserve this myth that notebooks and drafts are so rigidly separated from final versions, so that the process of thought as a dialectic of writing and reading (in the case even of 'individual' thought, as a dialogue with oneself) is obscured and is presented as an internal affair made public only when finished. In addition, drafts and notes, when they are made public, are seen as the raw material, itself still partly inchoate and incoherent, out of which the final, coherent version is fashioned. Thus incompatible elements have to be made compatible, and it is this general compatibility and consequentiality which marks the completion of a work. Within a Modernist view, however, all work is work in

progress, the circle is never closed. Incompatible elements in a text should not be ironed out but confronted.

This is the context in which Godard's films should be seen. Godard's work represents a continual examination and re-examination of the premises of film-making accepted by film-maker and by spectator. It is not simply a question of the juxtaposition of different styles or of different 'points of view', but of the systematic challenging of the assumptions underlying the adoption of a style or a point of view. In Godard's earliest films the narrative and dramatic structure are taken for granted, but the characters in the films question each other about the codes they use, about the sources of misunderstanding and incomprehension. Then, as his career continued, he began more and more to question, not the interpersonal communication of the characters, but the communication represented by the film itself. Finally, he began to conceive of making a film, not as communicating at all, but as producing a text in which the problems of film-making were themselves raised. This is as political an aspect of Godard's cinema as the overtly political debate and quotation which also take place in it. For it is precisely by making things 'difficult' for the spectator in this way, by breaking up the flow of his films, that Godard compels the spectator to question himself about how he looks at films, whether as a passive consumer and judge outside the work, accepting the code chosen by the director, or whether within the work as a participant in a dialogue.

Godard's work is particularly important for the cinema because there, more perhaps than in any other art form, semiological mystification is possible. This is because of the predominantly indexical-iconic character of most films and the 'illusion of reality' which the cinema provides. The cinema seems to fulfil the age-old dream of providing a means of communication in which the signals employed are themselves identical or near-identical with the world which is the object of thought. Reality is, so to speak, filtered and abstracted in the mind, conceptualised, and then this conceptualisation of reality is mapped on to signals which reflect the original reality itself, in a way which words, for instance, can never hope to match. Thus the cinema is seen to give world-views in the literal sense of the term, world-conceptions which are literally word-pictures. The dross filtered out of the sensuous world by the process of abstraction and thought is restored in the process of communication. Hence the immense attraction of Realist aesthetics for theorists of the cinema.

For Realist aesthetics, the cinema is the privileged form which is able to provide both appearance and essence, both the actual look of the real world and its truth. The real world is returned to the spectator purified by its traverse through the mind of the artist, the visionary who both sees and shows. Non-Realist aesthetics, as is pointed out elsewhere in this book, are accused of reducing or dehydrating the richness of reality; by seeking to make the cinema into a conventional medium they are robbing it of its potential as an alternative world, better, purer, truer, and so on. In fact, this aesthetic rests on a monstrous delusion: the idea that truth resides in the real world and can be picked out by a camera. Obviously, if this were the case, everybody would have access to the truth, since everybody lives all their life in the real world. The Realism claim rests on a sleight of hand: the identification of authentic experience with truth. Truth has no meaning unless it has explanatory force, unless it is knowledge, a product of thought. Different people

may experience the fact of poverty, but can attribute it to all kinds of different causes: the will of God, bad luck, natural dearth, capitalism. They all have a genuine experience of poverty, but what they know about it is completely different. It is the same with sunshine: everybody has experienced it but very few know anything scientifically about the sun. Realism is in fact, as it was historically, an outgrowth of Romanticism, typically Romantic in its distrust of or lack of interest in scientific knowledge.

Besides Realism, the other main current in film theory has been the attempt to import into the cinema a traditional Romantic concept of the artist, the privileged individual with the faculty of imagination. Basically, the concept of imagination was the short cut by which Romantic writers on aesthetics crammed the classical duality of thought plus expression, reason plus rhetoric, into one copious portmanteau. The imagination produced not concepts plus similes, but metaphors which fused concept and simile into a whole. Thus the artist in the cinema is able to produce visual metaphors, in which the act of thought and the act of filming are simultaneous and inseparable. This idea of the imaginative artist makes it possible to go beyond the old distinction of scriptwriter and director which divorced composition from execution. One of the problems that had always faced film aesthetics was how to get round this awkward division, which made it impossible to see a film as the creation of a single subjectivity. Gradually, in the acknowledged 'art' cinema first of all, the gap was bridged and the director was acknowledged to be the imaginative artist. A few critics, attached to the idea of the priority of the scriptwriter and of composition before execution, have held out against this trend, but not with much success. While it is possible to argue that the composer of a musical score envisages every note auditorily or that the writer of a play has an idea of how it should be performed inherent in the text, because of the primacy of words in the bourgeois theatre, it is difficult to argue along similar lines about the scriptwriter.

At this point, it is necessary to say something about the auteur theory since this has often been seen as a way of introducing the idea of the creative personality into the Hollywood cinema. Indeed, it is true that many protagonists of the auteur theory do argue in this way. However, I do not hold this view and I think it is important to detach the auteur theory from any suspicion that it simply represents a 'cult of personality' or apotheosis of the director. To my mind, the auteur theory actually represents a radical break with the idea of an 'art' cinema, not the transplant of traditional ideas about 'art' into Hollywood. The 'art' cinema is rooted in the idea of creativity and the film as the expression of an individual vision. What the auteur theory argues is that any film, certainly a Hollywood film, is a network of different statements, crossing and contradicting each other, elaborated into a final 'coherent' version. Like a dream, the film the spectator sees is, so to speak, the 'film façade', the end-product of 'secondary revision', which hides and masks the process which remains latent in the film 'unconscious'. Sometimes the 'façade' is so worked over, so smoothed out, or else so clotted with disparate elements, that it is impossible to see beyond it, or rather to see anything in it except the characters, the dialogue, the plot, and so on. But in other cases, by a process of comparison with other films, it is possible to decipher, not a coherent message or world-view, but a structure which underlies the film and shapes it, gives it a cer-

tain pattern of energy cathexis. It is this structure which auteur analysis disengages from the film.

The structure is associated with a single director, an individual, not because he has played the role of artist, expressing himself or his own vision in the film, but because it is through the force of his preoccupations that an unconscious, unintended meaning can be decoded in the film, usually to the surprise of the individual involved. The film is not a communication, but an artefact which is unconsciously structured in a certain way. Auteur analysis does not consist of retracing a film to its origins, to its creative source. It consists of tracing a structure (not a message) within the work, which can then *post factum* be assigned to an individual, the director, on empirical grounds. It is wrong, in the name of a denial of the traditional idea of creative subjectivity, to deny any status to individuals at all. But Fuller or Hawks or Hitchcock, the directors, are quite separate from 'Fuller' or 'Hawks' or 'Hitchcock', the structures named after them, and should not be methodologically confused. There can be no doubt that the presence of a structure in the text can often be connected with the presence of a director on the set, but the situation in the cinema, where the director's primary task is often one of co-ordination and rationalisation, is very different from that in the other arts, where there is a much more direct relationship between artist and work. It is in this sense that it is possible to speak of a film auteur as an unconscious catalyst.

However, the structures discerned in the text are often attacked in another way. Robin Wood, for example, has argued that the 'auteur' film is something like a Platonic Idea. It posits a 'real' film, of which the actual film is only a flawed transcript, while the archi-film itself exists only in the mind of the critic. This attack rests on a misunderstanding. The main point about the Platonic Idea is that it predates the empirical reality, as archetype. But the 'auteur' film (or structure) is not an archi-film at all in this sense. It is an explanatory device which specifies partially how any individual film works. Some films it can say nothing or next to nothing about at all. Auteur theory cannot simply be applied indiscriminately. Nor does an auteur analysis exhaust what can be said about any single film. It does no more than provide one way of decoding a film, by specifying what its mechanics are at one level. There are other kinds of code which could be proposed, and whether they are of any value or not will have to be settled by reference to the text, to the films in question.

Underlying the anti-Platonic argument, however, there is often a hostility towards any kind of explanation which involves a degree of distancing from the 'lived experience' of watching the film itself. Yet clearly any kind of serious critical work – I would say scientific, though I know this drives some people into transports of rage – must involve a distance, a gap between the film and the criticism, the text and the meta-text. It is as though meteorologists were reproached for getting away from the 'lived experience' of walking in the rain or sunbathing. Once again, we are back with the myth of transparency, the idea that the mark of a good film is that it conveys a rich meaning, an important truth, in a way which can be grasped immediately. If this is the case, then clearly all the critic has to do is to describe the experience of watching the film, reception of a signal, in such a way as to clear up any little confusions or enigmas which still remain. The most

that the critic can do is to put the spectator on the right wavelength so that he can see for himself as clearly as the critic, who is already tuned in.

The auteur theory, as I conceive it, insists that the spectator has to work at reading the text. With some films this work is wasted, unproductive. But with others it is not. In these cases, in a certain sense, the film changes, it becomes another film – as far as experience of it is concerned, it is no longer possible to look at it 'with the same eyes'. There is no integral, genuine experience which the critic enjoys and which he tries to guide others towards. Above all, the critic's experience is not essentially grounded in or guaranteed by the essence of the film itself. The critic is not at the heart of the matter. The critic is someone who persists in learning to see the film differently and is able to specify the mechanisms which make this possible. This is not a question of 'reading in' or projecting the critic's own concerns into the film; any reading of a film has to be justified by an explanation of how the film itself works to make this reading possible. Nor is it the single reading, the one which gives us the true meaning of the film; it is simply a reading which produces more meaning.

Again, it is necessary to insist that since there is no true, essential meaning there can therefore be no exhaustive criticism, which settles the interpretation of a film once and for all. Moreover, since the meaning is not contained integrally in any film, any decoding may not apply over the whole area of it. Traditional criticism is always seeking for the comprehensive code which will give the complete interpretation, covering every detail. This is a wild-goose chase, in the cinema, above all, which is a collective form. Both Classical and Romantic aesthetics hold to the belief that every detail should have a meaning – Classical aesthetics because of its belief in a common, universal code; Romantic aesthetics because of its belief in an organic unity in which every detail reflects the essence of the whole. The auteur theory argues that any single decoding has to compete, certainly in the cinema, with noise from signals coded differently. Beyond that, it is an illusion to think of any work as complete in itself, an isolated unity whose intercourse with other films, other texts, is carefully controlled to avoid contamination. Different codes may run across the frontiers of texts at liberty, meet and conflict within them. This is how language itself is structured, and the failure of linguistics, for instance, to deal with the problem of semantics is exemplified in the idea that to the unitary code of grammar (the syntactic component of language) there must correspond a unitary semantic code, which would give a correct semantic interpretation of any sentence. Thus the idea of 'grammaticality' is wrongly extended to include a quite false notion of 'semanticity'. In fact, no headway can be made in semantics until this myth is dispelled.

The auteur theory has important implications for the problem of evaluation. Orthodox aesthetics sees the problem in predictable terms. The 'good' work is one which has both a rich meaning and a correspondingly complex form, wedded together in a unity (Romantic) or isomorphic with each other (Classical). Thus the critic, to demonstrate the value of a work, must be able to identify the 'content', establish its truth, profundity, and so forth, and then demonstrate how it is expressed with minimum loss or leakage in the signals of the text itself, which are patterned in a way which gives coherence to the work as a whole. 'Truth' of content is not envisaged as being like scientific truth, but more like 'human' truth, a

distillation of the world of human experience, particularly interpersonal experience. The world itself is an untidy place, full of loose ends, but the artefact can tie all these loose ends together and thus convey to us a meaningful truth, an insight, which enables us to go back to the real world with a reordered and recycled experience which will enable us to cope better, live more fully and so on. In this way art is given a humanistic function, which guarantees its value.

All this is overthrown when we begin to see loose ends in works of art, to refuse to acknowledge organic unity or integral content. Moreover, we have to revise our whole idea of criteria, of judgement. The notion behind criteria is that they are timeless and universal. They are then applied to a particular work and it is judged accordingly. This rigid view is varied to the extent that different criteria may apply to different kinds of works or that slightly different criteria may reflect different points of view or kinds of experience, though all are rooted in a common humanity. But almost all current theories of evaluation depend on identifying the work first and then confronting it with criteria. The work is then criticised for falling short on one score or another. It is blemished in some way. Evidently, if we reject the idea of an exhaustive interpretation, we have to reject this kind of evaluation. Instead, we should concentrate on the *productivity* of the work. This is what the 'modern movement' is about. The text, in Octavio Paz's words, is something like a machine for producing meaning. Moreover, its meaning is not neutral, something to be simply absorbed by the consumer.

The meaning of texts can be destructive – of the codes used in other texts, which may be the codes used by the spectator or the reader, who thus finds his own habitual codes threatened, the battle opening up in his own reading. In one sense, everybody knows this. We know that *Don Quixote* was destructive of the chivalric romance. We know that *Ulysses* or *Finnegans Wake* are destructive of the nineteenth-century novel. But it seems difficult to admit this destructiveness into court when judgements are to be made. We have to. To go to the cinema, to read books or to listen to music is to be a partisan. Evaluation cannot be impartial. We cannot divorce the problem of codes from the problem of criteria. We cannot be passive consumers of films who then stand back to make judgements from above the fray. Judgements are made in the process of looking or reading. There is a sense in which to reject something as unintelligible is to make a judgement. It is to refuse to use a code. This may be right or wrong, but it is not the same thing as decoding a work before applying criteria. A valuable work, a powerful work at least, is one which challenges codes, overthrows established ways of reading or looking, not simply to establish new ones, but to compel an unending dialogue, not at random but productively.

This brings us back to Godard. The hostility felt towards Godard expresses precisely a reluctance to embark on this dialogue, a satisfaction with the cinema as it is. When, in *East Wind*, Godard criticises not only the work of other film-makers, but his own practice in the first part of the same film, he is at the same time asking us to criticise our own practice of watching his film. At the same time as he interrogates himself, we are interrogating ourselves. The place of his interrogation is the film, the text. This is not simply a question of self-consciousness. It is consciousness, first and foremost, of a text, and the effect of this text is like the effect of an active intruder. It is this intrusion which sets up conflicts which cannot be

settled by one (rational) part of consciousness surveying another part of its own past and then bringing it back into line. It is only natural that people should want to drive the intruder out, though it is difficult to see how a critic could justify this.

Godard represents the second wave of impact of the 'modern movement' of the cinema – the movement represented elsewhere by Duchamp, Joyce, and so on. During the 20s, Russian film-makers like Eisenstein and Vertov make up the first wave. It remains to be seen whether Godard will have any greater short-term effect than they had. But it is necessary to take a stand on this question and to take most seriously directors like Godard himself, Makavejev, Straub, Marker, Rocha, some underground directors. As I have suggested, they are not all doing the same thing, and it may be that a director like Makavejev is not really in the same camp as Godard at all. This remains to be seen. For this reason, I do not believe that development of auteur analyses of Hollywood films is any longer a first priority. This does not mean that the real advances of auteur criticism should not be defended and safeguarded. Nor does it mean that Hollywood should be dismissed out of hand as 'unwatchable'. Any theory of the cinema, any film-making, must take Hollywood into account. It provides the dominant codes with which films are read and will continue to do so for the foreseeable future. No theorist, no avant-garde director can simply turn their back on Hollywood. It is only in confrontation with Hollywood that anything new can be produced. Moreover, while Hollywood is an implacable foe, it is not monolithic. It contains contradictions within itself, different kinds of conflicts and fissures. Hollywood cannot be smashed semiologically in a day, any more than it can economically. In this sense, there may be an aspect of 'adventurism' or Utopianism in Godard. There certainly is in a number of underground film-makers.

So, looking back over this book, I feel that its most valuable sections are those on Eisenstein and on semiology, even though I have now changed my views on the latter. I no longer think that the future of cinema simply lies in a full use of all available codes. I think codes should be confronted with each other, that films are texts which should be structured around contradictions of codes. The cinema had its origins in popular entertainment and this gave it great strength. It was able to resist the blandishments of traditional 'art' – novel, play, painting and so on. Nevertheless, the period of the rise of Hollywood coincided in many respects with a move in Hollywood towards artistic respectability, personified for example by Irving Thalberg. This movement never really got beyond kitsch – Welles, who should have been its culmination, proved too much for it. At the same time, the popular side of Hollywood was never completely smothered by the cult of the Oscar and of fine film-making either. Now, for the second time – the first wave proved premature – the avant-garde has made itself felt in the cinema. Perhaps the fact that it is fighting mainly against Hollywood rather than against traditional 'art' will give it an advantage over the avant-garde in the other arts. It is possible that the transitional period we have now entered into could end with victories for the avant-garde that has emerged.

The Writings of Lee Russell:
New Left Review (1964–7)

Samuel Fuller

[First published in *NLR* no. 23, January/February 1964, pp. 86–9]

Samuel Fuller was one year old when Walsh made his first film, three years old when Chaplin made his first, four years old when Griffith made *Birth of a Nation*, six years old when Ford made his first. Many veterans of the silent film are still alive, working or looking for work: Swan, Lang, Hitchcock, Hawks, Renoir, Vidor. Fuller made his first film, *I Shot Jesse James,* after two decades of sound, in 1949. He is a post-Welles director, a little older than Welles, whose films appear along with films made by directors whose cinema careers began before Welles was born. The fantastically foreshortened time-scale of the cinema has meant that few American directors are seen in their proper perspective, Fuller perhaps least of all. Even an informed critic like Andrew Sarris, writing in *Film Culture*, has described Fuller as a 'primitive'; his failure to treat 'contemporary', 'real-life' subjects and situations has led most critics to lose sight of his distinctiveness and to relegate him into the ranks of the 'action directors' who are thought of as making up the solid, traditional rearguard of American cinema rather than its brilliant, exceptional vanguard. Ritt, Cassavetes and Sanders excite critical attention, while Fuller is neglected.

Fuller has worked consistently within the American cinema genres: Western, gangster, Pacific war. These genres, I would argue, are the great strength of the American cinema. America is a comparatively young nation which has grown very rapidly into a leading global power. It is no accident that the epochs of the cinema genres are also the epochs of crisis in America's consciousness of itself, its national identity and its role in history. The American cinema helped to develop the national consciousness while it developed its own genres, through its mutually responsive relationship with its mass public. American cinema has developed artistically out of the romantic movement and of national consciousness. This trend was strengthened by the emergence of the genres, in which themes and attitudes could be systematically developed. The work of Fuller in these genres represents a far point of bourgeois romantic–nationalist consciousness, in which its contradictions are clearly exposed.

Fuller's world is a violent world, a world of conflict: Red Indian *v.* white man, gangster *v.* police, American *v.* Communist. (Fuller has updated the Pacific war

movie to deal with both Korea and Vietnam.) But neither the fronts nor the occasions for conflict are clearly delimited. Battles take place in utter confusion: in thick fog, in snowstorms, in mazes. All Fuller's war films are about encounter behind the enemy lines. Nor do the protagonists even know why or for what they are fighting. 'How do you tell a North Korean from a South Korean?' asks a puzzled GI in *Steel Helmet*. His stogie-chewing sergeant replies: 'If he's running with you, he's a South Korean. If he's running after you he's a North Korean.' In *China Gate* we see the defence of the American alliance in Vietnam by a commando patrol: one is a German veteran of the Hermann Goering Brigade, one an American negro, both enlisted in the Foreign Legion. The only reason they give for being there is that the Korean War is over so they looked for another trouble-spot. They are, in fact, the dregs of society, psychopathic killers with no purpose in life. Fuller often points out how such people take the burden of defending the society which has rejected them.

The typical Fuller hero is poised ambiguously in the conflict. Often he is a double agent. In *Verboten* the neo-Nazi, Bruno, infiltrates the American Occupation HQ; in *House of Bamboo*, a military policeman infiltrates a gang entirely made up of men discharged with ignominy from the US army. In *Pick-up on South Street* and *China Gate* the central characters try to play both ends at once, America and Communism, to their personal advantage. 'Don't wave the flag at me,' says the pickpocket hero of *Pick-up* who has inadvertently lifted a microfilm from a Russian spy, and proceeds to auction it to the highest bidder. Lucky Legs, in *China Gate*, makes possible the success of a French mission by her friendship with the Vietminh lookouts and camps, whom she leads in singing the 'Marseillaise' while the legionaries sneak by. In the end they both choose America. Why? Irrational personal loyalties.

Ambiguity in its most extreme form is represented in Fuller's films by the Nisei, the Japanese American, and the Chinese American. In *Hell and High Water* a captured Chinese Communist appeals to an American Chinese, who is a stool-pigeon to get information from him. Despite the Communist's evident humanity and amiability the American Chinese betrays him. He is, as he sees it, a loyal American. Fuller takes the matter further. He asks how the white American sees the Chinese American. One of the major themes of his films is anti-racism, subordinated to the theme of nationalism. In *The Crimson Kimono*, set in Los Angeles, a white girl leaves her white boyfriend for his best friend, a Nisei. This film was made in the same year, 1959, as *Hiroshima, mon amour*. Fuller deals with the race problem much more radically than Resnais. The Nisei marries the white girl; the animosity of his friend when he realises what is happening is clearly shown, culminating in a bout of *kendo*-fighting, when he goes out of his mind and tries to kill the Nisei.

To Fuller, however, it is America that is always paramount. There is a clear contradiction between his attitude to the Nisei and the negro, whom Fuller sees as being necessarily integrated into American society, and the attitude he takes to the white 'renegade' O'Meara in *Run of the Arrow*, a Western. O'Meara, a Southerner, cannot tolerate the idea of living under the Union flag and the Union constitution, after Lee's surrender. 'They chased us when we had not legs; they crammed our bread into their mouths when we had no food.' He goes west and joins the

The Crimson Kimono *(1959).*

Sioux nation. When the Yankees come and make a treaty with the Sioux chief Red Cloud, Red Cloud insists that they employ a Sioux scout, not a Cherokee. The Sioux scout chosen by the chief is O'Meara. Fuller is scrupulously fair to the Indians: he permits O'Meara to criticise the treaty terms and sympathises when the Indians wipe out a US cavalry detachment after the terms are broken. But he insists that O'Meara cannot fully integrate himself into the Sioux nation. He returns with his Indian wife and child to the Union, recognising that he is an American. Yet he insists that the Nisei is not a 'renegade' and that he can be integrated into America. Fuller's anti-racism is limited by his nationalism and his nationalism is finally determined by his own nationality. Fuller is an American and in the end all his heroes choose America.

But Fuller does not evade the problems; he evades the answers. Although he is

committed to America, he is well aware of the contradictions in American society and does not hesitate to confront them. His America is a violent, divided America; his saviours of America are delinquents and misfits. His Americans rampage through South-East Asia – through Burma, Vietnam, Korea, Japan – and huge statues of the Buddha smile sardonically down on them. In *Steel Helmet* US troops crouched on the Buddha's lap fire over the Buddha's shoulder. Fuller's romantic nationalism is quite incapable of seeing any positive way forward, any real future. The America he celebrates is teetering into lunacy. This is further demonstrated by the plot-synopsis of the film he is now working on, *Shock Corridor*.

A journalist (Fuller himself was a journalist before he went into cinema, a formation he is proud of and which he has explicitly used in his film about journalism, *Park Row*) wants to win the Pulitzer Prize. He hears of an unsolved murder in a lunatic asylum and arranges to be drafted into the asylum – a double agent between sanity and lunacy – and write up the story. There are three key witnesses. First, the single negro student in a Southern university, who has gone mad and thinks himself the head of the Ku Klux Klan. Second, a GI who went over to the Communists after being captured in Korea. Third, an atomic scientist who has regressed to the mental age of six. The journalist solves the murder, writes the story and wins the Pulitzer Prize. But he is so disturbed by his experience that he too goes insane and is put in an asylum. His choice has been made.

Finally, a few comments on Fuller's style. Fuller has an extraordinary command over tempo. He is celebrated both for his quick jump-cutting – a decisive influence on Godard's *Breathless* – and for the length of individual takes. (A take in *Verboten* of 5m. 29s.; a take in *Run of the Arrow* of 4m. 11s.) His films contain unusually striking images: a view of Fujiyama between the shoes of a corpse (*House of Bamboo*); a battle in a maze of polygonal man-height tank-traps (*Merrill's Maurauders*); a dumb child being sucked into quicksand and blowing on a harmonica for help (*Run of the Arrow*). Finally, despite all the speculation about Lang and Losey, it seems to me that Fuller is the film director whose methodology closest approaches Brecht's theatre. Compare, for instance, his use of characters both as actors in a drama and spokesmen of their consciousness of the drama, his use of song and of exotic, distant settings, and even his use of posters and slogans: at the end of *Run of the Arrow* a rubric flashes on to the screen, 'The end of this story will be written by you'.

Fuller is an example of a distinctive creative personality (he has written, produced and directed the majority of his films) working within a traditional genre to extend and explore both its traditional themes and his own attitudes to them. The genres he has used are the genres which deal with the key areas of American history, and Fuller has used them to confront the problems which are raised by the contradictions of American history. He has not shirked those contradictions but has sought to dissolve them in an extreme statement of romantic nationalism. He has pushed romantic nationalism as far as it will go. His future films will show how far he can push his own energy and integrity.

Jean Renoir

[First published in *NLR* no. 25, May/June 1964, pp. 57–60]

In 1936, it is often forgotten, Jean Renoir made a propaganda film, *La Vie est à nous,* for the French Communist Party, starring Maurice Thorez, Jacques Duclos, etc: in 1937, he made *La Marseillaise* for the Trade Union movement (CGT). Then the war and exile in Hollywood. The heady days of the Popular Front never returned. In 1950, he made *The River* in India (his last American film), explaining that, whereas before the war he had tried to raise 'a protesting voice', he now thought that both the times and he himself had changed: his new mood was one of 'love', of the 'indulgent smile'. Following films seemed to confirm the trend: *French Cancan, Elena et les hommes.* Betrayal? Or maturity? The critics split. One camp praised the pre-war Renoir, the Renoir 'of the left'; the other praised the post-war Renoir, the Renoir of 'pure cinema'. One school, leaning on the authority of Andre Bazin, remembered 'French' Renoir; another, headed by the emerging critics of *Cahiers du Cinéma*, heralded 'American' Renoir. As Renoir grew older, the *Cahiers* critics argued, he grew more personal, hence more of an author, a greater director. Debate turned acrimonious. Renoir, one anti-*Cahiers* critic wrote, 'deified by imbeciles, has lost all sense of values'. And so on.

The truth is that Renoir's work is a coherent whole. The mainspring of his thought has always been the question of the natural man: nature and artifice, Pan and Faust, natural harmony. His differing attitudes to society have been the result of the 'natural' *naïveté* he has cherished. The Popular Front appealed to him, he has confessed, partly because it seemed to presage an era of harmony between classes, a national idyll; after the war the forces which had made up the Front showed discord rather than concord and Renoir retreated from political life, away from camps and blocs into the countryside, his father's estate, nostalgia and a kind of pantheism. Yet Renoir the pantheist is none other than Renoir the Communist, Renoir the 'red' propagandist. His first allegiance has always been to the ordinary man, asking nothing more than to eat, drink, sleep, make love and live in harmony with all the other millions of ordinary men throughout the world. He dislikes regimentation, systematisation – anything which threatens the natural, human qualities to which he is attached. He detests the conditions imposed on man by capital – at its furthest limit his detestation has led him to anarchism and pacifism – but he cannot accept the conflict or the discipline necessary for the overthrow of the capitalist system. His great philosophical ancestor is Rousseau; at one time his preoccupation has been the General Will, at another the Noble Savage.

Renoir recognises the existence of social classes and nationalities – he is fascinated by them, as phenomena – but he insists that these differences need not divide men in their human essence. Thus masters and servants – their lives and escapades – have always humanly interacted and interlocked in Renoir's world, though the two orders remain distinct. (Renoir has always preferred to depict master–servant relations than employer–worker: he is repelled by the anonymity of the factory.) Witness, for instance, the conversation about harems between the marquis and the servant in *La Règle du jeu*. The divisions which count are 'spiritual', not social, divisions. 'My world is divided into miser and spendthrift, careless and cautious, master and slave, sly and sincere, creator and copyist.' (Master

La Règle du jeu *(1939)*.

and slave, to Renoir, are spiritual categories – he uses 'aristocrat' in the same way.) Renoir is the spokesman for human values which capitalist society will destroy as far as it can – the values which Rousseau thought of as pre-social. He is confident that these values cannot be destroyed entirely, that there are spiritual recesses into which capitalism cannot reach, that human beings cannot be entirely dehumanised. Renoir believes that most people want no more than a simple, uncomplicated life; anything further is vanity, false pomp. This involves a renunciation of public life and a retreat into privacy, a flight from the central realities of an inhuman society to its human margins. It explains Renoir's fascination with women, wandering players, gypsies, vagabonds, poachers and so on – all those who live in this human margin. Yet Renoir's bonhomie – his open optimism – easily slips into buffoonery – a kind of hidden pessimism.

The purest expression of Renoir's attachment to the natural man is his film *Boudu sauvé des eaux,* made in 1932. Ever since he made it, he has said, he has been looking in vain for another such story. A Parisian bookseller rescues a tramp, Boudu, who has thrown himself into the Seine. He takes him home and starts trying to civilise him, to educate him in the desiderata of bourgeois life. But Boudu is intractable – a natural man, impervious to restraint or nicety – he climbs on to the dinner table, sleeps curled up on the floor, ruins rare books, tears down the curtains, assaults his benefactor's wife, etc. Eventually, a kind of settlement is reached and it is decided that Boudu is to marry the maid. (Marrying the maid is a recurrent feature of Renoir's films.) During the wedding party, Boudu upsets a boat on the Seine, swims ashore, lies down beneath a hedge and returns happily

to a life of vagrancy. Boudu's incursion into society is destructive, anarchic: the same bourgeoisie which, in Renoir's words, produced Proust and the railway, cannot cope with Boudu. It is clear which way of life Renoir regards as more authentic. But Boudu is an extreme case: on the whole, Renoir tempers nature with prudence.

> For me the red traffic-light symbolises exactly that side of our modern civilisation which I do not like. A red light comes on and everyone stops: exactly as though they had been ordered to. Everyone becomes like soldiers marching in step. The sergeant-major shouts 'Halt!' and everyone halts. There is a red light and everyone stops. To me, that is insulting. All the same you have to accept it, because if you carried on, despite the red light, you would probably get killed.

Renoir's masterpiece, *La Règle du jeu*, explores the same theme on a different level; it is more complex and more nuanced. André Jurieux, a popular hero (an ace pilot who is clumsy on the ground: the symbol is familiar), disturbs the aristocratic house party to which he is invited by his passion for his host's wife. The code of rules by which life is ordered breaks down and guests and host begin to fight 'like Polish navvies'. Jurieux, the disturbing force, must be expelled; he is shot and a speech of great delicacy by De la Chesnaye – the host, a marquis who adores mechanical music-boxes – restores order and the conventional code. The shooting of Jurieux echoes the shooting of birds and rabbits at the butts – the senseless destruction of natural beings in order to conform with a style of life. Such a schema does not suggest the full scope of the film: the surface is continually fluctuating and it is this fluctuating interaction of the characters, rather than the intrigue (a kind of Beaumarchais plot), which sets the pace and holds the eye. Renoir gives his actors a great deal of room and time – by the use of deep focus and long takes – and encourages them to move about. The film is awash with movement and gesture, so that the first impression is of a continual to and fro, combined with sharp psychological accuracy. The camera, in André Bazin's phrase, is 'the invisible guest, with no privilege but invisibility'. The construction of the film reveals itself little by little to the attentive spectator: Renoir does not belabour his points. Indeed, in *La Règle du jeu* tragedy emerges imperceptibly from breakneck farce; the aristocracy are most doomed – an aristocracy who are never cartoons, as they are in Eisenstein – when they are at their best.

After the war, Renoir returned again to the themes of *La Règle du jeu*, most obviously in *Elena et les hommes,* but also in *Le Carrosse d'or,* made in Italy in 1952. There is space here only to make some suggestive remarks about this film. First, it takes up again the same triad of characters who appeared in *La Règle du jeu:* Viceroy = Marquis, Bullfighter = Pilot (the popular hero), Felipe = Octave. But here is a difference: it is the woman, Camilla, who is the disruptive, natural force; the bullfighter is merely the suitor who is clumsy, even ridiculous, when outside the arena. Second, the golden coach itself is used as a symbol of human vanity, of the wish for public acclaim and pomp. It is the coach of Faust (mastery over nature): the viceroy must choose between the coach and Camilla (submission to nature). But third, Renoir introduces an idea which radically modifies his attitude to nature: that, in some circumstances, it is most natural to play artificial roles.

Thus, Camilla, the natural force, is only really her natural self when playing on the stage in the *commedia dell'arte*. Real life and theatre becoming inextricably confused: it would be, in a sense, unnatural for the viceroy to choose Camilla; he cannot. Yet finally, Felipe, who goes to live with the Indians (Rousseau's savages), can be natural, because he opts out of society altogether. He is, like Octave in *La Régle du jeu,* a failure, unable to choose at first between acceptance and refusal of society – between two sets of values – but finally constrained to leave.

Renoir has always been a pioneer. His film *Toni* (1934) is widely considered to be a main source of Italian Neo-Realism: there is a direct link through Visconti, who was Renoir's assistant. *La Règle du jeu* used deep focus before Welles. Renoir wanted to be more free to place his actors and let them move. The same kind of consideration led him to TV techniques for *Le Dejeuner sur l'herbe* and *Dr Cordelier,* shot with several cameras simultaneously and hidden microphones: this gave much more fluidity and also meant that the actors could not play to the camera. Renoir has never liked quick cutting: an extravagant camera movement, like the 360-degree pan so admired by Bazin in *Le Crime de Monsieur Lange*, is often preferred to a cut. His films use less and less *champs-contre-champs*, fewer and fewer close-ups. The tempo of his films comes from the actors, not from the montage. When he uses close-ups, for instance, it is not to stress a dramatic climax, but to punctuate with images from outside the main action. Often they are of nature ('quasi-animist' is Jacques Rivette's phrase): the frogs and twitching rabbits in *La Règle du jeu,* the squirrel Kleber in *Diary of a Chambermaid,* the insects in *Le Déjeuner sur l'herbe.*

Undoubtedly Renoir is one of the great masters of the cinema. His work stretches from Gorky's *Lower Depths* to *commedia dell'arte*; it embraces Indian snake-charmers, nymphs and satyrs, Jekyll and Hyde, General Boulanger, test-tube babies, cancan dancers and the Communist Party. Some critics have seen no more in Renoir than the retreat into a pastoral idyll, a reminiscence of his father's painting. The enormous diversity of Renoir's material gainsays them. For, while he does insist on the values of the idyll – values uncorrupted by capitalism – he has never made the limits of the idyll his own horizon. On the contrary, he has insisted on applying these values to every kind of circumstance. Perhaps he has been over-optimistic. But it would be wrong to reproach him for the over-optimism of, say, *Elena et les hommes* – its pervasive atmosphere of benevolence and sympathy for everyone – and not for the over-optimism which marked his support of the Popular Front. Moreover, it is his optimism which enables him to reduce the values of bourgeois society to farce; it is not the hypocritical optimism of bourgeois sentimentality. It is a firm confidence in man and his attachment of authentic values. Apropos of *La Marseillaise,* Renoir commented on the men who stormed the Tuileries: 'Of course, first and foremost, they were revolutionaries, but that did not stop them eating, drinking, feeling too hot or feeling too cold. ... They were in the midst of events, which transformed the destinies of the world, like straws in a storm. But we must not forget that the storm which swept them along was their own work.'

Stanley Kubrick

[First published in *NLR* no. 26, Summer 1964, pp. 71–4]

Stanley Kubrick, by his meteoric rise to the top of the industry, has so far managed to outpace critical appraisal. At first he was greeted as the regenerator of the thriller; suddenly he turned to good causes and social content. And then no sooner had he won new friends with *Paths of Glory* than he strained their allegiance to the limit by choosing to make a blockbuster, *Spartacus*. Next, *Lolita* confirmed Andrew Sarris in the dark view he had taken of Kubrick, but was welcomed by Jean-Luc Godard in the pages of *Cahiers du Cinéma* as 'simple and lucid', a 'surprise'. Finally, *Dr Strangelove* split the more orthodox critics as unexpectedly as *Lolita* has split Sarris and Godard. To some it seemed a deeply serious film, courageous and progressive; to others, sick and nihilistic. By and large, two broad currents of opinion seem to have formed. On the one hand, Kubrick can be seen as trying bravely – and more or less successfully – to make 'serious', nonconformist films which, at the same time, reach a mass audience and benefit from all the resources usually available only to the mere 'spectacular'. Or, on the other hand, Kubrick can be seen as stretching his powers too far, as dissipating his talent in grandiose projects and 'big ideas', attractive for their scope, but which he can mark with his own personality only in quirks and fragments. But either way, uneasy doubts remain.

One crucial ambiguity in Kubrick's work lies in the relationship between his *bien-pensant* liberalism and his obsession with disaster. Kubrick has mentioned that Max Ophuls is his favourite director: most critics have thought this a stylistic preference and noted it alongside his addiction to tracking-shots. But here is another, more profound, common quality: Kubrick's films are pervaded with the Ophulsian bitter-sweet. *Lolita*, of course, is bitter-sweet through and through. In *Killer's Kiss,* the two lovers, Gloria and Davy, are both failures – a failed dancer, overshadowed by her ballerina sister, and a failed boxer, whom Gloria watches on the TV pummelled ignominiously on to the canvas. Two of Kubrick's films, *Paths of Glory* and *Dr Strangelove*, end with sentimental songs, used to counterpoint total defeat. In *Paths of Glory* the song mocks the order for battle-weary troops to return to the front after the execution of three among them for cowardice – three who were, in fact, innocent, who were arbitrarily chosen as scapegoats to cover up the blunders and savagery of a high officer. In *Dr Strangelove*, the irony is even more fierce: a Vera Lynn song accompanies a long sequence of atomic explosions and mushroom clouds. Yet there is a vital distinction to be made between Ophuls's pessimism and Kubrick's. Ophuls was a romantic – indeed, an arch-romantic. In *Lola Montès,* his greatest and most pessimistic film, the myth of Lola is that of Icarus: Lola's aspiration to an ideal, individual freedom is shattered by the reality of human history, a reality which, since her own vision remains pure, she cannot grasp even after her fall. She ends up in a cage in a circus menagerie, imprisoned, degraded, fallen – but still attached to her broken dream, which she re-enacts each night. The re-enactment – fictive and theatrical – is a heroic reassertion of the value of the aspirations of her wrecked life: the triumph of myth over reality through art. But for Kubrick, there are no myths, no freedom, no hope: only their absence. The counterpart of Kubrick's jejune liberalism is a jejune nihilism.

Dr Strangelove *(1963)*.

Kubrick's *Lolita* is dominated not by the quest for an impossible passion (imposs-ible because Lolita must live in time) but by the search for Quilty, tracking him down and killing him. Kubrick's world is dehumanised; human passions are fatu-ous. His pessimism is cold and obsessive.

For Kubrick, the bitter-sweet easily spills over into the grotesque and into black farce. This streak showed itself very early and it has gradually grown dominant: the fight with fire-axe and fire-pole between Davy and Rapalo in *Killer's Kiss,* in which a roomful of tailor's dummies are hacked to pieces by huge swipes, limbs and heads flying everywhere; Nikki's conversation with the negro car-park atten-

dant in *The Killing;* the ping-pong before Quilty's murder in *Lolita,* the grotesque Pentagon war-room sequences in *Dr Strangelove.* Expressionism is pushed toward Surrealism – bizarre juxtaposition, macabre undertones, the triumph of the irrational. But Kubrick goes much further than Welles, particularly in his choice of actors. It is entirely logical that Kubrick should have fixed on Peter Sellers for his two latest films: an actor with almost no human essence, an impersonator and a caricaturist. And whereas in Welles caricature-actors are used as foils for the massive, perverted, but very human quality of Welles himself, in Kubrick there is nothing but caricature. The real logic of *Dr Strangelove* is that Sellers should play, not just three, but all the parts. For Welles, the world is a nightmare which perverts man's Faustian aspirations into Mephistophelean evil: the only authentic response is stoicism and scepticism – Welles's favourite writer is Montaigne. For Kubrick, everything is diseased, all human qualities are caricatures, there is no authenticity. (Even his apparently positive characters – Dax and Spartacus – experience nothing authentically but defeat: hope, for them, is just ignorance.)

Before he went into movies, Kubrick worked as a still photographer for *Look.* His first films were praised by critics for their 'visual flair': *Killer's Kiss* is full of carefully composed shots – reflections, shadows, silhouettes, etc. The general effect is rather fussy and over-ornamental. *The Killing* is a much cleaner film. It tells the story of a racetrack heist; the tasks of each member of the gang are slotted into a precise schedule. The cutting is brilliant; the plan of the film reflects the plan of the robbery in its precision. Some sequences are repeated twice, from different viewpoints, as the different roles of different actors in each operation are followed. The camera is very mobile. This mobility becomes over-obvious in *Paths of Glory:* the camera tracks endlessly down trenches full of exhausted soldiers – the trench walls circumscribe the camera's range too blatantly. In another scene the camera tracks back and forth across the end of a large hall as Colonel Dax, defender in a court martial, paces back and forth with it. All Kubrick's films tend to be over-directed. In his later films, the construction becomes much looser, the camera-work more expressionistic still. The retreat from naturalism is very obvious in *Lolita,* which was made in England: the paean of praise to the American landscape – motels, tollgates, clover-leafs, neon, etc. – which might have been expected from Nabokov's book, was completely foregone by Kubrick. In *Dr Strangelove* the plot develops very loosely and schematically – it does not seem to matter how much time there is left; the point is that there is not enough.

Kubrick is an ambitious director. But his more grandiose projects do not seem to have forced him to deepen his thought: fundamentally, *Dr Strangelove* is an advance over *Killer's Kiss* only in so far as its pessimism is spread much wider, more universalised and more cosmic. Certainly this makes a more sensational effect: the end of the world is necessarily sensational. But, at the same time, it is not the end of the real world; it is the end of a monstrous caricature. For, the more universalised the pessimism becomes, the more it is necessary to dehumanise the world and to caricature mankind. Thus *Dr Strangelove* has no real bite. On the other hand, Kubrick is certainly not a Preminger. The claim of 'daring', of 'confronting problems', is obviously hollow with Preminger; even though he has made films about drug addiction, rape, Israel, homosexuality in the United States senate, the Ku Klux Klan and so on, he has never been more than a parasite on controversy.

Indeed, his two latest films have been apologias for the American constitution and the college of cardinals. Compared with Preminger, Kubrick is a genuine nonconformist. Indeed, he seems increasingly anti-American: he has even gone into voluntary exile. But the more Kubrick retreats into expressionism and caricature, the more his pessimism becomes merely a question of mood, rather than the outcome of a confrontation of real problems.

In the last resort, perhaps, Kubrick shows no more than the easy way out of the liberal impasse. He sees the inadequacy of liberalism, its impotence when it comes to a crisis, but he cannot abandon it. He goes on repeating its platitudes. Each time they taste sourer in the mouth. Dalton Trubo gives way as scriptwriter to Terry Southern. And as the platitudes become more and more bitter, more and more farcical, so does the world. Everybody becomes Peter Sellers. Humanity becomes the most grotesque platitude of all. Meanwhile, his best film remains *The Killing*, where the human quality of the characters (Sterling Hayden, Kola Kwarian, Tim Carey, Ted de Corsia, Jay C. Flippen), seen in relation to each other and to their work, is as yet unmatched. Yet, despite the facility of Kubrick's development, it would be wrong to discount him altogether. Somewhere inside him is lurking a Nathanael West struggling to emerge. If he does not succeed in releasing him, Kubrick will end up as fatuous as the world he depicts.

Louis Malle
[First published in *NLR* no. 30, March/April 1965, pp. 73–6]

The *nouvelle vague* is now at least six years old and the time has come to take stock. Perhaps the best way to do this is to consider the work of Louis Malle, never at the heart of the group who took the headlines, yet in a way the *nouvelle vague's* arch-exponent, and certainly its most consistently successful in terms of both box office and prizes. In his latest film, *Le Feu follet*, Malle showed himself perhaps closer to the original spirit of the movement than others who have sheered off in their own personal or hyper-personal directions. Malle, the most eclectic, is also the most typical. The paradox need not surprise: unable to develop a style with its own dynamic, the eclectic devises a composite, whose surface shimmers with unresolved tensions, but which is easily assimilable. In the wrong circumstances, the eclectic becomes either an academic or a grotesque. Malle, an intelligent director, has been saved from these extremes both by the progressive atmosphere surrounding him and by his own good judgement. But, whereas Godard is Godard and Truffaut is Truffaut, Malle is the *nouvelle vague*.

It is worth recapitulating why it was that the first films of the movement created such a vivid impression of novelty. Partly it was a question of *mise en scène*: semi-newsreel, often hand-held camera-work; a carelessness about framing and a much greater insistence on texture; a belief that the camera should follow actors encouraged to act naturally rather than perform in front of the autocratic camera; a new willingness to use unorthodox effects more or less casually rather than as set pieces. Partly it was a new approach to content and a new kind of content: epi-

sodic construction, often with many parentheses; a fearlessness about introducing 'intellectual' material, conversation and allusions; a phenomenological approach to domestic psychological problems; a more candid treatment of sexuality; a preference for natural, 'spontaneous', rather than instrumental, plot-forwarding dialogue, often improvised on the spot. Other features were more superficial: in jokes, tributes to the American gangster movie, visual puns. Also there was a clear insistence, often to the point of flagrancy, on having a developed cinematic culture, leading to an insistence on clear-cut directional control.

Almost all these qualities and characteristics are to be found in Malle's films. His first film, *Ascenseur pour l'échafaud*, did not fully satisfy him – unlike other *nouvelle vague* directors, who managed to make their own projects as first films, Malle had the screenplay forced on him. It was a film which was given *nouvelle vague* treatment (the Miles Davis soundtrack, for instance), it established Malle's talent, but did not give him the chance to make his *own* film. *Les Amants*, his next film and his own project, was clearly too concerned with the kind of preoccupations a *nouvelle vague* film ought to have. Its central feature, a long erotic sequence of love-making, signalled a new liberty without making any real new advance. The plot, despite its modern trappings – the 2CV and the bathroom – was essentially ultra-romantic and anachronistic. As so often with Malle, the most distinctive feature of the film was its ornament: the polo, the bathroom, etc.

Zazie dans le métro was a more important work, not exactly because of its merits, but because it was an unashamed attempt to make a split-level film, which would appeal to *cinéphiles* and the general public, but for different reasons. On the one hand, it was an anthology of allusions and quotes from numerous historic movies; on the other, it was a zany crackpot comedy, with lots of chases and slapstick. The film also showed Malle's mounting interest in camera-work; plot and character hardly exist and the film is kept from sagging almost entirely by stimulating the eye and not allowing it to settle. *Zazie* showed how it was possible to use typical *nouvelle vague* devices in order to enliven an action of little interest to the director in itself and turn it into a virtuoso stylistic exercise. (This, of course, is what Richardson tried to do with *Tom Jones*.) It should be said that since Queneau's original book was little more than a virtuoso semantic exercise itself, it is arguable that Malle was translating it faithfully into cinematic terms. But this merely underlines the point that Malle has been unable to find his own dynamic.

The *nouvelle vague* was always careful not to seem afraid of commercialism; its admiration for American cinema implied a belief that good cinema might well also be good box office. Yet it soon became quite clear that the leading *nouvelle vague* directors, far from being shadowy figures in the Hollywood jungle, were going to be enthroned as the idols of the intelligentsia, in the full glare of the limelight and applauded by the very critics who spurned the American cinema. Besides, they were nearly all intellectuals themselves and, though it is one thing to insist that the cinema – for all the merits of American directors – still lacked a certain intellectual dimension, it is quite another to litter Faulkner's *Wild Palms* or Goethe's *Elective Affinities* around on the screen and comment on them in long passages of screenplay. Consequently, there was always a fundamental tension in *nouvelle vague* cinema, sometimes expressing itself in surprising ways, apparently perverse: thus Godard makes films with Brigitte Bardot and Eddie Constantine.

Vie privée *(1961)*.

Malle too made a film with Brigitte Bardot, *Vie privée*. Godard's *Le Mépris* was utterly paradoxical, to the point of self-destruction; it was an attempt to make 'a film of Antonioni in the style of Hitchcock and Hawks', a bizarre juxtaposition of *Playboy*-type close-ups of Brigitte with a recondite allegory based on *The Odyssey*. But Malle's film was, as one might expect, a more or less straight commercial property, similar in its key idea to Clouzot's *La Vérité*, but given a new kind of stylistic gloss. Its two most striking features – Decae's experimental *pointilliste* photography and a long sequence of Brigitte Bardot falling through space, based on the parachute jump in Sirk's *Tarnished Angels* – had no relevance to the plot of the film, which seemed to demand either newsreel treatment or else out-and-out Ophulsian theatricality. Once more, however, Malle lapsed at crucial moments into a weak romanticism which belied his quirks of experimentation. The film seemed subservient to conservative box-office opinion and not committed to the belief that advanced cinema could pay well, Moreover, he seemed quite incapable of dealing seriously with any of the themes – such as the nature of stardom, the private and the public face, etc. – which the film might have suggested.

It seemed, after *Vie privée* had been shown, that little more could be expected from Malle. However, he proved resilient enough to make a comeback and his most recent film, *Le Feu follet*, was well received almost everywhere. It was not an outstandingly good film, but it was a film which perhaps more than any other was calculated to catch the attention of the intellectual. The screenplay was based on an adaptation of a novel by Drieu La Rochelle, with the hero changed from a drug addict to an alcoholic. This shift brought the film into line with its prevailing

mood, which was clearly signalled by a number of allusions to Scott Fitzgerald. Although the film, like the book, ends with the hero's suicide, it was not so much a suicide of an oppressed or broken man as of a privileged yet doomed man, a man who obscurely feels that he has no further time to live and that to continue living, perversely, would be to live in such a condition of radical separation from others as hardly to be living at all. The film does not consider the origins of this feeling of fatality and of separation, but chronicles a series of episodes in which it becomes manifest. The camera, therefore, is the typical *nouvelle vague* following camera, but it is also endowed, for quite long periods, with the hero's own subjectivity.

The principal episodes are in the form of vignettes of the hero's friends: an earnest adept of the kabbala, a beatnik girl and a Maecenas who likes to entertain the wealthy and the witty. Like the hero, they are all intellectuals. During the day, the hero, who has just undergone an alcoholic's cure, gets incapably drunk. However, this is not the centre of the film; alcoholism, it is evident, is a symptom and not a disease. What is really at stake is the essential character of the intellectual, his obsession with the problematic, his fear that the problem is a false problem. The film owes its success to the fact that its audience – an audience of intellectuals – through the obsessive camera, is made to share the activities of other intellectuals and see them as unintelligible, phantom-like. Thus Malle makes use of the process of audience identification with the camera and the radical separation between the audience and the shadows on the screen. Cinema, in this sense, becomes the central rite of a cult, by which a defined group makes its autocritique, its confession of fear that life cannot be made intelligible, and enacts the suicide in shadows which it will not – need not – make in substance.

Evidently, underlying a cinema of this kind is a fundamental jadedness and lack of energy. It seeks to evoke a state of mind, a quality of feeling, which is saturated in intellectuality but does not give its material any intelligible structure. It is this basic lack of orientation which allows Malle to oscillate so violently between the hyper-intellectual and the vulgar. His next film, *Viva Maria*, starring Brigitte Bardot and Jeanne Moreau, promises to be yet another tightrope-walk. Doubtless, it will be both a commercial success and strong contender for a Golden Lion. But it will probably do little to solve the problems which beset Malle and the rapidly dissipating *nouvelle vague*. It is not only fresh ideas about cinema which are now needed, but fresh ideas about society, about people, about the world. A new cinema demands a new anthropology.

Budd Boetticher

[First published in *NLR* no. 32, July/August 1965, pp. 78–84]

Budd Boetticher is not a well-known director; indeed, even such a knowledgeable critic as Andrew Sarris ranks him among 'esoterica'. Most critics would be inclined to dismiss him as responsible for no more than a few run-of-the-mill Westerns, hardly distinguishable from his equally anonymous fellows – a typical Hollywood technician, a name which flashes past on the credits and is soon forgotten. This

would be to misjudge Boetticher. His works are, in fact, distinctive, homogeneous in theme and treatment, and of more than usual interest. He is an author and well aware of it himself; he is lucid about his own films. It is high time critics were equally lucid.

Budd Boetticher's first contact with the movies was in 1941, when Mamoulian went to Mexico to make *Blood and Sand*. Boetticher had already been in Mexico some years – he went there to recuperate after an American football season – and while there had taken up bullfighting, eventually becoming a professional. Mamoulian hired him, as an American and a torero, as the technical adviser on bullfighting for his film. Boetticher became as enthusiastic about movies as he had about bullfighting and, after three years as messenger boy and assistant director, made his first film, *One Mysterious Night*, in 1944. For a number of years he made ephemeral quickies; his *prise de conscience* as an author in his own right did not come till 1951, when he made *The Bullfighter and the Lady*. For this film, he changed his signature from Oscar Boetticher Jr. to Budd Boetticher; he himself has recognized it as the turning-point in his career. Even then, it was another five years before Boetticher found the conditions which really suited him. The break-through came in 1956 with *Seven Men from Now*; his first film for Ranown Productions, *The Tall T*, came the next year. During these two films the team was assembled with which Boetticher was to make his most characteristic work: Randolph Scott as star, Harry Joe Brown as producer, Burt Kennedy as scriptwriter. *Seven Men from Now* was also Boetticher's first film to get critical ac-knowledgement: André Bazin reviewed it in *Cahiers du Cinéma* under the head, 'An Exemplary Western'. Boetticher made five Westerns with Ranown; they are the core of his achievement. Finally, in 1960, he made his most celebrated work, *The Rise and Fall of Legs Diamond*, for Warner. To make this film, he had to tear up a Philip Yordan script in front of Yordan's face and shoot in such a way that the producer could not puzzle out how to do the montage. Exasperated, he left Hollywood and America, determined, in future, to work under conditions of his own choice. Since then he has made only the unreleased *Arruza* in Mexico, after considerable difficulties. He now has numerous projects but uncertain prospects.

The typical Boetticher–Ranown Western may seem very unsophisticated. It be-gins with the hero (Randolph Scott) riding leisurely through a labyrinth of huge rounded rocks, classic badlands terrain, and emerging to approach an isolated swing-station. Then, gradually, further characters are made known; usually, the hero proves to be on a mission of vengeance, to kill those who killed his wife. He and his small group of travelling companions, thrown together by accident, have to contend with various hazards: bandits, Indians, etc. The films develop, in Andrew Sarris's words, into 'floating poker games, where every character takes turns at bluffing about his hand until the final showdown'. The hero expresses a 'weary serenity', has a constant patient grin and willingness to brew up a pot of coffee, which disarms each adversary in turn as he is prised away from the others. Finally, after the showdown, the hero rides off again through the same rounded rocks, still alone, certainly with no exultation after his victory.

At first sight, these Westerns are no more than extremely conservative exercises in a kind of Western which has been outdated. This impression is strengthened by Randolph Scott's resemblance to William Hart, noted immediately by Bazin. The

Westerns of Ince and Hart were simple moral confrontations, in which good vanquished evil; since then, the Western has been enriched by more complex sociological and psychological themes. John Ford's *The Iron Horse* (1924) already presaged new developments, which he himself was to carry through as the Western became the key genre for the creation of a popular myth of American society and history. Today, Westerns as diverse as Penn's *The Left-handed Gun*, almost a psychological study of delinquency, or Fuller's *Run of the Arrow* have completely transformed the genre. Bazin saw, in Boetticher and Anthony Mann, a parallel tendency towards the increasingly subtle refinement of the pristine form of the genre; it cannot be denied that there was a strain of nostalgia for innocence in his attitude. In fact, Boetticher's works are something more than Bazin's expressions of 'classicism', the 'essence' of a tradition, undistracted by intellectualism, symbolism, baroque formalism, etc. The classical form which he chooses is the form which best fits his themes: it presents an ahistorical world in which each man is master of his own individual destiny. And it is the historic crisis of individualism which is crucial to Boetticher's preoccupations and his vision of the world.

'I am not interested in making films about mass feelings. I am for the individual.' The central problem in Boetticher's films is the problem of the individual in an age – increasingly collectivised – in which individualism is no longer at all self-evident, in which individual action is increasingly problematic and the individual no longer conceived as a value *per se*. This problem is also central, as has often been pointed out, to the work of such writers as Hemingway and Malraux (Boetticher has himself expressed his sympathy for aspects of Hemingway). This crisis in individualism has led, as Lucien Goldmann has shown, to two principal problems: the problem of death and the problem of action. For individualism, death is an absolute limit which cannot be transcended; it renders the life which precedes it absurd. How then can there be any meaningful individual action during life? How can individual action have any value, if it cannot have transcendent value, because of the absolutely devaluing limit of death? These problems are to be found in Boetticher's films. Indeed, Boetticher insists on putting them very starkly; he permits no compromise with any kind of collectivism, any kind of transcendence of the individual. Two examples will show this.

Boetticher has made only one war film, *Red Ball Express*, with which he was extremely dissatisfied. He later contrasted the Western 'in which individuals (the story must be kept very personal) accept to face dangers in which they risk death, in order to achieve a definite goal' with the war film 'in which armies are flung into danger and destruction by destiny at the command of the countries involved in the war'.

'In other words, I prefer my films to be based on heroes who want to do what they are doing, despite the danger and the risk of death. . . . In war, nobody wants to die and I hate making films about people who are forced to do such and such a thing.' Courage in war is not authentic courage, because it is not authentically chosen; it is a desperate reaction. The same point comes out in *The Man from the Alamo*, about a Texan who leaves the Alamo just before the famous battle; he is branded a coward and a deserter. But for Boetticher he shows more courage than those who stayed; he made an individual choice to leave, to try to save his family

in their border farmstead. He risked his life – and his reputation – for a precise, personal goal rather than stay, under the pressure of mass feeling, to fight for a collective cause. He is a typical Boetticher hero. 'He did his duty, which was as difficult and dangerous for him as for those who stayed.' (In the same vein, Boetticher speaks of Shakespeare's *Henry V* and of the scene in which the king goes round the camp the night before the battle, when Shakespeare raises the whole issue of the personal involvement of the soldiers in the king's war.)

The risk of death is essential to any action in Boetticher's films. It is both the guarantee of the seriousness of the hero's action and the final mockery which makes that action absurd. Meaningful action is both dependent on the risk of death and made meaningless by it. Goldmann has described how, in the early novels of Malraux, a solution to this paradox is found by the total immersion of the hero in historical, collective action (the Chinese revolution of 1927) until the moment of death, not for the values of the revolution itself, quite foreign to a hero who is neither Chinese nor revolutionary by conviction, but for the opportunity it offers of authentically meaningful action. Boetticher, as we have seen, rejects this solution; he cannot identify himself, in any circumstances, with a historic cause or a collective action. He takes refuge, therefore, in an ahistorical world, in which individuals can still act authentically as individuals, can still be masters of their own destiny.

The goal of vengeance for a murdered wife which Boetticher's heroes have so often set themselves offers, in a society in which justice is not collectivised, the opportunity of meaningful personal action. Of course, this significance is still retroactively destroyed at the moment of death. The full absurdity of death is

The Tall T *(1957)*.

quite ruthlessly shown in *The Tall T* in which bodies are thrown down a well – 'Pretty soon, that well's going to be chock-a-block' – and in which the killer (Henry Silva) invites a victim to run for the well and see if he can get there before he is shot, 'to kind of make it more interesting'. The removal of an individual exactly amounts to the removal of all meaning from his life.

Of course, it is quite clear that the moral structure of Boetticher's world is utterly different from the simple moralism of Ince and Hart. There is no clear dividing line between bad and good in Boetticher's films. 'All my films with Randy Scott have pretty much the same story, with variants. A man whose wife has been killed is searching out her murderer. In this way I can show quite subtle relations between a hero, wrongly bent on vengeance, and outlaws who, in contrast, want to break with their past.' And, about the 'bad men' in his Westerns: 'They've made mistakes like everybody; but they are human beings, sometimes more human than Scott.'

The question of good and evil is not for Boetticher a question of abstract and eternal moral principles; it is a question of individual choice in a given situation. The important thing, moreover, is the value which resides in action of a certain kind; not action to values of a certain kind. Evidently, this is a kind of existentialist ethic, which by its nature is impure and imperfect, but which recognises this. Hence the irony which marks Boetticher's films and particularly his attitude to his heroes. The characters played by Randolph Scott are always fallible and vulnerable; they make their way inch by inch, not at all with the sublime confidence of crusaders. Yet it is possible for Andrew Sarris to talk of the 'moral certitude' of Boetticher's heroes; in fact, he is confusing the philosophical integrity which structures the films with what he takes to be the absolute moral endorsement of the hero. Boetticher sympathises with almost all of his characters; they are all in the same predicament in which the prime faults are inauthenticity and self-deception, rather than infringement of any collectively recognised code. The fact that some end up dead and some alive does not necessarily indicate any moral judgement, but an underlying tragedy which Boetticher prefers to treat with irony.

Something ought to be said about the heroes' style of action; this is not emphasised for its style in itself but as the most effective way of carrying out the action needed to achieve the goal chosen. Boetticher's heroes act by dissolving groups and collectivities of any kind into their constituent individuals. Thus in *Seven Men from Now* and *The Tall T*, the hero picks off the outlaws one by one, separating off each member of the band in turn. And in *Buchanan Rides Alone* the same method is applied to the three Agry brothers who run Agry Town, who, at first grouped together against Buchanan (Randolph Scott), end up, after his prodding and prising, in conflict with each other. Similarly, in the same film, when Buchanan is about to be shot he manages to ally himself with one of the gunmen against the other, by confiding to Lafe from east Texas that all he wants is to head out and get himself a spread by the Pecos River. Buchanan's technique is, by his personal approach to Lafe, to reveal his own individuality to him so that he is no longer willing to act as an agent for somebody else or for the collectivity at large, enforced and enforcing.

Evidently the themes and problems which I have discussed have a close connection to the ethos of bullfighting, about which Boetticher has made three films,

and which is personally of great importance to him. The ethos of bullfighting also contains obvious traps and pitfalls; around it has crystallised an extremely repugnant élitism, quick to degenerate into a cult of violence, tradition and super-humanity. Boetticher does not escape these traps. It is impossible to separate the personal encounter between the bullfighter and the bull, the individual drama of action and death, from the society and social context which surrounds and exploits it. Thus, in *The Bullfighter and the Lady*, the role of the crowd, incapable itself of action, is to provoke the bullfighter into action, even when he is wounded. In this respect, the crowd in Boetticher's bullfighting movies is similar to the women in his Westerns – phantoms, with no authentic significance. 'What counts is what the heroine provokes, or rather what she represents. She is the one, or rather the love or fear she inspires in the hero, or else the concern he feels for her, who makes him act the way he does. In herself, the woman has not the slightest importance.' The crowd, like the heroine, represents passivity in contrast with the hero, the bullfighter, who is the man of action. The danger is clear; it is not so unlikely that Boetticher could follow Malraux into an élitism, in which men of action are thought of as creating values. It is a pity that *Arruza*, the latest and most personal bullfighting film, has not yet been released; it would help clarify this point.

Finally, there is *The Rise and Fall of Legs Diamond*. Legs Diamond (Ray Danton) is the last individualist, the last single king of crime; in the end he is replaced by the syndicate, by the confederation of crime bosses seated around a round table, at which there is no chair for Legs. At which, indeed, he wants no chair. Legs Diamond, moreover, believes himself to be invulnerable, bullet-proof, immortal; he believes in fact that it is impossible that death should deprive his life of all significance. For him his own individuality is an absolute; hence his ruthlessness – afraid that his brother, stricken with TB, will be used as a pawn against him, he abandons him, refuses to pay the clinic bills and shrugs when he is shot dead in his wheelchair. Instead, he boasts that nobody can hurt him, because he has no ties with anybody. And this, in the end, is his downfall. 'You were invulnerable as long as somebody loved you,' and 'He didn't love anybody; that's why he's dead.' Boetticher seems to condemn Legs Diamond because he is incapable of any interpersonal relationships, and to hold that individualism only has any meaning in so far as it recognises the individuality and personality of others and hence its own relativity. 'In the last shot, you are left with just the slush and sleet. That is all that remains of Diamond. But it is Alice who has to face it. Diamond will never be worried by the cold of the night again.' His life, in fact, was a tragi-farce – and this is how the movie is conceived, not as a didactic story like most gangster movies. In *Legs Diamond*, unlike the Westerns, the heroine, Alice (Karen Steele), is more authentic than the hero, in that she is willing to risk her life acting to save him, but he is unwilling to do the same for her. He has no goal except his own absolute aggrandisement; he dupes himself that there is no further problem.

Legs Diamond is technically and stylistically Boetticher's most remarkable film. It is shot entirely with the techniques actually available and in use in the 20s; deep focus, uniform lighting, no tracking shots, no dolly, etc. This also enables him to integrate stock shots and newsreel sequences into the movie much more successfully than is usually the case. It is constructed with great dramatic skill,

economy and flair with gags. Boetticher has said that he would not want there to be any 'Boetticher touch' like the 'Lubitsch touch'. He distrusts the elegant compositions and 'Frankenheimer effects' and puts the narrative as his first priority; he is not interested in style as such. Nevertheless, *Legs Diamond* is stylistically extremely original. Boetticher's other great asset is his handling of actors: Ray Danton had such a success in *Legs Diamond* that he was even given a cameo appearance in the same role in Pevney's *Portrait of a Mobster*, about Dutch Schulz. Boetticher has given breaks to a great number of good actors: Lee Marvin, Richard Boone, Henry Silva, Skip Homeier, etc. With women he is much less sure – for Boetticher, acting and action as he understands it go together. He is always keenly interested in what actors can do well in real life and tries to fit it into the film (Robert Stack and shooting in *The Bullfighter and the Lady*); he complains about having to use stand-ins for actors who cannot ride, fight bulls, etc. (he himself stood in for Stack in *The Bullfighter and the Lady*). Finally, Boetticher has always insisted that cinema is a visual art; he has more than once expressed his admiration for Cezanne, Van Gogh, Gauguin etc., and regretted that they were never able to make a film.

There is much else which could be said – about Boetticher's attitude to his favourite country Mexico, for instance. But the important thing is to recognise the nature of Boetticher's achievement up till now. In many ways, he is a miniaturist – he does not have great imaginative vigour or panoramic sweep or painful self-consciousness, but works on a much smaller scale and in a much lower key. In many ways, his concern with individualism is anachronistic, though less so, perhaps, in America, where old myths die hard. But it would be quite wrong to assume that, because his movies are not about the sociological and psychological problems to which we are more attuned, they are without theme or content. I realise that in this review I have committed the cardinal sin of talking about Westerns and philosophy in the same breath; I am quite unrepentant. André Bazin described *Seven Men from Now* as 'one of the most intelligent Westerns I know, but also one of the least intellectual'. Boetticher, himself always a man of action (bullfighter, horseman, etc.) does not give his movies an openly intellectual dimension; nevertheless, he has always insisted that the Western is more than cowboys and Indians, it is an expression of moral attitudes. He has always, since at least *The Bullfighter and the Lady*, taken film-making seriously, to the point of jeopardising his career. And he has consistently made intelligent movies, treating – however intuitively – fundamental themes with great lucidity. He feels that he has not yet made a really successful movie; certainly, some of his films are failures, others – I have mentioned his bullfighting movies – contain dangerous flaws. It is to be hoped that he will be able to complete *The Long Hard Year of the White Rolls-Royce*, which he feels will be *the* film. We can then make a much more definite assessment of his place and of his whole work. He may well surprise many who have till now ignored him.

Alfred Hitchcock

[First published in *NLR* no. 35, January/February 1966, pp. 89–92]

Hitchcock, of course, is a household name. His first film was made in 1921, his first sound film (*Blackmail*) in 1929, his first American film (*Rebecca*) in 1940. He has come to dominate completely the suspense thriller genre; his silhouette on publicity posters is enough to chill spines in anticipation. But he is not only a household name; his films are also, arguably, the pinnacle of film art. At least three serious and extremely interesting book-length exegeses have been devoted to Hitchcock's work; Rohmer and Chabrol's classic *Hitchcock* (Paris, 1965), Jean Douchet's *Hitchcock* (Paris, 1965), and Robin Wood's *Hitchcock's Films* (London, 1965). All these books contain exhaustive accounts and theories of Hitchcock's principal themes: Wood's book, though not the most brilliant, is perhaps the best. The critic, therefore, who now chooses to write about Hitchcock is not, as is usually the case with auteur criticism, starting *ex nihilo*; there is already an established area of critical agreement, and a number of embryonic critical debates are under way. On the other hand, there is still an important task of popularisation of this critical debate to be accomplished. Perhaps the next step should be, as far as space allows, to sketch out the main themes which have been discerned in Hithcock's films – particularly his recent films – and then, in conclusion, to make some general and synthesising remarks about their implications, connections and importance.

First, there is the theme of guilt: of common guilt and exchanged guilt. A recurrent pattern in Hitchcock's films is that of the man wrongly accused of some

I Confess *(1953).*

crime he has not committed; the plainest example is *The Wrong Man*. This theme is typically developed by revealing how the wrongly accused man could very well have been guilty; he is compromised in all kinds of ways. And by identification with the hero, the audience is compromised as well; this is the theme of common guilt. A frequent dimension of this theme is the transition from play to reality; in both *Rope* and *Strangers on a Train* ordinary people at a party play with the idea of murder, revelling in the idea; in each case they are talking to a real murderer: words have become unpleasantly and ambivalently involved with deeds. *Strangers on a Train* takes the theme further with the notion of exchanged guilt: Guy and Bruno both have strong motives for committing murder, as they mutually – though tacitly – admit; when Bruno actually commits one murder, Guy is inevitably implicated in his guilt. Hitchcock's world is never one of a simple division between good and evil, purity and corruption; his heroes are always involved in the actions of the villains; they are separated from them only by a social and moral convention. During the film they become guilty, and this guilt can never entirely leave them. In *I Confess*, for instance, the priest hero is found legally guilty of murder – there was a clear motive – but the true murderer is later revealed and the priest freed; but, though the juridical guilt is thus annulled, the moral guilt remains.

Second, there is the theme of chaos narrowly underlying order. Hitchcock's films begin, typically, with some banal events from ordinary, normal life. The characters are firmly set in their habitual setting, a setting more or less the same as that in which the audience must pass their lives. Then by a trick of fate, a chance meeting or an arbitrary choice, they are plunged into an anti-world of chaos and disorder, a monstrous world in which normal categories shift abruptly and disconcertingly, in which the hero is cut off from all sustaining social relations and flung, unprepared and solitary, into a world of constant physical and psychological trauma. In contingent detail this anti-world is the same as the normal world, but its essence runs completely counter. It is a world of excitement as against banality, but it is also a world of evil, of unreason. Thus, in *The Birds* the quite ordinary small-town world of Bodega Bay is abruptly shattered by the meaningless attacks of the birds. Everything is turned upside down: instead of civilised man caging wild birds, wild birds encage civilised man, in telephone kiosks and in boarded-up houses. This is not just an image of doomsday or vengeance; it is also an image of the precariousness of the civilised, rational order. Even a film like *North by Northwest*, usually considered nothing more than a divertissement, exhibits the same theme: Thornhill is kidnapped in a hotel lobby and is suddenly flung into a world of international political intrigue and calculated murder. The utterly public and commonplace Mount Rushmore monument is turned into the scene of an intense, private drama, quite surreal and incomprehensible to an outsider, a normal onlooker. (Hitchcock frequently uses these public monuments for startling episodes in the intrigues of the chaos-world: the Albert Hall, the United Nations, etc.; their use universalises the chaos.)

Third, there is the theme of temptation, obsession, fascination and vertigo. Once the heroes have left the world of order and reality for the world of chaos and illusion, they are incapable of drawing back. They are enthralled, terrorised but excited; chaos and panic seem to meet some unexpressed inner need; there is a kind of obsessive release. In *North by Northwest* Thornhill insists on re-entering

the chaos-world when, after his trial for drunkenness, he has a chance to fall back into normal life; it is as if he must find out the meaning of the absurd events which overtook him and somehow capture them for the world of reason. In fact, he enters more and more into the world of unreason, unintelligibility and the absurd. In *Rear Window* Jeffries obsessively involves himself in the unreason he observes in the block opposite until it bursts into his own private room. And in *Vertigo*, when Scottie is cheated of his dream he tries to rebuild it out of reality, almost demanding the disaster which eventually occurs. The film, as Rohmer has pointed out, is full of spiral images, images of instability and mesmerisation, images of spinning down into darkness. (These spiral images in Hitchcock's films are usually associated with the eye, spiralling out of the light into the dark pupil and again – with a special meaning in the context of the cinema – being mesmerised by the world of appearances.)

Fourth, there is the theme of uncertain, shifting identity and the search for secure identity. In the great majority of Hitchcock's films, there are repeated and complicated cases of mistaken or altering identity. Clearly, this links up with both the exchange of guilt theme and the chaos-world theme. One implication is that identity is a purely formal social attribute, rapidly destroyed by kaleidoscopic changes in social co-ordinates; only rarely can it be said to represent a relatively autonomous core of being. And, not only is it a formal attribute, but it is easily confused and merged with the identity of others. Mere accidents of physiognomy, clothes, documents, etc., not only confer the formal identity of somebody else, but even their moral being, their history and their guilt. And, in the same way that identities merge, they also split up and disintegrate into separate, parallel identities: in *Marnie* for instance, the heroine changed her identity by changing her clothes and dyeing her hair. The same thing happens with the transformation of Madeleine into Judy in *Vertigo*.

Fifth, there is the theme of therapeutic experience, strongly insisted on by Robin Wood, but about which I am more dubious. Wood argues particularly from the case of *Marnie* instead of representing a development in Hitchcock's moral thought, a recognition that descent into the chaos-world is not irrevocable, that identity can be secured, that guilt can be purged, that it might turn out to be merely a more superficial film with rather a shallow confidence. Again, it seems to me rather doubtful to argue, as Wood does, that Jeffries goes through a therapeutic experience in *Rear Window*. Wood quotes Douchet's view that the block opposite is like a cinema screen on to which Jeffries projects his own subconscious desires in a kind of dream form – particularly his desire to get rid of Lisa, his future wife – and that these desires erupt destructively into his own life, punishing him. And, in particular, punishing him (and by implication the involved cinema audience) both for the sin of curiosity and for the urge to work out interior desires in externalised fantasy. Wood insists that a murder is actually detected and a marriage actually affirmed. But, on the other hand, he concedes that, in one sense, nothing has changed: Lisa, at the end, is looking at the same fashion photos, though this time inside a news magazine cover: her new understanding is hypocritical and illusory. And, though murderers are brought to justice in Hitchcock films, this does not simply mean a triumph of order and reason; more often than not, reason can only be reasserted through the violent and inextricable entry of

unreason into its world: a dialectical paradox vividly expressed in the startling, mad denouements of so many Hitchcock films: the nun in *Vertigo*, the Mount Rushmore climax of *North by Northwest*.

Finally, there is the notorious mother theme, important in *Strangers on a Train* and reaching its final macabre conclusion in *Psycho*. Even in the family, what is presumed to be the most secure and loving of relationships is revealed, in the most grotesque and macabre way, to be potentially horrific and destructive. The world of chaos inhabits the family itself. It is worth noting that the theme of the mother has really come into its own in American films: presumably, the legendary American mother made a strong impression on Hitchcock.

Indeed, Hitchcock's pessimism and emphasis on unreason and chaos has grown immeasurably stronger during his American period. His British films, by comparison, are light-hearted and amusing, without either the sinister undertones of the American films or, more importantly, the serious themes which shape them. Hitchcock seems to have been rather affectionate towards English hierarchised class society and rather admiring of its continuity and stability. It was not till he reached America that he began to see society as precarious and fragile, constantly threatened by unreason.

Something should also be said about two further dimensions of Hitchcock: his Catholic upbringing and his attitude towards psychology. Rohmer and Chabrol insisted that Hitchcock is still a Catholic director; I do not think this can be sustained, though clearly he has been very much influenced by Catholicism. This is readily confirmed by the overt evidence of *I Confess* or *The Wrong Man*; the theme of guilt is particularly pertinent. On the other hand there is no parallel theme of redemption, certainly not through the proper channels.

Many critics have attacked Hitchcock for his rather ham-handed attitude to Freudian psychological theory – his vulgarisations of dream experience and psychotherapy in *Spellbound* and *Vertigo*, his portrayal of trauma in, say, *Marnie* and the glib conclusion of *Psycho*. It must be admitted that there are few niceties in Hitchcock's psychology; he has adopted various key Freudian ideas which he uses quite unashamedly in whatever way he sees fit. But the point is that Hitchcock is not primarily interested in the medical diagnosis and therapy of psychosis; indeed, this is just the kind of ordered, rational triumph of reason over disorder which he rejects. He is concerned with showing the proximity of chaos to order and their recurrent, arbitrary (irrational) interpenetration, their mutual subordination to each other. He is interested in the moral reality of unreason and not the medical categories of madness. Freudian vocabulary and imagery is necessary to locate his themes in the modern world; but he is himself locating Freud in a different world of his own.

Hitchcock's films are primarily moral. They portray a dialectical world in which the unreason of nature narrowly underlies the order of civilisation, not only in the external but also in the internal world. This unreason is common to all men, erupts in all men. We are fascinated by it and need to involve ourselves in it in an attempt to make it intelligible. There can be no purity, no withdrawal. We must recognise the precariousness of our security. Hitchcock's vision is intensely pessimistic, in a sense almost nihilistic, but it is worked out on several levels and in several dimensions. He is a great film-maker.

Josef von Sternberg

[First published in *NLR* no. 36, March/April 1966, pp. 78–81]

Josef von Sternberg remains best known as the director of a sequence of films with Marlene Dietrich in the 30s, starting with *The Blue Angel* in Germany and then continuing in Hollywood. Usually these are thought of as 'glamour' films, successful because they took people's minds off the miseries of the Depression era, but today dated, bizarre and basically contentless and empty. Josef von Sternberg is remembered as an eccentric and monomaniac director, creator of a shopgirl's dream world, unable to ride with the times into the post-war 40s. Still he retains a certain legendary splendour, an aura of the days when Hollywood was really Hollywood.

In fact, Sternberg's career stretches both before and after the Dietrich period, starting with *Salvation Hunters*, shot in Hollywood in 1925, and concluding with *The Saga of Anatahan*, shot in Kyoto in 1953. Throughout this period Sternberg fought a continuous bitter battle for full control over the films he was directing, in order to put into effect the theories of cinema which he had developed. This struggle met with limited and uneven success. Indeed, it was not until his very last film, made not in Hollywood but in Japan, that Sternberg was allowed anything like the freedom he desired. As we see Sternberg's films, then, we are forced to decipher the true sense of his work through a structure which has been repeatedly distorted and betrayed.

Sternberg strongly believes – and his belief has been strengthened by his experience in the cinema – that art is the prerogative of a creative élite, appreciated only by a minority. He interprets interference by producers with his work as an attempt to cater to the taste of the masses, necessarily a lowest common denominator. Cinema is always being degraded and debased, but its vocation is to be an art. His view of human history is fatalist and stoic. Little changes. There is no essential point of difference between Heraclitus and John Dewey, Praxiteles and Malliol, Aesop and Walt Disney. Perhaps there is progress in technique, but, on the other hand, perhaps taste actually deteriorates. Fundamentally, mankind is still in its infancy – uncontrollable and self-destructive, panic-struck and full of guilt – and shows scant sign of ever escaping it. Only the artist is able to create anything which escapes the depredations of his fellows and of time. His task is to grasp the myths which most highly express the human predicament and, by mastery of style and technique, reinterpret them to each age. To achieve this, he must understand both the character of the human condition and that of his chosen art.

Cinema, to Sternberg, is a new art with its own specific qualities. The secret of the cinema is light: image in motion encountering light and shadow. He puts great stress on this formal specificity of the cinema: he even envisages projecting his films upside-down so that the play of light and shadow in movement is undisturbed by the intrusion of extraneous elements.

Sternberg maintains a contemptuous attitude towards actors, whom he views as no more than the directors' instruments. 'Monstrously enlarged as it is on the screen, the human face should be treated like a landscape.' Fundamentally, its expressivity is due, not to the intelligence or skill of the actor, but to the way in which the director illuminates and obscures its features. (It is not surprising that

the two actors about whom Sternberg is most scathing – Emil Jannings in *The Last Command* and Charles Laughton in the unfinished *I, Claudius* – are especially famous for their virtuosity as actors. Similarly, Marlene Dietrich, whom he launched from nowhere and whom he depicts as always unbelievably servile to his slightest whim, was his favourite actress. He was destined, in a society where women – and, by extension, actresses – are predisposed to be servile and passive, to be a 'woman's director'.)

It is clear that somebody who, like Sternberg, views human history as a goalless charade and art as a privileged activity, should stress not realism but artificiality. He has always prided himself on the artificiality of his sets and his plots. 'I was an unquestioned authority on Hollywood, and that made it difficult to be unrealistic in picturing it. I felt more at home with the Russian Revolution, for there I was free to use my imagination.' On the other hand, Sternberg nurtures the fond hope that, in this way, he can go to the heart of a situation, undistracted by petty detail, by what he refers to as 'the fetish of authenticity'. In this sense, he sees his work paradoxically as realist rather than symbolic.

Sternberg's work, if anything, is baroque. Yet, at the same time, this is vitiated by a strong streak of nineteenth-century sentimentality. Perhaps it is rather facile to connect this with his early years in Vienna; Sternberg himself acknowledges the influence of Schnitzler, but hardly ever mentions the baroque which dominates the city. But all the marks of the baroque are in his work: the importance of movement, of light and shade, the multiplicity of ornament, the curious co-existence of abstraction and eroticism, extravagance and chimeras, the retreat from realism into imagination. Sternberg's vision of himself and his art is curiously akin to that of, say, Bernini, even down to the fascination with carnivals. The typical Sternberg film is festooned with streamers, ribbons, notes, fronds, tendrils, lattices, veils, gauze, interposed between the camera and the subject, bringing the background into the foreground, casting a web of light and shadow (as Sternberg put it, concealing the actors). All sharp edges and corners are veiled and obscured and everything, as far as possible, made awash with swirls of moving light.

Connected with this baroque sensibility is Sternberg's obsessive interest in the phantasmagoric quality of human life. His autobiography contains numerous long drawn-out evocations (echoed in *Shanghai Gesture, Macao,* etc.) of gambling dens in Shanghai, cock-fighting arenas in Java, striptease shows in Havana, pagan dances in India, camel markets in Egypt, etc. (Shanghai and Havana, of course, are now denied him: China has been 'shuffled', in Cuba Castro is 'drest in a little brief authority'). He seems to owe this fascination – or at least relate it – to his childhood fascination with the Prater Gardens in Vienna, a phantasmagoric memory of jugglers, tumblers, midgets, sword-swallowers, weight-lifters, bearded women, Red Indians, elephants, two-headed calves, magicians, cannibals, mazes of mirrors, etc., all thrown together under the giant ferris wheel. (Sternberg directly celebrates the Prater in *The Case of Lena Smith* in 1929.) However, it presents some theoretical difficulties for him, since these entertainments are so unashamedly – even luridly – popular.

Whenever on occasion my work has found favour with the crowd, the sources

within me which were tapped were never obvious to me. To make contact with the emotions of a crowd would not have been difficult for me had I accepted its criteria and used the formulas to please it, which never vary ... [and yet] ... nothing that has ever stirred a crowd has failed to find an echo in me. I plead guilty to more susceptibility than I was always able to cope with. Nor are my intentions, rarely successful, meant to camouflage my mistakes.

In fact, Sternberg's 'mistakes' are an integral part of his vision of the world: the counter of his aristocratic disdain and aloofness, of seeing in art the only stability, is to be obsessed with the grotesque, fantastic dream-like quality of popular life and its ceaseless carnival-like instability, as he would see it.

Something more, perhaps, should be said about the roles of Marlene Dietrich in Sternberg's films. Sternberg himself indignantly disavows every accusation that he set out to exploit Marlene Dietrich's physical attraction; indeed, he is constantly very contemptuous about the 'attractiveness' of actors and actresses, contrasting them unfavourably with scarecrows, which are designed to repel. He refers to her always in the most abstract terms. He modelled her, he claims, on the paintings of Felicien Rops and Toulouse-Lautrec; what appealed to him was her disdain and coldness: in this, he was consciously distancing her from what he thought of as erotic. He deliberately encouraged a de-feminising image of her, by dressing her in men's clothes for her nightclub performances. In *The Scarlet Empress* she ends up playing an explicitly male role. Of course, this contrasts strangely with his autocratic manner towards her and his claim that she would obey anything he ordered, to the extent of laying an egg for him if he didn't like the one prepared for his breakfast. Once again he ended up producing in art the

The Scarlet Empress *(1934)*.

direct converse of what he thought true of life. He was fascinated by the shifting and ambiguous roles of dominance and servility: this is made clear by *The Blue Angel* and *The Last Command*, in which a despotic Russian general becomes – by a twist of fate – an abused film extra who is made to play the role of a despotic Russian general. In his attitude to Dietrich, strains show: for instance, the sentimentality of the child's bedtime story in *Blonde Venus* or the prayer and station reconciliation scenes in *Shanghai Express*. These are the occasions on which woman is – rather pathetically – put back in her place. But, as a general rule, woman is consciously de-feminised – yet she remains so radically 'other' that this only serves to accentuate her specificity and hence, by making her even more problematic, her mystery.

Finally, a word should be said about *The Saga of Anatahan*, Sternberg's most personal film, in which he recapitulates the whole of human history and his urge to destruction. Perhaps the most interesting aspect of this film is his attempt to overcome the problems brought by the introduction of sound film. For Sternberg, this was almost a disaster: it threatened to subordinate the tempo of cinema to that of speech, the camera to the microphone and the director to scriptwriter and actor. In *Morocco* he deliberately chose a fatuous story in order that the importance of words should be minimised. In *The Saga of Anatahan* he reaches a more satisfactory solution: the actors talk throughout in Japanese and a commentary by Sternberg himself is inserted over the other sound. This gives him much greater freedom in choosing the right rhythm for the montage. It has been the most important attempt to solve the difficult problem of sound, which – as Eisenstein foresaw and feared – destroyed classical montage, perhaps until the work of Godard, who has, of course, found a much more complex and original solution, based partly on the use of visual written words, partly by sound mixing, partly by deliberate passages of silence and by special use of music and song.

By emphasising the role of the (autocratic) director and by fixing the specificity of the cinema to the problems of light and shade, Sternberg became a director of great originality. His work is unmistakable. On the other hand, these very characteristics, in his case, went hand in hand with other *parti pris* which tend to vitiate his achievement. His emphasis on the privileged role of the creative individual has led him to a retreat from realism which, on occasion, becomes blind and ludicrous. His distaste for words and for actors has led him to a dehumanisation which, at the same time, is infected with an unrejected Viennese sentimentalism. The whole trend of cinema has been away from the baroque sensibility which most obviously marks the work of Sternberg. But the obvious similarity between the predicament of the baroque artist and that of the cinema director means, almost certainly, that Sternberg will have and hold a (constantly disputed) place in the history of the cinema. Few, at any rate, will want to deny the originality of the director of *Underworld* (the seminal gangster film), *Dishonoured* and *The Saga of Anatahan*.

Jean-Luc Godard

[First published in *NLR* no. 39, September/October 1966, pp. 83–7]

I had intended to write about Godard before reading Robin Wood's article [also in *NLR* no. 39]; the first thing which struck me as I read it was that, though I agree that the issue which he raises is one of the key ones, the words which he uses and stresses are quite different from those I would choose. This springs, of course from an underlying difference in critical method: his terminology, like his method, is largely derived from that of F. R. Leavis. There is no doubt about the provenance of words such as 'tradition', 'identity', 'wholeness', etc. In a sense, then, my own interpretation of Godard's films, juxtaposed with Robin Wood's, implies not only a clash of opinions but also a clash of method and, in the last analysis, a clash of world-views. But first Godard's films.

The cultural references in Godard's films are, as Robin Wood writes, 'not decorative but integral'. For Godard culture is hardly able to sustain itself; it is not intelligence, but violence, which makes the world go round. 'Il faut avoir la force quelquefois de frayer son chemin avec un poignard.' It is the world of *Les Carabiniers* of *Ubu Roi*, which Godard has said he would like to film. It is a world in which the newspapers, as in *Bande à part*, are full of almost surrealistic excesses of violence; it is a world of Algeria, of San Domingo, of Vietnam, to which Godard makes constant references and which give the larger context of his films. And this all-pervasive violence is also vandalism. It is the execution of the girl who recites Mayakovsky in *Les Carabiniers*, it is the destruction of books in *Alphaville*, it is the suicide of Drieu La Rochelle or Nicolas de Stael.

But we do not condone this world of violence and vandalism into which we are thrown. Where is the vein of optimism which prevents us from committing suicide? The answers which Godard explores are the romantic answers of beauty, action, contemplation. The antinomy between action and contemplation or reflection is recurrent in Godard's films. Action is the correlate of adventure; it is to leave behind the everyday norms of life, to leave for Rome, for Brazil (both *Le Petit soldat* and *Bande à part*), for the Outerlands: topographic symbols for a world in which all conduct is improvised, experimental – yet at the same time symbols also of withdrawal, of distancing and hence of contemplation, of repose (the Jules Verne paradise of *Pierrot le fou*). In *Le Petit soldat* reflection follows action ('Pour moi, le temps de l'action a passé! J'ai vielli. Celui de la reflexion commence'). In the story of Porthos told by Brice Parain in *Vivre sa vie* reflection prevents action, it is a form of suicide; in *Pierrot le fou* action, incarnated by Marianne, and contemplation, by Ferdinand, prove mutually destructive.

The problem is also that of time: above all, of the ambiguous nature of the present. For Godard, the present is both the moment in which one feels oneself alive, the existential moment of responsibility for lighting a cigarette, and also the monstrous unstructured, dehistoricised desert of *Alphaville* or *La Femme mariée*. Increasingly, in Godard's films, the present has become the realm of woman: he remains uncertain whether it is a realm of innocent hedonism or of mindless viciousness. Already – in Veronica, in *Le Petit soldat* – we see this dilemma: the beautiful cover girl who likes Paul Klee and Gauguin and who is at the same time a terrorist who dies under torture. In *Pierrot le fou* it is even more evident. (While

Le Petit soldat *(1960)*.

on this point, it may be worth commenting on the resemblance between Alpha 60's interrogation of Lemmy Caution and Nana's of Brice Parain.)

Another recurrent feature of Godard's attitude to women is that they are traitors. Patricia betrays Michel in *A bout de souffle*; Marianne betrays Fredinand in *Pierrot le fou*. Living in the present means to be unable to bear any fixity of relations with others, which would imply a past and a future. Yet set against this image of woman is one drawn from romanticism, from association with ideas of purity, beauty, etc. It is Godard's inability to resolve this contradiction which explains his continuous hostile fascination with women, reminiscent in a way of Hitchcock.

Hence, too, the instability of his portrayal of women: certain constant features remain, but with different degrees of emphasis and in a number of different combinations. Thus, for instance, there is a criss-crossing of roles between *A bout de souffle* and *Pierrot le fou*: the car-stealer, murderer, gangster is no longer Michel but Marianne; the companion is not Patricia but Pierrot. (The character of Patricia is further complicated by a reversal of roles between Europe and America – a kind of anti-Henry James – in which Michel is the B-feature Bogart hero, Patricia the intellectual reading *Wild Palms*.) Again, some of Patricia's innocence survives in Veronica and is then further refined into the girl who recites Mayakovsky in *Les Carabiniers*. And she, in turn, is the polar opposite of the protagonist of *La Femme mariée*, who herself inherits something of Patricia's shiftlessness and capacity for betrayal.

Next, there is Godard's attitude to freedom. For him, freedom is always personal freedom: he recognises no social ties. His heroes, like those of Samuel Fuller, op-

erate in a perpetual no man's land, a labyrinth in the interstices of society. Freedom is, in very simple terms, doing what you want to when you want to. The sharpest test of freedom, for Godard, is torture. Bruno, in *Le Petit soldat*, does not want to give information: even if he did, he would not want the occasion forced on him. To do what one wants – to be silent – when under torture is the extreme of personal freedom. Yet at the same time freedom is interwoven with destiny: men choose their own fate, but it remains a fatality also in its impact on us. Thus Michel Poiccard chooses, by not escaping, to be shot by the police – but when he is shot, it takes on the form of destiny. And when Ferdinand dies at the end of *Pierrot le fou*, he has chosen to commit suicide while, at the same time, the image of the spark travelling along the fuse makes it a fatality.

These themes interconnect with Godard's attitude to the cinema itself. The cinema is both the double of life and, at the same time, an artifice. It is both instantaneity – action now – and permanence, a kind of memory. It is both America, innocent, without history, and Europe, part of a fragmented culture and itself the most eclectic of arts. It is both the freedom of the travelling shot and the necessity of the frame. Robin Wood comments on the analogy between the improvised conduct of Godard's heroes and the improvised form of his films and on the use of allusions to strip cartoon to emphasise one aspect of cinema, just as documentary is used to emphasise another. Godard himself has commented on the paradoxical nature of the cinema, on its being a series of Chinese boxes of reality and illusion, as in Renoir's *The Golden Coach*. This reflects not only his attitude to the cinema, but also his attitude to life itself, in which war, for instance, as in the Mayakovsky fable in *Les Carabiniers* or the Vietnam charade in *Pierrot le fou*, is both an absurd pantomime and a horrible reality. But in the last resort the problem for Godard has always been to tell the truth – hence his admiration for Brecht and Rossellini.

In many ways, what I have said about Godard echoes what Robin Wood says, though with a different accent. But I feel there is also a radical difference between our points of view. The problem centres round his use of the word 'tradition', in a way which makes it almost synonymous with 'culture'. For Godard, I think, culture is not intimately part of society: it is what remains of the work of artists, many of whom were antagonistic to society, marginal to it, indifferent to it. If society has any meaning at all it is as an instrument of violence. It is defined by the soldier and the police.

The artist is something quite different; he is somebody who is pursuing a kind of personal adventure. There seems no reference in Godard to the possibility of a culture securely integrated into society, in the sense suggested by tradition. Thus there is not wholeness and fragmentation, by violence and beauty, vandalism and art, brute force and intelligence. The first are the main characteristics of the world into which we are thrown, the second are the values on which we may base a personal search.

'Godard rejects society because society has rejected tradition.' I think not: Godard's belief, as shown in the films, is that the exercise of freedom is incompatible with observance of prevalent social norms (whether these could be called traditional or not) and that art or culture has no social function but is all that remains of a disparate number of individual adventures, individual searches. In fact,

in that society is fundamentally vandalistic, art is essentially dysfunctional: there is no possibility whatever of a cultural tradition in Robin Wood's sense, only a kind of cultural guerrilla war.

The void in Godard's view, evidently, is the absence of politics. In a sense, Godard himself acknowledges this: he talks, for instance, of the possibility of making political films in Italy, though not in France. Yet, in another sense, he is not deeply interested: he talks of politics as what you see the other side of the window and, citing Velázquez, speaks of portraiture as the highest form of art. Interestingly, whenever revolutionary politics enters his films, it is defeated: Veronica is killed in *Le Petit soldat*, the partisans are shot in *Les Carabiniers*, the Dominican student is exiled in *Pierrot le fou*. I think this helps Godard evade the issue; it is the romantic cult of defeat, of nostalgia for Spain, etc. Desperately, Godard falls back on individualism and attempts to reconstitute the legend of the American frontier in contemporary France: Jesse James re-appears as Pierrot le Fou. Yet, as Robin Wood says, he adopts no easy or comforting solutions: there is a relentlessness about *Pierrot le fou* which is, not that of a lost traditionalist, but that of a lost revolutionary.

For if, as seems evident enough, Godard is radically dissatisfied with society, then it is the absence of politics which condemns him to rootlessness and despair. To be dissatisfied, after all, is to want change. Politics is the principle of change in history; when we abandon it nothing remains except the scattered, expendable efforts of artists and romantics. In this sense, as Godard has said, art is always left wing. Tradition is the enemy. The tradition of our society, it would be hard to deny, is violence, vandalism, oppression and its developing sanctions, the advertiser's copy and the carabinier's gun.

Roberto Rossellini
[First published in *NLR* no. 42, March/April 1967, pp. 69–71]

Rossellini's reputation has ebbed and flowed more perhaps than that of any other leading director. In part this has been because of the nexus between politics and film criticism in Italy, in part because of changes in fashion and taste, in part because of the personal scandals which have punctuated Rossellini's career. Nevertheless, looked back on now, from the near peak of his achievement, *The Seizure of Power by Louis XIV*, his work shows a remarkable consistency, thematically and stylistically. He has persevered on his own path; sporadically this has criss-crossed with the stampede of popular and critical taste.

Rossellini's themes are fundamentally Italian, indeed southern Italian. The humus from which his themes spring is that of traditional Catholic (superstitious and semi-pagan) southern Italy about to be sucked into the vortex of northern Europe, with its entirely different kind of civilisation, cultural and social. Thus we find at the centre of his work the antagonistic couplet north *v.* south, cynicism *v.* innocence, positivism *v.* spirituality, etc. His Bergman cycle, for instance, is dominated by the theme of the northern woman coming south and undergoing a spiritual crisis, from which she emerges with a kind of religious faith. It would be

misleading to call this faith Catholic: in many ways, with its emphasis on accep-
tance, it is Oriental (Buddhist or Hindu) and, of course, this becomes explicitly
apparent in his film *India*. In terms of Christianity, Rossellini's vision of sainthood
is close to the Dostoyevskian holy fool, to Simone Weil (whose influence Rossellini
acknowledges) or to a kind of legendary Francisanism, alluded to in several films,
including of course his version of *The Little Flowers*.

This emphasis on naïve faith and acceptance naturally goes hand in hand with
an unabashed populism: in *The Miracle* or *The Machine for Exterminating the
Wicked* this takes the form of an extreme indulgence in southern Italian supersti-
tion, to the point of centring films around 'miraculous', supernatural events,
which Rossellini justifies as part and parcel of popular culture. In *Europa 51* there
is a clear distinction drawn between the 'human' slum-dwellers and the 'inhuman'
bourgeois and bureaucrats: priest and *Paese Sera* journalist occupy an uneasy
middle position. Again, Rossellini's Resistance films are populist in tone, with the
same curious tensions between priest and Communist. This populism has led to
political difficulties for Rossellini: he has often succeeded in disgruntling both the
Communist Party and the Catholic Church. (In *Vanina Vannini*, for instance,
Rossellini actually used both Marxists and priests as scriptwriters, so that the ten-
sion between Catholic and *Carbonaro* in the film was actually thrown back into
the scriptwriting, with predictable results.) In fact, Rossellini is scarcely interested
in politics, but he has a troubled consciousness (which would now be called
Johannine) of the overlap of Church and Party in much popular (peasant and
petit bourgeois) culture, which is uneasily reflected in his films.

The counterpart of Rossellini's populism is an intense patriotism and also a
concern with heroism: not as a psychological so much as a socio-political cat-
egory. His patriotism is the natural result of his confidence in Italy and expresses
itself in his constant return to first the Resistance, then the *Risorgimento*.
(Rossellini's retreat backwards into history, following that eastwards to India,
springs from his disenchantment with the cynicism of modern Europe: a search
for the pure well of life, in fact.) In *Viva l'Italia* it is clearly linked with the theme
of heroism: Garibaldi is the popular hero (in the same way that St Francis is the
popular saint). The two films have the same oleographic quality. Rossellini's
approach is to bathe Garibaldi in a charismatic aura, while at the same time stress-
ing his 'human' weaknesses and foibles, such as his gout. With this kind of concept
of the hero, it is not hard to make the transition from Garibaldi to Louis XIV.

I have sketched Rossellini's themes first because it is important to point out that
his work has this thematic consistency, in view of the rhetoric about 'realism' with
which critics have always surrounded his films. It is easy to see what 'realism'
means when applied to Rossellini: it means the absence, to an unusual degree, of
professional actors, stage sets, make-up, a pre-arranged shooting script, etc. It
means a grainy, rather rough-and-ready look, reminiscent of newsreels, far from
Hollywood 'quality'. But this is a question of method and style: it in no way means
any greater quotient of truth or reality as regards the thematic content of the film.
This is not to say that form and content are unrelated: the ideology of 'acceptance'
and 'patience' which relates to Rossellini's views of sainthood also relates to his
methods of work, to the concept of the camera which records (accepts the given,
eliminating directorial intervention) and follows (patiently waiting the moment

of revelation). Similarly, his episodic method of construction (*Paisà, The Little Flowers, India* etc.) springs from a dislike of 'artificial' plots, which parallels his dislike of the 'artificiality' of modern European society.

In some ways, Rossellini's 'realism' is a correct, more honest concept than others: the natural concomitant of the non-intervention of the director is the non-intervention politically of man in the natural course of history (or, as in *India*, in the natural cycle of life and death). The left-wing ideology of 'realism' has great difficulty in overcoming the inconsistency of an approach that both stays at the level of the phenomenal forms and also demands the revelation of an esoteric (essential) meaning: the traditional Marxist attack (derived from Taint and Blinks) adumbrates a theory of types, as distinct from contingent phenomena, but this has obvious drawbacks: it easily falls into schematism or even sentimental idealisation.

Rossellini's impact has been considerable; he has represented the opposite pole to, say, the American musical (the Lumière tradition as against Méliès). He has reminded directors that there is a scale of possibilities of *mise en scène*, at one end of which he stands. He has thus contributed enormously to the development of contemporary cinema: we can see his influence on Godard, for instance, in his use of episodic construction (*Vivre sa vie*), his deliberately non-quality photography (*Les Carabiniers*), his portrait of Karina (echoing Rossellini's portraiture of Bergman). In this sense, Rossellini is a historic director. He is also a consistent author, who has persevered in developing his personal themes and style in adverse circumstances. He also has obvious limitations, as this article will have suggested, if only cursorily: these are clearly related to the uncritical character of his realism. For, despite the vaunted objectivity of the lens, the world reveals itself to Rossellini much as he had subjectively envisaged it.

Afterword (1997): Lee Russell interviews Peter Wollen

When did you write this book?

A long time ago! In fact, as it happens, I wrote *Signs and Meaning in the Cinema* in the month of May, 1968. As fortune decreed, this has become an emblematic date. May, 1968 – it seemed like the beginning of a new epoch. *Signs and Meaning* is full of the same sense of a beginning – a new approach to film studies, a new intellectual seriousness, new theoretical developments, the promise of a new cinema, even the foundation of a new academic discipline.

You were working at the British Film Institute?

Yes. In the BFI Education Department, under Paddy Whannel. We were intellectual activists. We organised a series of seminars. We taught an annual summer school. We started the *Cinema One* series of books. We re-founded *Screen* magazine as a theoretical journal. In retrospect, it all looks positively heroic in its optimism. Yet, in some ways, that optimism turned out to be quite justified. Cinema studies has become a recognised academic discipline and, as a discipline, it has developed its own distinctive style and tradition, its own theoretical foundation. In other ways, it has simply led to a typical process of academicisation.

When I wrote the book, I was not working in a university, as I am now. I saw myself as an intellectual rather than an academic and I was consciously not writing for a university readership, if only because none existed. I envisaged readers who were being swept along by the same artistic and intellectual tides as I was myself – readers who were excited by the films of Jean-Luc Godard, the rediscovery of a hidden Hollywood, the structuralism of Claude Lévi-Strauss, the newly launched venture of semiology and the politics of the 'New Left', or perhaps I should say the 'New New Left'.

'The New New Left'? Perhaps you had better explain that. The way I remember it, the 'New Left' would have been the group which founded the journal New Left Review at the end of the 50s. Ex-Communists like Edward Thompson and Raymond Williams, who had left the Party in 1956, after Hungary, and were searching for a new politics.

It was launched in 1959. There was a merger of ex-Communists from the *New*

Reasoner with Stuart Hall's *University and Left Review*. But then in 1962 there was an internal *coup* and a new editorial group came into the *NLR* office, with Perry Anderson replacing Stuart Hall as the editor and E. P. Thompson ejected as the chair of the board.

And the new regime was what you mean by the 'New New Left'?

That's right. The new team wanted to develop the journal in a very different way. They weren't so directly concerned with English – or British – culture. They felt Britain was too insular. They wanted to import fresh ideas from Western Europe, from France and Italy especially – Sartre, Lévi-Strauss, Gramsci, and so on. Later they went on to introduce Althusser and Lacan to England. They were interested in psychoanalysis and they had a very different cultural policy.

They came from Oxford too, like you did.

Mostly – but not exclusively! Their intellectual agenda was formed at Oxford. I think that's fair to say.

What do you see as the underlying rationale for their new policy agenda?

Well, the way I see it, they wanted to provide a nucleus from which a new critical intelligentsia could develop, by combining 'western Marxism' with a broader cultural and artistic radicalism and a strong commitment to theory. It was never an academic journal. Actually, in 1968 two of the editors lost their teaching jobs for their role in the student uprisings – at Hornsey College of Art and the LSE.

What did you mean by saying just now that cinema studies has undergone 'a typical process of academicisation'? Can you expand on that?

It is a natural process, isn't it? The first generation were freelance intellectuals who were interested in laying the foundations of film study – the broad theoretical issues of film aesthetics, film semiotics and film historiography which would give the field credibility and a definite shape, which would enable it to stand on its own feet rather than be just an adjunct to literature or art or communications. When the field was successfully established as a discipline in its own right, then inevitably there came a loss of focus, with a growing range of different research agendas. It is probably a cyclical process. An interest in 'high theory', in the old Enlightenment sense, will roll back again in the future, I imagine, in an effort to redefine the discipline again.

But hasn't theory always persisted, even pervaded the discipline? In fact, you could easily argue that the humanities in general became completely dominated by theory. Overdominated, I would say. I must admit I was attracted by the element of cinephilia and that's precisely what got lost with the relentless expansion of theory over the face of academe. The auteur theory may have been called a theory, but really it was an expression of fanatical love for the cinema.

True enough, theory has expanded everywhere, but it has ceased to be film theory as such. Barthes or Foucault or Derrida were introduced into film studies from outside.

That's precisely my point. They weren't introduced to explain film better, but because academics became fascinated by theory in itself, for itself. Theory for theory's sake.

But then there is someone like Deleuze, who does write specifically about film. There's a cinephile side to Deleuze.

But I still feel that his work on the cinema is basically a by-product of some much broader theoretical project.

I am not going to argue about Deleuze's concept of time or whatever! I never followed Deleuze closely. In fact, I never did theory in that sort of way at all. I was always interested in the ontology of film as such, just as the Russian Formalists spoke about literature as such. That kind of theory has gone out of fashion. But it will come back. Mark my words!

In the book, you put aesthetics first, rather than semiotics. Why was that?

I wanted to establish, first and foremost, that film was an art and therefore it should be studied for its own sake in the same way as the other arts – literature, painting, music, etc. At that time, film was primarily seen in the context of the mass media, which led to a communications or sociological approach, rather than an aesthetic approach. Of course, viewing the mass media as art was polemical and provocative.

Do you think that particular battle was won?

Yes and no. Take Alfred Hitchcock, for example. I regard Hitchcock as one of the great artists of the twentieth century, genuinely on a par with Stravinsky or Kafka. I don't think that is generally accepted, even now. For the book, I decided to write about Eisenstein rather than Hitchcock, partly because Eisenstein was already accepted as a great artist, even though he had worked with a large budget in an industrial context. He was a kind of wedge that I could use to break open the crust of prejudice and philistinism and hopefully smooth the path for others, like Hitchcock. And then Eisenstein also provided me with a way of linking the cinema to theory and semiotics through his own concerns with the nature of 'film language'. But later on in the book, in the section on auteurism, I chose Hawks rather than Hitchcock, which was a more polemical choice. All or nothing. It is difficult to imagine the battles that we fought in those comparatively recent years, not simply for auteurism or semiotics, but for cinema itself.

As an art form?

Yes, as an art form. In fact, as the art form of the twentieth century. Part of the problem facing the cinema, from an aesthetic point of view, was the total domi-

Alfred Hitchcock in the late 1950s.

nance of Modernism in the other arts. In literature or painting or music, Modernism had become, so to speak, the guarantor of 'Art-ness' – as Roland Barthes might have said, Modernism connoted 'Art-ness'. But Modernism had made very little headway in Hollywood. Eisenstein, on the other hand, was clearly a Modernist, as I described, and that was part of the reason for focusing on him. Since then, I have become interested in Hawks's relationship to Modernism as well, in two rather different senses – both his sense that a film should work like a piece of precise engineering and his prolonged partnership with Faulkner. Hitchcock, too, had both explicit and implicit connections with Modernism. And Hitchcock's preoccupation with the look or the gaze – what William Rothman calls 'the "I" of the camera' – can perfectly well be seen in conjunction with Sartre's concerns. Sartre's analysis of the look in *Being and Nothingness* reads like a critical commentary on Hitch.

What about experimental and avant-garde film? They didn't figure so prominently until much later. How did you come to make the leap from Hollywood to the avant-garde?

Well, the book ended by invoking Godard. 1968 was the year when Godard made his definitive break with mainstream cinema and set off on his long march through the wilderness. At the time I wrote the book, I was not yet very familiar with avant-garde film, although I was interested in Steve Dwoskin's work (which I still admire very much) and I knew Piero Heliczer, who came out of the Warhol circle. It was only after I had finished the book that I really discovered the avant-

Wavelength *(Michael Snow, 1967)*.

Le Gai savoir *(Jean-Luc Godard, 1969)*.

garde, through North American 'Structural Film'. Michael Snow's *Wavelength* was made in 1967. Ken Jacobs's *Tom, Tom the Piper's Son* was 1969. Hollis Frampton's *Zorns Lemma* was 1970. Then there was a time-lag before their impact was felt

across the Atlantic and a new British avant-garde appeared – Malcolm LeGrice's *Berlin Horse* was made in 1970. Chris Welsby's *Wind Vane* was 1972. Peter Gidal's *Room Film* was 1973. There was the same time-lag with my own work.

With your film-making work or with your theoretical work?

Both, but I was really thinking about the theory. Structural Film demanded an interest in theory, which earlier Underground Film hadn't. And Godard's *Le Gai savoir* was itself a film-theoretical film, a film about the nature of film-making.

Pehaps the time-lag might also explain why you needed to add a new 'Conclusion' at the end of the 1972 edition?

Exactly. The new 'Conclusion' to *Signs and Meaning* reflected the impact of post-1968 Godard and Structural Film. It looked forward to the films which I began soon afterwards with Laura Mulvey – *Penthesilea* and *Riddles of the Sphinx*.

Which also involved redefining your theory of the film text, if I can use the jargon of the time?

Yes, I had started to argue that films were indeterminate and that their eventual meaning was produced by the viewer, under certain conditions, rather than being intrinsic to them. I was influenced by a somewhat strange combination of ideas – the Freudian tradition of unconscious meaning, Umberto Eco and the 'open text', even Derrida's idea of 'dissemination'.

You used Godard's films as model examples for your theory.

I looked on his post-1968 films as semiotic machines for making viewers think actively about the world in a new way, rather than as vehicles for communicating a film-maker's own pre-existing ideas to a passively receptive audience.

Yet you still defended auteurism, didn't you, in spite of your admiration for the new Godard? Do you see auteurism the same way today, or would you now give avant-garde film more priority?

I am still an auteurist. I still give priority to the avant-garde.

What does that really imply? An old-style Cahiers *auteurist? How would you formulate the question of auteurism today?*

It is really a question about the 'Movie Brats'.

Whatever do you mean by that? That isn't what I expected!

Well, the auteurist pantheon was essentially a way of ranking Hollywood studio directors. It was developed during the closing years of the classical studio system.

Bonnie and Clyde *(Arthur Penn, 1967).*

But it began to mutate almost as soon as it was formulated, which was around the time that the studio system began to crack. The emphasis switched from Hawks and Hitchcock to Sam Fuller and Nicholas Ray, both of whom had become independent film-makers and ended up in Paris as the studios crumbled away under their feet. That was the situation as auteurism entered the 60s, by which time the French New Wave was already under way.

Cahiers *auteurism was tied to the fortunes of the old studio system. So when the 'New Hollywood' came along . . .*

It went into crisis. That's right. As the 60s progressed, Hollywood began to split apart between an Old Guard and a New Guard, until the Coppola–Lucas–Spielberg generation of 'Movie Brats' showed how it could be restabilised on a new basis. In retrospect, we should probably see this in terms of the crisis of classical Fordism and its replacement by a new post-Fordist industry, a reorganisation of the institution and its production process. Again, it is interesting to look back to the time when the new Hollywood started, say, in 1967. That was the year of *Bonnie and Clyde*, but also of *Wavelength*, as well as Jim MacBride's *David Holzman's Diary*, which was kind of midway between the two. They all carried the signs of an impending change.

I'd like you to clarify that. You're saying that two trends were running in parallel – anti-Hollywood avant-gardism and the rejuvenation of Hollywood itself?

Exactly. Look, 1968 brought us not only Godard's *Le Gai Savoir* and *One Plus One*, but also Brian De Palma's *Greetings* and Kubrick's *2001: A Space Odyssey*. In 1969 there was Godard's *British Sounds*, Ken Jacobs's *Tom, Tom the Piper's Son*, Robert Kramer's *Ice*, Sam Peckinpah's *The Wild Bunch* and the Scorsese–Wadleigh duo *Who's That Knocking At My Door* and *Woodstock*. Snow's experimental epic, *La Région Centrale*, and Hollis Frampton's *Nostalgia* came out in 1971, the same year as Spielberg's *Duel* and Lucas's *THX-1138*. So the Hollywood 'Brats' (Spielberg, Lucas, De Palma, Scorsese, etc.) came to prominence at exactly the same time as Structural film (Snow, Frampton, Jacobs).

And Godard's turn to the avant-garde was at the same time. So are you claiming that there was a connection between Hollywood and the avant-garde or was it just a coincidence?

I see all those films as representing a concerted effort to reinvent the cinema, whatever their genre was, whether they were made inside the industry or outside it. Similarly I think *Signs and Meaning in the Cinema* could be seen as part of the same cohort, because of the way in which it pays tribute to both Godard and John Ford, just as the Movie Brats did.

That's all very well, but weren't those really quite contradictory tendencies? The fact that they occurred at the same time doesn't make them any more compatible with each other. Sooner or later you had to choose, didn't you?

It didn't seem like that at the time. Who was to guess how wide the gap would grow been Godard or Snow, on the one hand, and Spielberg or Lucas, on the other? I guess it's like the gap between revolutionary and reactionary Modernism.

Or, in this case, Postmodernism?

Postmodernism did emerge around the same time. There could be a connection, couldn't there? But it's a slippery label.

Riddles of the Sphinx *(Laura Mulvey, Peter Wollen, 1977)*.

The Last Movie *(Dennis Hopper, 1971)*.

You still didn't quite answer my original question – auteurism or avant-gardism? What about Penthesilea *and* Riddles of the Sphinx, *the films you made with Laura Mulvey at that very time? How did they relate to* Star Wars?

Well, as I have been describing, there was a strange kind of transitional epoch, which started, say, around 1966 (*Chelsea Girls, Masculin-Féminin, You're a Big Boy Now, Blowup*) and ending somewhere in the mid-70s, when Yvonne Rainer's *Lives of Performers* coincided with *The Godfather*, Jon Jost's *Speaking Directly* coincided with *Jaws* and, yes, *Riddles of the Sphinx* coincided with *Star Wars*! But, of course, while I recognise that Coppola and Spielberg and Lucas were undoubted auteurs, I am much more interested in someone like David Cronenberg, who was rooted in 60s experimentalism.

I still think you're being evasive. Which is it to be – auteurism or avant-gardism? OK, Cronenberg, and Lucas's THX-1138 *could be seen as an experimental film. I'll give you Hopper's* The Last Movie *too. But the general trend launched by Lucas and his group was towards the youth-market, high-tech, speed-and-action blockbuster which dominates the industry today. Were you so eager to be rid of* The Sound of Music *that you welcomed almost any signs of change or are you claiming that there really was a change for the better, rather than just for the bigger and brasher?*

I think there was a potential change for the better – Hopper, yes; Walter Murch, maybe; but Lucas and Spielberg, no, you're right. In a nutshell, *Star Wars* was *The Sound of Music* all over again. But I would like to rephrase my point in another way, if I can. This key period, from the mid-60s to the mid-70s, was one of genuine renovation, both for avant-garde film and for Hollywood. In the avant-garde, the impetus finally drained away, although important films continued to be made, and I think the long-term result was the incorporation of avant-garde film practice into the art world via video art. In Hollywood, the long-term result was a restabilisation of the industry, in which Spielberg and Lucas emerged as key players and Scorsese as a *grand maître* who never won an Oscar. For one brief, exciting moment auteurism and avant-gardism made contact – look at *Performance* or *Stereo* – and then, of course, they broke apart again. Inevitable, but a tragedy.

Only a tragedy if you believed in it, I would say.

Well, I still like to imagine there could be an eclectic cinema with that same kind of contact once again.

Let's get back to film theory. Always a safe haven.

So much less controversial!

I have a question about the auteur theory. Your version was unabashedly Structuralist. You took the politique des auteurs *and gave it, so to speak, a Structuralist make-over. Do you have the same reverence for Lévi-Strauss today?*

Well, I'm not a Structuralist today. But I'm not a Post-Structuralist either.

So what are you?

Let me go back to Structuralism first. The Structuralist–auteurist chapter in my book derives directly from the short critical essays which you wrote for *New Left Review*. The problem with those pieces though, as I saw it in 1968, was that their theoretical framework was supplied by Lucien Goldmann and his concept of 'world-view'. Then, not long afterwards, Structuralism and semiology hit Britain in a big way – Claude Lévi-Strauss and Roland Barthes. Barthes's *Elements of Semiology* swept me off my feet, first when I read it in French in *Communications* and then when it came out in translation as a Jonathan Cape pocket-book. Barthes was still a militant Structuralist and so I naturally turned back to re-read Lévi-Strauss, who I hadn't looked into since his great ethnographic memoir, *World on the Wane*. Rereading Lévi-Strauss, I saw how your work could be reconfigured by using Lévi-Strauss instead of Goldmann.

It was a productive idea at the time, I must admit. But what do you think about Structuralism now?

Well, in the mid-1970s, I went to work in the Linguistics Department at the University of Essex. It was a strange experience. The faculty members all had their 'own' languages, in which they were specialists, and I was viewed as the expert on a language called 'Film'. Although there was some interest in semiology there, the main preoccupation was with Chomsky's transformational grammar and the battle over the revisionist critique of Chomsky which was raging at the time.

What was all that about?

Montague logic, generative semantics, things like that. In any case, I got a really thorough grounding in Chomsky's linguistics and the technical arguments for and against it.

So what was the relevance of all that to film studies?

That's what I'd like to explain. The one thing that everyone agreed upon was that Structuralism was utterly irrelevant. Saussure was dead as a doornail. Jakobson was an honoured but superseded pioneer. There were no French linguists worth talking about, least of all Martinet, the leading French Structuralist. In effect, everybody accepted Chomsky's arguments against Structuralism as taken for granted, however much they might differ about Chomsky himself and what should or should not come after him. I was stunned by their curt dismissal of Saussure, whose work was the fundamental starting-point for Lévi-Strauss, Barthes, Lacan and even for Derrida. Suddenly, I discovered that Saussure wasn't taken the least bit seriously.

Chomsky's revolution had shifted the nature of the whole field. His work was all about syntax and about sentences, about the rules which mapped meaning on

to sentences through their hierarchy of clauses and sub-clauses, through word order and through the morphology of the constituent words. Saussure hardly mentions syntax. Neither do Barthes or Jakobson. They assume that semantic content is mapped directly on to syntactic form in a relatively unproblematic way.

Chomsky's demolition of Structuralism was summed up by his famous example of the inescapable difference between 'John is easy to please' (in which 'John' is object of 'please') and 'John is eager to please' (in which 'John' is subject of 'please'). The two sentences have the same surface appearance, but they have two quite contrary patterns of meaning, one in which John is pleased and the other in which he pleases. The two sentences may look the same but, in reality, they have these very different underlying structures.

There is no direct relationship between signified and signifier. The deep structure is not mapped mechanically on to its surface structure. Instead, there is a complex system of syntactic rules which transform semantic input into surface output. Saussure didn't deal with that at all. Yet now the question became, 'What do the syntactic rules look like?' For the Structuralists, that question didn't even arise.

True, but nobody has managed to come up with a successful theory of what the syntax of cinema might look like, have they? In fact, as far as I remember, you toyed with the idea of using Vladimir Propp's morphology of narrative as the basis for a film grammar, but you never really explained how narrative came to be transformed into film language.

You're implying that the linguistic model was doomed from the start, that it didn't lead anywhere, and that introducing Propp failed to save the situation. I understand why you might say that, but it's certainly not the conclusion I reached. Yes, I was eventually forced to reject both Saussure and Chomsky as models, but I still believe that film has a grammar. I began to be interested in the way creole languages develop. Creoles are real-world models of how new languages are formed on the ground, historically. And that led me to Talmy Givon's work on functional grammar.

I don't want to sound sceptical, but what made you think you could solve these problems with yet another dose of linguistics? How does that relate to the role of narrative?

Like any other language, film language must have developed historically through a process of 'grammaticalisation'. With verbal language, we can see how this works in the development of creole languages out of pidgins. And a similar kind of process must have taken place with the grammaticalisation of film language. The pressure to grammaticalise clearly had to come from the practical need to tell a story, which then explains why a theory of narrative was needed.

And what does that lead you to in practice?

Well, for example, if we look at the way in which verb forms develop, specifically

in relation to storytelling, as Givon has described it, we find that they differenti-
ate first between tense, mode and aspect. Tense signals a departure from the main
time-line of a narrative. Mode indicates a shift into the non-factual or doubtfully
factual – the subjunctive, the conditional, or even, in some languages, the future.
Aspect signals that actions are habitual or ongoing, rather than completed events.
In the cinema, flashbacks are tense-like; dream sequences are mode-like; montage
sequences are aspect-like. Film also needed to develop ways in which the case roles
of participants in an action could be pinpointed, ways in which the semantic
shape of actions or happenings was clarified, through the system of master shot,
medium shot and close-up. Close-ups of a face, for example, show the case role of
'experiencer', rather than the action-related roles of 'subject' or 'object', as we can
see in early Griffith.

*How does all this relate to Peirce? By choosing Peirce rather than Saussure as your
semiotician of reference, hadn't you already downplayed the importance of the lan-
guage model?*

True, because even then I wasn't convinced that the Saussurean model was
adequate for film. Peirce sees language as just one of many sign systems, each op-
erating with different kinds of rules. I think that is plainly true of the cinema. It
has a documentary and a pictorial aspect as well as a symbolic or language-like
aspect. I was interested in the way that the three main trends in film aesthetics
seem to run parallel with the three types of sign which Peirce had isolated – the
index, which is existentially linked to its object, like a thermometer reading;
the icon, which signifies through resemblance to its object, like a picture; and the
symbolic, which has an arbitrary relation to its object, like a word. Realist aes-
thetics are a projection of the indexical, pictorialist aesthetics are a projection of
the iconic, and what we might call 'discursive' aesthetics, with the stress on con-
ceptual meaning, are projections of the symbolic.

*Fair enough. A comprehensive aesthetic of the cinema certainly has to deal with all
three types of sign and the complex kinds of relationship which can exist between
them. I wonder whether there isn't the basis for a theory of genre here, distinguishing
documentary, dramatic and essay film.*

Well, I would argue for a combination of all three genres: documentary, drama
and essay, to use the full potential of cinema. *Riddles of the Sphinx* was intended
to exemplify that kind of experimental pan-generic genre.

*So the theoretical aspects of your book are directly relevant to your film-making as
well as to film study?*

Absolutely. At the time I wrote the book, I still had not done any film-making, but
I was writing scripts and it was definitely there on the agenda. And then the ar-
rival of the new Godard and structural film and experimental narrative, like
Yvonne Rainer's *Lives of Performers*, or Chantal Akerman's *Je Tu Il Elle*, all set me
thinking about film-making in terms of the avant-garde rather than the industry.

I remember you had been involved in the industry.

Yes. In 1968 I was still involved with screenwriting, with my writing partner, Mark Peploe, and soon afterwards we wrote the script for *The Passenger*, which Antonioni directed. After *The Passenger* went into production, I sort of thought I'd achieved whatever goals I ever had as far as the industry was concerned – Antonioni, MGM, Jack Nicholson! So I turned to film-making myself, but as an experimental film-maker, working with Laura Mulvey. We saw our work as film-makers as closely connected to our work as theorists. Of course, Eisenstein was the distant model for this, even if he was defeated in the end.

Isn't there something defeatist about the whole idea of commitment to experimental film, an idea that the industry is fundamentally irrecuperable?

I am tempted to answer 'So be it'! What is wrong with a commitment to experimental film? To me, the most exciting Hollywood directors always had an experimental edge. What are the great Hollywood films – Griffith's *Intolerance*, Keaton's *Sherlock Junior*, Murnau's *Sunrise*, Sternberg's *Morocco*, Chaplin's *Modern Times*, Welles's *Citizen Kane*, Hitchcock's *Rope*, Fuller's *Shock Corridor*, Kubrick's *2001*, Ridley Scott's *Blade Runner*. They all have an experimental dimension. I am a great admirer of the few film-makers who have managed to balance a professional career in the industry with an ongoing commitment to experiment. Like everybody else, I have some petty reservations about Peter Greenaway's films – but there is absolutely no doubt in my mind that he set a truly heroic example for others to follow.

Is Eisenstein's example still relevant? He taught in a film school, didn't he, during the lean times of the 1930s? Do you think theory and practice can be combined even in film school?

Eisenstein taught directing in a way which included teaching theory. But that's very rare. In my experience, even the best film schools keep the two apart. They might argue that film-making simply doesn't leave enough time for serious study of film theory, but I think that is just a way of avoiding the issue. In an ideal world, production students would have a solid grounding in history and theory, just as academic students should have a grounding in production. But it isn't going to happen. The division between the two curricula gets more and more engrained each year that goes by.

It matters?

Yes, it does matter. It really troubles me that most students who are doing academic degrees never get a serious chance to make a film – and vice versa, that production students don't have the time or the mind-set to think seriously about film theory.

What are you talking about? Separatism? Philistinism?

The system simply does not work in the way it should. That's why it's so astonishing to read Eisenstein's class lectures. His directing classes did not simply draw on his practical experience, but were crammed full of theory as well – semiotics, aesthetics, art history.

How did that come about? I mean his interest in theory.

Restless curiosity. His background in experimental theatre. And then he must have been influenced by the way Marxism stressed the need for theory as a guide to practice.

But he is unique even among Soviet directors.

Yes but, if you look closely, you will find there is a theoretical dimension to the way in which many great directors approached their work, in Hollywood as well as in Europe. Eisenstein was much more systematic than most, but there are fascinating insights in the occasional writings of Sternberg or Hitchcock, for instance. Academic theorists don't pay nearly enough attention to Eisenstein, let alone the work of other film-makers. But they are well worth studying.

Do you want to revise your account of Eisenstein's career at all, with the benefit of hindsight?

Well, so much more of his writing is available now. But I am not sure that I want to revise the main lines of what I said in *Signs and Meaning*. It still seems accurate to me and, in general, it has been confirmed by all the new publications – the only revisions I might make are shifts of emphasis rather than shifts of substance. But I think the main thrust of new research is still to come. I would assume it will be in the area of political history and its impact on Eisenstein. There must be an enormous amount of material buried in the former Soviet archives which will throw fresh light on Eisenstein's career. We should eventually be able to reconstruct all the subterranean twists and turns of Soviet policy for the arts and the cinema. We know the public history of all that, but there must be a secret history as well, which will slowly come to light as the files are finally opened.

You drew a clear distinction between Eisenstein's career in the 20s and his career after the consolidation of Stalin's rule, when he was forced to make painful accomodations – not only to continue working, but presumably even to survive.

Yes, I'm surprised he was able to work on *Ivan the Terrible* after producing Wagner at the Bolshoi, during the period of the Stalin–Hitler pact. And then there are his 'pornographic' drawings (Salome, St Sebastian, the crucifixion of Christ). How do they relate to his films or to his homosexuality? How does religion fit in? Eisenstein's private life is still very obscure – it's not on the public record. It is all a matter of anecdote and speculation.

The Mexican work may be crucial, because it was less constrained – he had dropped over the horizon, so to speak.

Que Viva Mexico! *(S. M. Eisenstein, 1931).*

Exactly. It is a fascinating period in his career – and not only sexually. William Harrison Richmond's book, *Mexico Through Russian Eyes*, is full of thought-provoking material. I should like to know a lot more about Eisenstein's conversations with Siqueiros (in which Hart Crane also participated) and the ways in which they influenced each other. Those took place in Taxco in 1932 and apparently they discussed aesthetics, the role of art in politics and the role of folk art. And I am very intrigued by Eisenstein's working visit to the town of Tehuantepec, where he shot part of *Que Viva Mexico!*

Tehuantepec?

The image of the Tehuana woman, from Tehuantepec in the south, was a constant artistic preoccupation in the Mexican Renaissance. After his return from Paris, Diego Rivera was sent down to Tehuantepec by Vasconcelos, the revolutionary Minister of Culture, in order to reassimilate himself into Mexican life, and Tehuana women appear prominently in his great murals in Mexico City. Frida Kahlo adopted Tehuana costume for her self-image of choice, in self-portrait after self-portrait. Tina Modotti made the pilgrimage to Tehuantepec to photograph Tehuana women. Even Eisenstein's 'caretaker' on *Que Viva Mexico!*, Best-Maugard, did a gouache of a Tehuana.

 Perhaps my interest is a bit exaggerated – I co-curated a retrospective show of Kahlo and Modotti as well as writing about Eisenstein – but, a few years ago, I was lucky enough to see a great show in Mexico City tracing the whole history of Tehuana imagery in Mexican art and it began to dawn on me how important it had been to Eisenstein. He was familiar with a whole range of theories about

'primitive matriarchy' (Bachofen, Engels, Lévy-Bruhl and others) and it certainly tied in with both his semiotic and his cultural interests. I think it relates to his interest in James Joyce's *Ulysses* too.

Do you think Eisenstein's theories were themselves a kind of myth which he needed for his artistic work?

I don't think 'myth' is the right term. I think they might fall under the heading of speculations or hypotheses. But then you could say that about Barthes or Eco too. Semiology is still a new field of enquiry and consequently it has to be concerned with hypotheses, rather than established truths. Any new discipline is going to be hyper-conjectural, in comparison with other, more established fields. But that is not a shortcoming. It is a necessity. And it's fun.

And your use of Peirce in relation to the cinema is speculative too?

Look, one of Peirce's books is actually entitled *Speculative Grammar*. I don't have any problem with the speculative. It is an absolutely necessary component of any serious thought. Look at Freud and Lacan! You couldn't be more speculative! Speculation provokes critique and counter-argument and re-formulation, which are all part of the process of theory-building. Peirce is very clear about this in his writings on 'abduction', which he sees as a necessary part of theory-building, of equal weight with induction and deduction. 'Abduction' is his term for the process of forming hypotheses and conjectures. It involves an element of guesswork marshalled to explain an otherwise surprising fact. Peirce believed that guessing was an intrinsic part of science, just as crucial as observation or reasoning. You should look at the book Umberto Eco put together with Thomas Sebeok. It is called *The Sign of Three*, and it is subtitled 'Dupin, Holmes, Peirce'. That is the same Dupin we meet in 'The Purloined Letter'.

Poe or Lacan? And the Holmes is Sherlock?

Precisely, my dear Watson.

So you think theory advances by asking questions, creating conjectures, forming hypotheses by abduction, testing them inductively by asking another question, and so on?

Yes. As Jaako Hintikaa put it, in *The Sign of Three*, we need 'a sharp theory of the question-answer relationship'. Hintikaa sees question-and-answer sequences as 'games played against nature' – nature is our opponent as we attempt to pry out new bits of knowledge, which we can use to formulate further conjectures, which lead to more questions, in a chain of interrogation. I find this emphasis on questioning rather than answering very sympathetic.

Yes, you would. After all, you made Riddles of the Sphinx.

Absolutely. That's a film structured entirely around a series of questions which it

asks in order to challenge Lacan's assumption that language is primarily a vehicle for the patriarchal Law, rather than for the matriarchal Riddle. It's about how Lacan's writings themselves need to be questioned rather than presented as the 'Law' – but we are probably straying too far from *Signs and Meaning* ... which needs to be questioned too! That's your job!

You were saying earlier that Signs and Meaning *should be read in conjunction with viewing your films, weren't you?*

Very true. But writing books and making films remain very different kinds of discourse, each with its particular kind of questioning. Maybe there is a reciprocal relationship. *Signs and Meaning* asks the question, 'What kind of film should we make?', which *Riddles* answers. Then *Riddles* asks, 'What kind of theory should we write?'.

What kinds of questions do you think film theory should be asking us now?

Questions about the avant-garde. And the questions we were talking about earlier – film pragmatics and film language, the way in which film became grammaticalised.

What do you mean by 'film pragmatics'?

The way in which film language evolved in response to practical needs and problems. If we look at the development of film language during the early years of the cinema, we can see that it responds to the practical needs of narrative.

What drives the pragmatic development of film language? Could you give a concrete example from a particular film?

I shall try to. I'll choose a fairly standard example from the early years of cinema. Let's take a look at André Gaudreault's essay on 'The Development of Cross-Cutting', in Thomas Elsaesser's anthology *Early Cinema*. Gaudreault is discussing a well-known Edwin Porter film, *Life of an American Fireman*. There are two extant versions of this film, one with nine shots, made in 1903, called the 'Copyright' version, and one with twenty shots, called the 'Museum of Modern Art' version. They are identical up to the last two shots of the 'Copyright' version, which were broken down, in the 'Museum' version, into thirteen separate cross-cut segments.

Concretely, in the 'Copyright' version, the next to last shot (Shot 8) shows a continuous series of mini-events occurring in the interior of an upstairs room in a burning house – (a) a woman wakes to find her room filled with smoke, (b) she goes to the window, (c) she staggers back and collapses on her bed, (d) a fireman enters through the door and breaks the window, (e) he lifts the woman up and carries her through the window, (f) he re-enters the room and picks up a child and leaves again through the window, and (g) two more firemen come through the same window with a hose and extinguish the fire.

Then, following that, in Shot 9, the final shot, we see the same rescue sequence

171

Life of an American Fireman *(Edwin S. Porter, 1903).*

from the exterior of the house – (a) the woman appears at the window, (b) a fireman enters the house, (c) firemen place a ladder against the house, (d) the fireman carries the woman down the ladder, (e) the fireman remounts the ladder and the woman despairs, (f) the fireman reappears with her child and the mother welcomes and hugs her.

But, in the later 'Museum' version, the same rescue sequence which is shown in these two single shots (as interior and exterior views) is broken down into thirteen alternating shots (seven from Shot 8 cross-cut with six from Shot 9). This 'alternating' version is generally considered to be a later 'improvement' of the 'Copyright' version, which incorporated the new developments in cross-cutting which we associate with D. W. Griffith.

Gaudreault discusses this film in purely temporal terms. The key concepts, for him, are 'simultaneity' and 'succession'. He argues that there are two simultaneous lines of action in these shots and that cross-cutting works because it provides the means 'to express simultaneity by means of successiveness'. But, in fact, although different aspects of the event may be simultaneous, they are not really separate lines of action. Threat and rescue may be co-occurrent, but the threat motivates the rescue and the more urgent the threat, the more urgent the rescue becomes. There is a logical relationship between threat and rescue. Cross-cutting captures the complex logical structure presupposed by rescue, which involves a succession of sub-actions, a multiplicity of participants and an ongoing separation of spaces. The temporal logic of the event is sequential, but the spaces in which it takes place are discontinuous, until we reach the happy end and the rescue is concluded.

172

You are saying that time and space are semantic features of the narrative – they shouldn't be seen as independent of it?

Exactly. Cross-cutting is a 'linguistic' device which grammaticalises a specific type of narrative action. It gives priority to the internal morphology and development of an action – in this case, the action of 'rescue', which itself presupposes, first peril, then communication, then physical movement between two spaces and two roles (rescuer and rescued). The separation of spaces and the logical succession of sub-actions both derive from the underlying semantic features of rescue from peril. In fact, as cross-cutting developed, it discarded simultaneity. Short segments of logically related action alternate without overlapping at all.

It seems that what you are doing is arguing down from an analysis of the whole narrative in Proppian terms to the morphology of each narrative function subdivided down into constituent actions and sub-actions.

That's right. Propp was correct to point out that narrative is a logical rather than a chronological system. And then each action and sub-action has an inherent case structure or 'valency'. Thus rescue = rescue of x by y from z in such and such a place – or places. Experiencer, patient, agent, ablative, locative. Each action is broken down so that its semantic contours and its case structure are clear. The fire is 'agent' of peril. The firemen are 'agents', or subjects, of rescue. The damsel in distress is the 'experiencer' of peril and then the 'patient', or object, of rescue.

So the development of film language can be viewed as a process of problem-solving – how to clarify the semantic and logical structure of each event within the narrative, in the most economical way possible.

Precisely. If film had developed in a different way – as portraiture, or as landscape, or as diary (all genres which exist under the general heading of 'experimental film'), then the language would have evolved differently. That is why experimental films are difficult for people to grasp. The fact that they are non-narrative means that they employ, or imply, a different kind of film language. You have to learn it. Experimental films often are abstractly analytic in terms of space and time, and they are not necessarily story-driven.

How does this relate to what you said about film aesthetics? Going back to Riddles, *it seems you wanted to make a film which was both story-driven and yet reacted against narrative syntax. Isn't that some kind of a paradox?*

Yes, it tells a story – or more than one story – but it does not use the conventional film language.

It uses a series of 360-degree pans, each showing a single unbroken sequence, containing one principal action.

In a way, 'it was constructed like a necklace', as Eisenstein said of *Que Viva Mexico!*

173

In fact, it went further than Eisenstein, because we subordinated the action to framing and composition. We de-dramatised even further. We saw the dramatic story as simply an underlying fable which echoed the Oedipus story as seen through the lens of Jacques Lacan and Maud Mannoni. I suppose we wanted to take Eisenstein's idea of 'intellectual montage' into another dimension, into an even more radical deconstruction of mainstream film language.

Why? How do you relate this to your auteurism and your loyal praise of Hollywood cinema – or at least your appreciation of Hollywood's 'pantheon' directors?

There are two ways of answering that. The first is to say that I followed Godard in moving out of the Hollywood orbit after being formed by it. The second is to say that I was very influenced by Godard's example, but I also became increasingly critical of it, as he began to abandon storytelling, or to minimise it. I wanted to re-tain narrative, but to tell stories in a different kind of way. The first film I made with Laura Mulvey, *Penthesilea*, was in the form of a palimpsest, telling the same story over and over again, each time in a different mode or style. Juxtaposition rather than continuity.

So you rejected Hollywood but you could still retain an interest in storytelling and narrative?

I feel as if you are somehow forcing me into making a confession. My cinephilia, my obsessive love of the great old Hollywood films, never ever left me. I could not rid myself of it, even if I wanted to. In the end, it reasserted itself. At some level, cinephilia simply transcended the politics of art or the aesthetics of the avant-garde. That same cinephilia, after all, was really the basis of my conviction that cinema is an art, that aesthetics is more important than ideology. It explains why I never liked the idea of culture or 'Cultural Studies'. I wanted art and aesthetics.

Can you explain that a bit? How did you see the difference between 'art' and 'culture'? What was it about 'art' that made it a priority for you, and what was it that you dis-trusted about the idea of 'culture'?

You know, I have never been very explicit about this, but it has been implicit in everything I have ever written about the cinema. I am interested in art and I am interested in ideas, but I have never understood the appeal of 'culture'. I will try and analyse it for you, but I am not sure how successful I shall be. Personal taste gets mixed up with intellectual history!

As you must know, the idea of 'Cultural Studies' comes from England, and it was enshrined in the title of the Birmingham Centre for Contemporary Cultural Studies, founded by Richard Hoggart back in 1961. Hoggart was joined there by Stuart Hall, after he resigned from the editorship of *New Left Review*. Birmingham gave an institutional form to the approach developed in Hoggart's own *The Uses of Literacy* (1957) and, of course, Raymond Williams's magisterial *Culture and Society*, which came out the next year, in 1958.

These two books promoted the idea of 'culture' as the expression of a com-

munity's way of life. In both cases, the writers drew on their own childhood experience, growing up in the working class, explicitly with Hoggart, implicitly with Williams – who was more explicit in his novels. I suppose this idea drew on T. S. Eliot and F. R. Leavis, the first of whom was a radical conservative and the second a conservative radical. They both proposed the idea that culture was a way of life, which gave texture and meaning to social existence. They were both extremely suspicious of the commercialised mass culture of the twentieth century and, in Leavis's case at least, there was also a deep-seated resentment of class privilege and the idea of culture as the property of an élite rather than the people as a whole.

Hoggart's book articulated his attachment to the working-class culture in which he was brought up and his confusion when, as a result of the long-awaited democratisation of the universities, he found himself inducted into the privileged élite. Williams's book, on the other hand, traced the ways in which a battle for the concept of 'culture' had marked British intellectual history, concluding with an attack on mass communications and a renewed call for the revitalisation of a common culture – a 'living culture' – based both on natural growth and on its careful tending.

How did you react? Negatively?

I am afraid I came down on the side both of aestheticism and the mass media. Let's talk about the mass media first – specifically, American cinema. This whole trend of thought – Orwell, Hoggart, Williams – was explicitly and implicitly anti-American. The cultural community they wrote about was traditional and English – or perhaps I should say British, without trying to unravel the distinction. They recognised that Britain was the country with the longest history of proletarianisation and consequently with a working class which had enjoyed, if that's the word, the opportunity and the length of time necessary to create an organic way of life and its own rich culture. This culture was now threatened by a new wave of commercialisation, not from within, as with the rise of the mass circulation press, but from without, with the invasion of the Hollywood film.

Williams held the line against Hollywood with tenacity. He did not denounce the cinema as such. In fact, he was a pioneer in introducing film into the university – at Cambridge where he taught – and he even co-wrote a book about the cinema, *Preface to Film*, with Michael Orrom, a friend who came out of the British documentary movement. But he kept well clear of Hollywood – except for Griffith, I think. After that he looked at Eisenstein and Pudovkin, German silent cinema and then on to Bergman and eventually Godard. I had a completely different view of Hollywood. In effect, I felt that British culture was stifling, from top to bottom, across classes, and my conclusion was that it needed input from abroad to break up its provincialism and insularity. Hence, my interest in Hollywood cinema and French theory came from the same root. It was a kind of pincer movement – low art from across the ocean, high theory from across the Channel.

What is the burden of this distinction you are making between 'art' and 'culture'? Is it a clear distinction or is there a kind of gradient between the two?

Well, if we accept Williams's definition of culture, then art is clearly distinct. Art

means a body of texts rather than a way of life. Actually, I am not so far away from Williams in my views about art – Williams looked on artworks as texts and stressed the primacy of form. Maybe he had a different interpretation of what he meant by 'text' or 'form', but the necessity to distinguish art from culture in that kind of way was still implicit. Also, Williams was eager to reject orthodox views about taste and quality. One of the things he especially liked about I. A. Richards's work, for example, is that Richards would give students texts to read without telling them who the author was. He discovered that their aesthetic response was quite different when the canonical status of a work was not signalled by an authorial attribution.

Then, when Williams wrote about Ibsen, it turned out that he preferred *Ghosts* to *A Doll's House* and vigorously defended this choice, when he was challenged, by arguing that the 'whole mode of composition' was more serious in *Ghosts* and that its form was much more significant, irrespective of whether it was more socially progressive. For Williams, art had a role within culture, but it clearly was not the same thing as culture. Parenthetically, I should add that, for Williams, film was a prolongation of drama, so that Bergman was following in the footsteps of Strindberg. Film was a dramatic art.

Not a visual art? What do you think?

I think film is plainly a polymorphous art. There is a limited sense in which film is a visual art, but it is also a narrative art, a dramatic art, a kinetic art, an auditory art, a performance art and so on. It operates on multiple sensory bands – optical, auditory, even tactile – and with multiple sign systems. That is its great strength as a form.

That it is polymorphously perverse.

If you like. But the point I was making is that art is defined by its formal qualities, by the way in which a text is structured. Film is formally distinct from theatre though related to it. Within the cinema, genres are formally distinct, and so are movements like Expressionism or Poetic Realism or Structural Film, and so are auteurs. At the same time, art, as Williams pointed out, is also the site of a kind of truth – an 'imaginative truth' in his terms. A work of art is a vehicle for a way of viewing the world, a way of framing it thematically – re-situating it, in a unique way, as what I called a 'heterocosm', in the auteurism chapter of *Signs and Meaning*. Thus, we can look at Hawks, for example, and see recurrent stylistic qualities in his films, but also recurrent thematic preoccupations, which together give his work its 'form', in Williams's sense of the word.

Williams ends his book on drama by talking about Brecht. He sees Brecht as having created a new and original dramatic form. Again, at this point, there is a convergence. Williams argued that Brecht's innovation was to transform naturalism by replacing the indicative mode by the subjunctive – in fact, on this basis he eventually called for a Brechtian cinema (or television) which in his words would be 'the combination of three directions, the more mobile dramatic forms of the camera, direct relationship with more popular audiences, and development of

subjunctive actions'. That is not so far from my position, except that I would interpret every single one of those conditions in a very different way.

Didn't you call for a Brechtian cinema too? Wasn't that one of your watchwords when you were writing in Screen?

Yes, but Williams's idea was that camera mobility could give film the freedom of the novel and the ability to move into and through open spaces, while still retaining its dramatic form. But in *Riddles of the Sphinx* our project was to use camera mobility to produce an estranged look at the world, which destroyed the possibility of empathy. Brechtian, of course, but very different from Williams. The idea was to use a popular form – storytelling through film – but direct it towards specific subcultures, artistic, political and intellectual. Finally, he defines 'subjunctive actions' as those which ask the question: 'If we did this, what would happen next?' He is talking about outcomes in possible worlds – kind of thought experiments. But I think you can only understand this tactic of Brecht's in conjunction with his theory of the *'gestus'* – the idea that something was being demonstrated, that he was presenting the audience with a kind of socio-political diagram, which would provoke them into formulating questions of their own.

I would like to get back to Hollywood, to mass cinema. How does Brecht fit in with Hollywood?

Awkwardly, in practice. In theory, there was a close fit. Brecht adored cheap popular culture. For me Sam Fuller was the Hollywood Brechtian. There wasn't any direct influence. But Fuller had similar tastes to Brecht – cheap popular culture, pulp novels, tabloid journalism – which he wanted to redeem, if that is the word, by using them as a means of attacking crucial and topical questions of ethics and politics, as Brecht did. Fuller went straight for the pressure points. His films are like fables of our epoch, and they ask questions. *Run of the Arrow* actually finishes with an unresolved plot and a closing subtitle – 'The end of this story will be written by you' – directed straight at the audience.

Fuller, yes. And I know there is a kind of Brechtian argument for Sirk. And Brecht himself admired Welles's work in the theatre. But what about Sternberg? Or Hitchcock?

Sternberg is more on the side of Breton than Brecht. *Shanghai Gesture* – mad love, oneirism. The other side of *Cahiers* taste – alongside a taste for B pictures and pulp fiction – was a taste for the delirious. I always loved films like *Shanghai Gesture*, or *Pandora and the Flying Dutchman*. Maybe Charles Laughton somehow combines the two elements in his *Night of the Hunter*. That's a really great film. He must have learned something from Brecht.

And Hitchcock?

There is a surrealist side to Hitchcock, for sure – dream films like *Vertigo*, *Marnie*, *The Birds*. He knew a lot about surrealism and he talked about it.

177

Night of the Hunter *(Charles Laughton, 1954).*

And he hired Salvador Dalí to work on Spellbound.

He was a master of the uncanny. And, like Welles, he was fascinated by magicians.

While we are on Hitchcock, I should like to backtrack to the question of Hollywood films and French theory. How did that particular pairing come about, in your view?

Well, obviously the link was *Cahiers* and, before that, there was the whole post-war French fascination with film noir. It takes us right back to the 20s, to their fascination with jazz and skyscrapers and comic strips. There was a real attraction to the underside of American culture in Sartre's writings as well. And Sartre was a key figure for me, because my interest in French theory itself leads back to Sartre and to Existentialism. In England Laing and Cooper latched on to Sartre as a theorist and the fascination with America showed up simultaneously in pop art and popular music.

On the subject of American popular culture, there is something else I should like to stress. In England, cinephilia ran concurrently with the discovery of American music – I mean Chuck Berry, Little Richard, Muddy Waters, John Lee Hooker, Howling Wolf. Discovering *Run of the Arrow* and *Underworld USA* was the same kind of experience. In the music world this led to the Rolling Stones and the Beatles and all that. In the art world, it was the time of British pop art – Richard Hamilton made conscious allusions to Hollywood. And Pauline Boty. The unlikely aspect of it was the way in which this Americanophilia leapt the tracks

from pop into the New Left. *New Left Review* covered Sam Fuller, as you know, but also John Lee Hooker and the Rolling Stones and even William Burroughs.

That's true. I was partly responsible for that. I think the point with the Rolling Stones was that they took what they got from black blues singers like John Lee Hooker or Howling Wolf or Muddy Waters and then returned it to the United States in a new, mutated form. This never really happened with film. Film was too tainted with the idea of a 'national cinema', whereas popular music wasn't. Although I suppose that if you looked back to the heroic days of British cinema – to Carol Reed and Michael Powell – you could argue that they were 'mutating' Hollywood and sending it back home in a new guise.

In any case, the Old New Left supported a concept of a national cinema which rejected directors like Michael Powell. If you look at the documentaries which Karel Reisz and Lindsay Anderson made in the 50s, they were extremely hostile to 'trashy' popular culture and especially to Hollywood.

Anderson liked John Ford for his sentimental nationalism and for his masculine sentimentality.

Exactly. The shift only came about after the change of guard in 1962 when Edward Thompson and Raymond Williams and the older generation departed into the gloom. *NLR* had a 'national nihilist' streak in those happy days, a wonderful leaning towards dismissing everything English.

You put a pantheon of ten Great Hollywood Directors (Chaplin, Ford, Fuller, Hawks, Hitchcock, Lang, Lubitsch, Ophuls, Sternberg, Welles) at the end of the first edition of Signs and Meaning. *It disappeared from the second edition. Why was that? Change of heart?*

Death of the author? In a way, yes. Basically, I felt that Barthes's and Foucault's famous pronouncements on this subject were, well, ridiculous. They were extreme tropes, generated by their theories of text and discourse. All the same, I still felt called upon to revise my own section on auteurism and give it a Post-Structuralist gloss, pointing out the difference between the manifest 'author' and the latent 'author', so to speak. The author became a kind of effect of the text, which is not so far wrong in itself, but also served to occlude the question of the relationship between the actual author and the textual 'author effect'. I'm sorry about that. Sam Fuller may not knowingly have become 'Sam Fuller', but you couldn't have the latter without the former, and there were real determinations between the two. Biography is relevant to issues around authorship. But then so is textuality.

What would your pantheon be now, nearly 30 years later?

The old one was too conventional, wasn't it? Let's try something different, with a completely new set of names: Sirk, Siodmak, Lupino, Tashlin, Kubrick, Polanski, Cronenberg, Demme, De Palma, Hopper. And I seemed to have overlooked

Scorsese and John Woo. I could go on debating the list with myself for months. All the same, I still think that pantheons are of value. And I am in favour of the idea of the canon, although naturally I prefer revisionist and dissident canons. The canon should be open to the *film maudit*, the film without a future. The Surrealist canon was a great influence on me, when I was still at boarding school – Swift, Sade, Poe, Desbordes-Valmore … down to Jarry, Vaché and Roussel. I never did check out on Desbordes-Valmore though. I still don't know who he was.

Why do you like the idea of the canon?

It's simply a shorthand for a methodical and principled taste. It seems perverse to me to refuse to ask which work is good and which is bad. When you make a film, you ask yourself whether a cut is good or bad, whether a way of delivering a line is good or bad, whether a camera movement is good or bad. Production mainly consists of judgements about value and quality. Critics and theorists shouldn't try to insulate themselves from a discourse which is so intrinsic to art practice. After all, our natural response after seeing a film at the cinema is to talk about whether it was good or bad. On the other hand, canons shouldn't be frozen. We should go on fighting over them, in a passionate and informed and reasoned way, but that is another matter. I strongly believe we need to make judgements of taste and then defend them with rational arguments, as Shaftesbury recommended over two centuries ago. Maybe that means a new aesthetics.

Isn't the canon debate really about identity politics?

Well, it's about what has been 'hidden from history'. All I want to claim is that when we set out to revise the canon, we should be able to argue our position on aesthetic grounds. Of course, we should reinstate Dorothy Arzner and Ida Lupino. We should look again at film-makers like Bill Gunn, who made *Ganja and Hess* in 1970. And we should look seriously at 'hidden' areas of world cinema too – Bombay and Mexico City and Cairo. Kamal Amrohi's *Pakeezah* is a great masterpiece, comparable at the very least with Max Ophuls's *Lola Montès*. I think that Paul Leduc's *Latino Bar*, made in Venezuela, is the great film of the last decade. And then there's Ousmane Sembene, Lino Brocka, Glauber Rocha – what more need I say?

And top ten lists are a kind of shorthand for a shorthand?

Exactly. They are a kind of polemical condensation of a canon which is a condensation of a whole aesthetics – with a personal twist, of course. Actually, my favourite list was the one I was asked to do on sports films for a Finnish film magazine called *Filmihullu*, which means 'Film Crazy'. I started with Hellmuth Costard's amazing football film, in which the camera stays on Georgie Best through the whole of one match. He only touches the ball a few times, but at one of them he scores a goal. You don't see the ball go into the net. You only realise what happened when his team-mates throw themselves all over him.

Strangers on a Train *(Hitchcock, 1951).*

What were the others?

Satyajit Ray's chess film. Godard's *Sauve qui peut,* which has some weird Swiss sport. Greenaway's *Drowning By Numbers . . .*

Wait! Let me be a bit more classical! Hitchcock: Strangers on a Train. *And Hawks:* The Crowd Roars. *Now let's really change the subject. New media. Any closing comments?*

I think there is the same kind of excitement about new possibilities now that there was with experimental film in the 60s and 70s. I am talking about the potential of new media for generating new forms of art, of course. I am not interested in cyberspace, except as a mode of textuality. What is its semiotic structure? What are its forms of discourse?

Signs and meaning in the digital age?

The ultimate aftermath of 1968 – the final disintegration of the 'Public Sphere', perhaps. The triumph of the 'Society of the Spectacle'. The Situationists vindicated! Well, vindicated negatively. 1968 was an emblematic moment which spectacularised the idea of change itself, but, as always, history plays strange tricks and the change which came wasn't the one that had been expected. It was the end of

Fordism, the end of Keynesianism, the end of classic social democracy, the beginning of a new world order, constructed around a string of world cities linked by a lattice of electronic communications which facilitated a sweeping reconfiguration of world capital.

Was Marx vindicated? And all his discredited theories about the organic composition of capital and the immiseration of the proletariat proved correct?

It looks that way, doesn't it?

And the links between aesthetic and political avant-gardes?

We probably need to ask whether there are any avant-gardes at all? In the public consciousness, at least. Unless we want to say that the avant-garde has mutated into MTV and high-style advertising.

So you have mixed feelings about current trends in art? What about current trends in the universities?

I have become much more attached to history and to the writing of history. I enjoy reading Shaftesbury and Lessing and Schiller. I reread Eisenstein and Kracauer and Arnheim. I don't consider them irrelevant. When the future is unclear, it's good to delve back into the past and see what looks new amid the old, what can be salvaged in an unexpected way, what gives a new twist to our perception of the present. *Signs and Meaning* discusses Lessing and emblem books and medieval *tituli*. Thinking theoretically is inseparable from thinking historically.

Who was Shaftesbury? What exactly can you learn from him?

Well, Shaftesbury was an English virtuoso who died in Naples in 1713. He was educated by John Locke, the philosopher, who was his tutor. Locke had been the political adviser and speech-writer for his father. Shaftesbury always insisted on the need for a rigorous theory of taste. He was reacting against the doctrine of the *je ne sais quoi*, which he associated with French court aesthetics. He wanted, as he put it, 'to dissect the *je ne sais quoi*. And in his *Second Characters*, which he was writing at the time of his death, he preceded Lessing in distinguishing between the semiotic systems of narrative and visual representation. There is a clear line which runs from Shaftesbury to Lessing and then on to Arnheim's *A New Laocoön*, which sets out to theorise the relationship between sound and image in the cinema. Finally, Shaftesbury consistently stressed the links between aesthetics, ethics and democratic politics.

And old films are as important as old theories?

Yes. Why do you think we have suddenly become so interested in early cinema? It's

more than archaeology. It is to regain a sense of cinema as potential, not yet frozen into the world spectacle. It is to imagine a renaissance.

But can cinema ever be as central as it seemed to be in the 60s? Debates about cinema don't seem to be as important as they used to. Aren't digital media going to change everything?

Not long ago, when I was thinking about the rise of multi-channel television and the new media, I wrote a piece saying that Hollywood film might become an extinct art like stained glass or fresco or tapestry, which were once dominant in their day. I think I was being over-rhetorical. Digital technology is being absorbed into the cinema. For the time being, at least, it has revitalised Hollywood, helping to create more and more action-packed spectacle, an extravagant technological sublime. It has shifted the cinema away from the indexical towards the iconic register, perhaps.

That sounds right. Away from realism and towards spectacle. While retaining narrative as its deep structure.

Retaining it but speeding it up. Compressing duration. In contrast, in a kind of dialectical reversal, I expect to see new experiments, new concepts, new cinematic art forms, new alternatives to Hollywood and, to accompany them, new modes of theory. In short, new signs and new meaning in a new cinema.

That must be the cue for your slow walk into the sunset.

Music. Roll end credits!

Index

184

187

Acknowledgments

We should like to thank the Novosti Press Agency for their help in illustrating the Eisenstein chapter: the photographs of his production of *The Wise Man* were provided by them, as were the photographs of Stanislavsky's production of *Armoured Train 14–69* and the set for Meyerhold's production of *Dawns*, and the portraits of Stanislavsky and Max Reinhardt. They also gave us their permission to reproduce the four drawings by Eisenstein. The Trustees of the British Museum kindly permitted us to reproduce the Toulouse-Lautrec poster, and the prints by Sharaku, Daumier and Hogarth.

Ullstein Bilderdienst provided the Brecht photos. The photograph of Kabuki theatre was kindly supplied by the Japanese Embassy.

We should also like to thank the various companies, stills from whose films appear in this book, especially: Anouchka Films (*La Chinoise, Made in USA*), British Lion (*Saga of Anatahan*), Columbia (*Only Angels Have Wings, His Girl Friday, Lady from Shanghai*), Contemporary (*Time in the Sun, Kino-Pravda, La Règle du jeu, Toni*), Ganton (*Maciste the Mighty*), MGM (*Mrs Miniver, On the Town*), Paramount (*The Devil is a Woman, Vertigo, Hatari!, The Man Who Shot Liberty Valance, The Emperor Waltz, Donovan's Reef, To the Last Man*), Rank (*Henry V, The Mummy*), Republic (*The Bullfighter and the Lady*), 20th Century–Fox (*Gentlemen Prefer Blondes, My Darling Clementine*), United Artists (*The Prowler, Scarface*), Universal (*All that Heaven Allows*), Warners (*The Searchers, The Rise and Fall of Legs Diamond, Land of the Pharaohs, Cheyenne Autumn, A Midsummer Night's Dream, Gold-Diggers of 1933, Air Force*). Finally, the author would particularly like to thank Brian Darling for allowing him to look through his collection of *Esprit*.